EXPLORING WORLD ART

EXPLORING WORLD ART

Eric Venbrux
Pamela Sheffield Rosi
Robert L. Welsch

WAVELAND
PRESS, INC.

Long Grove, Illinois

For information about this book, contact:
Waveland Press, Inc.
4180 IL Route 83, Suite 101
Long Grove, IL 60047-9580
(847) 634-0081
info@waveland.com
www.waveland.com

Contents

Preface

Imagine a world without art. It would be a world without one of humanity's greatest achievements—not a nice place to have in the mind's eye. Luckily, ever more art from all over the world is coming within our reach. Times are changing and so are the ways in which we view art. In light of such a beneficial time, this reader invites students to explore world art.

Many of the articles in this volume represent case studies about contemporary art in a specific part of the world. The art traditions discussed blur the conventional boundaries of "tribal art," and the authors address intricate questions about the connections between local artists and the global art market. Numerous facets of the complex array of social, economic, political, and cultural factors that together make up world art are presented, providing examples of intercultural relationships, meanings, and movements of materials, ideas, styles, and people. Together, these articles bound the phenomenon we refer to as "world art." Through them, students will become acquainted with how contemporary art in non-Western contexts is being shaped and influenced by global art worlds.

The design of this collection is intended to help students grasp the authors' arguments and the exploration of world art. While the many themes, problems, issues, and connections found within this world are multilayered, each section or article can be used as a distinctive topic of study and is facilitated by pertinent questions that will provoke further thought, discussion, and understanding.

This project emerged from an invited session on world-art worlds at the Annual Meetings of the American Anthropological Association in New Orleans in 2003, and came to fruition thanks to the enthusiasm of Waveland Press's Tom Curtin whom we happened to meet there.

In addition to this original group of papers, nearly all of which were substantially revised to make them more accessible for undergraduates, we have also added several outstanding contributions published elsewhere. Further, two essays were written especially for this volume, as well as an entirely new introduction, to help situate them in the broader context of the anthropology of art and the art history of non-Western art.

We owe a great thanks to Tom Curtin for guiding this volume through the process of preparation and publication. We also want to thank Diane Evans for her

help in copyediting the manuscript and with following up on the myriad details required to produce the finished product. It has been a delight working with both Tom and Diane throughout the project.

We also want to thank Amy Witzel and Fran Oscadal, reference librarians at Dartmouth College Library, for their help in tracking down obscure citations. Also we want to thank Rob O'Connell, Kerry Bushway, and Peter Collins from the Interlibrary Loan Department at Dartmouth College Library, who were able to procure a wide variety of titles from diverse places with remarkable ease. Without their efforts this volume would not be the same.

We feel that *Exploring World Art* offers you a stimulating set of reading and a variety of insights into contemporary world art. As you will see, it cannot be ignored because it both engages and enriches our world.

<div align="right">

Eric Venbrux
Pamela Sheffield Rosi
Robert L. Welsch

</div>

Exploring World Art
An Introduction

Robert L. Welsch, Eric Venbrux, and Pamela Sheffield Rosi

Until recently, when students studied the history of world art they might have read a book like H. W. Janson's *History of Art* (Janson and Janson 1962). Inside this hefty volume the world is divided up into regions, periods, and art traditions. Here one finds important chapters on the ancient Egyptians, the art of classical Greece and Rome, Medieval art, the Renaissance, and an extended discussion of art traditions in western Europe. Each of these European and Mediterranean traditions gives way to the next, influenced by or created in reaction to past traditions. In early editions, Janson's chapter on Islamic art was tucked in between Byzantine and early Medieval art, while the arts of China, Japan, and India were covered only briefly in a postscript—seemingly as an afterthought. African art, the traditional art of the Americas, and the art traditions of Oceania were covered in nine pages at the end of the first chapter (which covered prehistoric art, followed by discussions of the Venus of Willendorf and Stonehenge during the Stone Age of Europe).

In 1975, another survey of the history of art, *Gardner's Art Through the Ages,* began to offer an expanded view of non-Western art. In the sixth edition, sections were dedicated to the ancient world, the Middle Ages, the Renaissance, Baroque, and the modern world (Gardner, de la Croix, and Tansey 1975). These are followed by a final section of about 100 pages dedicated to the non-Western world, which contains chapters on the art of India, China, Japan, and pre-Columbian art, before turning to the final chapter on North American Indian, African, and Oceanic art. Although this treatment of non-Western art traditions will likely seem comfortable and natural to many of us today, it is nevertheless a recent innovation in art history. But even in Gardner's book, non-Western art lies at the margins of the more important story: the history of Western art.

Many art historians accept such views about the relative importance of Western and non-Western art, but anthropologists interested in the arts have come to

reject this ethnocentric perspective. In part, this rejection comes from historical views that reduce the great diversity of forms and traditions found in third and fourth world societies to a handful of simple themes: magic, ritual, timelessness, and primitive culture. Janson, for example, associated art with magic and ritual in both prehistoric and contemporary "primitive" societies. And Gardner's book accepted non-Western art as art, but as traditions with much less depth and complexity than the art traditions of Europe. Why have art historians paid so little attention to African or Oceanic art? Why do the arts from these regions get pushed to the margins of our art museums?

Non-Western Art and the Legacy of Colonialism

Reflecting nineteenth-century ideas about progress and social evolution, colonial powers have always looked down on their colonized, dependent peoples as less sophisticated and less dynamic than the civilized societies of their metropolitan capitals. This view had important implications for how Western peoples, including scholars, understood non-Western art. To people in Britain, France, Germany, and even the United States, the concept of art became associated with civilized refinement, beauty, and individual creative genius. With these ideas as a yardstick, non-Western art represented the most "uncivilized" aspects of tribal societies: their art was considered ugly, misshapen, out of proportion, and associated with "primitive" rituals and magic. Such objects offered proof that tribal peoples were too primitive to manage the valuable resources of their native countries, resources that European industrialists coveted.

At the Brooklyn Museum in 1923, anthropologist Stewart Culin installed one of the earliest exhibitions of African objects as art in the United States (Webb 2000:16–17). Nevertheless, until the 1930s, collections of art objects from these colonial possessions were rarely, if ever, displayed in art museums or galleries; such objects were considered curios or ethnological specimens, but certainly not fine art comparable to that of the great masters of the Renaissance or the Baroque. In the nineteenth and early twentieth centuries, non-Western objects were exhibited at colonial expositions or world's fairs or in national museums, in museums of ethnology or anthropology, or in natural history museums.

The 1886 Colonial and Indian Exposition in London, for example, was an effort to highlight the resources of the British colonies and their economic potential for industrial investment. France and Germany also sponsored expositions to highlight the resources and traditional crafts and manufactures of their colonial possessions. In 1898, the United States joined the club of imperial world powers when it took over the Philippines as a colonial possession at the end of the Spanish-American War. At the St. Louis World's Fair of 1904—officially called the Louisiana Purchase Exposition—the American exhibits included a Philippine village com-

plete with more than a thousand Igorot tribesmen dressed in loincloths and wielding bows, arrows, and other traditional tools and weapons. These tribesmen and women lived in their "village" on the fairgrounds for eight months. Besides the village there were also displays of Igorot arts and crafts, many of which were made in St. Louis. In a similar way, when national museums exhibited the art from their colonial possessions, such objects similarly became proof of the colony's need for the assistance of the mother country. Colonial carvings, masks, and other art objects were displayed in contrast to sophisticated European artworks, reinforcing the view that colonial peoples were indeed "primitive."

Ethnology or anthropology museums in the tradition of the "Volkskunde-Völkerkunde" tradition of continental Europe presented colonized peoples largely as a survival of ancient prehistoric times. These institutions would include the Museum für Völkerkunde in Berlin (Germany), Museum für Völkerkunde in Basel (Switzerland), the Rijksmuseum voor Volkenkunde in Leiden (the Netherlands), and the Musée de l'Homme in Paris (France), most of which have rather recently changed their names. Nearly every city in these countries had its own smaller version of these larger institutions. These museums tended to collect all aspects of a tribal society's material culture—the tools, ornaments, pottery, wooden plates and

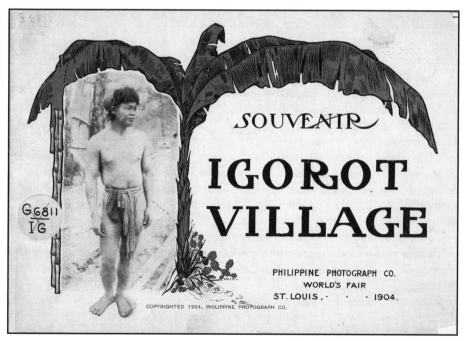

Figure 1. Cover of souvenir booklet about the Igorot Village at the Louisiana Purchase Exposition, 1904.

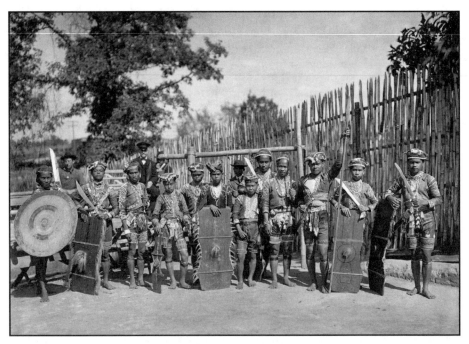

Figure 2. Igorot warriors posing with decorated shields and weapons, Louisiana Purchase Exposition, 1904. Photo by Charles Carpenter. CSA 13739. Courtesy of The Field Museum.

bowls, and hunting and fishing equipment—as well as decorated objects, masks, and carved figures. Ethnological exhibits presented tribal art in its local context. The focus was not on the aesthetic qualities of individual objects, but on what all of the objects might say about the society and culture of the people who made them.

The English-speaking world tended to establish natural history museums for its collections of tribal art, including such institutions as the British Museum in London, the American Museum of Natural History in New York, the Smithsonian Institution in Washington, The Field Museum of Natural History in Chicago, and the Australian Museum in Sydney. These museums displayed the material culture and art of "primitive" peoples alongside plants, animals, and paleontological specimens. Drawing on the evolutionary models of their times, such museums presented the art of so-called simple societies as a natural outgrowth of prehistoric objects and societies. All of these museums emphasized the simplicity of "primitive" or tribal art and generally followed the evolutionary models proposed by Sir Edward Tylor (1871) or Lewis Henry Morgan (1877) in the nineteenth century.

The application of these evolutionary models provided a message to visitors that social status was essentially static and only changed slowly. Nowhere is this idea made so clear than in the Pitt Rivers Museum at the University of Oxford,

where the collection was displayed according to functional categories such as shields or weapons or containers. Other museums typically displayed objects according to where they were made. But General Pitt Rivers accepted a view of cultural evolution that held that all societies passed through the same general stages of "human progress." According to this view the objects made and used in a community allowed anthropologists to determine where the society was along a set of evolutionary stages. In 1884, Pitt Rivers donated his collection to the university and Edward Tylor was appointed to teach anthropology using the Pitt Rivers Museum as his main methodology. Pitt Rivers's ordering of objects was explicitly intended to show that progress "naturally" came only in small steps, as a gradual social evolution (Bennett 1995:198–201).

General Pitt Rivers assembled his personal collection from diverse sources and always had been attracted to decorative objects. Like Pitt Rivers, other British anthropologists early in the twentieth century, such as Alfred Haddon at Cambridge, Henry Balfour (curator at the Pitt Rivers Museum), and Sir Baldwin Spencer in Melbourne, were also interested in "decorative art," especially in the evolution of design. So-called primitive peoples were considered contemporary ancestors. Hence, their art was regarded as from the Stone Age. As Adrian Gerbrands (1957:26–52) points out, the earliest forms of art that archaeologists in Europe were able to find happened to be two-dimensional, geometrical ornaments. Until World War I, the idea prevailed that the evolution of art could be reconstructed by looking at the form of decorations.

By the 1950s or 1960s, most of these museums, like anthropologists generally, abandoned the evolutionary approach in favor of a functionalist view of culture. This view presented tribal societies as static and unchanging, detached from the flow, pace, and dynamism of the rest of the world, at least until the arrival of European colonizers. Colonial "pacification" of tribal societies heightened the impression that these societies were static. Most collections in the larger natural history museums were collected in the decades before World War I, so that by the 1950s such collections represented the ethnographic past of traditional societies rather than the contemporary lives of those same communities. The objects had become relics of a past that had now disappeared. These traditional objects were aging in the museums and literally becoming "artifacts" of the past. Despite decorative elements or arresting forms, such objects were understood as artifacts or specimens instead of artworks to be appreciated aesthetically, admired, or contemplated in the Western tradition of art appreciation.

The interest in form, prevalent in earlier evolutionist and diffusionist approaches, shifted to an interest in the content behind the forms as anthropologists gradually adjusted their focus to understanding tribal art in terms of its worldview. For example, anthropologists started looking at Aboriginal Australian rock, sand, body, and bark paintings in terms of myths and local cosmology instead of using these motifs as evidence of the community's retarded evolutionary development (Mountford 1966; Munn 1973; Morphy 1991).

Tribal Art Enters the Art Museum

After "primitive" art became a source of inspiration for avant-garde artists in Paris at the beginning of the twentieth century, the movement to recognize tribal art as significant in its own right began in earnest in New York during the 1930s and 1940s. Its earliest phase was related in large part to the Museum of Modern Art (MoMA) and to the efforts of art historians Alfred Barr and René d'Harnoncourt. MoMA was founded in 1929 and played a key role in bringing all sorts of new art to New York audiences. After mounting exhibitions on such artists as Cézanne, Gauguin, Seurat, and Van Gogh in 1929, Paul Klee and Winslow Homer in 1930, Toulouse-Lautrec and Matisse in 1931, and Edward Hopper in 1933, as well as dozens of modern artists unknown to New Yorkers, the museum turned to other kinds of artwork that was unfamiliar to most Americans. These exhibitions focused on such traditions as those of the Mexican muralist Diego Rivera (MoMA 1931) and American folk art (MoMA 1932). In 1935, the museum mounted the first American exhibition of African art since Culin's exhibition in 1923 (Sweeney 1935; see also Webb 1995; Staniszewski 1998:110–139).

The Rivera exhibition was MoMA's response to a traveling exhibition of the folk art of Mexico organized by d'Harnoncourt (1930), which had opened at the Metropolitan Museum of Art (the Met) in 1930. This exhibition brought d'Harnoncourt to prominence in New York, leading to an exhibition of Native American art at MoMA in 1941 entitled Indian Art of the United States (Douglas and d'Harnoncourt 1941). Two years earlier, while working as administrator of the Indian Arts and Crafts Board (which was a part of the Bureau of Indian Affairs), d'Harnoncourt had mounted one of the first exhibitions of American Indian art at the Golden Gate International Exposition in San Francisco. In 1944, d'Harnoncourt was appointed director of MoMA and soon after mounted the first exhibition of Pacific art with the title Art of the South Seas (Linton, Wingert, and d'Harnoncourt 1946).

Decades later, during 1984–85, MoMA mounted the provocative and controversial exhibition "Primitivism" in 20th Century Art: Affinity of the Tribal and the Modern, curated by William Rubin and Kirk Varnedoe. The exhibition was an attempt to show the influence of the tribal arts on modernist primitivism in Western art (Rubin 1984) and was an extension of some of Robert Goldwater's ideas at the Museum of Primitive Art. Objects such as masks or carved figures from Africa were juxtaposed to the paintings of Picasso or the sculptures of Brancusi. This exhibition became a catalyst for a postmodern critique of the politics of representation (e.g., Clifford 1988; Karp and Lavine 1991). How to present non-Western art as art was also of concern to The Center for African Art, later renamed the Museum for African Art, in New York (Roberts, Vogel, and Müller 1994). Susan Vogel, who for several years had been curator at the Museum of Primitive Art and also worked for ten years as a curator at the Met, was a driving force. One of the

center's highlights was the exhibition ART/artifact, which called Western views and classifications of African art into question (Danto, Gramly, Hultgren, Schildkrout, and Zeidler 1988). The Museum for African Art extended their critique with its exhibition Memory: Luba Art and the Making of History (Roberts and Roberts 1996). During the same period, The Asia Galleries in New York introduced contemporary Aboriginal art to the global art world with its exhibition Dreamings: The Art of Aboriginal Australia (Sutton 1988), after which Australian Aboriginal art came to be recognized internationally.

In Canada, museums were not quite as slow as those in the United States to acknowledge that the art of the First Nations was fine art, but Canadians, who were dealing with other cultural tensions, took longer to embrace it. One of the best-known art traditions of Native Canadians consists of totem poles and ritual paraphernalia associated with Northwest Coast societies. As Douglas Cole (1985) noted in his study *Captured Heritage,* anthropological and natural history museums scrambled to buy up as many of the traditional totem poles and other art objects as possible. These included museums in the United States and Europe as well as in Vancouver, Victoria, Ottawa, and Toronto (see Hawker 2003:46–49). Up to the 1920s, the Canadian federal government was openly hostile to all of the customary rituals in which such art was used, most importantly the potlatch, and passed several acts between 1913 and 1927 aimed at suppressing these ritual exchanges. When the Indians persisted in holding potlatches, the government confiscated ceremonial objects, which later were given to provincial and federal museums. Those museums exhibited Native art and other heritage objects as anthropological specimens, not as fine art, in much the same way as had happened in the United States.

In 1927, Canada celebrated its jubilee, which included a show at the National Gallery of Canada in Ottawa entitled Exhibition of Canadian West Coast Art, Native and Modern. This show included both white Canadian artists Langdon Kihn, Emily Carr, and A. Y. Jackson as well as traditional Northwest Coast carvings, textiles, and works by First Nation artists Frederick Alexie and Charles Edenshaw. This was the first time that named Native artists were exhibited at the National Gallery. The following year the same exhibition traveled to Toronto and Montreal. Despite this early acceptance of First Nations art, it was not until the 1950s that public institutions began to take Native arts seriously in a consistent way (Hawker 2003:3–9, 184–185).

Marjorie Halpin (1981:2) noted that government projects aimed at introducing First Nations art to nonindigenous Canadians in the 1950s and 1960s led to an "enthusiastic revival" of Native art. The turning point in Canadian–First Nation relations and how public museums viewed their art came with the Indian Pavilion at Montreal World's Fair in 1967 called Expo 67, which brought together a network of artists from across Canada (see Hawker 2003:9). The same year the artwork of contemporary Northwest Coast artists Bill Reid and Henry Hunt were first displayed next to the work of traditional Haida artist Charles Edenshaw, who had

died in 1920. These events, together with the Arts of the Raven exhibition at the Vancouver Art Gallery, helped frame and establish Northwest Coast and First Nations art as fine art.

Many authors and curators continued to discuss or exhibit traditional art (see, e.g., National Gallery of Canada 1969; Darbois and Clark 1970; Canadian Eskimo Arts Council 1971; University of British Columbia Museum of Anthropology 1975; Brasser 1976). These studies included important art historical analyses, such as Bill Holm's (1965) analysis of the formline in Northwest Coast art. But gradually exhibitions of contemporary Indian and Inuit art began to emerge with some regularity (see, e.g., Indian and Northern Affairs Canada 1983a, 1983b). In part, this interest in the contemporary art of First Nations was encouraged, if not inspired, by a small number of prominent Native artists like Haida artist Bill Reid, who is well known for his carvings in wood, silver, and gold (see, e.g., Reid 1974; Duffek 1986; Shadbolt 1986). And among the Inuit, both government agencies and scholars played a key role in expanding the market for Inuit soapstone carvings (Graburn 1976, 1999). Tourism has also played a key role in promoting the importance of First Nations art, particularly in recent years, but Aldona Jonaitis (1999) suggested this was the case in the nineteenth century as well.

Because Canada is a multicultural society dominated by English and French speaking citizens, the shift to full recognition of the rights of its First Nation peoples was much easier than in the United States. Canadian universities and museums developed important museum programs to help First Nation bands protect, store, and exhibit their traditional and contemporary art. One of the leading centers is the Museum of Anthropology at the University of British Columbia (UBC) in Vancouver. Despite its focus on anthropology, it routinely exhibits its collections with the same aesthetic appreciation as any art museum. Michael Ames (1992) and Ruth Phillips (Berlo and Phillips 1998), two of the Museum of Anthropology at UBC's most prominent directors, revolutionized the teaching of musesology and the art of First Nation peoples. Scholarly interest in First Nation artists and contemporary First Nations art in Canada has in many ways become more developed than comparable studies in the United States (Jonaitis 1991; Nemiroff, Houle, and Townsend-Gault 1992; MacDonald 1996; Black 1997; Townsend-Gault 1997; Thunder Bay Art Gallery 1998; Berlo 1999; von Finckenstein 1999; Wright 2001). In the Provincial Museum in Victoria, and at the Museum of Anthropology in Vancouver, Native carvers periodically work at their art on the museum grounds, making the production of art an exhibit in its own right. And as in Australia (see Venbrux, article 9), Northwest Coast art has been appropriated by the state as a symbol of Canadian identity.

From "Primitive Art" to the Arts of Africa, Oceania, and the Americas

Franz Boas (1927) published one of the earliest analyses of art in tribal societies, which he referred to as "primitive art" (see van Damme, article 3, for more details). His analysis tried to assess whether different kinds of art, such as geometrical forms or naturalistic representations of animals or humans, delineated the kind of evolutionary trajectories earlier anthropologists hinted at. He concluded that primitive art, like everything else in tribal societies, needed to be analyzed in its own terms, not as evidence of some global evolutionary program. In subsequent years, when anthropologists looked at tribal art they considered art as merely one form of material culture. In this sense, while Boas clearly appreciated the aesthetics of Northwest Coast Indian art, his interest in art was merely a part of a broader assemblage of material culture. But beyond his own appreciation of Northwest Coast art, he recognized that Indians also had aesthetic sensibility. Their aesthetic system was different from that of America or Europe, but nevertheless present in Native American communities.

Like Franz Boas, anthropologist Leonhard Adam (1940) published a book with the title *Primitive Art*. For the most part, the volume contained a few brief analytical chapters assessing the relationship between art and religion or art and society. Most of the book was given over to extended chapters about the art of Africa, the Americas, Oceania, Australia, and Asia. In one curious chapter about primitive art in museums, Adam (1949:240) suggested that "primitive art must be studied in ethnographical museums . . . because the aesthetic approach to primitive art became popular only a few decades ago." By then, most of the important works of "primitive art" had been collected by ethnographical or ethnological museums, "not as works of art . . . but as ethnographical specimens." For him, this was not an altogether unfortunate situation because to understand primitive art it required a knowledge of its religious and social implications. In this he mirrored Boas's approach to the topic.

About the same time, anthropologist David G. Mandelbaum helped mount one of the earliest exhibitions of "primitive art" in North America at the University Gallery at the University of Minnesota (1940). Mandelbaum (1940) defined "primitive art" as the art of nonliterate peoples. Like Boas before him, he insisted that tribal peoples had their own aesthetic values. These standards may be different from ours in the West, but nevertheless all societies had art. Three years later in Melbourne, Australia, the National Gallery of Australia opened its first exhibition of "primitive art" as well (Public Library, Museums, and National Gallery of Victoria 1943). The same kinds of objects shown in these exhibitions had been exhibited in natural history museums, but these exhibitions suggested an entirely new way to view ethnographic and ethnological collections—as art. According to Wally

Caruana (1993), the first exhibition of Australian Aboriginal art was organized in the same gallery in 1929 and included, among other items, bark paintings that Baldwin Spencer collected in 1912.

During the 1950s, "primitive art" emerged as a suitable topic both for art museums and for natural history museums. The Field Museum (then called the Chicago Natural History Museum) hired anthropologist Phillip H. Lewis as curator of primitive art. Lewis's (1958, 1961) earliest publications and exhibitions after arriving at the museum were focused on the question, "What is primitive art?" In the Boston area, the Fogg Art Museum had an exhibit entitled African and Oceanic Art as early as 1934, and the Museum of Fine Arts (1958) held an exhibition of primitive art in the fall of 1958 (see Geary 2004). In 1962, the University of California at Los Angeles (UCLA) Art Galleries (1962) had their own exhibition, followed soon after by the Art Institute of Chicago (1965). In Sydney, the Art Gallery of New South Wales started its primitive art collection in 1956 (Tuckson, Tuckson, and Channell 1973:3). In Australia, the growth of anthropological studies also led to a greater appreciation of Aboriginal art through exhibitions mounted during the 1950s by Charles Mountford and Ronald and Catherine Berndt (Caruana 1993:19). The Berndts were the first to identify artists and situate them within stylistic traditions. Exhibitions of primitive art had finally entered the art world.

In 1954, Nelson A. Rockefeller founded the Museum of Primitive Art (MPA) in New York, appointing Robert Goldwater its director and Douglas Newton its curator. Originally, the MPA was called the Museum of Indigenous Art, but the public found this name hard to interpret and its name was changed to MPA. The museum opened in 1957 and conceived itself explicitly as an art museum, focusing its energies on displaying non-Western art. Newton and Goldwater, together with Julie Jones, Tamara Northern, and Susan Vogel, all of whom curated shows, put on a dazzling array of exhibitions about pre-Columbian (e.g., MPA 1958; Jones 1964), African (MPA 1959a; Sieber 1961), Mexican (MPA 1959b), and New Guinean (Kooijman 1959; Newton 1961) art traditions, as well as more general exhibitions of primitive art (Redfield, Herskovits, and Ekholm 1959; MPA 1960, 1974; Movius, Kooijman, and Kubler 1961; Newton 1978). Newton was one of the most important figures in promoting an appreciation of primitive art as "art," and he did so through his numerous exhibitions at the MPA, and in more than a dozen other museums in the United States, Europe, Australia, and New Zealand (Welsch 2002).

As a subject for academics, "primitive art" had burst on the scene in a big way as well. Erwin O. Christensen (1955), Douglas Fraser (1962), and Paul S. Wingert (1962) each published general volumes on "primitive art." Each of these books had opening chapters that dealt with what primitive art was and what viewers should expect to see in primitive art objects. But each book focused most of their discussions on a survey of differing art regions—Africa, the Americas, Asia, and the Pacific (usually referred to with the term Oceania).

Once primitive art was established as a legitimate topic for research, anthropologists and art historians began to publish essays and books about the role of art in tribal societies. Marian Smith (1961), for example, edited a collection about tribal artists, and several years later Warren L. d'Azevedo (1973) assembled a collection of papers about the role of the artist in African societies. Daniel Biebuyck (1969) assembled a collection of essays entitled *Tradition and Creativity in Tribal Art,* which addressed the question of whether primitive artists were constrained by tradition or free to be as creative as in the West. Carol F. Jopling (1971) edited a volume called *Aesthetics in Primitive Societies,* and during the same year Charlotte M. Otten (1971) published a similar collection. Using a grant from the Wenner-Gren Foundation for Anthropological Research, Anthony Forge (1973) published a collection of readings entitled *Primitive Art and Society,* and a few years later Michael Greenhalgh and Vincent Megaw (1978) edited a volume on approaches to style entitled *Art in Society.* William Fagg (1968, 1970) consistently stressed the individuality of particular artists, and Robert Farris Thompson (1965, 1966, 1974) provided some of the earliest systematic studies of how African artists were responding to their changing contemporary worlds.

But by the 1970s, native peoples in the third and fourth worlds had come of age as well and they began to react to being called "primitive." In response, anthropologists began to find the term too pejorative for use in any serious anthropological essay, including anthropological studies of art (see, e.g., Dark 1978; Anderson 1979, 1989; Layton 1981). As a consequence, a wide variety of synonyms emerged, some of which we have used here: tribal, ethnic, preindustrial, small scale, preliterate. Unfortunately, most of these terms have simply become euphemisms for "primitive" and a politically correct way of talking about "primitive" art, with all of the same assumptions as before. Changing the adjective did not immediately change the way many scholars thought. But one thing was becoming clear, few of the ethnic or tribal peoples anthropologists studied in the 1970s and 1980s were truly preliterate, preindustrial, small scale, or even tribal; nearly everyone in these formerly traditional, small-scale societies were engaged with their colonial overlords or then newly independent national governments. For the most part, few of the new artworks made in the 1970s and 1980s—often by educated people using modern, Western media such as paints and canvas—entered the collections of either art museums or natural history museums (see Rosi 1994, 1998a).

When the MPA closed its doors in December 1974, its collections, which included the renowned Nelson A. Rockefeller collection (Newton 1978), were given to the Met as the Michael C. Rockefeller memorial collection, in memory of Nelson's son who went missing in the Asmat area of Dutch New Guinea in 1961 (now the Indonesian province of Papua) (see Stanley, article 15; Gerbrands 1967a). The Met had exhibited non-Western art before this time, such as the Nathan Cummings collection of Peruvian ceramics (Sawyer 1966). But until the 1970s the Met did not play a significant role in establishing objects from tribal societies as art in

the same ways it would after acquiring the MPA collections. One exception was an exhibition jointly mounted with the MPA in 1969 entitled Art of Oceania, Africa, and the Americas (MPA 1969). This exhibition had been mounted after Rockefeller decided to turn over his personal collection to the Met.

When the Met took the MPA's collections it established a new Department of Primitive Art, which in 1991 was changed to the Department of the Arts of Africa, Oceania, and the Americas, deliberately avoiding the term "primitive" that characterized the collections for more than forty years. In addition to the collections, the Met also took MPA staff, particularly Newton (who was named curator and chair of the new department), Julie Jones (curator of pre-Columbian art and curator-in-charge since Newton's retirement in 1990), Susan Vogel, and Virginia-Lee Webb (who curates the collection of ethnographic photographs). With four curators and an extensive library, the Met's department has been the largest of its kind in the United States since its founding. When the Michael C. Rockefeller Wing opened to the public in 1982, it had exhibits of African, Oceanic, and pre-Columbian art. These exhibits of traditional non-Western art are among the most visible and well-known in the United States. The Oceanic galleries saw little change from 1982–2002. The Beneson Gallery opened in 1996, replacing the Sub-Saharan African Gallery, and the Jan Mitchell Treasury Gallery opened in 1993, redesigning the Pre-Columbian Gallery. Together, these galleries have done more to define the art of Africa, Oceania, and the Americas than any other exhibition or venue in America. These objects, these exhibits, and the appreciation of traditional non-Western art remain an important legacy of the former Museum of Primitive Art and its last director, Douglas Newton (see Welsch 2002).

From Art Regions to World Art

Naming a department at the Met after the art regions in its collections has many benefits over naming it the "department of primitive art." Nomenclature helps define the field of study, and studying the art of Africa or New Guinea suggests different questions to the researcher and scholar than studying the "primitive art" from Africa or New Guinea. But in a similar way, the study of art in the Department of the Arts of Africa, Oceania, and the Americas suggests a much more parochial view than if the same department were called the department of world art.

Yet, at the same time, such departments at the Met and at other large art museums continue to define the scope of their collections and exhibitions as dealing almost exclusively with traditional, older objects, implying many of the same understandings of such tribal art as when first exhibited at MoMA during the 1930s and 1940s. Traditional objects from these regions continue to be associated with magic, spirits, and ritual, just as art from the Renaissance or the Baroque periods of Europe were embedded within the religious ideas of their day. However,

while the art of Europe was considered dynamic and always changing, the arts of Africa, Oceania, and the Americas were also changing. Often these changes occurred much more rapidly than museums like the Met or the MPA were able to recognize. Yet none of these changing styles, forms, and traditions will get much attention in a museum in which the underlying assumption is that traditional non-Western art is static, while Western art is creative and dynamic.

While we may salute the efforts of anthropologists and art historians to use more appropriate terms than "primitive" or "savage," naming departments or curatorships after specific regions poses other problems for how we appreciate the art from those areas. Just how should we approach the art of the third and fourth worlds? Few specialists on African or Pacific art, for example, will intuitively feel that calling themselves an Africanist or specialist on Oceanic art could be anything but accurate. Yet these regional labels imply that the art of these different regions remains distinct, intact, and essentially stable. In a sense, with such regional labels we continue to distinguish the rather stable and static non-Western art from the dynamic and always changing traditions of Western art. Western art extends across the globe wherever a Western artist may roam. Whether the artist lives in New York or Paris, or paints in some remote corner of Tahiti like Paul Gauguin (see Sharman, article 2), the art is nevertheless considered Western art.

The same cannot be said of artists in the third or fourth worlds, who remain fixed and tethered to their particular regions—at least in the minds of scholars (see Silverman, article 12, who addresses these contradictions directly in his discussion of the New Guinea Sculpture Garden at Stanford University). Moreover, if we look at the artworks that art museums like the Met collect and accession into their collections, nearly every object is old, representing the timeless, unchanging, and primitive styles one might have seen a century or more ago. The problem with these assumptions about non-Western art is that few third or fourth world communities have remained unchanged by the world outside their villages. They are all a part of a global and interconnected world. Some communities remain more isolated than the rest, but no one living today is truly isolated from the world at large or the social and economic pressures that come from being connected to centers of power.

A very different view of non-Western art traditions appears in John Onians's (2004) *Atlas of World Art,* which covers all parts of the world from 5000 BC to the present day. But even in this work, the art from numerous local art traditions in small-scale societies receives less attention than European art with its much better known traditions. Nevertheless, Onians and his many contributors have consciously attempted to place each region's art in context with all others by showing the connectedness of the world's art regions throughout human history.

In addition, Onians has self-consciously attempted to place the nineteenth- and twentieth-century art from every region into a historical context by including maps, commentary, and illustrations about each region during various periods: 5000–500 BC, 500 BC–AD 600, 600–1500, 1500–1800, 1800–1900, and 1900–2000.

The effect of this approach (broad sweeps of time and space) minimizes the importance of individual artists, such as Picasso or Rembrandt, or local art traditions, such as woodcarvings or masks from Africa or New Guinea. Such treatment emphasizes the movements of peoples over time and the ongoing migrations of individuals, ideas, and materials around the world, suggesting that the twentieth- and twenty-first-century movements from one continent to another seem much less exceptional than most of us might assume. Onians vividly shows that all people at all times and over all parts of the globe had some sort of art tradition, and that these traditions were anything but isolated.

Innovation and the Dynamism of Non-Western Art

In this respect, Onians attempted to do on a broad scale what a select group of anthropologists and art historians had already been doing in their study of local regions. We are thinking here about scholars like Philip J. C. Dark (1954, 1973, 1974, 2002), who has been studying changing art traditions in the non-Western world throughout his entire career. Working first among the so-called Bush Negroes of Surinam, Dark (1954) attempted to show how the art of these descendants of African slaves had borrowed heavily from their African traditions while introducing many innovations that reflected their current lives in the New World (for a recent study, see Price and Price 1999). In a similar way, Dark (1962, 1973) studied important museum collections of Benin bronzes in Chicago and Great Britain to understand how these art objects were related to the changing conditions of the precolonial Benin kingdom and the earliest part of the colonial period. Finally, his work with contemporary artists among the Kilenge people of Papua New Guinea represented a sharp break with earlier styles of anthropological and art history research (Dark 1974), a theme he extended to art throughout the Pacific (Dark 2002; see also Welsch 2002). His coresearcher among the Kilenge, Dutch anthropologist Adrian Gerbrands, similarly focused on individual artists in a study of eight woodcarvers among the Asmat of Dutch New Guinea (Gerbrands 1964, 1967b; see also Stanley, article 15).

In 1965 and 1966 the Museum and Laboratories of Ethnic Arts and Technology at UCLA held an exhibition of the recently acquired Sir Henry Wellcome collection. Associated with this exhibition the museum organized a lecture series and symposium called Individual Creativity and Tribal Norms in Non-Western Arts. These lectures were compiled into a single volume edited by Daniel P. Biebuyck with the title *Tradition and Creativity in Tribal Art*. In this book, William Fagg (1969) and Robert Thompson (1969) acknowledged innovation in African art, but both took a much more traditionalist view of tribal art, distinguishing it from Western art's dynamism. (In several of his other books, such as *African Art in Motion*, Thompson [1974] moved well beyond his earlier essay, stressing the innovative

qualities of Gelede masking traditions in Nigeria and other African arts; see also Hermer, article 16.) In the same volume French anthropologist Jean Guiart (1969) and Adrian Gerbrands (1969) addressed the concepts of artistic norms and style in Oceanic art, and William Bascom (1969) wrote an essay called "Creativity and Style in African Art." All three of these authors took a much more dynamic approach to creativity, innovation, and individuality in traditional tribal art than was typical at the time. All of these studies acknowledge the dynamism of indigenous art by looking at how creative indigenous artists could be, and how these artists could embrace changes in their social, economic, and political situations. For Guiart, Gerbrands, and Bascom in particular, innovation and artistic creativity existed before the arrival of European colonizers in their regions of study.

For a century, anthropologists observed that tribal peoples readily adopted imported European materials and pigments in their art. But instead of embracing such changes, anthropologists were driven to buy up as many of the traditional looking objects as possible before they disappeared. In 1910, for example, Field Museum curator A. B. Lewis—whose Melanesian collection included more than 14,000 objects—saw masks and other objects in German New Guinea that exhibited innovations in materials and in what they were representing. But he wanted a collection of tradi-

Figure 3. Dancing mask, Panim village, near Madang, which A. B. Lewis refused to buy because it was made partly of imported paper and cloth, 1912. Photo by A. B. Lewis A-32062 (369). Courtesy of The Field Museum.

tional objects. On April 12, he wrote in his field diary that he "saw one dance mask or headdress, shaped like a house, with a long pole on top, covered with feathers and cloth. The house was of painted bark, also paper and cloth, so that it was of no worth" (Welsch 1998, 1:224, 235). Lewis was not studying the impact of colonialism on tribal art or society; he was focused exclusively on what he could learn about traditional Melanesian societies and their material culture before the colonial impact (figure 3). For him, the paper and cloth demonstrated all too vividly that these societies had changed in response to Europeans. Thus, the paper and cloth prevented such a mask from being of scientific significance. A similar feeling continues to hover around the non-Western collections in many art museums today.

One of the earliest scholars to discuss the radical innovations sweeping across tribal art was anthropologist Julius Lips (1937). In his book, *The Savage Hits Back,* Lips surveyed the work of indigenous artists in colonial territories around the world, focusing specifically on how the artworks illustrated indigenous impressions of the colonizers and the society these Europeans imposed. Lips worked on the manuscript in Leipzig, Germany, when Hitler came to power. Such a volume demonstrated that colonial peoples had artistic skill and held unflattering thoughts about their colonial overlords. Hitler wanted to squash the volume because it went against the image of the non-Western world the Führer promoted. Lips left Germany for the United States, where he was able to publish his book in English.

In the view of anthropologist Paul Stoller (1995:83–90), the artistic representations of white people in West Africa during the colonial and postcolonial eras were attempts to appropriate colonial power. Philip Ravenhill (1996) analyzed them as images of otherworld mates of the opposite sex among the Baule in the Ivory Coast of West Africa. Both stress the dimension of power and argue that these objects can only be properly understood in their local settings. But as Christopher Steiner (1994:148–154) has shown, such statues have become fashionable among Western art collectors and tourists visiting West Africa. As a result, they have taken on a different meaning. African art dealers adjust this "tourist art" to the taste of Western consumers by undoing the brilliant colors with sandpaper and artificially aging them so they get an "old" patina that fits with what Western collectors imagine as typical of the colonial era—but which in fact was not the way these objects would have actually appeared. Ironically, "Rather than achieve their value or authenticity by an empathic denial of foreign contact, the *colon* figures are interpreted by their buyers as a celebration of modern Western expansionism" (1994:154). In other words, although Lips made it clear that the imagery of the colonial overlords was anything but flattering, in the eyes of Western buyers, the objects are now given importance as nostalgic symbols of former colonial domination. It seems that the power Western art buyers and tourists have in dictating what is offered for sale has backfired because of their colonial nostalgia, especially among collectors in Europe.

Perhaps the most influential book about innovation in tribal art was Nelson Graburn's (1976) *Ethnic and Tourist Arts,* which was the first effort to assess the rela-

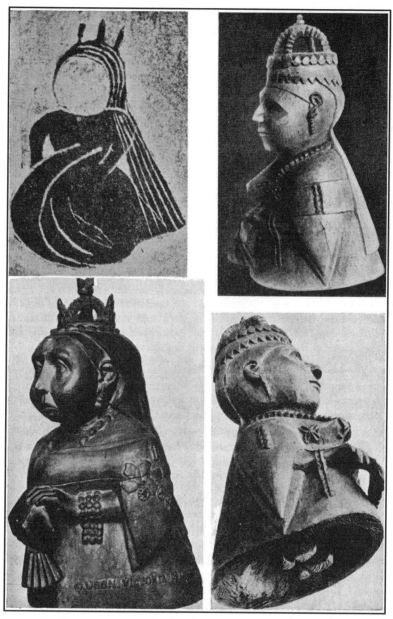

Figure 4. Nineteenth century images of Queen Victoria in a Bushman painting from South Africa and carvings by a carver from the Guinea Coast of West Africa, published by Julius Lips in 1937 in his book *The Savage Hits Back: The White Man Through Native Eyes.*

tionship between traditional cultures and what has pejoratively come to be known as "tourist art" or "airport art." Most anthropologists and art historians dismissed objects made for sale to foreign visitors in much the same way A. B. Lewis had in 1910. But Graburn argues that commercial and tourist art nevertheless represents an indigenous cultural expression and plays an important role in shaping and maintaining indigenous identities. A key feature of these innovative artworks is that they represent changes in the formal and symbolic systems of the artist's culture. Such changes in the arts spur other social and technical innovations (1976:30–31). Most importantly, Graburn and his contributors were among the very first to point out that such ethnic artworks had meaning for their international consumers, just as they had meaning for indigenous peoples. Not all ethnic art is made for foreigners, but many artworks are. Graburn offered an important new way of understanding and framing our analysis of these art objects. By looking at artwork as representing a complex interplay between tribal peoples and Western consumers, Graburn had opened up a new way of thinking about non-Western art and its dynamic complexities.

A decade later, Arjun Appadurai (1986) suggested that scholars should study the "social life of things." Appadurai's concern was with objects as commodities, and as Graburn (1976) and others noted, ethnic arts were becoming an international commodity. In the international flow of objects, each object has its own social life, and is given new meaning with each new set of hands it passes through. Museum anthropologist Igor Kopytoff (1986) developed this theme a bit further by writing of the "cultural biography of things." Bronislaw Malinowski (1922) wrote about especially valuable shell ornaments used in the ceremonial exchange system of the Trobriand Islands known as *kula*. He said that these kula objects took on new significance with every transaction, in much the same way that the temporary owners of these valuables gained prestige because of their association with them. Kopytoff went on to say that all art objects take on new biographic details with each new owner. This approach to objects opened the door for Nicholas Thomas (1991) to write about Pacific objects as being "entangled" in the cultures and meaning systems of their various indigenous and Western owners. The same approach also led Douglas Cole (1985) to examine how museums had "captured" the artistic heritage of the Northwest Coast and Enid Schildkrout and Curtis Keim (1998) to publish *The Scramble for Art in Central Africa*. In a similar way, historian of anthropology George W. Stocking, Jr. (1985) suggested that besides their physical (length, width, and depth) and temporal dimensions, objects also had at least three other dimensions: power, ownership, and aesthetics.

Only by changing the way we look at objects as complex symbols within a changing field of international power relations, as well as the even more complex concerns about ownership, can we understand the current trajectory of world art as we discuss it in this volume. The social life of these artworks is one of intercultural and transcultural negotiation.

But Is It Art?

In her book on art theory, art historian Cynthia Freeland (2001) asks the question "But is it art?" about many different kinds of art objects. Some of these were in provocative exhibitions like Sensation, which became politically controversial when exhibited at the Brooklyn Museum of Art in 1999. Like so many contemporary American art objects, many of the artworks exhibited in Sensation were not beautiful in the classic sense of Western aesthetics. In a similar way, we may also ask if artworks from traditional African or Melanesian societies are really art. To most early visitors to such non-Western communities, the art objects they encountered often looked misshapen and frightening. They were religious objects or objects of local veneration. They may have had important symbolic significance and meaning for their makers and those who venerated them, but they did not look like art. For example, when Western people look at the masks from Africa and Papua New Guinea shown in figures 5 and 6, it is only people who are familiar with these art traditions who will immediately recognize them as interesting examples of African and New Guinea art respectively.

It takes considerable study and viewing of other objects from these traditions to appreciate whether either of these masks is made with skill, to know that they embody high aesthetic qualities. Connoisseurs often say that they can appreciate a good example of art from any region because of some special innate ability they possess. But as Sally Price (1989) noted, connoisseurs, curators, collectors, and specialists learn how to appreciate aesthetic traditions, just as any workman learns his trade: through practice. These specialists have seen many examples in museums, and can relate any new example they may encounter against those they have previously seen (see also Errington 1998). This connoisseurship is a matter of taste, developed from Western preferences for certain forms and types of objects. Furthermore, a taste for certain types of art has been seen as a means of social distinction, especially class distinctions (see Bourdieu 1984; Halle 1993). The collectors and connoisseurs with the greatest "cultural capital," however, are not necessarily the people with the most "economic capital" and wealth. And, as Plattner (1996) points out, not all members of the higher classes are art connoisseurs.

These connoisseurs have also come to understand indigenous aesthetic concepts when making their judgments about which masks or carvings are of high aesthetic quality and which are not. But as Susan Vogel (2001) suggests, for many years art specialists have offered pronouncements about particular objects without even knowing what the original forms of these objects were, much less the original aesthetic systems in which they were made.

When displaying tribal masks, or other kinds of tribal art, many natural history museums might have a label identifying them as masks used in certain rituals or religious ceremonies (see, for example, figures 5 and 6). But such identifications do little to explain the meaning of these masks to those who made or used them. To

understand these meanings requires detailed information from the communities where these objects were collected (see Arnoldi 1995). Unfortunately, most early objects were usually collected without bothering to ask about any such details. As a consequence, we are forced to evaluate such pieces from our own culture's aesthetic rather than the aesthetic of the original artist. Today, researchers acquire much of their knowledge from indigenous artists through fieldwork. And a number of scholars have taken photographs of objects in museums to the villages where they were likely collected to find out what village elders are able to tell them about the objects, their manufacture, and their use.

In the tribal societies of Africa, Oceania, and the Americas, one can often find words for "designs" or decorative elements in most of the local languages. But the majority of these languages has no traditional concept for "art" that means the same things as the word "art" does in English (but see van Damme 1997). In his book, *Calliope's Sisters*, anthropologist Richard Anderson (1990) states that we can find something akin to art in all cultures. For him, these aesthetic systems may vary quite wildly, but every culture has some sense of what is aesthetic and what is not.

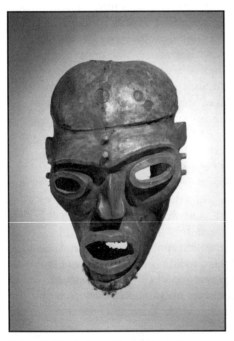

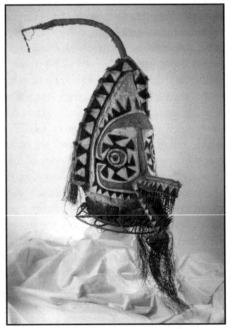

Figure 5. Mask from Cross River, Cameroon (175598), used by curator Phillip H. Lewis (1958) in his exhibition What is Primitive Art? A102049. Courtesy of The Field Museum.

Figure 6. Mask of bark cloth, Opau, Gulf Province, collected by A. B. Lewis, 1912 (142111). Photo by James Balodimas. Courtesy of The Field Museum.

One challenge that has faced anthropologists and art historians who study art in non-Western societies has been to articulate the parameters and dimensions of these different aesthetics. These were key concerns that motivated anthropologists in the 1960s and 1970s (see, for example, Forge 1973; Greenhalgh and Megaw 1978).

But today, in a world increasingly interconnected in global ways unimagined even thirty or forty years ago, contemporary art produced by non-Western artists is reaching locations thousands of miles from its point of origin, taking on new meanings, and fitting into new aesthetic systems. Gone are the days of a parochial view that non-Western art could only refer to the traditional and untainted arts of Africa, Oceania, and the Americas. Today's ethnic art is world art that has taken on many different parameters from those artworks studied by anthropologists and art historians a generation ago. Such changes have raised controversies over issues of authenticity, appropriation, ownership, and the roles of various gatekeepers who control emerging art worlds.

From a Parochial View to a Global View of World Art

For Prince Harry it was a painful embarrassment when Australian Aborigines accused him of stealing their sacred motifs for his art. The son of Prince Charles and the late Princess Diana, at 18, used the totemic motif of a lizard in his A-level artworks. To Aboriginal artists, this "appropriation" was an infringement of traditional intellectual property rights, a violation of rights comparable to any American who willfully uses the cartoon image of Mickey Mouse on a T-shirt without paying permission fees to the Disney corporation (Mithlo, article 17, considers a similar case). The concerns of Aboriginal artists and activists received worldwide publicity. Buckingham Palace denied the allegations (Shadbolt and Collins 2003), and art critic Jonathan Jones (2003) came to Prince Harry's defense, saying that "Harry's art is ridiculous but it derives ultimately from the modernist sublime."

In the tradition of modern art, the imagery from (non-Western) religious sources was given a very different "aesthetic, secular significance." "Modernism is something from which Aboriginal art in particular has directly benefited. It is the reason this art is currently respected, collected, and, in Harry's case, lamely emulated worldwide" (Jones 2003). He reasoned that in spite of the fact that Aborigines had been dispossessed in the name of Harry's royal ancestors, one should not be too harsh on the young prince: "To deny that Aboriginal art can be enjoyed around the world as art (which includes imitating it) would be to cut short a conversation that has just begun." Confronting world art in ways unthinkable in the past, the increasingly globalized art world is, however, seeing a shift in the balance of power.

As this anecdote suggests, the contemporary visual arts of non-Western peoples are increasingly part of a capitalistic global art world with diverse gatekeepers, tastes, venues, individuation of artists, and hybrid sources of inspiration. This collection explores several dimensions of this developing phenomenon we call world

art. We examine the art world by looking at cases from around the globe, from both local and comparative global perspectives. Our interests span a number of critical topics concerning visual culture: artistic agency, new art forms and media, arenas of cultural production, and the role of gender in these innovative traditions. The construction of new art markets involves the politics of representation, contested copyrights, and concepts of identity. Simultaneously, each of these themes must be worked out interculturally and often internationally because, as Prince Harry's project suggests, all artworks can now cast a global shadow.

Developing Strategies for Exploring World Art

To understand these emerging international art worlds, anthropologists and art historians face a number of challenges that were never present when "primitive" artists carved objects for local rituals and later sold them to a collector. We have come to realize, as Paul Stoller (article 4) puts it, "the economic and social forces of globalization have altered the spaces in which art, commerce, and scholarship are negotiated." Several scholars (Onians 1996; Anderson 2001; Morphy 2001) have called for the need to develop new, interdisciplinary approaches to the visual arts. These approaches should apply both to Western and non-Western art, and deal with form as well as context. Some, like Nicholas Thomas (2001:10), are skeptical and do not believe that art history and anthropology can ever establish a sympathetic understanding or appreciation of one another. In this volume, we are not as concerned with a rapprochement between the anthropology of art and art history as with the business of exploring the many new parameters that define world art. All of the articles speak to this theme. They suggest that the intercultural traffic in art has reshaped how indigenous identities are formed. An indigenous identity has by now become an integral part of cultural production.

Exploring world art as a scholarly endeavor involves grappling with the problem of how to conceptualize the creation of new cultural forms by actors from distinctive but interconnected lifeways. Producers and consumers of world art may be worlds apart, but they are nevertheless mutually involved, either directly or indirectly, in the global processes of cultural production. These new artscapes have ramifications for producers, intermediaries, and consumers, a topic that increasingly has been drawing the attention of anthropologists and art historians for the past quarter century (Phillips and Steiner 1999; Welsch 2002). Ethnographic case studies like the articles in this volume have much to offer in illuminating what is actually going on in the production and sale of art in a variety of places around the globe. Each article highlights a different aspect of these new international processes that give meaning to artworks made in one social context but are sold to people in another. Each of these cases offers a different kind of challenge for anthropologists and art historians when studying "primitive" art in a single tribal society. The

ground rules for these disciplines have changed from the days when the people stud-ied could not read the reports issued about them and when their artworks were only used in local rituals before they were collected by anthropologists for a museum.

Part of the process of forming or supporting new identities has to do with con-tested representations, what can sometimes be a delicate matter of exhibition and how best to exhibit non-Western art. One of the most celebrated examples is the 1989 exhibition entitled Into the Heart of Africa at the Royal Ontario Museum (ROM) in Toronto, which was curated by cultural anthropologist Jeanne Cannizzo (1989, 1991). This was the ROM's first African exhibition and Cannizzo's first major effort as a curator. It consisted of a postmodern critique of Western involve-ment with Africa's traditional societies by exhibiting 375 African objects collected between 1870 and 1925, along with a large number of photographs taken by Cana-dian missionaries and military officers serving in Africa. Cannizzo hoped to offer an honest look at the smug and superior attitudes Canadian missionaries and ser-vicemen took with them to Africa, using quotation marks around politically incor-rect language and with tongue-in-cheek exhibit labels. But instead of praise for presenting a serious critique of Canada's involvement with colonialism, the public response was often hostile (Butler 1999). Many Canadians, including those in the black community, interpreted the labels as support for racist missionary views. Simultaneously, families of the missionaries and servicemen were offended that their family photos were being used to attack their family members. The contro-versy that ensued had to do with how social groups were being represented in the museum, emerging from contested ideas about curatorial authority. This was also an issue that arose over the curatorial voice in an exhibition of the *Enola Gay* at the U.S. National Air and Space Museum when curators planned to present interpreta-tions of the bombing of Hiroshima that veterans groups did not like. Carol Hermer (article 16) offers another example of how curatorial authority can be misinter-preted. And Nancy Mithlo (article 17) suggests that artists can confront problems deciding which voice to raise when they simultaneously serve as curators.

Discussions about globalization frequently mention the occurrence of so-called "creolization" or "hybridization" of form, imagery, and symbolism. These terms refer to a process of blending or mixing. Such a cultural process cannot be taken for granted, but needs to be carefully examined, preferably in specialized empirical research (see Myers, article 8). During the last century, anthropologists predicted that globalization would "increasingly influence, and rejuvenate, cultural forms" (Hopkins 2000:242). But whether or not such claims are true can only be estab-lished on the basis of empirical evidence and fine-grained case studies (Bundgaard [article 7] offers an example of precisely this kind of fine-grained field research, which is needed to understand what is now shaping one south Asian art tradition). In a similar way, anthropologists have long assumed that cultural identities focus on a single ethnic or local identity. Sharon Macdonald (2003:6) recently suggested that local ethnic identities "are being superseded by identities predicated on cultural

mixing and crossover, on intercultural traffic" instead of being built around clan, tribal, or other ethnic boundaries. While this process has been observed in some cases, including in many of the articles presented here, it remains to be seen whether the process will be universal. The articles by Russell Sharman (article 2), Eric Venbrux (article 9), Jacquelyn Lewis-Harris (article 10), Morgan Perkins (article 13), and Alexis Bunten (article 14) suggest that art can be used to support local boundaries even as it presents artists with larger, nonlocal identities. What is more, the different articles in this volume speak to this issue in a number of ways, including being self-confrontational (see Mithlo, article 17; and also Lewis-Harris, article 10).

To illustrate some of the complexities of how contemporary art is helping to create new and broader identities at the same time that it is reinforcing and giving new meanings to older identities, consider three paintings by contemporary artists in Papua New Guinea (PNG). All three of these artists are from the Highlands ethnic group known as Chimbu, and all were protégés of Mathias Kauage, who died in 2003. These artists paint in a simple style, often placing their figures on a light blue background. A collector, Hugh Stevenson (1990), referred to this group of artists as the "naïve" school because all are grassroots artists who received little formal training in art. The Chimbu painters, thus, differ from other PNG artists considered in this volume—Larry Santana and Martin Morububuna are discussed by Pamela Sheffield Rosi (article 11), and Wendi Choulai is discussed by Jacquelyn Lewis-Harris (article 10)—all of whom had received formal training. Figures 7, 8, and 9 illustrate how the Chimbu artists have addressed issues of their own and PNG's national identity (Welsch 2005).

In the first of these (figure 7), Oscar Towa introduced an innovative way to represent rain falling on a village scene. The painting depicts a traditional scene of

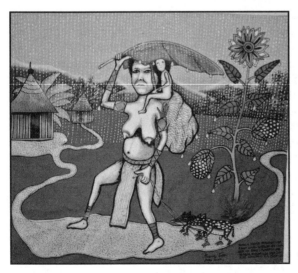

Figure 7. Oscar Towa (Papua New Guinean from Chimbu Province), *Tupela mama pikinini igo raun long garden na ikam bek na rain I pundaun na tupela hariap i go bek long ples wantaim pik bilong ol* (Mother and child go off to the garden and when they come back the rain comes down and the two hurry back to the village with their pig), 2004. Acrylic on canvas (Collection R. L. Welsch).

a mother and her child returning from the garden hiding from an afternoon rainfall under a makeshift banana leaf umbrella. This sort of scene seems natural and typical to anyone who has visited almost any Highlands village. The only difference from the reality of today is that the woman would likely be wearing clothes and carrying an umbrella, all of which she would have bought at a tradestore near her home. We could call this painting an example of the hypernostalgic—it depicts a traditional Chimbu identity as distinct from foreigners and from other Papua New Guineans.

Figure 8 was painted by the late James Kera, who died in 2003. It represents a young, single Papua New Guinean woman, one half of whom is dressed traditionally, while her other half is clothed in a blouse, slacks, and high heels, ready for the disco or club scene in Port Moresby, the nation's capital. This woman could be from any part of the country, but the artist has used several features that suggest a Chimbu identity. In all likelihood, the artist has merely used familiar symbols and imagery rather than trying to refer specifically to conditions among the Chimbu. As Rosi (1997, article 11) has noted, the subject matter of this painting is a common theme in contemporary PNG art, and one that foreigners like to buy as well. It depicts the social tensions all Papua New Guineans encounter as they adapt and adjust to modern life in Melanesia. But this painting and others like it also focus specifically on the tensions that PNG men have long felt were part of the major problems with development and modern life: PNG women are increasingly abandoning their traditional gendered roles as wives and mothers to partake inappropriately in the disco. In 2004, Chimbu artists began to paint PNG men who are split down the middle between tradition and modernity. Unlike Towa's nostalgia, Kera's painting—and many others like it—depicts the tensions of contemporary PNG life and gives meaning to national identity and newly contested gender roles.

The third painting (figure 9) is by Joe Mek and depicts the terrorist attack on the World Trade Center in New York on September 11, 2001. This vibrantly painted canvas uses a style that Kauage developed of filling windows in airplanes and buses (and here a building) with faces painted as if for a ceremonial dance. This feature, plus several of the decorative elements, defines this painting as a contemporary Papua New Guinean artwork, even though its subject matter—the destruction of the Trade Center—occurred some 10,000 miles away. Although PNG was one of the few countries who lost no citizens in the attack, this painting demonstrates that Papua New Guineans not only know about events overseas in the global village, but that they also feel part of the same international community. Here the artist painted two figures in the foreground to the left and right of the Trade Center, representing Osama bin Laden and George W. Bush respectively. Both men are painted with swarthy complexions and wear ornaments common in PNG. Finally, Mek covered the entire painting with paint dripping down the front like tears that embrace one of the world's great international tragedies. In a similar fashion described by Rosi (1998b, article 11) regarding Santana's work, Mek

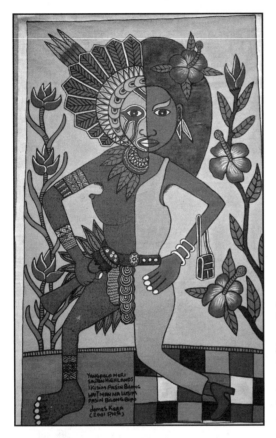

Figure 8. James Kera (Papua New Guinean from Chimbu Province), *Yangpela meri sauten highlands i kisim pasin bilong waitman na lusim pasim bilong bipo* (Young woman from the Southern Highlands who follows the customs of the White man and loses the customs of before), 2003. Acrylic on canvas (Collection R. L. Welsch).

embraced the complexities of the modern, international world and depicted this world in Papuan New Guinean terms. This painting, like so many of Santana's, presents a PNG identity in international terms. Yet, like both of the other paintings we have discussed, it creates international identity in terms of both a contemporary PNG life (represented by the building and airplane) and the use of nostalgic decorative elements throughout. Identity is no longer—if it ever was—a simple matter of defining ethnicity and ethnic boundaries, but has become an issue of multiple, nested, and overlapping identities that are no longer bounded by national borders.

If anthropologists have generally begun to take more interest in studying art, it is probably because the visual arts have become a major arena for identity formation on a global scale. Indeed, as anthropologist Jeremy MacClancy (1997:2) notes, "if the degree of structural difference between societies is being steadily eroded by the seemingly unchecked advance of global capitalism, then art becomes, partially by default, a key means of proclaiming continuing cultural difference." He draws

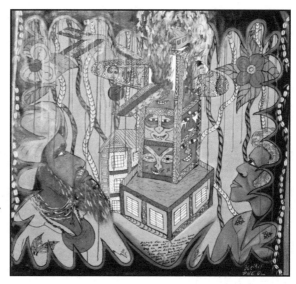

Figure 9. Joe Mek (Papua New Guinean from Chimbu Province), *Dispela stori bilong Amerika balus bilong USA yet I bin bambim haus long en* (This is the story of an American airplane that crashed into one of their buildings . . .), 2004. Acrylic on canvas (Collection R. L. Welsch).

attention to the use of art and art objects for contesting cultural attributions in the multicultural milieu in which we all participate. Essays by Sharman (article 2), Bundgaard (article 7), Rosi (article 11), Perkins (article 13), Stanley (article 15), and Mithlo (article 17) illustrate just how important art can be. The emergence of art as a common denominator of cultural and political processes in the global village is at least partly due to the high status and social distinctions that have long been given to art in the West. As George Marcus and Fred Myers (1995:11) have suggested, "Art continues to be the space in which difference, identity, and cultural value are being produced and contested."

The increasing prominence (and omnipresence) of visual culture also contributes to the privileged standing of the visual arts worldwide. The current "crisis" in Western art (Wolfson 2003)—especially the demise of autonomous high art—has opened up new spaces for forms of art by non-Western artists that previously went unrecognized. The research of economic anthropologist Stuart Plattner (1996) suggests that even when there were few economic benefits to be found in the local art world of St. Louis, young artists found great personal meaning in being a part of this art world. And as the canon has become wider it has given more space for non-Western artists and their creations on the global art stage (e.g., Mithlo, article 17). Western and non-Western artists are traversing geographical spaces in reverse directions (see Stanley, article 15). Such movements leave their marks as sources of artistic inspiration and attempts at intercultural communication that renegotiate differences between Western and non-Western art.

But Is It Art? (Redux)

Whether any particular Western or non-Western art object is art or not is always a question for researchers. The definition of art is perpetually linked to broader issues, and different definitions are part and parcel of struggles within art worlds for all of the different participants. Howard Morphy (2001) argued that any art that developed independently from the Western scene has the capacity to undermine these definitions for Western collectors and curators at a very basic level (see also Myers, article 8). Non-Western artists who receive Western art training and adopt corresponding values may be confronted by "traditionally oriented" relatives and members of their society insisting on their cultural property rights (Lewis-Harris, article 10). And as Alexis Bunten (article 14) points out, commercially produced objects that have no direct analog to traditional aesthetic systems can now be embraced by the community to express local identities. These "conflicts between tradition and academic freedom" (Graburn 1999:348), and the negotiations to resolve them, are also likely to affect notions of "traditional" art. As Welsch (2002:9) notes for the Pacific, with changes in art "the meaning of any art tradition will be in transition as well."

This destabilization of the categories of art also follows from the fact that during its circulation, at different points in time and through various owners, an object can be defined as either commodity, artifact, or art (Stocking 1985; Kopytoff 1986; Marcus and Myers 1995; Phillips and Steiner 1999). Consequently, Ruth Phillips and Christopher Steiner (1999) have argued that scholars should not keep trying to define art (see also Thomas 2001). Instead, they should be engaged more profitably in studying why people construct the various categories of art that they do (Sharman, article 2; van Damme, article 3). The focus of our investigations should be on the process of categorization instead of trying to apply some arbitrary definition of fine art: "No longer treatable as distinct and separate categories, the art-artifact-commodity triad must now be merged into a single domain where the categories are seen to inform one another rather than to compete in their claims for social primacy and cultural value" (Phillips and Steiner 1999:17). As we will see, this domain is not necessarily limited to tangible objects (Kasfir, article 5; Venbrux, 2002, article 9).

For pragmatic reasons, however, we still need some kind of working definition of art, if only to indicate what it is we are talking about. Considering the impact of non-Western art, it is telling that art historian Cynthia Freeland (2001:77–78), in her recent and comprehensive introduction to art theory, adopted a definition by Richard Anderson (1990:238): "Art is culturally significant meaning, skillfully encoded in an affecting, sensuous medium." If we want to understand art cross-culturally, we think this is a suitable working definition, and one that can be applied to transcultural productions as well as the more traditional monocultural ones.

Despite the increased mixing and blending of contemporary global art forms, including the transcultural features of objects as well as the innovative designs of museum exhibits (Macdonald 2003), the concept of authenticity has acquired an important role as a boundary marker in the visual arts of indigenous peoples. Claire Smith, Heather Burke, and Graeme Ward (2000:10) argued that "the notion of authenticity is central to the production of indigenous art, the negotiation of indigenous identity through art, and the explicit assertion of rights that can flow from this." In nearly all of the contributions in this collection, issues about authenticity are played out in a variety of ways and in different venues, ranging from tourist markets and migrant communities to galleries, museums, and overseas exhibitions. Although every one of these authors feels the artworks they discuss are authentic examples of art, these case studies nevertheless describe many situations in which some of the interested parties challenge whether such innovative artworks are authentic or not. Robert Welsch (article 18) will return to this set of questions in the afterword.

Most importantly, these articles suggest that art worlds should be conceived of as fields of cultural production. In these fields, indigenous interests are both mediated and advanced by artistic practices, indigenous knowledge systems, and aesthetic strategies. The articles consider the arts of Africa, Oceania, the Americas, and India to identify the major challenges we currently face in exploring world art by focusing on the contextual and processual dimensions of art production, use, and display.

How to Use This Book

This anthology contains 16 articles, organized into seven thematic sections, followed by an afterword. Each of the articles represents a case study about contemporary art in a specific part of the world. But in each case study, the art tradition discussed blurs the traditional boundaries of "tribal art," and each author has addressed questions about the connections between the artists in local communities and the global art market. Each author presents a somewhat different facet of the complex array of social, economic, political, and cultural factors that together make up world art. Each case study is an example of intercultural relationships, meanings, and movements of materials, ideas, styles, and people. Together, these articles bound the phenomenon we refer to as "world art."

There is no special order in which these articles should be read. Each section, as well as each article within the seven sections, can be read independently of the others. Each section begins with a short introduction that lays out the general theme and outlines some of the connections among the articles. Each article is followed by a number of questions that will help students digest the article's contents. We intend for these questions to provoke further thought and discussion.

Suggestions for Students

When reading essays about the anthropology or art history of tribal peoples, we urge students not to focus too much on foreign terms and strange customs. Such local ethnographic details are not the main point of any of these articles, but merely provide a necessary context for understanding the production of contemporary art, its use, its markets, and the desires of its consumers, many of whom live very far away from these local communities.

Of much greater concern than ethnographic detail is what question each of the authors raises in his or her essay. Only by understanding the question the author is asking can one appreciate the argument provided as an answer to the question.

When reading any of these articles, keep in mind the following:

- Who is the author and what is his or her particular disciplinary background?
- What question is the author asking?
- What kind of evidence is the author offering to help determine an answer to this question?
- What answer does the author provide to his or her question?

These questions are useful for reading any essay in the humanities and social sciences. They are essential questions for understanding nearly every academic article.

In this volume, which approaches questions about how contemporary art in non-Western contexts is being shaped and influenced by global art worlds, we suggest four more questions that will help students appreciate the common themes that run through the articles:

- What are the linkages between artists in their local communities and consumers in distant parts of the world?
- How are markets and the international marketplace shaping the kinds of artworks local artists are producing?
- To what extent is contemporary art produced in third or fourth world communities related to the traditional art from these same regions?
- Is the contemporary art described in the case study evidence of a completely new aesthetic, or is it a natural outgrowth and development of art traditions that existed before contact with the West?

Armed with these questions, we feel students are ready to begin exploring world art in its many forms and in its different settings around the world.

References

Adam, Leonhard. 1940. *Primitive Art.* Harmondsworth: Penguin Books.
———. 1949. *Primitive Art.* Rev. ed. Harmondsworth: Penguin Books.

Ames, Michael M. 1992. *Cannibal Tours and Glass Boxes: The Anthropology of Museums.* Vancouver: University of British Columbia Press.

Anderson, Richard L. 1979. *Art in Primitive Societies.* Englewood Cliffs, NJ: Prentice Hall.

———. 1989. *Art in Small-Scale Societies.* Englewood Cliffs, NJ: Prentice Hall.

———. 1990. *Calliope's Sisters: A Comparative Study of Philosophies of Art.* Englewood Cliffs, NJ: Prentice Hall.

———. 2001. "Bringing the Study of Art to Age." *Anthropology News* (October), p. 5.

Appadurai, Arjun, ed. 1986. *The Social Life of Things: Commodities in Cultural Perspective.* Cambridge: Cambridge University Press.

Arnoldi, Mary Jo. 1995. *Playing with Time: Art and Performance in Central Mali.* Bloomington: Indiana University Press.

Art Institute of Chicago. 1965. *Primitive Art in the Collections of the Art Institute of Chicago.* Chicago: Author.

Bascom, William. 1969. "Creativity and Style in African Art," in *Tradition and Creativity in Tribal Art,* ed. Daniel P. Biebuyck, pp. 99–119. Berkeley: University of California Press.

Bennett, Tony. 1995. *The Birth of the Museum: History, Theory, Politics.* London: Routledge.

Berlo, Janet C. 1999. "Drawing (upon) the Past: Negotiating Identities in Inuit Graphic Arts Production," in *Unpacking Culture: Art and Commodity in Colonial and Postcolonial Worlds,* ed. Ruth B. Phillips and Christopher B. Steiner, pp. 178–193. Berkeley: University of California Press.

Berlo, Janet Catherine and Ruth B. Phillips. 1998. *Native North American Art.* Oxford: Oxford University Press.

Biebuyck, Daniel P. 1969. *Tradition and Creativity in Tribal Art.* Berkeley: University of California Press.

Black, Martha. 1997. *Bella Bella. A Season of Heiltsuk Art.* Toronto: Royal Ontario Museum.

Boas, Franz. 1927. *Primitive Art.* Cambridge: Harvard University Press.

Bourdieu, Pierre. [1979] 1984. *Distinction: A Social Critique of the Judgement of Taste.* Trans. Richard Nice. London: Routledge.

Brasser, Ted J. 1976. *"Bo'jou, Neejee!": Profiles of Canadian Indian Art: A Travelling Exhibition of the National Museum of Man.* Ottawa: National Museum of Man

Butler, Shelley Ruth. 1999. *Contested Representations: Revisiting Into the Heart of Africa.* Amsterdam: Gordon and Breach.

Canadian Eskimo Arts Council. 1971. *Sculpture/Inuit: Sculpture of the Inuit: Masterworks of the Canadian Arctic.* Toronto: Author.

Cannizzo, Jeanne. 1989. *Into the Heart of Africa.* Toronto: Royal Ontario Museum.

———. 1991. "Exhibiting Cultures: 'Into the Heart of Africa.'" *Visual Anthropological Review* 7(10):150–160.

Caruana, Wally. 1993. *Aboriginal Art.* London: Thames & Hudson.

Christensen, Erwin O. 1955. *Primitive Art.* New York: Crowell.

Clifford, James. 1988. "Histories of the Tribal and the Modern," in *The Predicament of Culture: Twentieth-Century Ethnography, Literature, and Art,* ed. James Clifford, pp. 189–214. Cambridge: Harvard University Press.

Cole, Douglas. 1985. *Captured Heritage: The Scramble for Northwest Coast Artifacts.* Seattle: University of Washington Press.

d'Azevedo, Warren L., ed. 1973. *The Traditional Artist in African Societies.* Bloomington: Indiana University Press.

d'Harnoncourt, René. 1930. *Mexican Arts: Catalogue of an Exhibition Organized for and Circulated by the American Federation of Arts, 1930–1931.* Portland, ME: The Southworth Press.

Danto, Arthur, R. M. Gramly, Mary Lou Hultgren, Enid Schildkrout, and Jeanne Zeidler. 1988. *ART/artifact: African Art in Anthropology Collections.* New York: The Center for African Art and Prestel-Verlag.

Darbois, Dominique and Ian Christie Clark. 1970. *Indian and Eskimo Art of Canada.* Toronto: Ryerson Press.

Dark, Philip J. C. 1954. *Bush Negro Art: An African Art in the Americas.* London: A. Tiranti.

———. 1962. *The Art of Benin: A Catalogue of an Exhibition of A. W. F. Fuller and Chicago Natural History Museum Collections of Antiquities from Benin, Nigeria.* Chicago: Chicago Natural History Museum.

———. 1973. *An Introduction to Benin Art and Technology.* Oxford: Clarendon Press.

———. 1974. *Kilenge Life and Art: A Look at a New Guinea People.* London: Academy Editions.

———. 1978. "Review of Ethnic and Tourist Arts, edited by Nelson H. H. Graburn." *American Anthropologist* 80:400–401.

———. 2002. "Persistence, Change, and Meaning in Pacific Art: A Retrospective View with an Eye Toward the Future," in *Pacific Art: Persistence, Change, and Meaning,* ed. Anita Herle, Nick Stanley, Karen Stevenson, and Robert L. Welsch, pp. 13–39. Honolulu: University of Hawai'i Press.

Douglas, Frederic H. and René d'Harnoncourt. 1941. *Indian Art of the United States.* New York: Museum of Modern Art.

Duffek, Karen. 1986. *Bill Reid: Beyond the Essential Form.* Vancouver: University of British Columbia Press.

Errington, Shelly. 1998. *The Death of Authentic Primitive Art and Other Tales of Progress.* Berkeley: University of California Press.

Fagg, William. 1968. *African Tribal Images: the Katherine White Reswick Collection.* Cleveland: Cleveland Museum of Art.

———. 1969. "The African Artist," in *Tradition and Creativity in Tribal Art,* ed. Daniel P. Biebuyck, pp. 42–57. Berkeley: University of California Press.

———. 1970. *African Sculpture.* Washington: The International Exhibitions Foundation.

Forge, Anthony, ed. 1973. *Primitive Art and Society.* London: Oxford University Press.

Fraser, Douglas. 1962. *Primitive Art.* Garden City, NY: Doubleday.

Freeland, Cynthia. 2001. *But Is It Art?* Oxford: Oxford University Press.

Gardner, Helen, Horst de la Croix, and Richard G. Tansey. 1975. *Gardner's Art Through the Ages.* 6th edition. New York: Harcourt Brace Jovanovich.

Geary, Christraud M. 2004. "On Collectors, Exhibitions, and Photographs of African Art: The Teel Collection in Historical Perspective," in *Art of the Senses: African Masterpieces from the Teel Collection,* ed. Suzanne Preston Blier, pp. 25–41. Boston: MFA Publications.

Gerbrands, Adrian A. 1957. *Art as an Element of Culture, Especially in Negro-Africa.* Mededelingen van het Rijksmuseum voor Volkenkunde, vol. 12. Leiden: E.J. Brill.

———, ed. 1964. *Matjemosh.* 16 mm film. Utrecht: Stichting Film en Wetenschap.

———. 1967a. *The Asmat of New Guinea: The Journal of Michael Clark Rockefeller.* New York: The Museum of Primitive Art.

———. 1967b. *Wow-Ipits: Eight Asmat Woodcarvers of New Guinea.* The Hague: Mouton.

———. 1969. "The Concept of Style in Non-Western Art," in *Tradition and Creativity in Tribal Art,* ed. Daniel P. Biebuyck, pp. 58–70. Berkeley: University of California Press.

Graburn, Nelson H. H., ed. 1976. *Ethnic and Tourist Arts: Cultural Expressions from the Fourth World.* Berkeley: University of California Press.

———. 1999. "Ethnic and Tourist Arts Revisited," in *Unpacking Culture: Art and Commodity in Colonial and Postcolonial Worlds,* ed. Ruth B. Phillips and Christopher B. Steiner, pp. 335–353. Berkeley: University of California Press.

Greenhalgh, Michael and J. V. S. Megaw, eds. 1978. *Art in Society: Studies in Style, Culture, and Aesthetics.* New York: St. Martin's Press.

Guiart, Jean. 1969. "The Concept of Norm in the Art of Some Oceanian Societies," in *Tradition and Creativity in Tribal Art,* ed. Daniel P. Biebuyck, pp. 84–97. Berkeley: University of California Press.

Halle, David. 1993. *Inside Culture: Art and Class in the American Home.* Chicago: University of Chicago Press.

Halpin, Marjorie M. 1981. *Totem Poles: An Illustrated Guide.* Vancouver: University of British Columbia Press.

Hawker, Ronald W. 2003. *Tales of Ghosts: First Nations Art in British Columbia, 1922–61.* Vancouver: University of British Columbia Press.

Holm, Bill. 1965. *Northwest Coast Indian Art: An Analysis of Form.* Thomas Burke Memorial, Washington State Museum Monograph No. 1. Seattle: University of Washington Press.

Hopkins, David. 2000. *After Modern Art 1945–2000.* Oxford: Oxford University Press.

Indian and Northern Affairs Canada. 1983a. *Contemporary Indian and Inuit Art of Canada.* Ottawa: Author.

———. 1983b. *Contemporary Indian Art at Rideau Hall.* Ottawa: Author.

Janson, H. W. with Dora Jane Janson. 1962. *History of Art: A Survey of the Major Visual Arts from the Dawn of History to the Present Day.* New York: Abrams.

Jonaitis, Aldona. 1991. "Representations of Women in Native American Museum Exhibitions: A Kwakiutl Example." *European Review of Native American Studies* 5(2):29–32.

———. 1999. "Northwest Coast Totem Poles," in *Unpacking Culture: Art and Commodity in Colonial and Postcolonial Worlds,* ed. Ruth B. Phillips and Christopher B. Steiner, pp. 104–121. Berkeley: University of California Press.

Jones, Jonathan. 2003. "Aborigines Are Wrong about Harry: The Prince's Art is Ridiculous, but it Derives from the Modernist Sublime." *The Guardian* (August 20), p. 20.

Jones, Julie. 1964. *Art of Empire: The Inca of Peru.* New York: Museum of Primitive Art.

Jopling, Carol F., ed. 1971. *Aesthetics in Primitive Societies: A Critical Anthology.* New York: E. P. Dutton.

Karp, Ivan and Steven D. Lavine, eds. 1991. *Exhibiting Cultures: The Poetics and Politics of Museum Display.* Washington, DC: Smithsonian Institution Press.

Kooijman, S. 1959. *The Art of Lake Sentani.* New York: Museum of Primitive Art.

Kopytoff, Igor. 1986. "The Cultural Biography of Things: Commoditization as Process," in *The Social Life of Things: Commodities in Cultural Perspective,* ed. Arjun Appadurai, pp. 64–91. Cambridge: Cambridge University Press.

Layton, Robert. 1981. *Anthropology of Art.* New York: Columbia University Press.

Lewis, Phillip H. 1958. "What is Primitive Art?: Answer Told in Exhibition." *Chicago Natural History Bulletin* 29(7):3–4.

———. 1961. "A Definition of Primitive Art." *Fieldiana Anthropology* 36(1):221–241.

Linton, Ralph and Paul S. Wingert, with René d'Harnoncourt. 1946. *Arts of the South Seas.* New York: Museum of Modern Art.

Lips, Julius E. 1937. *The Savage Hits Back: The White Man through Native Eyes.* New Haven: Yale University Press.

MacClancy, Jeremy. 1997. "Anthropology, Art, and Contest," in *Contesting Art: Art, Politics and Identity in the Modern World,* ed. Jeremy MacClancy, pp. 1–25. Oxford: Berg.

MacDonald, George F. 1996. *Haida Art.* Seattle: University of Washington Press.

Macdonald, Sharon J. 2003. "Museums, Nationalism, Postnationalism and Transcultural Identities." *Museum and Society* 1:1–16.

Malinowski, Bronislaw. 1922. *Argonauts of the Western Pacific: An Account of Native Enterprise and Adventure in the Archipelagoes of Melanesian New Guinea.* London: G. Routledge & Sons.

Mandelbaum, David G. 1940. "The Art of Primitive Peoples," in *Primitive Art,* pp. 3–6. Minneapolis: University of Minnesota, University Gallery.

Marcus, George E. and Fred R. Myers. 1995. "The Traffic in Art and Culture: An Introduction," in *The Traffic in Culture: Refiguring Art and Anthropology,* ed. George E. Marcus and Fred R. Myers, pp. 1–51. Berkeley: University of California Press.

Morgan, Lewis Henry. 1877. *Ancient Society: Or Researches in the Lines of Human Progress from Savagery, through Barbarism to Civilization.* New York: H. Holt.

Morphy, Howard. 1991. *Ancestral Connections: Art and an Aboriginal System of Knowledge.* Chicago: University of Chicago Press.

———. 2001. "Seeing Aboriginal Art in the Gallery." *Humanities Research* 8:37–50.

Mountford, C. P. 1966. *Ayers Rock: Its People, Their Beliefs, and Their Art.* Honolulu: East-West Center Press.

Movius, Hallam L., Jr., S. Kooijman, and George Kubler. 1961. *Three Regions of Primitive Art.* New York: Museum of Primitive Art.

Munn, Nancy D. 1973. *Walbiri Iconography: Graphic Representation and Cultural Symbolism in a Central Australian Society.* Ithaca: Cornell University Press.

Museum of Fine Arts. 1958. *Masterpieces of Primitive Art, Oct. 16–Nov. 23, 1958.* Boston: Author.

Museum of Modern Art. 1931. *Diego Rivera: December 23, 1931–January 27, 1932.* New York: Author.

———. 1932. *American Folk Art: The Art of the Common Man in America, 1750–1900.* New York: Author.

Museum of Primitive Art. 1958. *Pre-Columbian Gold Sculpture: Autumn 1958.* Museum of Primitive Art Selections 5. New York: Author.

———. 1959a. *Sculpture from Three African Tribes: Senufo, Baga, Dogon, Spring 1959.* New York: Author.

———. 1959b. *Stone Sculpture from Mexico, Summer 1959.* New York: Author.

———. 1960. *The Raymond Wielgus Collection.* New York: University Publishers.

———. 1969. *Art of Oceania, Africa, and the Americas from the Museum of Primitive Art.* New York: Metropolitan Museum of Art.

———. 1974. *Primitive Art Masterworks: An Exhibition Jointly Organized by the Museum of Primitive Art and the American Federation of Arts, New York.* New York: The Federation.

National Gallery of Canada. 1969. *Masterpieces of Indian and Eskimo Art from Canada.* Paris: Société des Amis du Musée de l'Homme.

Nemiroff, Diana, Robert Houle, and Charlotte Townsend-Gault, eds. 1992. *Land, Spirit, Power: First Nations at the National Gallery of Canada.* Ottawa: National Gallery of Canada.

Newton, Douglas. 1961. *Art Styles of the Papuan Gulf.* New York: Museum of Primitive Art.

———. 1978. *Masterpieces of Primitive Art: The Nelson A. Rockefeller Collection.* New York: Knopf.

Onians, John. 1996. "World Art Studies and the Need for a New Natural History of Art." *Art Bulletin* 78:206–209.

———, ed. 2004. *Atlas of World Art.* Oxford: Oxford University Press.

Otten, Charlotte M., ed. 1971. *Anthropology and Art: Readings in Cross-Cultural Aesthetics.* American Museum Sourcebooks in Anthropology. Garden City, NY: American Museum of Natural History Press.

Phillips, Ruth B. and Christopher B. Steiner. 1999. "Art, Authenticity and the Baggage of Cultural Encounter," in *Unpacking Culture: Art and Commodity in Colonial and Postcolonial Worlds,* ed. Ruth B. Phillips and Christopher B. Steiner, pp. 3–19. Berkeley: University of California Press.

Plattner, Stuart. 1996. *High Art Down Home: An Economic Ethnography of a Local Art Market.* Chicago: University of Chicago Press.

Price, Sally. 1989. *Primitive Art in Civilized Places.* Chicago: University of Chicago Press.

Price, Sally and Richard Price. 1999. *Maroon Arts: Cultural Vitality in the African Diaspora.* Boston: Beacon Press.

Public Library, Museums, and National Gallery of Victoria. 1943. *Primitive Art Exhibition, May 1943.* Melbourne: S. Taylor.

Ravenhill, Philip L. 1996. *Dreams and Reverie: Images of Otherworld Mates among the Baule, West Africa.* Washington, DC: Smithsonian Institution Press.

Redfield, Robert, Melville J. Herskovits, and Gordon F. Ekholm. 1959. *Aspects of Primitive Art.* Museum of Primitive Art Lecture Series 1. New York: Museum of Primitive Art.

Reid, William. 1974. *Bill Reid: A Retrospective Exhibition at the Vancouver Art Gallery, November 6 to December 8, 1974.* Vancouver: Vancouver Art Gallery.

Roberts, Mary Nooter and Allen F. Roberts, eds. 1996. *Memory: Luba Art and the Making of History.* New York: The Museum for African Art.

Roberts, Mary Nooter, Susan Vogel, and Chris Müller, eds. 1994. *Exhibition-ism: Museums and African Art.* New York: The Museum for African Art.

Rosi, Pamela S. 1994. Bung Wantaim: The Role of the National Arts School in Creating National Culture and Identity in Papua New Guinea. PhD diss., Bryn Mawr College.

———. 1997. *O Meri Wantok* (My Countrywoman): Images of Indigenous Women in the Contemporary Arts of Papua New Guinea. Paper delivered at the Association of Social Anthropologists in Oceania Meetings, San Diego.

———. 1998a. "Cultural Creator or New Bisnis Man? Conflicts of being a Contemporary Artist in Papua New Guinea," in *Modern Papua New Guinea,* ed. Laura Zimmer-Tamakoshi, pp. 3–54. Kirksville: Thomas Jefferson University Press.

———. 1998b. *Nation-Making and Cultural Tensions: Contemporary Art from Papua New Guinea.* Boston: Pine Manor College.

Rubin, William. 1984. *"Primitivism" in 20th Century Art: Affinity of the Tribal and the Modern.* 2 vols. New York: Museum of Modern Art.

Sawyer, Alan R. 1966. *Ancient Peruvian Ceramics: The Nathan Cummings Collection.* New York: Metropolitan Museum of Art.

Schildkrout, Enid and Curtis A. Keim. 1998. *The Scramble for Art in Central Africa.* Cambridge: Cambridge University Press.

Shadbolt, Doris. 1986. *Bill Reid.* Seattle: University of Washington Press.

Shadbolt, Peter and Peter Collins. 2003. "Harry Paints His Way into Outback Row: Prince Accused of Stealing Aboriginal Motifs in His Art." *The Guardian* (August 19), p. 3.

Sieber, Roy. 1961. *Sculpture of Northern Nigeria.* New York: Museum of Primitive Art.

Smith, Claire, Heather Burke, and Graeme K. Ward. 2000. "Globalisation and Indigenous Peoples: Threat or Empowerment?", in *Indigenous Cultures in an Interconnected World,* ed. Claire Smith and Graeme K. Ward, pp. 1–24. St. Leonards, NSW: Allen and Unwin.

Smith, Marian W., ed. 1961. *Artist in Tribal Society: Proceedings of a Symposium.* Royal Anthropological Institute of Great Britain and Ireland, Occasional Paper 15. London: Routledge.

Staniszewski, Mary Anne. 1998. *The Power of Display: A History of Exhibition Installations at the Museum of Modern Art.* Cambridge: MIT Press.

Steiner, Christopher B. 1994. *African Art in Transit.* Cambridge: Cambridge University Press.

Stevenson, Hugh. 1990. "The Naïve Group of Artists," in *Luk Luk Gen! Look Again!: Contemporary Art from Papua New Guinea,* ed. Susan Cochrane Simons and Hugh Stevenson, pp. 47–58. Townsville: Perc Tucker Regional Gallery.

Stocking, George W., Jr. 1985. "Essays on Museums and Material Culture," in *History of Anthropology,* vol. 3, *Objects and Others: Essays on Museums and Material Culture,* ed. George W. Stocking, Jr., pp. 3–14. Madison: University of Wisconsin Press.

Stoller, Paul. 1995. *Embodying Colonial Memories: Spirit Possession, Power, and the Hauka in West Africa.* New York: Routledge.

Sutton, Peter, ed. 1988. *Dreamings: The Art of Aboriginal Australia.* New York: Viking/The Asia Society Galleries.

Sweeney, James Johnson, ed. 1935. *African Negro Art.* New York: Museum of Modern Art.

Thomas, Nicholas. 1991. *Entangled Objects: Exchange, Material Culture, and Colonialism in the Pacific.* Cambridge: Harvard University Press.

———. 2001. "Introduction," in *Beyond Aesthetics: Art and the Technologies of Enchantment,* ed. Christopher Pinney and Nicholas Thomas, pp. 1–12. Oxford: Berg.

Thompson, Robert Farris. 1965. *Tribes and Forms in African Art.* New York: Tudor Publishing.

———. 1966. *Nigerian Images: The Splendor of African Sculpture.* New York: Praeger.

———. 1969. "Abatan: A Master Potter of the Egbado Yoruba," in *Tradition and Creativity in Tribal Art,* ed. Daniel P. Biebuyck, pp. 120–182. Berkeley: University of California Press.

———. 1974. *African Art in Motion: Icon and Act in the Collection of Katherine Coryton White.* Washington: National Gallery of Art.

Thunder Bay Art Gallery. 1998. *The Helen E. Band Collection of First Nations Art: From the Permanent Collections of the Thunder Bay Art Gallery.* Thunder Bay: Author.

Townsend-Gault, Charlotte. 1997. "Art, Argument, and Anger on the Northwest Coast," in *Contesting Art: Art, Politics and Identity in the Modern World,* ed. Jeremy MacClancy, pp. 131–163. Oxford: Berg.

Tuckson, Tony, Margaret Tuckson, and Gillian Channell. 1973. *Aboriginal and Melanesian Art: The Primitive Art Collection of the Art Gallery of New South Wales.* Sydney: Art Gallery of New South Wales.

Tylor, Edward Burnett. 1871. *Primitive Culture: Researches into the Development of Mythology, Philosophy, Religion, Art, and Custom.* London: J. Murray.

University of British Columbia Museum of Anthropology. 1975. *Northwest Coast Indian Artifacts from the H. R. MacMillan Collections.* Vancouver: University of British Columbia Press.

University of California at Los Angeles Art Galleries. 1962. *Primitive Arts: An Exhibition Organized by Ralph C. Altman for the UCLA Art Galleries, March Fourth through April Fifteenth, 1962.* Los Angeles: Author.

University of Minnesota University Gallery. 1940. *Primitive Art.* Minneapolis: Author.

van Damme, Wilfried. 1997. "Do Non-Western Cultures Have Words for Art?", in *Proceedings of the Pacific Rim Conference in Transcultural Aesthetics*, ed. Eugenio Benitez, pp. 97–115. Sydney: University of Sydney.

Venbrux, Eric. 2002. "The Craft of the Spider Woman," in *Pacific Art: Persistence, Change, and Meaning*, ed. Anita Herle, Nick Stanley, Karen Stevenson, and Robert L. Welsch, pp. 324–336. Honolulu: University of Hawai'i Press.

Vogel, Susan M. 2001. *Fang: An Epic Journey.* Prince Street Pictures.

Von Finckenstein, Maria. 1999. *Celebrating Inuit Art, 1948–1970.* Hull, Quebec: Canadian Museum of Civilization.

Webb, Virginia-Lee. 1995. "Modern Times 1935–1946: Early Tribal Art Exhibitions at the Museum of Modern Art in New York." *Tribal Arts* 2(1):30–41.

———. 2000. *Perfect Documents: Walker Evans and African Art, 1935.* New York: Metropolitan Museum of Art.

Welsch, Robert L., ed. 1998. *An American Anthropologist in Melanesia: A. B. Lewis and the Joseph N. Field South Pacific Expedition, 1909–1913.* Honolulu: University of Hawai'i Press.

———. 2002. "Introduction: Changing Themes in the Study of Pacific Art," in *Pacific Art: Persistence, Change, and Meaning*, ed. Anita Herle, Nick Stanley, Karen Stevenson, and Robert L. Welsch, pp. 1–12. Honolulu: University of Hawai'i Press.

———. 2005. Contemporary Art and Identity in Papua New Guinea: The Case of the Chimbu Painters of Port Moresby. Unpublished paper prepared for the Pacific Arts Association, Salem, Massachusetts.

Wingert, Paul S. 1962. *Primitive Art: Its Traditions and Styles.* New York: Oxford University Press.

Wolfson, Rutger, ed. 2003. *Kunst in Crisis.* Amsterdam: Prometheus.

Wright, Robin K. 2001. *Northern Haida Master Carvers.* Seattle: University of Washington Press.

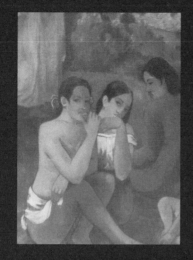

• • • • • • • • • *Section One* • •

Theoretical
Orientations to the
Subject of World Art

*M*any theoretical orientations characterize how scholars conceptualize and study world art. The first article in this section is concerned with a cross-cultural approach to art production as "socially valued experience" that shows some resemblances to ethnographic practice. The second article, which is somewhat broader in scope, distinguishes three general notions of what the anthropology of art is or can be about.

Russell Leigh Sharman argues that the anthropology of art needs to move beyond the study and classification of art objects. He argues that we should instead focus on the importance of artists themselves and the political and social contexts in which art is produced. The art discussed consists of oil paintings on canvas made by a local school of artists in the Costa Rican port city of Puerto Limón, who create "nostalgic scenes of Afro-Caribbean life on the Central American coast." By observing and talking with these artists Sharman learned that they were attempting "to rescue the culture." Living as they do in a marginal backwater, they portray the rustic life of Jamaican migrants to Costa Rica before the arrival of white men and their hegemonic culture. The artists' imaginative interpretations of black culture not only represent their local vision of what they feel is meaningful, but also seeks to re-create an experience of a significant black cultural legacy. Like the images created by the great artist Paul Gauguin in the South Pacific, Sharman states that the work of the Puerto Limón painters is "inherently ethnographic."

Besides regarding art as ethnography, Sharman considers ethnography an art form because interpretative ethnography represents "the literary equivalent to the aesthetic revolution of primitivism of the late nineteenth century." As he explains, Gauguin's quest was to re-create the meaningful experience of aspects of human creativity in French Polynesia. Similarly, ethnographers try to bring to life elements of the experience of another lifeworld for their readership. Sharman reflects on the construction of art worlds, especially their cultural legitimation, in the Costa Rican town as well as in academic anthropology. He offers a theoretical perspective on artistic activity that is particularly useful in the cross-cultural study of art: "Art production refers to that aspect of an aesthetic system where socially valued experience is re-created through various media in the ongoing construction of culture as an evaluative process." Art may have meaning, but more important is that through "sensuous experience" art is made meaningful in particular social contexts. Sharman stresses art's role in mediating social relations, thereby connecting shared values to everyday life, and in the creative valuation of a local vision.

In article 3 the Dutch anthropologist Wilfried van Damme relates anthropological approaches to art to several theoretical approaches to world art. Unlike Sharman, who approaches theory through his own field research, van Damme takes a broader view. He asks how anthropologists and art historians should con-

ceptualize world art. Then, he attempts to turn these concepts into workable research practice. He suggests that the anthropology of art can be linked to three views about what anthropology is. By reviewing these notions, he seeks to clarify for the reader the ways in which anthropologists have approached artistic phenomena—now collectively identified as the "anthropology of art."

The broadest conception (Anthropology A) defines anthropology as the study of human beings. Following this model, the anthropology of art would include an examination of all human artistic expression through time and space. But, as van Damme points out, this vast schema has been barely touched by anthropologists. Ironically, it has been scholars from outside anthropology that have begun tackling some of its fundamental issues.

The second concept of anthropology (Anthropology B) is based in what anthropologists most frequently do—the study of non-Western societies, particularly those of small-scale societies today or in the recent past. When these anthropologists focus on art, observations are based on field data and considerable attention is paid to embedding objects into rich contextual settings that can be interpreted through various theoretical lenses. Van Damme notes that scholars operating in this framework largely work in an ahistorical context because they only see what goes on about them during fieldwork. Recently they have begun to extend their research to study non-Western arts in contexts of intercultural encounter and exchange. Van Damme points out that these anthropological studies are very similar to those made by art historians in non-Western settings since they both draw on fieldwork and an "overall holistic perspective." He suggests that a better way to conceptualize these scholars would be to refer to them as regional specialists—Africanists, Oceanianists, or Americanists.

The third concept of anthropology is a disciplinary perspective (Anthropology C). Van Damme proposes that it has three primary hallmarks: an empirical-inductive orientation, a contextual emphasis, and an intercultural comparative perspective. The first and second of these features relate to local research in all environments; the third, however, is global.

Given the range of the three anthropologies of art outlined above, van Damme indicates that each can contribute to the development of world art studies. For those who want to explore the literature on the various anthropologies of art further, this article contains a valuable reference list.

2

Gauguin, Negrín, and the Art of Anthropology
Reflections on the Construction of Art Worlds in a Costa Rican Port City

Russell Leigh Sharman

In June of 1898, while living in Tahiti, Paul Gauguin finished a monumental canvas. Meant as his last gasp of creative expression (though fortunately it was not), the artist painted on a surface he himself stitched together from old gunny sacks and stretched across the length of his secluded island hovel. With its completion, he painted the title in a bold French script, "Where do we come from? What are we? Where are we going?" Five years later he would die, disease ridden and in constant pain, on the Marquesas Islands, still asking those nagging questions. This work, like most of his paintings, was a product of Gauguin's relentless probing of human experience, especially his experience of Western Europe's encroachment into a non-Western, small-scale society during the last decades of his life.

Of course, Gauguin himself was an embodiment of this encroachment, participating in it as a stockbroker in Paris before he left Europe. Eventually disillusioned by the idea of economic self-improvement, as much by the cruel fickleness of the market as by his ongoing passion for art, he gave himself fully to painting. First, he painted the world around him, the French countryside, and the islands of Brittany. But soon the treasure hunters and artistic avant-garde astonished elite society with the prizes of so-called primitive art showcased in museums and, more surprisingly, in upscale art galleries. The objects surely resonated with memories of Peru, where Gauguin had spent much of his youth with his mother's family. Not surprisingly, Gauguin was not content to gawk at isolated bits of sculpture or ritual masks in the antiseptic environment of galleries and exhibitions; he wanted to experience their

Reprinted from *Visual Anthropology Review* 17(1), with the permission of the American Anthropological Association.

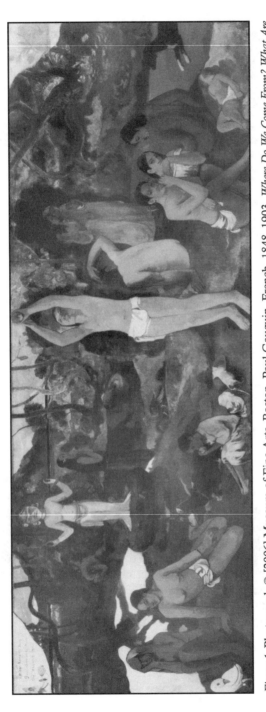

Figure 1. Photograph © [2006] Museum of Fine Arts, Boston. Paul Gauguin, French, 1848–1903. *Where Do We Come From? What Are We? Where Are We Going?* 1897–1898. Oil on canvas. 139.1 × 374.6 cm (54 3/4 × 147 1/2 in.). Museum of Fine Arts, Boston, Tompkins Collection 36.270.

production firsthand. But perhaps even more compelling was Gauguin's lusty embrace of the impressionist movement, where, for him, the immediacy of experience was less an aesthetic philosophy than a philosophy for life. So, traveling to the Caribbean, Latin America, and eventually the South Pacific, he finally settled in Tahiti, eventually accepting his slow death in the nearby Marquesas Islands.

Confronting an Art World in Costa Rica

Precisely 99 years after Gauguin painted his three questions, I packed up and shipped off to a sleepy Caribbean port city in Central America for my own ethnographic fieldwork. In many ways, Puerto Limón, Costa Rica, is a city Gauguin would have found appealing. Not far from the Caribbean side of the Panama Canal where Gauguin spent several miserable months during his first international foray, Limón is that subtly depressing blend of tropical paradise and urban decay. In his book *The Old Patagonia Express*, Paul Theroux (1979) not nearly as charitably asked, "Was there a dingier backwater in all the world?"

Indeed, to walk the streets of the tired port city was to experience some of what must have inspired Theroux's disdain. Seven years after a devastating earthquake the streets still lay cracked and often impassable. The city park, Parque Vargas, once the jewel of the province and the country, had become the home of drug deal-

Figure 2. Negrín at work in his public studio. Photo by Russell Leigh Sharman.

Figure 3. Rommel Spence painting at his home in the suburbs of Puerto Limón. Photo by Russell Leigh Sharman.

ers and prostitutes. The municipal government was rife with scandal, and the once powerful labor unions were a shadow of their former existence. Limón had become that embarrassing relative many Costa Ricans would rather ignore, though its port continued to sustain the economy of the country.

Still, it was with some relish that I escaped the dreamy spires of Oxford and ensconced myself in a port city few would willingly visit. I expected to wade through creative nuance and aesthetic subtlety, seeking that elusive aesthetic of everyday life. Its very dinginess seemed to promise that "art" as such would not be the discrete practice of local aesthetes, but rather a more diffused and ineffable search for beauty. As such, before I left England I was actually encouraged when a Costa Rican friend upbraided me for planning 12 months of fieldwork on Limón aesthetics. "There is no art in Limón," he explained. "What do you expect? Limón is a forgotten province in a developing country."

My experiences, however, quickly forced me to reevaluate my position. In my first week, I came across canvas artists painting in the dusty streets of the city center and in the rambling excuses for suburbs that extend haphazardly for miles from the port itself (figures 2 and 3). They were a discrete and quite self-conscious association of artists, all painting with the same vibrant colors, the same exaggerated human figures, and the same nostalgic scenes of Afro-Caribbean life on the Central American coast (figure 4).

Figure 4. Honorio Cabraca, *Untitled*. A typical scene of Afro-Caribbean life in the Limón style of canvas art.

The thematic consistency among the artists would prove crucial to understanding how this creative form fit the local emphasis on art as culture, and the wider distinctions between art and craft. Both of these issues will be taken up below, but they must be viewed in the context of Limón's ethnic history.

The artists reflect the demographics of a city that is roughly half black and half white. Their canvases reflect the perceptions of the city—that is, a black enclave, an "Africanized" and somewhat marginalized coastal community. These perceptions were born in a postcolonial period of industrial and agricultural development on the mostly uninhabited Caribbean coast. The United Fruit Company (UFC) brought thousands of Jamaican laborers to build a railroad and then work the banana fields of Limón Province. Soon, white Costa Rican migrant laborers from the highlands joined the Jamaicans in the banana fields, followed by white Costa Rican bureaucrats in front offices and city government. Eventually enfranchised as Costa Ricans, the largely black population of Limón remained a controversial threat to the white myth of racial purity cultivated in Costa Rica throughout the colonial period (Godmundson 1986; Sharman 2001).

The artists I spoke with, black and white, were committed to re-creating that perception of blackness in their canvases, as much to antagonize highland sensibilities as to affirm their own connection to the further reaches of the mainland Caribbean coast. (The question of why whites would collude in this practice of erasing their presence in Limón through painting is taken up in detail elsewhere [Sharman 1999, 2001].) Many of them spoke of parents and grandparents working on the Panama Canal, not far south of Limón. I imagined the spirit of Gauguin, who also worked on the canal, infecting their drive to paint, and infecting my drive to write about them painting.

My fieldwork, like that of Gauguin, presupposed a limiting specificity on concepts like culture, aesthetics, art, and meaning, but the inherent malleability of the local context challenged our assumptions. More often than not, the questions we turned to, "Where do we come from? What are we? Where are we going?" had less to do with our subjects than with our own social position. Limonense artists, like Gauguin, like myself, were trying to "rescue culture," that is, actively and intentionally re-creating bits of salient experience in the artistry of a word or a brushstroke. We were also conceiving culture as something we both create and are created by. But this presupposes a consensus on what we mean by culture, art, and "meaning" itself. What follows is a conceptual refiguring of culture, aesthetics, art, and meaning born out of the challenge of local context in the pursuit of an anthropology of art. The specter of Gauguin's art as ethnography runs throughout, questioning more specifically the role of ethnography as art itself.

Rescuing Culture

The artist who calls himself Negrín—also known as Ricardo Rodriguez-Córdoba—pioneered what is today known as the Limón style. He lives with his wife, Ofelia, in a faux-rustic block house painted in a fading pink amidst the dusty streets of the city center. All sixty of his years show in his hard-bitten features, and the rumors of his alcoholism seem more believable with each meeting. Like most artists in Limón, Negrín paints on the sidewalk in front of his house. He is a permanent fixture in the hustle and bustle of city life that we occasionally stop and attend to, but for the most part pass by on the way to the post office or the market, mentally filing away the experience as one of many others. Like his paintings, and like all of the artists in Limón, Negrín is both known and anonymous. It is partly what lends power to his expressive products: they are known and therefore attended to but also anonymously woven into the fabric of everyday experience.

I asked Negrín how he came to paint for a living. Negrín explained, "I started when I was very young. I always practiced drawing. For a while I worked at the port, at the customs office, worked a lot, but for the past twenty years I have been painting professionally."

"So what are some of your influences as a painter?" I asked.

Negrín responded quickly, "I never had any teachers, I just practiced and practiced, and read books and studied art history. I don't think anyone influenced my art because my painting, the Afro-Caribbean painting that I do, is born in me. I don't think anyone influenced me. Of course, I like Velazquez, Rubens, Degas, Titian, Rafael, Tintoretto. Degas is an impressionist. But no one influenced my painting, it is simply that I paint the thing that I think has to be."

Apparently, what Negrín thinks "has to be" is a nostalgic portrayal of Afro-Caribbean life on the coast. When I asked, "How do you choose your themes?" Negrín responded without hesitation.

"I am trying to rescue the culture."

"And why do you not paint the city as it is today?" I countered.

He thought for a moment, then motioned to the street. "Because there is nothing to see. It was better in the past. There was more scenery, more culture, more inspirations to paint. Now there are no inspirations, there are cars and highways and the people are of a different sentiment."

We discussed these changes for some time, and Negrín finally concluded, "Of course, it's all different. The blacks, like with baskets on their heads and things like that, it's all in the past. Now the culture is the same as anywhere in Costa Rica. My job is to rescue the old culture."

"Rescuing the culture" is a constant refrain among the canvas artists of Limón. Negrín, the self-proclaimed and universally acknowledged father of the form, seems its most vocal proponent. But the attitude filters into the dispositions of his disciples and competitors alike.

Rommel Spence, a young black Limonense painter, explained, "It is to recover some of this culture. . . . Because everything is being lost. Here in Limón it is already dying. Yes, it's almost all gone."

William Duran, a white Limonense artist, and an ardent disciple of Negrín, added, "The government doesn't want to develop the culture, the Limonense culture that I knew . . . I think programs around culture could help my city . . . with my paintings [for example]."

And German Mora, a maverick white Limonense painter who resists associating with Negrín, argued, "I am rescuing the culture, I believe the culture of Limón is dying . . . like the black women do not wear the turbans anymore. . . . So I have to paint as a memorial. It is not that wearing turbans is important. No one is going to start doing drugs or something just because they do not use turbans anymore. But it is a very beautiful image that is being lost and I want to conserve it."

Each artist seems to dip in and out of the variant connotations of culture in their quest to rescue what seems largely ineffable. Much of this has to do with the peculiar history of Limón, especially as it relates to the racialization of space in the geography of Costa Rica. Founded by the UFC toward the end of the nineteenth century, and populated largely by Afro-Caribbean migrant workers cum permanent

Figure 5. German Mora, *Untitled*. Rescuing the culture through canvas art.

settlers, Limón has always been viewed as the black city in the black province of a white nation. A civil war in 1948 nationalized the port and "whitened" the demography of the region, but the legacy of racial marginalization continues to plague Limón's connection to the rest of Costa Rica. This marginalization is often expressed in a mournful reminiscence for the "culture" of a black enclave diminished by a white invasion. But the artists' use of the term black seems to combine a "lifeways of the Other" connotation of culture (especially since many of the artists are white) with the more generalized elitist notion of "culture," specifically as it relates to fine art forms such as canvas art.

This apparent contradiction was also part of Gauguin's creative activity in the South Pacific, although it is unclear whether he had any intention to "rescue the culture" of his subjects. It seems Gauguin's project was more internal, less concerned with freezing some moment in time than with creating something entirely new from the raw materials of what he saw as culturally primordial. Certainly, Gauguin expressed disdain for the white invasion of French Polynesia (not unlike that of Limonense in regard to white Costa Ricans), but rather than purge his scenes of any European influence, his paintings often portrayed the effects of that invasion. As such, Gauguin's paintings reflect his own interpretation of local culture through the medium of that elite cultural form, canvas art.

Despite these differences, Gauguin and the Limonense artists share a common cause in that the products of their endeavors are inherently ethnographic. That is to say, their paintings record something of the life of a people through the lens of a participant-observer. Both capture something of the way things were, though neither can claim objective accuracy or even absolute authority. Even Negrín admits his paintings are products of his own imagination. When asked if the culture he was rescuing was the culture he knew when he was young, Negrín answered, "No, no, they are people that I invent, but yes, they are from the past." Note also Negrín's previous reference to the European art masters in regard to his aesthetic influences (or alleged lack thereof). Gauguin and Negrín both seem to move in and out of variant connotations of culture as they engage their craft. Not unlike anthropologists, both seem torn between their indebtedness to the European founders of their form and the subjects of their compositions.

For a case in point compare figure 1 and figure 6. The second of these illustrates a painting by one of Negrín's closest protégés, Honorio Cabraca. Both Cabraca and Gauguin (illustrated in figure 1) create a tableaux of local figures arranged in a stylized portrayal of life in situ. Both mourn the loss of those portrayed. The old Jamaican storytellers have long since passed (see Sharman 2000), and Gauguin's notebooks are filled with his dismay at the "corruption" of Tahitians

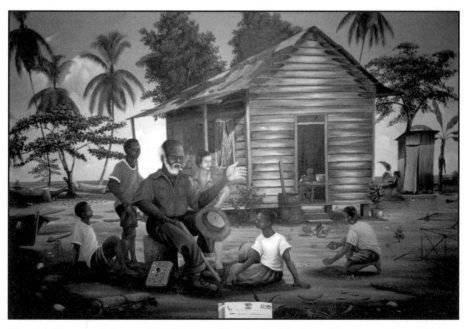

Figure 6. Honorio Cabraca, *Untitled.* Repetition in the Limón style ensures a homogeneous re-creation of local "culture."

and "Maoris" by the church and colonization. But, in as much as their work may "rescue" the culture around them, their canvases are themselves part of culture, commodified and exchanged in the same system that precipitated the need for rescuing in the first place. So Gauguin suffers bitterly in anticipation for what Parisians will think of his masterpiece, and Cabraca, realizing a market for his work, has no trouble repeating the exercise (compare figures 4 and 6). The result is an ethnographic imperative that drives artists to document a disappearing "culture" in a form that then becomes a part of their own burgeoning "culture."

Culture and Meaning

This ambiguity is certainly not restricted to Limón. With Edward Tylor's ([1871] 1988:64) first use of the term "culture" as an anthropologist, we see both its suitably indeterminate boundaries of descriptive power and its interchangeable association with "civilization," whose boundaries were precisely determined by the global elite:

> Culture or Civilization, taken in its wide ethnographic sense, is that complex whole which includes knowledge, belief, art, morals, law, custom, and any other capabilities and habits acquired by man as a member of society.

From its inception, culture has implied an evaluative process initiated by outsiders. Whether under the guise of scientific anthropology or armchair social philosophy, culture was a commodity to dole out as needed in the ever-widening conception of global human development, a sliding scale of perception where the needs of empire presided over the conditions of acceptance. According to this model of human social organization, everyone had culture, though some may have had more than others.

As anthropology explored this notion of culture, our understanding of its contours expanded. Brushing away the layers of colonial sediment revealed that culture was far from a commodity to be imposed or withheld. People did not *have* culture, culture had them. It was a solid structure that people inhabited. We were allowed to rearrange the furniture once in a while, but the walls were solid and the doors were locked from the outside.

But even this view of culture as a solid structure could not last. It would not be (too) long before we realized this solidity was an illusion of our own fashioning. Culture was no solid structure, it was the wool pulled over our eyes, a "web of meaning" we ourselves created. Interpretive anthropology reduced our lives to a text and gave us all the editor's red ink to redraw the lines of significance.

Beneath this rolling wave of theoretical revision there was another, alternate etymological trend that had broken off from Tylor's first use. It can be stated as follows: Culture, taken in its narrow, ethnocentric sense, is that complex part of social life that includes specialized knowledge, taste distinctions, "fine art," morality,

judgment, manners, and anything else that serves to distinguish one social class from another. This connotation of culture is more well-known in the popular imagination than Tylor's. This notion of culture has always been associated with social value and its perilous association with elite taste in the Western state society. One may or may not *be* cultured. To be uncultured is to be without the hallmarks of elite society, however those hallmarks are constructed and given value. Like Pierre Bourdieu's *Distinction* (1984), which links these variant connotations of culture in one study, taste defines social status and status is bound up in those webs of meaning that are perhaps less pliable than we once thought.

In each of the term's incarnations, the issue of meaning has loomed large. When Tylor invoked the litany of knowledge, belief, art, morals, law, and custom, he implied a consensus on meaning for each of these categories. If we all agreed on what these categories meant, then we had found ourselves in, or with, a culture. For the structuralists, meaning slipped below the surface of consciousness, becoming the load bearing members for a solid structure of culture. Meaning was something agreed upon before we arrived, leaving us to live within the contours of our predecessors' values. With the rise of interpretive anthropology, meaning once again rose to the surface, made manifest in everyday decisions and even social action.

But where does all of this meaning come from? I propose that meaning is not merely the cumbersome task of intelligible reference, it is also the distinguishing of relative value. A particular experience can both *have* a meaning and *be* meaningful within a particular cultural milieu. The misstep is assuming that to be meaningful, the experience must communicate some symbolic referent that is ultimately reducible to linguistic intelligibility. But how often is some experience meaningful precisely because one *cannot* put it into words? Perhaps our desire to refine language and its symbolic power of reference derives from the underlying importance of socially valued experience. We place value on some unintelligible experience and then seek out some way to de-scribe it.

Social life is not woven whole cloth out of mental constructs. Mental constructs themselves derive from our interaction with one another, objects, performances, and history—in a word, experience. In that never ending stream of experience there are moments of salience, bits of experience that hold sway over our connection to one another in a particular setting, what John Dewey (1934) called "an experience," or others more elaborately, a phenomenological reduction. We place value on that experience in honor of its salience, its connective power among us. That value is not necessarily a symbolic one, though we may try to encode a signifier at some point to communicate more efficiently. It is at first a recognition of importance, something especially resonant in that constant stream of experience. As Gauguin once wrote, "You can give me a talented description of a tempest, but you will never succeed in making me feel it" (Guerin 1978:9). An experience, then, is given value because it *is* meaningful, though at some point it may also *have* some symbolic, linguistic meaning for the purposes of abstract reference.

To place things in perspective thus far, culture refers to shared meaning, which is not only conceptual or symbolic, but is also—and perhaps more importantly—a distinguishing of socially valued experience. Contrary to popular opinion, then, culture is not rooted in language, but in the evaluative process that makes language possible. Culture is rooted in the attachment of value to experience, a process that may then produce mental constructs able to be referenced by language.

To be clear, culture is rooted in the process of value attachment, but is not itself that process. Culture is the product of consensus within a social context in regard to the evaluation of experience. We have another way of describing the actual process itself.

Culture as an Aesthetic System

Culture is also an aesthetic system. In brief, and to grossly oversimplify, culture, however one decides to define the concept, is bound up in shared meaning. Shared meaning refers to an evaluative process whereby a certain group of human beings over the course of time place a social value on certain collective experiences. The attachment of value to experience is precisely what the Greeks had in mind when they coined the term *aesthetica*. Aesthetics refers to the attachment of value to experience and the recreation of that socially valued experience through practices such as art production as a system.

The Greek aesthetica referred to the sensory perception of the material world. This was in contrast to the purity of intellectual reason promoted by Plato and other contemporaries. According to Plato, aesthetics, relying as it does on the emotions, polluted the purity of intellectual reason. The great irony for Plato (1987:51) was that practices such as poetry, which affect the senses and thus employ an aesthetic emphasis, only work when the creator is "out of his sense, and the mind is no longer in him." Thus, Plato banned aesthetic practices from his ideal state, not just for some benign inability to impart truth, but for an insidious undermining of truth. According to Plato, "the dramatic poet sets up a vicious form of government in the individual soul. . . . He is an image maker whose images are phantoms far removed from reality" (1941:329).

This philosophical attitude toward aesthetics and its practice established by Plato remained in place for the better part of two millennia. His legacy set the tone for philosophical inquiry (or lack thereof) into aesthetics and sensory experience in general. Despite occasional correctives like those of Alexander Gottlieb Baumgarten and the English Romantic philosophers, it was not until Immanuel Kant that the concept of aesthetics reentered mainstream philosophy.

For Kant, like Plato, all aesthetic judgments are subjective and allied to the immediacy of the imagination, as opposed to logical judgments that are objective and allied to a mediating cognition:

> The judgment of taste is therefore not a judgment of cognition, and is conse-
> quently not logical but aesthetical, by which we understand that whose deter-
> mining ground can be *no other than subjective*. (Kant [1790] 1968:37, emphasis
> in original)

As an unmediated perception, an aesthetic judgment must be disassociated with
any functional or utilitarian quality. Otherwise, the perception would conjure up a
concept that involves cognition, which would render the judgment mediated, logi-
cal, and thoroughly unaesthetical in Kant's formulation.

This concept of disinterested appreciation was based on the Cartesian revolu-
tion of scientific method carried to its logical conclusion. For Descartes—and for
Kant—being was rooted in contemplation, which in turn was rooted in the disem-
bodied mind. Sensory experience, as it relied on the mediation of the body, was
inherently unreliable, requiring the corrective of pure contemplation. As a result,
the extraction of the object of contemplation from any association with its relation-
ship to the body (i.e., its usefulness in everyday life or as a material means to an
end) was central to the Kantian concept of aesthetics as it applied to the judgment
of taste.

While Kant brought the term aesthetics back into the realm of philosophical
contemplation, it was in a new and much narrower formulation than that of the
Greeks. In Kant's redemption of aesthetics from the Platonic disavowal of its inher-
ently emotional quality, the term came to be inextricably associated with disinter-
estedness and elitism. But a more appropriately anthropological approach defines
aesthetics as more than just undifferentiated sensory perception. In a sense (forgive
the pun), Plato and Kant had it right: something happens when our senses are
affected. Part of that "something" is our response to the effect, an evaluative pro-
cess that proceeds in fits and starts as part of a social environment. Kant's disinter-
ested appreciation is one example of how a social environment constrains
individuals to attach value to certain kinds of experiences. But it does not end
there. As passive receivers, we can do little more than perceive the constant stream
of experience, picking out those moments that are socially valued. As active partic-
ipants, however, we can re-create some of those valued experiences and thus inter-
rupt the steady flow. These re-creations, based on those famous mental constructs
that are themselves derived from the immediacy of sensory perception in the every-
day flow of experience, are reinserted into sensory perception, but in an active and
intentional way.

Aesthetics, then, is a system where value is attached to the sensory perception
of experience and then re-created actively and intentionally to be confirmed or dis-
mantled as socially valuable. The product of this aesthetic system, where experi-
ence is both meaningful and has meaning, is what we call culture.

Art and Meaning

When Negrín began painting on the streets of Puerto Limón, he was re-creating the experience of Afro-Caribbeans on the mainland coast through his canvases, thereby engaging the local aesthetic system. By using canvas art to engage this system, he was also tapping into the cultural legitimacy of "fine art" as constructed in North America and Europe. This incongruity of context was problematic for Gauguin as well, for both Negrín and Gauguin were applying a European tool of cultural production, canvas art, to a non-European setting, Limón and French Polynesia respectively.

The result was a distance between themselves as artists and Others as subjects. For Gauguin this gap was manifest in his condescension toward the "primitive" and his perpetual angst over his art's marketability. For Negrín, this gap is marked in his own campaign to create a cultural elite in Limón, one that clearly distinguishes his art from the craft of others.

Rosa Hernández runs a souvenir shop by the port in Limón (figure 7). She and a few dozen women have been turning out T-shirts, coconut carvings, and small paintings for several years, and recently formed an association of Limonense artisans. Reflecting on her own work in relation to Negrín, Hernández said:

Figure 7. Rosa Hernández in her souvenir shop by the port in Limón. Photo by Russell Leigh Sharman.

> Who knows how many are more or less at his level, because Negrín is a very special painter. I could be as good as Negrín, but it will take a lot of time. I can paint little things very quickly, in ten minutes I can turn out flowers and trees and such, but for him it is leaf by leaf. He has a reputation for a very specific technique.

Negrín's reputation for that very specific technique has established a select cadre of painters in Limón who draw on his influence and marketability. For years this was an informal association, though exclusive enough to keep Hernández and many other, mostly female, artists out. In 1999, the association became formalized as *"Asociación Pintores Limonenses: PAtrimonio CUltural NEgrín"* (The Association of Limonense Painters: The Cultural Heritage of Negrín). Known as PACUNE, the association maintains about a dozen members, with a dozen more in training, all hoping to reach Negrín's standards.

The formation of PACUNE confirmed canvas art as an important Limonense aesthetic form. The medium's association with European and North American fine art adds to its value as a legitimate art form and helps to distinguish it from the more mundane world of tourist art, specifically that of Rosa Hernández's association. But with such legitimacy comes the burden of maintaining a certain aesthetic ideal associated with so-called fine art. This maintenance of an aesthetic ideal inevitably involves constant vigilance over the boundary between the canvases of artists and the souvenirs of artisans.

The result is a rather subjective, arbitrary, and often ambiguous, distinction between art and craft in Limón. When asked about painters who may have come before him, Negrín comments, "Yes, there were painters, but they did not paint anything like I paint. They painted small things, not as a profession." The "professionalism" of the artist and relative size of the product seem to be common indicators of an object's categorization, with the implication that if it can fit into a tourist's suitcase, it must not be art. It also seems that within this culturally specific aesthetic dichotomy, craft is defined as any visually expressive form not under the rubric of the Limón style in canvas art.

Olga Mendez is not a member of Negrín's association of canvas artists in Limón. Like many women in Limón who are attempting to make a living at creative work, she is a member of Hernández's artisan association. I asked her if she could explain the difference between the work of artists like Negrín and her own creative products. She thought for a moment and responded, "For me, well, I paint. I paint these things, but other things as well and I don't know if you would call it art or craft. I have a friend, an artisan, and he paints roosters on pieces of wood, and I don't know the distinction."

John Douglas Brown is a canvas artist in Limón, although not a member of PACUNE because of stylistic differences. He has his own take on what constitutes art:

> The work of art stands apart because of the setting in which it was done. You have people [who] put a [scene] on a dish or a vase, and that would be craft. But

once you put it aside on a canvas for a special purpose and it inspires people, and they can see that and through it recall the experience of the moment, the work of art speaks to you in its own language, to the psyche in an unconscious way, and it strikes so many emotions that arise in you, and that's what differentiates it from craft. Because an ordinary cup that is decorated, it could be a work of art, but one that is not concentrated.

Rosa Hernández offers another comparison between art and craft: "I don't think there is a difference—it's the same. They may be inspired to paint on canvas, and I may be inspired to paint on a shirt, but it is the same inspiration to make something, to make something to present to tourists or to people here who like it." Later, Hernández somewhat contradictorily added, "After I am finished with this area of artisans, I am going to spend more time painting. My dream is to one day paint on canvas and have a big exposition."

William Duran, one of Negrín's first pupils and a founding member of PACUNE, explains:

I don't paint for tourists. If someone wants to buy a painting, that's okay, but I don't paint for tourists. There are those who will put paint on a canvas in four hours, but not me. In San José they have expositions for groups of artists, and we barely sell any. There are those in San José who decide who is good and who is bad. I saw on television someone say that the painters in Limón are copiers, just copying nature. And I say, what painter in the world doesn't paint their surroundings. It is the source of all our art. It's illogical.

The specter of art versus craft colors the responses of artists and artisans, complicated further by the fact that white collectors in San José see little difference in the works of Hernández's association and those of PACUNE; they are all "cultural" objects, ethnic craftwork, tourist art. As Gauguin opined about the European response to Marquesan art, "There is not the prettiest official's wife who would not exclaim at the sight of it, 'It's horrible! It's savagery.' Savagery! Their mouths are full of it" (Gauguin 1968:95). This distinction between art and craft is more economic and political than aesthetic.

Part of the problem lies in the etymology of the word *art*, which resembles the most complex of bifurcating kinship charts. Branching off in all directions, it seeks to incorporate "skilled work" and "disinterested appreciation," admitting the social conventions of various definitions without excluding the possibility of beauty as a cross-cultural concept. At very few points in the course of social development, at least in Europe and the United States, has there been much consensus on the application of the term. It was not until the nineteenth century that its English usage indicated a differentiation between art as skilled labor and art as disinterested appreciation, or "for its own sake." The divisions within that same context in regard to the so-called fine arts is also a relatively recent development, with poetry more classically linked to history, music to mathematics, and painting to religious

iconography. Even now, in the aftermath of modernism, very few are willing to delineate once and for all the boundaries of art production in Western state society. A term that has the potential to apply to all activities in general can have little meaning in specifics. Art seems to have lost meaning in the midst of its ubiquity.

It is precisely its lack of fixed boundaries that makes art suitable for ethnographic study. Yet, the most intractable obstacle to embracing art as a cross-cultural phenomenon is its association in complex state societies with meaningful objects. Anthropologists are themselves typically socialized into a milieu where meaning adheres to objects, obscuring the way the objects mediate social relations. For instance, religion is important to anthropologists not because it has some meaningful content (that of course is left to theologians), but because it mediates social relations. It was this revelation that allowed for the anthropology of religion, where before the cosmology of small-scale society was at best fodder for theological speculation or derision. For much of its history, anthropology has viewed art in terms of its meaningful content, obscuring its more important role, ethnographically speaking, as a mediator of social relations. As a mere receptacle of meaning, the objects themselves were at best fodder for economic speculation by collectors or derision by art critics. But, as a mediator of social relations, the study of art becomes more concerned with the process of creative production, where the end product, the object or performance, is but one aspect of a much larger phenomenon.

I have already described this larger phenomenon as the attachment of value to experience and the re-creation of valued experience as part of a system, namely an aesthetic system, the product of which is culture. Art production refers to that aspect of an aesthetic system where socially valued experience is re-created through various media in the ongoing construction of culture as an evaluative process. Objects and performances are produced that sensuously resonate with certain valued experiences. To the extent that the creative form resonates with that collective experience, it does so because the creator or creators express something meaningful through it. This is what Alfred Gell (1998) means when he calls art an "index of agency," or what Leo Tolstoy ([1896] 1960) before him described as the role of art as a vehicle for human emotion. Art and the process of its production mediate social relations through intentionality, a causal relationship between artist—which is most often not a specialized office—and audience, which is most often composed of other living humans, but can include spirits and gods as well.

The artist in question rarely intends to create art as such, following a common and flawed definition of art. More specifically, the artist intends to re-create socially valued experience and in so doing produce some effect on their audience. Art, then, is less about encoding meaning in a nonverbal system of communication and more concerned with mediating relationships through sensuous experience.

Gauguin long struggled against the notion that art must communicate some discursive meaning. He believed that painting, which for centuries helped to establish an emphasis on symbols and meaning, could be used to undermine the hege-

mony of semiotics: "Of all the arts, painting is the one which will smooth the way to resolving the paradox between the world of feeling and the world of intellect" (Guerin 1978:146). He often compared painting to music in its primary ability to affect an individual through feeling rather than the intellect: "A given arrangement of colors, lights, and shadows produces an impression. . . . Often you are seized by that magical harmony before you even know what the subject of a painting is" (1978:129). But perhaps his simplest expression of this idea was in a story about Gustave Courbet: "When a lady asked what he was thinking of before a landscape he was in the act of painting, [Courbet] gave this fine answer: 'I am not thinking, Madame; I am moved'" (1978:128).

The method by which art mediates social relations points to another mediation that art facilitates; that is, the relationship between collective values and lived experience. Inherent in the idea that art production re-creates socially valued experience is the idea that the process goes beyond encoding referents to an abstract concept. For art is itself sensuous experience, inserted actively and intentionally into the flow of everyday life, to which a group may attach value in the ongoing process of the aesthetic system. Art does not *have* meaning, it is itself meaningful experience.

When I asked Negrín how he felt art was part of the culture of Limón, he answered, "We are representatives of Limón." Limón, for Negrín and others, is inextricably associated with blackness. To represent Limón is to represent the reality of that experience. Unfortunately, it is a reality that many white Costa Ricans would rather ignore, and as such, Limonense artists find it difficult to show their work in galleries outside Limón. The occasional exhibition in San José is organized around a Limón theme, usually as a curiosity rather than an ongoing integration of Limón artists into the mainstream Costa Rican art world. Limón artists often complain that they cannot convince San José galleries to carry their work on a regular basis.

German Mora explained:

> For example, I brought my painting to a gallery in San José, and they said no, that it is not typical of Costa Rica, so it was rejected. But I think the people of the gallery and tourism should exploit this side [the Atlantic coast] more. They should support what is typical of Limón as well. And if we don't see them trying to do this, because there has not been any mixing or progress, then we will be closed off.

It is important to recognize that this exclusion is more than simply a judgment of taste on the part of curators, but a rejection of Limonenses in general. As Gell (1998) points out, objects "act" on behalf of their creators. From this perspective, the consistent imagery presented in Limón canvases are extensions of—or stand-ins for—Limonense artists. When highland galleries reject their canvases, they are rejecting the Limonenses themselves. According to George Marcus and Fred Myers (1995:34), "you carry with you into your own realm of meaning and art production

more that just the object. You carry its whole context of local culture." And just as Limonenses in general are excluded from, or at least marginalized within, the national identity, their canvases are treated in a similar way by San José galleries.

Rejection by highland galleries confines the market for Limonense canvases to Limón itself, which includes some of the wealthier local business owners and politicians, as well as the occasional individual collector. This confinement of their market has produced two important effects: Limonense artists rarely paint full time without other sources of income, a fact that often burdens their sense of professionalism in the art world. And the compositions themselves have to conform to the demands of the local market, which overtly seeks presentations of Limonense identity and its association with blackness.

Rommel Spence, another local canvas artist, represents much of the restlessness that local artists feel about the restrictions on their marketability. Spence's work sells well in Puerto Limón, but he has never shown any of his work in San José. This is due in part to the economics of transportation and not having the right connections. But it is also due to his conformity to the local canvas art style that glorifies those aspects of Limón history and demographics that remain unpalatable to collectors outside Limón. Spence argues, "The people here [in Limón] like this style very much. I paint this style because the people like it and I can sell more."

Spence understands the local market and conforms his painting to those creative boundaries, but he also understands that any art market is created out of a certain cultural context. As he explains:

> In San José, on that side of the country, they don't have this kind of painting. Like in San José maybe you can see various other styles also, and they are similar to each other. If you go to Guanacaste you will find something different, Puntarenas, another style, and so on for different provinces. Yes, because the people will surely paint with the vision they see.

Implicit in Spence's astute grasp of the Costa Rican art world is that while nationally there may be multiple stylistic visions, the economics of the dominant art market will only legitimize art that conforms to the dominant vision.

Spence would get along well with Arthur Danto, a philosopher who helped define the concept of an "art world." Danto ([1964] 1987:478) recognized that art was not an aesthetic universal, but a cultural symbol defined by two things: an "atmosphere of artistic theory" and a "knowledge of the history of art." One must become socialized into a particular way of seeing the world, with a working knowledge of how one's society labels objects as art or not art, in order to see certain creative practices as part of the legitimate art world. Without the properly socialized vision, one can only see an object's constituent parts. For gallery owners and collectors in San José, the canvases of Limonense artists were curious revisions of racial history, but not art as defined by their culturally specific art world. To paraphrase Danto, when Mora or Spence took their paintings to highland gallery own-

ers, "all they saw was paint" ([1964] 1987:477). Spence's observation that people paint "with the vision they see" was both a justification for the Limón style of vibrant colors and black figures and a challenge to carve out a piece of the legitimate art market in San José. Unfortunately, we will not see how far Spence could have taken that challenge in Costa Rica, because he has since moved to New York to paint with a new vision.

In all of this we see that the canvases of Limonense artists (along with the T-shirts and carved coconuts) are not mere receptacles of meaning. They are themselves part of meaningful experience among Limonenses, and even among San José gallery owners. As extensions of the Limonense self, the canvases are more about the ways Limonenses relate to each other and to outsiders than they are about their own semiotics. The canvases are part of the invention of a collective past, the struggle for social enfranchisement, and the shoring up of cultural autonomy. They are significant aesthetic acts mediating social relations through the re-creation of valued experience. They are more active than interpretive, more aesthetic than hermeneutic.

Gauguin's canvases were not all that different, especially those he was shipping back to Europe from Tahiti and the Marquesas. As his own experience entwined with his subjects, his canvases became extensions of himself and the Other transported into the salons of Paris. This was manifest materially as well, moving from canvas to burlap to wood. Even in his writings, Gauguin was keen to insert sketches and woodcuts in a intentional and neatly orchestrated manner, constantly disrupting the meaning of the text with the experience of an image. As he wrote over and over in his published journal, "this is not a book." And it was not. As much as the canvases of Limón, or his own works, his journals were aesthetic acts, challenging the conventions of art, blurring the connotations of culture, and mediating social relations across oceans and through time.

Art as Ethnography/Ethnography as Art

The dramatic and adventurous history of Gauguin, and the considerably less dramatic story of my own fieldwork, are in many ways an allegorical history of cultural anthropology. More specifically, they are reflections on the anthropological interest (or lack thereof) in art and its creators. Providence or fate firmly planted Gauguin (like myself and so many anthropologists) in the society of Western Europe, which trained him in the aesthetic conventions of that context. But he could see there was more beyond the authority of his social milieu, it was especially visible in the creative products of non-Western society. So he did his research. He spent time in the field doing participant observation, and in some cases doing his best to correct the image of the "primitive" in the eyes of Europe. In his journal, Gauguin (1968:95) wrote, "The Administration has never for an instant dreamed

of establishing a museum in Tahiti, as it could so easily do, for all this Oceanic art. None of these people who consider themselves learned have ever for an instant suspected the value of the Marquesan artists."

It was a position Franz Boas would have appreciated, even though Gauguin's salvage anthropology was little more than a disgruntled opinion. He certainly did not take the pains to establish a museum himself (nor have I, for that matter). Gauguin's mode of cultural preservation was in his brush, in rendering a bit of the reality of Polynesian life. For all of his fieldnotes and journals, as interesting as they are, it is in Gauguin's paintings that we may find some of the most interesting examples of this comparison between his story and that of cultural anthropology.

For Gauguin was part of what Danto once described as a critical moment in art history, when art as imitation became art as reality. Painters lost interest in "mere imitation," and turned more consciously to producing a bit of reality specifically intended not to deceive. In this way, Gauguin's innovative approach to painting is the aesthetic equivalent to ethnography's innovative approach to writing. As much as anthropologists strive to recount accurately the details of a particular cultural setting, they know their ethnographies are, in a sense, writing those settings into existence for the reader. Similarly, Negrín and the members of PACUNE are striving to "rescue the culture" of the past by creating images of life that Limonenses experience only through the canvases themselves. To borrow Danto's ([1964] 1987:473) words, ethnographies, the canvases of PACUNE, and those of Paul Gauguin all occupy "a freshly opened area between real objects and real facsimiles of real objects." Anthropologists, like Gauguin, aspire to reflect some of the reality of their experience in the field, without presuming to capture it entirely, nor admitting that it is anything less than accurate and valid in itself. The ethnographic present is the literary equivalent to the aesthetic revolution of primitivism of the late nineteenth century.

The result is a history of creative production, both ethnographic and on canvas, that attempts to render accurately the cross-cultural practice of producing art. Crucial to this project is recognizing the influence of biases and social position, and the fact that our audience ultimately lies with colleagues and a few interested nonspecialists, not with the people studied. This seems true of Limonense artists as well, whose audience remains the few collectors willing to pay the prices that ensure their elite position above common artisans. As German Mora once remarked, "I work for common people and they can't understand these very complicated things that come from those who study art at the university." Even Gauguin periodically shipped his canvases back to Paris for his agent to sell on his behalf. As he once wrote, "Hypocrisy has its good points" (Gauguin 1968: 84).

These biases and omissions are often as glaring as the paintings of Gauguin, where Tahitian women kneel at the cross or adore a distinctly Polynesian Virgin Mary (figure 8). It is this often bizarre conflation of personal experience and ethnographic detail that is the by-product—and some would argue the basis—of partici-

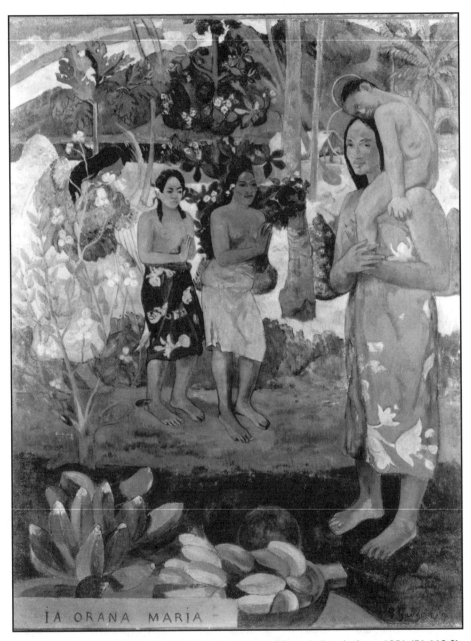

IA ORANA MARIA

Figure 8. The Metropolitan Museum of Art, bequest of Sam A. Lewisohnm 1951 (51.112.2). Paintings, French, Paul Gauguin (1848–1903), *La Orana Maria*, 1891, oil on canvas, 44 3/4 × 34 1/2 in. (113.7 × 87.7 cm).

pant observation. It is also a large part of why ethnographies, like the art objects described by Danto, stand in the freshly opened space between real objects or real experience on the one hand and imitations of real objects and experiences on the other. Recent debates over whether anthropology should be considered a scientific discipline or a creative endeavor are really about how close to a presumption of truth or the admission of complete fancy do one's ethnographic products lie. One hopes they lie somewhere comfortably and not too controversially in the middle. All anthropologists must confront this aspect of what they are in regard to where they have come from. It is especially important for an anthropology of art, the impetus for which is so blatantly rooted in Western ideas about beauty and tautological definitions of art and aesthetics.

For too long, anthropologists allowed the study of art to remain focused on the objects produced rather than the producers themselves, reducing the discipline's contribution to a cross-cultural understanding of human creativity to an ethnocentric cataloging of objects. The anthropology of art, with its museum displays and ethnographies full of glossy color plates, became a glorification of the art of anthropology at the expense of non-Western creativity.

But this critique of the anthropology of art is only an illustration of the underlying and ever present danger in ethnographic work. Though its susceptibility may seem more acute, the anthropology of art is but one example of a disciplinary conflict between narcissistic self-reflection and reflexive self-criticism. In as much as anthropologists hope their work brings some dignity, and in some cases political or social change, to the lives of people too long subjugated to the dominance of Western civilization, their academicization of that experience is what makes their work comparable to the creative products of avant-garde artists like Gauguin and Negrín. Fortunately, contemporary anthropology and its interest in art lends itself more readily to reflexivity. Hopefully a more reflexive attitude, already evident among some (Price 1989; Marcus and Myers 1995), will bring the discipline up to speed on the implications of a cross-cultural approach to art and creative production, such that the anthropology of art can *productively inform* the anthropology of race, gender, political economy, and so on.

For art is part of a system of value production about which revolves social, political, and economic interaction, and ultimately, identity formation. It is the kind of approach to art that anthropology so desperately needs to adopt, but finds so difficult in light of its fetishization of art objects. Since the watershed of Gauguin's work, so much of European and United States art history seems trapped between two things: an actual broadening of the legitimate boundaries of art production to include the work of cultural outsiders and the more indulgent navel-gazing that for so long allowed European interpretations of the "Other" to pass for cross-cultural canonical inclusion. As I have outlined above, in a similar but more reflexive way, anthropology seems too often trapped between a more rigorous anthropology of art and a more indulgent, self-conscious cultivation of the art of anthropology.

So, where have anthropologists come from? We've come at least a little bit from presuming so large a gap between a European sensibility and non-Western primitivism. We've also come a long way from presuming the work of ethnographers is any less a creative enterprise than the work of a painter rendering experience for the benefit of his or her audience, though we hope both remain true to that experience, resulting in a bit more than imitation. What is anthropology? We are who we study because our project is as creative as the artists we seek out in our fieldwork and because we invariably reflect our own understandings of creativity and beauty in an attempt to understand someone else's. Where is anthropology going? Well, I will allow my bias to thwart the perfect symmetry of my own Gauguin allegory, such that anthropology will not suffer a slow and painful death on some obscure island in the sea of academia. At the end of the day, where we are going is an unanswerable question, and rightly so. The project of cultural anthropology, like most creative institutions, is all about reinvention. It is, like the work of so many artists, a work in progress.

Questions for Discussion

1. The painters Sharman discusses do not use traditional media, nor are the paintings they create in any sense a traditional art form. Instead, these painters have developed their own contemporary styles. Why then do they think of their paintings as supporting traditional culture?

2. What does Sharman's case study have to say about the customary categories of "traditional art," "primitive art," and "modern art"?

3. In what sense is Sharman describing the formation of a hybrid art style? To what extent does he feel this is useful for understanding art in Puerto Limón, Costa Rica?

References

Bourdieu, Pierre. 1984. *Distinction: A Social Critique of the Judgment of Taste.* Cambridge: Harvard University Press.

Danto, Arthur. [1964] 1987. "The Artworld," in *Art and Its Significance,* ed. S. D. Ross, pp. 470–482. Albany: State University of New York Press.

Dewey, John. 1934. *Art as Experience.* New York: Berkley Publishing Group.

Gauguin, Paul. 1968. *Paul Gauguin's Intimate Journals.* Trans. Van Wyck Brooks. Bloomington: Indiana University Press.

Gell, Alfred. 1998. *Art and Agency.* Oxford: Clarendon Press.

Godmundson, Lowell. 1986. *Costa Rica Before Coffee.* Baton Rouge: Louisiana State University Press.

Guerin, Daniel, ed. 1978. *The Writings of a Savage: Paul Gauguin.* New York: Viking Press.

Kant, Immanuel. [1790] 1968. *Critique of Judgement.* Trans. J. H. Bernard. New York: Hafner.

Marcus, George E. and Fred R. Myers, eds. 1995. *The Traffic in Culture: Refiguring Art and Anthropology.* Berkeley: University of California Press.

Plato. 1941. *The Republic.* Trans. F. M. Cornford. Oxford: Oxford University Press.

———. 1987. "Ion," in *Art and Its Significance,* ed. S. D. Ross, pp. 47–58. Albany: State University of New York Press.

Price, Sally. 1989. *Primitive Art in Civilized Places.* Chicago: University of Chicago Press.

Sharman, Russell Leigh. 1999. "With the Vision They See": Identity and Aesthetic Experience in Puerto Limón, Costa Rica. PhD diss., Oxford University.

———. 2000. "Poetic Power: The Gendering of Literary Style in Puerto Limón." *Afro-Hispanic Review* 19(2):70–79.

———. 2001. "The Caribbean Carretera: Race, Space and Social Liminality in Costa Rica." *Bulletin of Latin American Research* 20(1):46–62.

Theroux, Paul. 1979. *The Old Patagonia Express.* London: Hamish Hamilton.

Tolstoy, Leo. [1896] 1960. *What Is Art?* Trans. Almyer Maude. New York: Macmillan.

Tylor, Edward. [1871] 1988. "Primitive Culture," in *High Points In Anthropology,* ed. P. Bohannan and M. Glazer, pp. 64–78. New York: McGraw-Hill.

Anthropologies of Art
Three Approaches

Wilfried van Damme

Ever since its beginning 150 years ago, "modern" anthropology has been concerned in various ways with what Westerners would broadly refer to today as the visual arts. But the label "anthropology of art" has been around for only a few decades. Its first prominent use was by Robert Layton (1981), although Herta Haselberger (1969) had previously introduced a similar term, *Kunstethnologie,* to the German-speaking world. The late introduction of these terms suggests that the anthropological study of art had not been conceptualized in any systematic way until rather recently. Even today, the use of the term "anthropology of art" can hardly be interpreted as offering a systematic view toward research about the visual arts. The label simply signifies that anthropologists have studied visual artistic phenomena (but see Gell 1998, and assessments of him: Arnaut 2001, Layton 2003, Pinney and Thomas 2001). A volume edited by Jeremy Coote and Anthony Shelton (1992) reflects this state of affairs rather well. This collection of essays, entitled *Anthropology, Art, and Aesthetics,* corresponds rather closely to what the anthropological study of art has been about in the decades following the Second World War—a period in which anthropological interest in artistic phenomena began to blossom. Coote and Shelton's volume contains richly contextualized case studies written by Western "field researchers" who dealt with visual art forms in particular indigenous cultures in Africa, Oceania, and the Americas. Such studies, however, do not exhaust the possibilities offered by examining art within an anthropological framework.

So what does it mean to marry the term anthropology to the study of the visual arts? In this article I suggest that there are several different ways of viewing the idea of an anthropology of art, depending on one's interpretation of the label anthropology. In making this analytical proposition, I hope to accomplish three objectives for the reader. First, I provide a clarification of three possible "anthropologies of art," raising some issues for further discussion. Second, I offer a brief survey of these "anthropologies" that will be of use to students of art and art history who turn to anthropology for useful insights in "exploring world art." Third, I suggest the rele-

vance of these anthropologies of art for the development of World Art Studies as a global, multidisciplinary examination of the visual arts. Overall, I argue that, in its most encompassing interpretation, the anthropology of art coincides with the idea of World Art Studies.

Humanity and the Visual Arts: Anthropology A

In its broadest etymological sense, anthropology refers to the study of human beings. But since this is not the only reading of this term, I suggest we provisionally dub this interpretation *Anthropology A*. The opening chapters of introductory textbooks in anthropology regularly advocate this sort of comprehensive conception of the idea of anthropology, although they usually have an emphasis on the sociocultural dimensions of being human.

In actual anthropological practice and theory, however, this encompassing, humanity-centered conception does not seem very popular today. It does have a long—if somewhat patchy—intellectual tradition in the West that nominally goes back to the German humanist scholar Magnus Hundt. In 1501, Hundt introduced the term *anthropologia* as a counterpart to *theologia*. Central to the endeavors of Hundt and other German humanists was an interest in elucidating "human nature." As Otto Casmann wrote in 1594, *"Anthropologia est doctrina humanae naturae"* (anthropology is the study of human nature) (cf. Stagl 2000:27). Having conceptual roots in early and classical Greek thought, this idea implied asking questions about the ways in which human beings both resembled and differed from other animals.

During the next few centuries, scholars who pursued this tradition incorporated into their analyses whatever contemporary scientific knowledge could teach them about the biological dimensions of being human. Whatever data were available about cultures other than one's own—both past and present—were equally of great interest (cf. Roughley 2000:2–4; Stagl 2000:28). Although this tradition is often referred to as *philosophical anthropology*, researchers from this tradition have had considerable interest in various types of empirical data. Being global in orientation and multidisciplinary in character, it seeks to establish and explain both commonalities and differences in the various forms of life developed by human beings. Anthropologist Bradd Shore's (2000:81) recent definition of anthropology seems to emerge from this school of thought; for him anthropology may be characterized as "the study of human nature in light of human variation."

If one conceives of anthropology as the study of humanity (Anthropology A), then the anthropology of art would refer broadly to the examination of artistic phenomena in human life. However etymologically correct, such an encompassing view of the "anthropology of art" is seldom, if ever, encountered. Indeed, even among anthropologists adopting an intercultural comparative perspective on the

visual arts, which is quite a rarity, only a few have ventured into analyses that go beyond the twentieth century cultures of Africa, Oceania, and the Americas (see Maquet 1979, 1986, Napier 1986, Gell 1998, and Anderson 2004; compare also the work of art historians such as Rubin 1988, Borgatti and Brilliant 1990, Belting 2001, and Summers 2003).

If we want to consider as varied a sample of human cultures as possible, the extensive conception of the anthropology of art (Anthropology A) suggests we should systematically examine, in panhuman terms, fundamental issues in the arts. These include such issues as: origins and development, style and reference, production and evaluation, patterns of use and function, innovation and diffusion, and more.

Interestingly, and ironically, it is in fact mostly nonanthropologists—or at least scholars from outside the field of academic anthropology—who have recently started to tackle issues that belong to this most basic and most broadly conceived idea of an anthropology of art. Thus, Ellen Dissanayake (1988, 1992), combining training in biology and art history with prolonged stays in various cultures, has dealt with the fundamental question of why humans display artistic behavior in the first place. While elaborating a biosocial approach to artistic and aesthetic phenomena, she explicitly addresses the issue of the origins of the arts (Dissanayake 2000). The latter topic is also discussed in books by the cognitive archaeologist Steven Mithen (1996, 1998), the evolutionary psychologist Geoffrey Miller (2000), the cognitive psychologist Robert Solso (2003), and the anthropologist Kathryn Coe (2003).

All of these authors, each in their own way, draw on current neo-Darwinian insights into the mental behavior of human beings. Thus, they bring evolutionary research and thinking to bear on the existence of the arts in human life (see also the volumes edited by Bedaux and Cooke 1999 and Cooke and Turner 1999; for bio-evolutionary perspectives on issues in visual aesthetics, see Aiken 1998, Etcoff 1999, van Damme 2000, and Voland and Grammer 2003). A general discussion and assessment of the study of art and aesthetics from a Darwinian point of view is provided by Denis Dutton (2003).

In addition, the philosopher Ben-Ami Scharfstein (1988) analyzes art and artists in a variety of human cultures past and present, and discusses art-like activities in nonhuman animals. His examinations take into account recent ethological, evolutionary, and neuroscientific findings. A similar interest in the "biology of art" is shared by the art historian John Onians (1996). Under the banner of "World Art Studies," a label he introduced in 1992, Onians has launched a global and multidisciplinary approach to the visual arts based on a neuropsychological understanding of visual perception and art-making (see also van Damme 2001 and Onians 2003). By taking a worldwide perspective on a particular dimension of being human, and by referring explicitly to humans' biological makeup, all of these scholars may in fact be associated with the humanity-centered, multidisciplinary tradition in anthropology briefly considered above.

The relevance of Darwinian or naturalistic perspectives for the study of artistic behavior should be clear. There is simply no creation or experience of art without an evolved body and nervous system that make these activities possible. Certain motor, perceptual, cognitive, and affective capacities had to develop first—through a combined process of random changes in DNA sequence and environmental selection—before the various arts as we know them could have come into being. While allowing for the existence of art, the evolved human organism ultimately presents the limits of our artistic imagination and aesthetic perception. Thus, it sets the parameters within which the artistic animal operates.

Bioevolutionary and neuroscientific approaches to artistic phenomena are thus fundamental to any attempt to come to grips with art in human existence. They intend to shed light on the origins of artistic and aesthetic behavior, as well as their continued existence in human life. But they also attempt to provide explanatory models to account for any regularities that may operate cross-culturally in the creation, perception, use, and function of the arts. Such regularities may turn up, for example, when examining occasions when the arts are produced, when studying prevalent features and themes, or when researching principles for evaluation. These approaches even try to illuminate the enormous variety in art forms worldwide by focusing on recurrent principles or processes in the interaction of genetic inheritance, physical and sociocultural environments, and the idiosyncrasies of individual lives, in so far as all of these pertain to the creation and experience of art.

Studying Non-Western Art: Anthropology B

None of the scholarly work cited above has as yet entered mainstream anthropological discussions of art, from which it is still far removed. Anthropology is usually associated with the study of other societies by Westerners, especially in those societies long referred to in the West as "primitive." Thus, the anthropology of art conventionally deals with the visual arts of these "non-Western cultures." This common conception of anthropology may be referred to as *Anthropology B*. Anthropologists of this school typically deal with present-day cultures or those of the recent past. When concerned with art, they usually focus their attention on a given range of visual forms in one particular location or culture, art forms that are preferably studied in situ. They may supplement this research with reference to relevant ethnographic literature and sometimes with additional research in archives and museum collections.

This is the field of study conveyed in a series of "classic" edited volumes and anthologies (see Smith 1961; Fraser 1966; Biebuyck 1969; Jopling 1971; Otten 1971; Forge 1973; Graburn 1976; Greenhalgh and Megaw 1978; Cordwell 1979; Coote and Shelton 1992; Anderson and Field 1993; Berlo and Wilson 1993). Anthropologists discuss the use of paintings and sculptures in initiation houses

along the Sepik River in New Guinea, or examine the production of blankets or pottery in Native American villages. They may study the staging of masked dances in a West African locality, or the meaning associated with personal adornment on a Polynesian island, and so on. Studies of this type are usually carried out within a broadly conceived particularist or cultural relativist paradigm and, as such, tend to offer a rich contextual perspective.

These studies are sometimes interpreted from the perspective of a more specific anthropological theory, such as functionalism (see Ben-Amos 1989; cf. also Adams 1989). For the most part, however, these studies are descriptive in nature and firmly situate art forms in their synchronic, sociocultural settings. As this work has accumulated, some of it has been summarized and thematized in several introductory textbooks (see Anderson 1979, 1989, Hatcher 1985, 1999, Layton 1991, and Kreide-Damani 1992; compare also the more theoretically oriented survey articles of Silver 1979 and Morphy 1994).

These careful field investigations of non-Western art forms are still vital as they continue to provide valuable data about artistic activities and products in a variety of local contexts. Furthermore, much of this recent work focuses on topics that have tended to permeate the humanities and social sciences more generally, such as issues of power, gender, identity, and agency. At the same time, anthropologists are moving into other areas of research, including studying non-Western objects in the contexts of intercultural encounters and exchange at both the regional level and globally. These intercultural contexts would, of course, include today's international "art worlds." Scholars are also critically examining Western practices of collecting in (post)colonial settings (see Welsch, article 18).

Generally, many of these studies emphasize such topics as the role of artworks in the Western presentation of non-Western cultures (and sometimes vice versa). They often focus on art as commodities in transnational networks, or artworks as instruments that create and promote cultural identities in national or worldwide contexts (e.g., Marcus and Myers 1995; MacClancy 1997; Phillips and Steiner 1999; Thomas and Losche 1999). Several articles in this book provide examples of these types of research and elucidate their topicality in today's globalizing world. In another extension of traditional research, anthropologists have started to address various types of visual art forms and their creation and consumption in Western societies (e.g., Plattner 1996; Anderson 2000).

The cultures traditionally considered in anthropological research only present a limited portion of human cultures in time and space. However vast and varied the field in question, this is a legitimate observation when looking at Anthropology B from the standpoint of Anthropology A. That having been said, however, studies that investigate the arts of these cultures are obviously important for a variety of reasons. One way in which the significance of these studies stands out is by looking at them from the perspective of the Western discipline of art history and its traditional subject matter. Indeed, the opportunity to take the arts of these cultures into

consideration as proper topics of research means "pushing back the boundaries" of conventional art history to a considerable and even unprecedented extent (see Zijlmans 2003). Room is thus created for the study of a multitude of art traditions, in addition to those of the West.

With this extension of art history now under way, it should be noted that a substantial number of art historians are involved in the study of the non-Western arts, especially those of African cultures. The majority of them share with "anthropologists of art" (of the B type) not only an interest in non-Western artistic phenomena, but a key methodological strategy, namely "fieldwork," as well as an overall holistic perspective. Such studies made by some of these art historians consist of detailed contextual analyses of non-Western art forms, leading some scholars to suggest that they are almost indistinguishable from those of anthropologists (Willet 1971:42; Coote and Shelton 1992:6). This assessment has also been disputed. The debates that have followed have helped to clarify the two disciplinary approaches involved (see also Kasfir 2003). These art historians may not have turned into anthropologists, but it would at least be fair to say that rather than operating as conventional art historians, they have become Africanists, Oceanianists, and Americanists. As a result, many of these art historians have become far removed from the center of their home discipline. Still, art history's growing interest in studying non-Western art may become instrumental in creating a gateway through which theoretical insights gained by anthropology-inspired historians of non-Western art might pass from the periphery to the center of academic art history—something advocated by such scholars as the Africanist art historian Suzanne Blier (1992:10; cf. also Phillips 1995).

Art and the Anthropological Lens: Anthropology C

But what is it in fact that art history might learn from anthropology? The existence of a specific anthropological approach to the arts is often assumed, but the question of what it might actually consist of is seldom explicitly discussed. Elsewhere, with respect to the study of aesthetic preference, I have suggested that an anthropological approach might be typified by means of three hallmarks: (1) the empirical-inductive stance, (2) the contextual emphasis, and (3) the intercultural comparative perspective (van Damme 1996:1–12). The first two refer to local research, although obviously not restricted to non-Western settings, whereas the third transcends the "idiographic" level of most of this type of research and has to do with adopting a worldwide perspective. (This approach may include a "nomothetic" strategy of establishing universal laws or principles about societies and—in this case—their arts.) Overlapping with and differing from both Anthropology A and Anthropology B, the idea of a particular anthropological approach to sociocultural phenomena may then be called *Anthropology C*.

The emphasis on sociocultural contextualization is probably the most salient characteristic of the approach that anthropologists have developed. It could be argued that this emphasis on context, in addition to various intellectual incentives, derives in part from the long-established anthropological practice of "fieldwork." Using this methodology, outsiders become immersed in a foreign culture as a whole, trying to understand some phenomenon, such as art, they have analytically singled out. They then examine this phenomenon in relation to the larger sociocultural matrix in which it occurs. When it comes to studying the visual arts, anthropologists tend to construe their subject matter broadly, paying attention to a wide range of "visual culture."

Anthropological examinations of art thus create or enhance an awareness of the myriad ways in which a variety of visual artistic phenomena may be related to the rest of culture. To contextualize an art object's subject matter, motifs, symbols, colors, and elements of style one must interpret them with reference to local ideas, institutions, and practices. In addition to and in conjunction with such broadly conceived iconographic and iconological analyses, these studies also focus on the actual uses of art forms (what, when, where, how, by whom, for whom) and the function that may be ascribed to such uses. Thus, a contextual focus may also lead to a whole series of questions regarding the place and role of art in the fabric and dynamics of culture. For example, in what contexts does art figure prominently, and why? What part does art play in nonverbal communication? Do art forms reflect and strengthen the status quo or are they instrumental in effecting sociocultural change?

Because they conduct firsthand studies of art in its context, anthropologists also tend to be attentive to questions about art patronage (who commissions artworks and for what purposes), the producers of art (their psychology, training, personal style, social position), the processes of creating art (including the tools and materials used and their economic and symbolic values), and the indigenous evaluative reception of artistic objects and events. Such studies emphasize the various ways in which a wide range of artistic objects (and the context of their creation, use, and effects) relate to a variety of dimensions of local sociocultural life (religious, political, social, economic, educational, etc.). In this way, contextual anthropological studies sharpen the sensitivity of what it means to study the art forms of a given culture comprehensively. In anthropological practice this usually means a culture other than one's own.

Conversely, contextual studies of the arts of other cultures are likely to throw into relief the art forms and practices of one's own culture, past and present. It should also be clear that a contextual approach to the arts, as developed in anthropology, may be applied fruitfully to cultures other than those traditionally studied by anthropologists and affiliated art historians. Contextualized empirical data on art worldwide may then become the subject of intercultural, comparative analyses that inductively aim at generalizations on various dimensions of art in its sociocul-

tural environment. Such data may also become the subject of hypothesis testing by scholars who derive predictions about the arts from existing theories, including present-day ethological and evolutionary theories.

As far as Western art studies are concerned, it could be argued that context-oriented approaches have already been in use for quite some time. For example, one may point to what is known as the "cultural historical" approach in Western art history, which has been influential from the nineteenth century onward. This approach, however, would seem by and large to be confined to "semantic contextualism" (particularly providing iconic analyses). It has been far less concerned with "functional contextualism" or other contextual issues, such as the production, actual use, and contemporary reception of art forms.

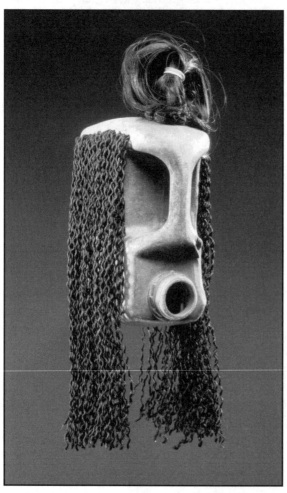

The second half of the twentieth century saw the development of a "social history of art." This approach focused increased attention to such topics as art patronage, artists' workshops, and commercial relationships in various "new art histories" (cf. Fernie 1995:12–15, 18–19). Nevertheless, broadly conceived contextual studies of the arts are a fairly recent phenomenon in the Western discipline of art history. Thus, in promoting the ongoing *Oxford History of Art* series, launched in 1997, it was claimed that its volumes offer "a fresh approach," meaning, among other things, that its au-

Figure 1. Romuald Hazoumé, *Mimi*, 1997, synthetic materials. © Africa Museum, Berg en Dal (609-35), on loan from Netherlands Institute for Cultural Heritage, Rijswijk, Amsterdam.

thors "set art within the social and cultural context of the time and place in which it was produced" (Oxford University Press 1997). This innovative, contextual approach to art history may well have developed in part through the influence—perhaps indirectly—from anthropological studies of non-Western art and culture. Indeed, this is an area where we need more intellectual-historical analyses: Which anthropologists have actually influenced historians of Western art? And as a corollary, which art historians have looked at anthropology for heuristic and hermeneutic guidance? Conversely, which art historians have been influential in the anthropological study of non-Western arts? And as a corollary, which anthropologists of art have turned to art history for analytical tools and interpretative inspiration?

The emphasis on sociocultural context that an anthropological approach provides should be considered complementary to other perspectives on artistic phenomena. For example, from an art historical perspective, Sidney Kasfir (2003:212) observes that whereas art historians usually remain close to the object in their analyses, anthropologists "tend instead to use objects as evidence for 'something else.'" This statement would not only seem to capture a prevailing view on a main difference in disciplinary approaches, but it is also intended as a warning not to de-emphasize the artistic objects or events that form the starting point of our analyses. As one critic has observed in commenting on a study of a famous Western painter's entrepreneurship, we should be careful not to end up with an "art history with the art left out." For all their rightful attention to context, this is a warning that anthropologists of art should take to heart as well.

Conclusion

All three types of "anthropology of art" outlined in this article may contribute to the scholarly exploration of art as a worldwide phenomenon. When conceived as the multidisciplinary study of the visual arts in human life, the "anthropology of art" could in fact serve as an overarching label and integrative framework for this type of research. However, given the association that has developed during the twentieth century between the idea of anthropology and the study of particular cultures outside Western traditions, it is doubtful that the qualifier "anthropology of art" will come to fulfill this function. World Art Studies—interpreted as the multidisciplinary examination of the visual arts in human existence—may well turn out to serve as a better overall label and develop into an umbrella discipline instead.

Given its worldwide focus, this type of study is in need of data on artistic phenomena in the many and various cultures long held to lie outside the province of mainstream Western academic art studies. Anthropologists, with their traditional focus on cultures beyond the West, indeed do provide such data for many contemporary cultures and those of the recent past. But in examining these cultures and their arts anthropologists have typically taken a particular perspective that is quite

different from conventional historical, philosophical, and psychological approaches to the study of art. Conceptualizing artistic phenomena as integrated with their sociocultural settings, anthropologists focus on gathering and contextually interpreting data about the production, use, meaning, function, and reception of visual art forms in a variety of frameworks.

Contextualized empirical data on art may then be compared in order to establish, and ideally to explain, similarities and differences in artistic phenomena worldwide. In order to be fully operational, especially on an explanatory level, such an anthropological approach needs to incorporate data and insights from other disciplines that attempt to shed light on the arts as a phenomenon in human life. To the list of relevant disciplines may be added human ethology, evolutionary psychology, and neuroscience, disciplines that have been instrumental in reestablishing the focus on the human being that gave anthropology its name in the first place.

In research on the visual arts, it is now above all the emerging field of World Art Studies that shares this emphasis on humanity as a whole. In addition to taking into account the art forms of all cultures in time and space, World Art Studies draws on data and the approaches of as many relevant disciplines as possible, ranging from biology to philosophy. Centrally situated within this disciplinary spectrum, the rich legacy and continued endeavors of various "anthropologies of art" are likely to occupy a prominent place in our attempts to comprehensively come to grips with the visual arts as a worldwide phenomenon.

Questions for Discussion

1. What distinguishes the three varieties of anthropology outlined in this article?

2. Which of the three types of anthropology discussed sounds most familiar to you?

3. Do you feel that bioevolutionary approaches may shed light on the visual arts (their creation, use, function, and meaning)? Or do you think that these issues can be explained adequately purely in cultural terms, without reference to human beings' biological constitution and evolutionary background?

Acknowledgments

This article was adapted from a paper originally published as "Anthropologies of Art," *International Journal of Anthropology* 18(4):231–244, October-December 2003, special issue: Conceptualizing World Art Studies, ed. Eric Venbrux and Pamela Rosi.

References

Adams, Marie-Jeanne. 1989. "African Visual Arts from an Art Historical Perspective." *African Studies Review* 32(2):55–103.

Aiken, Nancy E. 1998. *The Biological Origins of Art*. Westport, CT: Praeger.

Anderson, Richard L. 1979. *Art in Primitive Societies*. Englewood Cliffs, NJ: Prentice Hall.

———. 1989. *Art in Small-Scale Societies*. 2nd ed. Englewood Cliffs, NJ: Prentice Hall.

———. 2000. *American Muse: Anthropological Excursions into Art and Aesthetics*. Upper Saddle River, NJ: Prentice Hall.

———. 2004. *Calliope's Sisters: A Comparative Study of Philosophies of Art*. 2nd ed. Upper Saddle River, NJ: Prentice Hall.

Anderson, Richard L. and Karen L. Field, eds. 1993. *Art in Small-Scale Societies: Contemporary Readings*. Englewood Cliffs, NJ: Prentice Hall.

Arnaut, Karel. 2001. "A Pragmatic Impulse in the Anthropology of Art?: Alfred Gell and the Semiotics of Social Objects." *Journal des Africanistes* 71(2):191–208.

Bedaux, Jan Baptist and Brett Cooke, eds. 1999. *Sociobiology and the Arts*. Amsterdam, Atlanta: Editions Rodopi.

Belting, Hans. 2001. *Bild-Anthropologie: Entwürfe für eine Bildwissenschaft*. Munich: Wilhelm Fink.

Ben-Amos, Paula. 1989. "African Visual Arts from a Social Perspective." *African Studies Review* 32(2):1–53.

Berlo, Janet C. and Lee A. Wilson, eds. 1993. *Arts of Africa, Oceania, and the Americas: Selected Readings*. Englewood Cliffs, NJ: Prentice Hall.

Biebuyck, Daniel P., ed. 1969. *Tradition and Creativity in Tribal Art*. Berkeley: University of California Press.

Blier, Suzanne P. 1992. "First Word." *African Arts* 25(3):1, 8, 10.

Borgatti, Jean M. and Richard Brilliant. 1990. *Likeness and Beyond. Portraits from Africa and the World*. New York: The Museum for African Art.

Coe, Kathryn. 2003. *The Ancestress Hypothesis: Visual Art as Adaptation*. New Brunswick, NJ: Rutgers University Press.

Cooke, Brett and Frederick Turner, eds. 1999. *Biopoetics: Evolutionary Explorations in the Arts*. Lexington: International Conference on the Unity of the Sciences.

Coote, Jeremy and Anthony Shelton, eds. 1992. *Anthropology, Art, and Aesthetics*. Oxford: Clarendon Press.

Cordwell, Justine M., ed. 1979. *The Visual Arts: Plastic and Graphic*. The Hague: Mouton.

Dissanayake, Ellen. 1988. *What is Art For?* Seattle: University of Washington Press.

———. 1992. *Homo Aestheticus: Where Art Comes From and Why*. New York: The Free Press.

———. 2000. *Art and Intimacy: How the Arts Began*. Seattle: University of Washington Press.

Dutton, Denis. 2003. "Aesthetics and Evolutionary Psychology," in *Oxford Handbook of Aesthetics*, ed. J. Levinson, pp. 693–705. Oxford: Oxford University Press.

Etcoff, Nancy. 1999. *Survival of the Prettiest: The Science of Beauty*. New York: Doubleday.

Fernie, Eric, ed. 1995. *Art History and its Methods: A Critical Anthology*. London: Phaidon.

Forge, Anthony, ed. 1973. *Primitive Art and Society*. London: Oxford University Press.

Fraser, Douglas, ed. 1966. *The Many Faces of Primitive Art: A Critical Anthology*. Englewood Cliffs, NJ: Prentice Hall.

Gell, Alfred. 1998. *Art and Agency: An Anthropological Theory*. Oxford: Clarendon Press.

Graburn, Nelson H. H., ed. 1976. *Ethnic and Tourist Arts: Cultural Expressions from the Fourth World*. Berkeley: University of California Press.

Greenhalgh, Michael and Vincent Megaw, eds. 1978. *Art in Society: Studies in Style, Culture and Aesthetics.* London: Duckworth.

Haselberger, Herta. 1969. *Kunstethnologie: Grundbegriffe, Methoden, Darstellung.* Wien: Verlag Anton Schroll.

Hatcher, Evelyn P. 1985. *Art as Culture: An Introduction to the Anthropology of Art.* Lanham, MD: University Press of America.

———. 1999. *Art as Culture: An Introduction to the Anthropology of Art.* 2nd ed. Westport, CT: Bergin and Garvey.

Jopling, Carol F., ed. 1971. *Art and Aesthetics in Primitive Societies.* New York: E. P. Dutton.

Kasfir, Sidney L. 2003. "Thinking about Artworlds in a Global Flow: Some Major Disparities in Dealing with Visual Culture." *International Journal of Anthropology* 18(4):211–230.

Kreide-Damani, Ingrid. 1992. *KunstEthnologie: Zum Verständnis fremder Kunst.* Köln: DuMont.

Layton, Robert. 1981. *The Anthropology of Art.* London: Granada.

———. 1991. *The Anthropology of Art.* 2nd ed. Cambridge: Cambridge University Press.

———. 2003. "Art and Agency: A Reassessment." *Journal of the Royal Anthropological Institute* (N.S.) 9(3):447–464.

MacClancy, Jeremy, ed. 1997. *Contesting Art: Art, Politics and Identity in the Modern World.* Oxford: Berg.

Maquet, Jacques J. 1979. *Introduction to Aesthetic Anthropology.* 2nd ed. Malibu: Undena.

———. 1986. *The Aesthetic Experience: An Anthropologist Looks at the Visual Arts.* New Haven: Yale University Press.

Marcus, George E. and Fred R. Myers, eds. 1995. *The Traffic in Culture: Refiguring Art and Anthropology.* Berkeley: University of California Press.

Miller, Geoffrey. 2000. *The Mating Mind: How Sexual Selection Shaped the Evolution of Human Nature.* London: Heinemann.

Mithen, Steven J. 1996. *The Prehistory of the Mind: The Cognitive Origins of Art, Religion and Science.* London: Thames and Hudson.

———, ed. 1998. *Creativity in Human Evolution and Prehistory.* London: Routledge.

Morphy, Howard. 1994. "The Anthropology of Art," in *Companion Encyclopedia of Anthropology,* ed. T. Ingold, pp. 648–685. London: Routledge.

Napier, A. David. 1986. *Masks, Transformation, and Paradox.* Berkeley: University of California Press.

Onians, John. 1996. "World Art Studies and the Need for a New Natural History of Art." *Art Bulletin* 78(2):206–209.

———. 2003. "A Natural Anthropology of Art." *International Journal of Anthropology* 18(4):259–264.

Otten, Charlotte M., ed. 1971. *Anthropology and Art: Readings in Cross-Cultural Aesthetics.* Austin: University of Texas Press.

Oxford University Press. 1997. *Oxford History of Art* Series [online]. Available: http://www.oup-usa.org/oha.

Phillips, Ruth B. 1995. "Fielding Culture: Dialogues between Art History and Anthropology." *Museum Anthropology* 18(1):39–46.

Phillips, Ruth B. and Christopher B. Steiner, eds. 1999. *Unpacking Culture: Art and Commodity in Colonial and Postcolonial Worlds.* Berkeley: University of California Press.

Pinney, Christopher and Nicholas Thomas, eds. 2001. *Beyond Aesthetics: Art and the Technologies of Enchantment.* Oxford, New York: Berg.

Plattner, Stuart. 1996. *High Art Down Home: An Economic Ethnography of a Local Art Market.* Chicago: University of Chicago Press.

Roughley, Neil. 2000. "On Being Humans: An Introduction," in *Being Humans: Anthropological Universality and Particularity in Transdisciplinary Perspectives*, ed. N. Roughley, pp. 1–21. Berlin: Walter de Gruyter.

Rubin, Arnold, ed. 1988. *Marks of Civilization. Artistic Transformations of the Human Body.* Los Angeles: Museum of Cultural History, University of California.

Scharfstein, Ben-Ami. 1988. *Of Birds, Beasts, and Other Artists: An Essay on the Universality of Art.* New York: New York University Press.

Shore, Bradd. 2000. "Human Diversity and Human Nature: The Life and Times of a False Dichotomy," in *Being Humans: Anthropological Universality and Particularity in Transdisciplinary Perspectives*, ed. N. Roughley, pp. 81–103. Berlin: Walter de Gruyter.

Silver, Harry. 1979. "Ethnoart." *Annual Review of Anthropology* 8:267–307.

Smith, Marian W., ed. 1961. *The Artist in Tribal Society.* London: Routledge and Kegan Paul.

Solso, Robert L. 2003. *The Psychology of Art and the Evolution of the Conscious Brain.* Boston: MIT Press.

Stagl, Justin. 2000. "Anthropological Universality: On the Validity of Generalisations about Human Nature," in *Being Humans: Anthropological Universality and Particularity in Transdisciplinary Perspectives*, ed. N. Roughley, pp. 25–36. Berlin: Walter de Gruyter.

Summers, David. 2003. *Real Spaces: World Art History and the Rise of Western Modernism.* London: Phaidon.

Thomas, Nicholas and Diane Losche, eds. 1999. *Double Vision: Art Histories and Colonial Histories in the Pacific.* Cambridge: Cambridge University Press.

van Damme, Wilfried. 1996. *Beauty in Context: Towards an Anthropological Approach to Aesthetics.* Leiden, New York: Brill.

———. 2000. "Universality and Cultural Particularity in Visual Aesthetics," in *Being Humans: Anthropological Universality and Particularity in Transdisciplinary Perspectives*, ed. N. Roughley, pp. 258–283. Berlin: Walter de Gruyter.

———. 2001. "World Art Studies and World Aesthetics: Partners in Crime?", in *Raising the Eyebrow: John Onians and World Art Studies*, ed. L. Golden, pp. 309–319. Oxford: Archaeopress.

Voland, Eckart and Karl Grammer, eds. 2003. *Evolutionary Aesthetics.* Berlin: Springer.

Willet, Frank. 1971. *African Art: An Introduction.* London: Thames and Hudson.

Zijlmans, Kitty. 2003. "Pushing Back Frontiers: Towards a History of Art in a Global Perspective." *International Journal of Anthropology* 18(4):201–210.

Traditional and Modern Pathways for Contemporary African Art

*T*his section examines the tourist aesthetics on an East African coast and the West African art trade in New York. These modern pathways are shaped in part by a long history of non-Western mercantilism on the one hand and by Western aesthetics on the other. In a world compressed in space and time, they consist of "fleeting cross-cultural encounters" while retaining distinct lifeworlds.

In article 4, Paul Stoller argues "that the economic and social forces of globalization have altered spaces in which art, commerce, and scholarship are negotiated." He takes us to New York, where an African art dealer lures a white collector away from a prestigious antiquities show to his merchandise in a car parked nearby. Stoller explains that a space for African art was created by the history of modern art, introduced to the United States in New York early in the twentieth century. Avant-garde art was legitimated by reference to a European philosophy of aesthetics, granting art a transcendental quality, a conception of art as timeless and universal. The display of the art in museums and galleries further emphasized the celebration of form. The networks of people who engaged with this art (thereby forming an art world), as well as the establishment of a competitive market, helped to secure the creation of value. Considerations of form allowed plastic arts from Africa, Oceania, and the Americas to be absorbed by modernist aesthetics. So-called "primitive art" became a category of its own: it was collected, entered the museums, gained scholarly attention, and as a consequence a market for these objects emerged. Significantly, their authenticity was established not by a provenance that traced works back to particular artists, but by reference to their previous circulation at the high-end of the Western market. That is, the value of any non-Western artwork depended on the reputations of former owners.

The market for African art as high art grew in North America, according to Stoller, because of the attention drawn to an exhibition in the Museum of Modern Art that juxtaposed masterpieces of modern art with works of "primitive art" that served as sources of inspiration. In addition, African Americans with upward socioeconomic mobility found an "appeal of Afrocentrism" in African art. West African art traders quickly responded to these demands. Stoller provides a masterful insight into the world of these traders, how they operate, their motivations, and their organization in transnational networks. Their activities in North America are merely a recent extension of their much older patterns of long distance trade, intertwined with adherence to Islam.

Religious and social obligations appear to be more important to these traders than the artistic quality of their goods, which they term "wood" and "mud." Stoller vividly describes the West African art traders' main depot, "The Warehouse," in New York City. The place is stacked with African art, but for the cognoscenti it is just "a cultural curiosity" to visit since they put more trust in "authentic" African

art with reputations about Western ownership. Stoller concludes with a discussion of the "market driven ephemeral encounters" between "people holding two distinct and well-established universes of meaning." To understand the complexity of what goes on at "cultural crossroads" like the ones described is the major challenge of contemporary ethnography.

In article 5, Sidney L. Kasfir turns to tourism and art on the Swahili coast of Kenya. As an art historian Kasfir is interested in the ways African expressive culture has been caught up for centuries in coastal incursions fostered by trade, migration, and, more recently, international tourism. She examines tourist aesthetics in the global mix of visitors who have arrived on the Swahili coast. Formerly, trade was in luxury mercantile goods. But today, international tourism has largely replaced exchanges of material objects with an "experience economy."

Here staged identity is primary, since tourists are motivated by orientalist stereotypes offered and encouraged by the hotel industry. Tourist ideas are also shaped by interactions with Swahili-speaking people, who are also managed by hoteliers. These interactions lead to what the author calls "a working misunderstanding" because exchanges between tourists and coastal residents are often opaque. How has this situation come about? Kasfir weaves together two strands of cultural history to present her argument. Tourism can be subsumed within a long-standing tradition of travelers to the Swahili coast.

Today, these exchanges are being mediated by the Maasai's recent experiences with modernity. To illustrate this pattern, Kasfir introduces the historical and cultural complexity of the area and the orientalist expectations that have come to be associated with the region. Coastal tour operators compete with hinterland safari-style tourism. To strengthen the appeal of coastal tours they offer hotel packages on the beach, such as one might find in the Caribbean. After young Maasai and Samburu warriors from the hinterland came to the coast to find work, hoteliers found they could add excitement and authentic Africans to their tour packages, if these warriors wore their traditional costumes and sold beadwork and spears. As cultural tourism grew, intercultural tourist encounters and the politics of identity became further entwined. Kasfir's two main examples involve the production of "traditional" Swahili crafts for hotel furnishings and "warrior theater" involving the display of Maasai and Samburu masculinity. She argues that, in both cases, tourists end up with an image of local people in their quest to capture the experience of Otherness.

In contrast, local Swahili cultural identities are protected since families largely live separate and apart from tourists. Even without cattle, young Samburu and Maasai men retain their warrior identity as they too remain unassimilated in their colonization of local spaces. Consequently, what tourists see is what they get: the outward appearances, the theatricality, the "embodied warrior artifact" in various manifestations. Collected representations come without any particular meanings, so the cultural stereotypes that tourists have brought with them prevail. But at present, says Kasfir, this situation keeps all parties happy.

4

Circuits of
African Art/Paths of Wood
Exploring an Anthropological Trail

Paul Stoller

he Seventh Regent Armory on Park Avenue at 67th Street on the Upper East Side of Manhattan is hallowed ground in the history of twentieth century art. It was the site of the famous Armory Show of 1913 that introduced to North American art lovers the works of, among others, Marcel Duchamps and Pablo Picasso. It has also been the site of one of the most prestigious annual shows in the "tribal" art world: The New York International Tribal Antiquities Show, which in 2001 was held May 20–23. Given its renown and its opportunity for profitable exchange, the event draws an array of well-known "tribal" antiquities dealers, who display their treasures with great panache. These professionals present their jewelry, textiles, masks, and statuary with proper mounting and proper lighting—presentation that not only augments desire for an object's "allure," but also increases its perceived value.

In 2001, 52 dealers paid substantial fees to present their antiquities in New York. Of the 52 dealers represented at the tribal antiquities show, seventeen offered works of African art. Some of the dealers showcased West African masks and statuary, including some old terra cotta figures. Others featured Central African pieces, such as masks and statuary fashioned from wood, old carved ivory, and iron weapons. One dealer displayed neolithic projectile points from West Africa.

Propelled by various agendas, five groups of visitors streamed through the dimly lit corridors. Several dealers, who decided for various reasons not to display their pieces, trickled through the crowd. Perhaps they'd find a bargain. Maybe they'd size up the market. A swell of collectors moved through the aisles, hoping to add important pieces to their private fine arts collections. A strong current of curi-

Stoller, Paul. 2003. "Circuits of African Art/Paths of Wood: Exploring an Anthropological Trail." *Anthropological Quarterly* 76(2):207–234. Reprinted with permission of *Anthropological Quarterly*.

osity seekers coursed through the aisles, intending to look and learn rather than study and buy. A few students of the art market in New York—including, of course, myself—meandered through the crowd, hoping to arrange future interviews or gather pertinent information. Finally, a small group of African art traders steered through the corridors, looking for opportunities. During one of my visits a group of collectors gathered around a particularly compelling display of Central African masks and statuary.

At these antiquities shows collectors are often distinguishable by age and manner of dress. They are usually middle-aged people dressed in dark suits. This particular group of collectors talked in hushed tones. One collector asked the dealer about patina and provenance. After several moments of informed exchanges, an African trader, dressed in a stylish tweed sport coat and black dress slacks, approached one of the collectors, a tall silver-haired gentleman dressed in a navy blue suit.

"Sir, I notice that you are admiring the Fang pieces," he said, in heavily accented West African English, referring to rare reliquary statues that had been carved long ago in Gabon.

"They're magnificent, aren't they?" the gentleman answered.

"Yes, they are. Beautiful lines. They speak to me."

The gentleman smiled. "They've collected some fine ones here."

"Sir," the African trader said, "if you like what you see here, I have some very similar pieces." He paused a moment. "Much better prices."

"Really," the gentleman said.

"Here's my card," he said. "Contact me if you wish. I'll be in New York for three more weeks." He looked again at the Fang pieces. "If you like, I have a few of these pieces in my van, which is parked around the corner. We could go and take a look?"

Moments later the African trader and the tall silver-haired gentleman left the Seventh Regent Armory to look at art "displayed" in a van. In the process they were about to negotiate a new space—of African art.

Globalization and the Different Pathways of African Art

In this article, I argue that the economic and social forces of globalization have altered the spaces in which art, commerce, and scholarship are negotiated. There is a vast and varied literature on the social and economic impact of globalization. Some authors approach the problem from a macroeconomic vantage to probe new socioeconomic processes (Harvey 1989; Kantner and Pittinsky 1996); others consider how global processes have transformed immigration patterns (Basch, Szanton-

Blanc, and Glick-Shiller 1993; Foner 2000, 2001; Glick-Shiller and Fouron 2001). Another group of scholars has probed how global forces have reconfigured cities (Mollenkopf and Castells 1991; Sassen 1991, 1994, 1996; Portes and Stepick 1994). Several analysts argue that globalization has fundamentally altered the nature of cultural processes, political dynamics, and social interaction (Castells 1996, 1997, 1998; Burawoy et al. 2000). More philosophically disposed scholars suggest that global dynamics have repositioned epistemological priorities (Clifford 1988, 1996; Appadurai 1996; Taylor 2002). Writers concerned with contemporary dimensions of art aesthetics have focused on art production, marketing, and consumption. Many of them have discussed how the socioeconomic contours of global interdependence have not only shaped the traffic in "tribal" art (Steiner 1994; Marcus and Myers 1995; Myers 2002), but also the construction and reconstruction of the aesthetic value of "primitive" art (Price 1989; Steiner 1995; Vogel 1997; Errington 1998).

This article builds on this substantial and multifaceted body of scholarship in specific ways. In the first section, I demonstrate how historical and philosophical forces have shaped the space of African art. How has the history and culture of Western art affected the perception of and commerce in African sculpture, masks, and textiles? In the second section, I consider the impact of a different set of historical and philosophical parameters—the history of long distance trade and the impact of Islam on West African traders' perception of "wood," which is the term they use to denote African art. In the third section of this article, I analyze what happens when these two universes of meaning intersect in contemporary, transnational spaces. In the conclusion, I extend George Marcus's (1998) reflections on contemporary ethnography to argue that this continuously negotiated and renegotiated picture of perception and reality, art, and commerce will have a significant impact on twenty-first century practitioners of ethnography (see also Marcus and Myers 1995).

The Space of (African) Art

The space of (African) art has been shaped by an ethos of transcendentalism. In his *Critique of Judgment*, Immanuel Kant ([1790] 1966) first defined the field of rarefied aesthetics by establishing universal criteria for taste in art. In that work, Kant went to great lengths to (1) envision the preeminent sense of universal taste and (2) distance the observer from the observed (see Stoller 1989, 1997; Howes 1991; Synnott 1993). In so doing he laid the foundation for an objective, universal gaze that would elevate so-called high art to an almost sacred plain. This objective, almost quasi-religious tone is reinforced tenfold in G. W. F. Hegel's (1975) *Aesthetics*. Like all other elements in his philosophy, Hegel considered art from a teleological perspective. Rarefied and objectively classified, art became part and parcel of the process of human development, the unfolding of the human spirit. The Hegelian narrative on art is a story that

moves inexorably from the ancient world, to the Middle Ages, to the Renaissance, and then to the modern world (as in the table of contents of H. W. Janson's *History of Art* [1962]). This story's enabling assumption is that art always already was and that its story always already was there for the telling. No historiography, no social history need intrude on their straightforward and blessedly simple tale. (Errington 1998:54)

From the Hegelian perspective, the history of art—and the objective criteria for its assessment—goes hand-in-hand with the story of the development of human beings—in the ancient world, the Middle Ages, the Renaissance, and, finally and ultimately, in the modern world.

For Hegel the modern world means the nation state built on a foundation of transcendental Christian values (see Morris 1987). Put another way, the evolution of fine art has been an avenue leading to an evolving set of transcendental experiences—pathways that lead to the realization of the human spirit. The story of art is therefore a central theme in the evolutionary march of progress that has separated the West, as it were, from the rest.

Figures 1 and 2. African art for sale in Midtown Manhattan near the Museum of Modern Art, summer 1997. Photos by Jasmin Tahmaseb McConatha.

The Hegelian take on art compels the tasteful observer to focus on the object rather than on the social and economic considerations that led to its production—art for art's sake.

> Despite long-standing debates and challenges to the problem and ideal of art's autonomy in the West, for many people engaged with the arts the category of "art" remains a resolutely commonsense one, associated with essential value in relation to a generalized human capacity for spirituality and creativity. (Marcus and Myers 1995:7)

In the game of artistic judgment, transcendental Hegelianism is therefore still very much with us. In his noteworthy book, *High Art Down Home,* Stuart Plattner (1996:6–7) underscores this very point.

> While the specifics of artistic merit are contested by workers in different media, there is agreement that high art should give the knowledgeable viewer a "transcendental" aesthetic experience that can change the way the viewer looks at reality. This sort of art is often challenging to the average viewer, difficult to interpret, and sometimes ugly, confusing, or otherwise upsetting. For the connoisseur, high art can stimulate intense emotional and intellectual responses.

Connoisseurs have been collecting "art" for a very long time indeed. With the growth of the nation state, however, private collections of transcendental objects became increasingly housed in various kinds of state-sponsored museums. Many scholars have linked the growth of "art" to colonial exploitation and the processes that legitimized imperial expansion—the civilizing mission of European nation states. Despite the pull and power of ongoing discourses on transcendental art, as Shelly Errington (1998) points out in her insightful book, *The Death of Authentic Primitive Art and Other Tales of Progress,* "art" did not come into existence without a market. The great art auction houses, Sotheby's and Christie's, were both founded in the eighteenth century. Markets for high art expanded considerably in the nineteenth century—especially toward the end of that epoch.

Impressionism, which was an artistic revolt against the aesthetic hegemony of French academicism, was central to the development of modern art. Rather than exhibiting their art through "academic" channels, the impressionists displayed their paintings at private exhibits. These exhibits, which culminated in their last group show in 1886, established the impressionists as the practitioners of the avant-garde. The art also generated incomes that enabled many impressionist artists to pursue their art full time.

> The impressionists showed that financial success for artists was possible through the activities of key dealers and friendly critics, independent of state or official patronage. Moulin points out that Pissaro, Degas, Monet, Renoir, and other impressionists earned incomes commensurate with those earned by civil servants. Their "outrageous" art, when sold to discriminating, adventurous collectors, produced middle-class incomes for the artists. (Plattner 1996:30)

Plattner goes on to describe how impressionism established a new network among avant-garde artists, dealers, critics, and collector-connoisseurs. This network provided both the cultural and economic foundation for such various twentieth century avant-garde art movements as futurism, cubism, abstract expressionism, minimalism, conceptual art, and so on. The recognition of economic incentive and the production of value, of course, did not diminish the importance of an art object's transcendental power—one source of its economic allure. Sensing perhaps the allure and power of transcendentalism, dealers adopted an ethos of display that mimicked that of the great museums—high ceilings, white walls, dim lighting, and minimal presentation. This aesthetic is still with us as any visitor to a high-end art gallery in Manhattan can attest. Plattner (1996:126) describes a photo of an avant-garde art gallery in St. Louis. "The huge spaces, high ceilings, and dramatic exhibition style are designed to impress the viewer with the museum quality of the work." Beyond its transcendental allure, of course, "museum quality" also means "high prices."

The ethos linking transcendentalism, economic incentive, and visual display has been very much evident in the development of the taste in and the market for so-called "primitive art" (see Price 1989; Marcus and Myers 1995). Following Errington's (1998:64–69) succinct chronology, we must go back to the Armory Show of 1913 (the site, lest we forget, of the annual New York International Tribal Antiquities Show), which introduced modern art to North America. The impact of the show eventually compelled rich patrons, including Abby Aldrich Rockefeller, to create the Museum of Modern Art (MoMA) in 1929. Through exhibitions and its growing renown, curators at MoMA gave avant-garde modern art a profound legitimacy, which, of course, increased its value.

Meanwhile, Nelson Rockefeller began to collect "tribal" art from Oceania, Africa, and the Americas. When Rockefeller became MoMA's director in 1950, the museum paid serious attention to so-called "tribal" art. Just as MoMA's attention to modern art gave it a widespread aesthetic legitimacy and economic appeal, so its exhibitions of "tribal" art increased the desire for and the economic value of objects produced by nameless artists in Africa, Oceania, and the Americas. Critics wrote about these objects with new appreciation. Sensing the economic opportunity presented by "tribal" art, dealers purchased these kinds of objects and exhibited them in their museum-like galleries. Not to be outdone, connoisseurs flocked to the galleries hoping to buy truly unique objects from far away worlds.

In 1957, The Museum of Primitive Art opened in New York City. Because the Rockefeller collection comprised its core, it became the focus of "primitive art" in North America. It remained open for two decades.

> [The] two decades mark the golden age of primitive art's legitimacy. The existence of so many wonderful objects, beautifully exhibited and celebrated in fine arts museums as art, attested to the unproblematic nature of the category of authentic primitive art. During the period liberal and right-thinking people admired and celebrated it. Art historians and anthropologists discovered primi-

tive art as a worthy subject of study, and an increasing number of books and articles appeared on the topic. A few art history departments hired specialists in primitive art, and several PhD programs in non-Western art were established and produced their first graduates; a number of major museums established departments and curatorial positions of primitive art. As an essential category, primitive was almost unchallenged. (Errington 1998:68)

The Museum of Primitive Art closed to make way for the Michael Rockefeller wing of the Metropolitan Museum of Art. When that opened in 1982, primitive art had found a place in one of the most legitimate and prestigious spaces of art. The display reproduced the aesthetic qualities valorized by the thought of Kant and Hegel—high ceilings, open spaces, and minimal presentation—a display that impelled a close examination of the object's "transcendental qualities." Freed from the conditions of their production, the museum context gave these objects a time-less quality (see Clifford 1988; Price 1989; Torgovnick 1990; Marcus and Myers 1995; Steiner 1995).

In 1984, the MoMA's "Primitivism" in 20th Century Art exhibit extended the legitimacy of "tribal" art. The exhibition attempted to demonstrate how so-called primitive art had inspired the great practitioners of modern art. Georges Braque and Pablo Picasso, who collected "tribal art," kept many of the pieces in their stu-dios. By juxtaposing those objects to various modern works, the exhibit curators wanted the viewer to see unmistakable parallels in form. In this way, "primitive" art was not simply a legitimate category, but had become—at least in the eyes of some scholars, connoisseurs, and dealers—the inspiration for cubist and surrealist art. How wonderful it would be to own an object that had inspired Picasso! In this way, the primitivism show generated enormous interest in "primitive art." Several new museums opened—including the revamped and rehoused Smithsonian National Museum of African Art as well as the Museum for African Art, first on 68th Street in Midtown Manhattan and then in Soho. For their part, critics and scholars wrote much appreciated books and articles about primitive art. Journals like *African Arts* gave increased scholarly legitimacy to objects from the third world.

This series of events helped to reinforce a set of criteria for taste in "primitive" art. The objects needed provenance to establish their authenticity. Since the iden-tity of the makers of most primitive objects remained unknown, provenance was linked to an object's history of collection, sale, and exhibition. Objects collected and/or owned by well-known connoisseurs, artists, or dealers were highly valued—an important piece. The value would increase, moreover, if the object's plastic qual-ities conformed to the formal simplicity of modernist aesthetics.

> In the end, it is not the tribal characteristics of Negro art nor its strangeness that are interesting. It is its plastic qualities. Picturesque or exotic features as well as historical and ethnographic consideration have a tendency to blind us to its true worth. . . . It is the vitality of forms of Negro art that should speak to us, the simplification without impoverishment, the unnerving emphasis on the essen-

tial, the consistent, three-dimensional organization of structural planes in archi-
tectonic sequences, the uncompromising truth to material with a seemingly
intuitive adaptation of it, and the tension achieved between the idea or emotion
to be expressed through representation and the abstract principle of sculpture.
(Sweeney 1935:11, cited in Errington 1998:92–93)

Although Sweeney's ideas represent the intellectual ethos of the 1930s, they con-
tinue to reverberate today, for they underscore the timeless, transcendental con-
tours of the object rather than the economic and sociocultural context of its
production. They underscore how "tribal objects" continue to gain the aesthetic
legitimacy and economic value of high art. Sweeney's aesthetic continues to shape
the way dealers display "tribal art." Those displays may well provide the museum-
like context that triggers the transcendental moments that compel collectors to fre-
quent galleries—and tribal antiquities shows—to find and perhaps buy an "impor-
tant" piece of art. Collectors certainly collected important pieces at the 2001 New
York tribal antiquities show held at the Seventh Regent Armory—a hallowed space
of modernist art.

The Space of West African Wood

The Warehouse, in which art traders from West Africa store objects they have
recently shipped to North America, is a studied contrast to the antiquities shows at
the Seventh Regent Armory. Far from the Upper East Side, it is situated near the
Hudson River in Chelsea. Instead of being bordered by exclusive Park Avenue apart-
ment buildings, it is an intrinsic part of a patchwork of scrap metal yards, car
mechanic shops, and taxi garages. A large six-story facility, The Warehouse com-
prises one-half of a city block in Manhattan; the facility is stocked with "African art."

To facilitate storage and shipment, loading bays are located along the north
and south sides of The Warehouse. The first floor is a showroom and a meeting
center. Bordered by stalls in which individual dealers display their objects to poten-
tial buyers, there is a central space outfitted with cheap card tables, junkyard sofas,
and makeshift chairs. Here clusters of traders, some itinerant, others longstanding
immigrants, greet and talk with one another as they eat a lunch or dinner prepared
by two women in a small room that serves as the "African" kitchen. The lighting is
unintentionally dim; the air is dank and smells of wood smoke. Given the nature of
the inventory, smoking is not allowed inside The Warehouse.

Wooden masks and statues—tall, short, delicate, massive—fill every nook and
cranny of space. They are arranged in no particular order. Many of them are on
dollies or stacked on one another's corners. Open boxes of beads lie about. Large
sacks of *fonio*, a highly prized West African grain, lay on carts. Young men carry
objects inside to be stored or load objects into vans to be shipped to North Ameri-

can markets. At the Seventh Regent Armory the pace is studied and subdued. At The Warehouse, by contrast, there is a continuous buzz of activity, which periodically stops when the Imam calls the Muslim faithful to prayer. At those points in the afternoon everything stops as the Muslim traders prepare to pray in a small room, covered with rugs, that has been fashioned into a mosque. At the antiquities show at the Seventh Regent Armory, religious themes are sometimes transformed into a transcendental gaze focused on "art." At The Warehouse, "art" possesses no transcendental qualities; it lies about like any commodity stocked in a storage facility. Here, art is "wood" (statues or masks) or "mud" (terra cotta figures).

The aesthetic of West African "wood" and "mud" in New York City has been shaped profoundly by Islam and the history of long distance trading in West Africa. In a previous publication, *Money Has No Smell* (Stoller 2002), I described how Islam and the history of long distance trading in West Africa has shaped the economic and social practices of West African street vendors in Harlem (see also Steiner 1994). Although the West African art traders at The Warehouse are quite distinct from the street vendors described in that work, their ideas and expectations about display, trade, and marketing have been no less influenced by religion and history. Like the Harlem vendors, art traders at The Warehouse are usually members of West African ethnic groups—Sonninke, Hausa, and Wolof—that have long been the professional traders of West Africa (see Hopkins 1973). From the eighteenth century to the present these groups have traded cloth, kola, tobacco, and beads throughout West Africa. Through trade they not only helped to expand the political reach of nascent West African states, but also extended the reach of their religion—Islam (see Curtin 1975; Meillassoux 1991).

From its beginning, Islam has been inextricably linked with merchant capital. Commerce, in fact, has been central to the development and diffusion of Islam (Mennan 1986). In the Prophet Muhammad's new society, called the *Ummah,* society became a collection of human beings protected by Allah. In theory, allegiance to the Ummah transcended all class divisions and ethnic identification. Muhammad, whose wife Fatima was herself a prosperous merchant, deemed trade an honorable profession. Expansion of trade, in his view, would enable the Ummah to grow, prosper, and expand its power and influence. Trade, according to the Prophet Muhammad, should be conducted to foster and ensure good social relations; it should be straightforward, reliable, and, above all, honest. In various passages of the Koran and the *Sunnah* there are many statements about giving false oaths, correct weights, and goodwill in transactions. The Prophet Muhammad stressed that contracts be established clearly and comprehensively. He stood against monopolistic practices and forbade usury because these actions undermined commercial and social relations—which should not be deemed as separate (Mennan 1986). As pious Muslims, West African art traders at The Warehouse attempt to follow these traditional principles, though some of the dictates, as we shall see, have been refined to fit contemporary economic circumstances.

The economic principles of Islam reinforce familial solidarity generated by the real and fictive kinship ties of West African trading families. As in any kinship system the rites and obligations in West African trading families devolve from three factors: age, gender, and generation. Jean-Loup Amselle (1971) has written about these widespread trading families among the Kooroko of southern Mali. Among the Kooroko, the head of a household supplies food, shelter, clothing, and tax money for the people in his compound, who, in turn, give him what they produce. Sometimes the head of household is also a distinguished trader, a *jula-ba,* who manages the activities of a long distance trading network from the comforts of his compound. Well informed by kinspeople, affines, and friends, the great trader is apprised of changing market conditions close to and far away from home. When conditions are good, the great trader sends his *jula-ben* (literally "trader-child"— younger brothers, children, and his brothers' children) to distant markets to sell kola nut or buy cattle. In the distant markets (Cote D'Ivoire, Ghana, France, or even New York City), the "children" of the great trader are received, informed, and housed by hosts who usually have blood or marriage ties to the great trader. Following the transaction, the "children" of the trader return home and report to their "father." They receive no remuneration for their economic efforts. In time the paternal kinsmen of the great trader may ask for economic independence, which is granted along with a payment that is used to start a new enterprise.

Sometimes the great trader does not have a sufficient number of paternal kin to direct his long distance enterprises. In these cases, the jula-ba employs his maternal kin, the children of his sisters, or friends who are not part of his personal kindred. No matter the degree of blood-relatedness, the "children" must all observe the rights and obligations of the great trader's paternal kin. Like the great trader's paternal kin, they receive no remuneration for their initial services. After several successful missions, though, trader "children" in this category can ask their "father" for a loan to buy their own inventory. The "children" continue to perform services for the great trader but have entered into a contractual partnership—albeit an unequal one—with their "father."

In the early stages of the contractual relationship, "children" must give their "father" two-thirds of earned profits. If "children" manage to earn profits regularly from their loans, the great trader may offer them more credit. If "children" fail to produce profits, the great trader will continue to employ them but will never grant them another loan. Successful "children" eventually give the great trader 50 percent of the profits. If "children" become prosperous, they take their leave from the great trader and become jula-ba themselves (see Amselle 1971; Stoller 2002).

These patterns persist in New York City among West African street vendors in Harlem and West African art traders at The Warehouse (see Stoller 2002). Core networks often consist of paternal and maternal kin ("cousins") linked to a jula-ba in West Africa. Other networks link nonrelated traders who come from the same town or region. In New York, though, shared ethnicity seems to play a greater role

in establishing and maintaining networks than in West Africa (see Rouch 1956). Whatever the composition of the art trading network, however, participants, following the dictates of Islam, actively cooperate with one another. They share market information, divide the costs of transport from New York City to points in the American countryside (called the "bush"), and extend credit to one another. Their object is to move as much product ("wood" and "mud") as possible. Funds from the sale of "wood" and "mud" are reinvested collectively in more "wood," as well as precious gems, real estate, and transport vehicles. Money is also sent back to West Africa to support a trader's extended family.

Like the West African street traders in Harlem, West African art traders have had to adjust their commercial practices to North American economic realities (see Stoller 2002). They have been acutely sensitive to changing patterns of American consumption. Twenty-five years ago when El Hadj Ousmane of Niger began to trade in "wood," very few traders came to North America. They sold much of their inventory to gallery owners and to small numbers of private clients. According to El Hadj Ousmane, in the past five years the number of traders bringing objects to North America has increased exponentially. From El Hadj Ousmane's perspective, the North American market for African art has expanded. There are two reasons for the expansion. The hype surrounding MoMA's primitivism exhibit, to consider the first reason, augmented the legitimacy and increased the value of tribal art. This legitimacy attracted new groups of collectors looking to invest in objects, the values of which quickly increased with time. The appeal of Afrocentrism, to consider the second reason, has triggered much interest in Africa—including interest in African art—in African American communities. In Harlem, African American shoppers have bought Ghanaian *"kente"* cloth strips and hats from West African vendors. West African beads, incense, amulets, jewelry, and "kente" products, according to West African vendors in Harlem, underscore Afrocentric identification with Africa (see Stoller 2002).

Henry Louis Gates (cited in Wilde 1995) suggests that middle-class African Americans often feel the "guilt of the survivor," and buy Afrocentric products as a way of maintaining cultural fidelity with blackness. Kwame Anthony Appiah (1992), author of the much celebrated *In My Father's House*, says, "African American culture is so strongly identified with a culture of poverty and degradation . . . you have a greater investment, as it were, more to prove [if you are middle class], so Kwanzaa and kente cloth are part of proving that you're not running away from being black, which is what you're likely to be accused of by other blacks" (Wilde 1995; see also Early 1997). Understanding this hunger for blackness and Africa, West African art traders realized they could make money by tapping these new markets.

As a result they began to send larger and larger shipments of African objects to North America. Very few of these objects, according to the antiquities dealers I have talked to, qualify as "fine art." Some of them, though, qualify as decorative art—high quality reproductions. The vast majority of the new objects, however,

have been marked for quick sales to mass markets. They are mass-produced masks and statues, and recently sculpted terra cotta objects. The mass-produced objects are sold throughout the United States in street markets, well-known flea markets such as those in New Orleans and Santa Fe, and at third world and African American cultural festivals. Decorative objects are sold to wholesalers, to boutiques, to selected galleries, and to private clients.

These markets have expanded the networks of West African art traders. Principal traders often remain at The Warehouse to monitor the comings and goings of African objects. Some of the principal traders are documented immigrants and remain in New York City; others are older, more established traders who come to New York for short periods of time. They prefer to remain in New York where they sell higher-end objects to local clients or gallery owners. No matter the immigrant status of the principal traders, they are connected to mobile merchants, male and female traders who come to North America for three to six months. Hauling their own inventory as well as that of older, less mobile traders, they travel with "chauffeurs," West African men who drive these mobile merchants across the United States. They zigzag cross America, following circuits of African American and third world festivals. They also visit private clients as well as boutiques and African art galleries (see figure 2).

When they travel, they are received by North American "hosts," kinspeople or compatriots who have settled in such places as New Orleans, Atlanta, Miami, Chicago, Indianapolis, Houston, Dallas, Minneapolis, Detroit, Denver, Albuquerque, San Francisco, Seattle, and Los Angeles. Hosts often house their "cousins." They also help them to

Figure 3. African art for sale at Trader Jack's Flea Market, Santa Fe, New Mexico, summer 1997. Photo by Paul Stoller.

store inventory, inform them of potential outlets for their goods, and introduce them to potential clients. In this way, West African art traders have increased their client lists. They also know where to go for restoration, to make "wood" look more like "art"— especially to their high-end clients. In New York, a West African man has a workshop near The Warehouse where he repairs broken "wood" and "mud." He says that he does a great deal of work for African traders—especially in wood and the restoration of terra cotta figures. Mobile merchants on the West Coast employ the expert services of art restorers in San Rafael, California. These professionals do restoration of the following types of art: antique, contempo-

Figure 4. African art on display at the flea market, Santa Fe, New Mexico, summer 1997. Photo by Paul Stoller.

rary, ethnographic, Asian, African, Oceanic, pre-Columbian, and Indonesian. They restore art fashioned from wood, stone, ceramic, ivory, and metals. They also work on patinas and craft custom bases.

Looking to move "wood" and "mud," African mobile merchants travel from city to city, festival to festival, boutique to boutique, and client to client until they have depleted their inventories. When their Econoline vans are empty, they return to New York, settle their accounts with their "cousins," and return to West Africa where they settle more accounts—with their "fathers"—reinvest their profits, and look after their families. If they are able to steal some spare moments from their chaotic schedules, they might dress up in their best tweeds or damask *boubous* and attend the New York international antiquities show. Wandering the hallowed halls

of the Seventh Regent Armory, they may convince an eager investor to inspect some "important" pieces stacked in the back of his van.

African Art at the Crossroads

In West African religions, "crossroads" are places steeped in religious significance. Among the Yoruba of southern Nigeria, the crossroads is a space of danger; it is the domain of Eshu, the trickster deity. Among the Songhay of Niger the crossroads is also a space of danger, it marks the intersection of the social and spirit worlds. It is a space where spirits take the bodies of mediums, where sorcery becomes potent. Above all, the crossroads mark indeterminate space. Things are not what they seem.

The crossroads is a metaphor that captures the complex dynamics of contemporary social worlds. The various economic, technological, social, and political forces that define contemporary globalization have compressed, among other things, time and space (see Harvey 1989; Jameson 1991). This compression has compelled a widespread increase in transnational immigration, especially from the third world to North America (see Basch et al. 1993; Foner 2000, 2001). Global forces have also made social, economic, and political life more hybridized (see Bhabha 1994; Appadurai 1996). Much of the literature on social hybridity has been focused on refining social theory or methodological practice. It has often been driven by texts rather than by data (see Burawoy et al. 2000).

My concern in this article is less about the political or philosophical consequences of the global and more about its concrete ethnographic ramifications. What happens when two or more universes of meaning intersect, which today creates a transnational crossroads? This interest is not new. Many anthropologists have, after all, discussed how immigrants adjust to new circumstances. There are any number of excellent accounts of how new immigrants have recently established transnational networks and transcultural communities (Margolis 1994; Mahler 1995; Foner 2000).

My focus, here, though, is on market driven ephemeral encounters. What happens when people holding two distinct and well-established universes of meaning confront one another—at a crossroads like the New York tribal antiquities show? Steiner (1995:164) eloquently expresses the multiple textures of the fleeting "non-spaces," to borrow from Marc Augé (1995), one finds at transnational crossroads.

> Separated by oceans of geographic distance and words of cultural differences, African traders and Western consumers are brought together in a fleeting moment of economic exchange. From this brief transaction, buyers and sellers leave with vastly different impressions of their encounter.
>
> The buyers, on the one hand, depart with artifacts of seemingly remote and distant cultures that will become integrated into a world of meaning and value

comprehensible only through Western eyes. The sellers, on the other hand, walk away with renewed impressions of Western tastes and desires that will become part of their store of knowledge of how tourists and collectors perceive Africa and its art.

Sometimes these encounters lead to mutual understanding. They can also lead to misunderstanding, disappointment, and anger. Dealers at the New York antiquities show expressed anger at the African art traders who attempted to lure away potential buyers with "cheaper prices" for "similar pieces." At the crossroads, we should remember, things are not always what they seem to be. Consider the following example.

Ambassadors at The Warehouse

In June 2001, I went to The Warehouse to visit several Nigerien art traders who had recently come to New York City. As usual there were several vans backed up to loading docks. Young men loaded "wood" into the vans. I also noticed a black Mercedes sedan parked in front of The Warehouse's front door. Because one sees Mercedes sedans routinely in Manhattan, I gave it little thought. When I entered The Warehouse, I came upon a crowd of African traders gathered around three visitors. I immediately recognized one of the visitors—Richard Holbrook, the U.S. ambassador to the United Nations. In his company were a man and a woman who, unlike Ambassador Holbrook, were dressed informally.

"What's going on?" I asked several traders.

"Important people have come to visit us," one trader said in French.

A female trader grabbed my arm. "Look at them," she said, also in French. "Important people. The ambassador to the UN and the American ambassador to Nigeria."

"And the woman?"

"Mrs. American ambassador to Nigeria."

"I see."

"Do you want me to introduce you to them?"

I demurred.

"That's okay. They have so much money, but they won't buy anything here," she said, shaking her head. "You wait and see if I'm right."

The president of the African Art Traders Association, a prosperous man from Mali dressed in an elaborately embroidered gold damask robe, led the trio on a tour of The Warehouse. They toured the trader stalls on the ground floor, inspected the African kitchen, looked at the mosque, and took the freight elevators upstairs to inspect the storage facilities.

I met the Nigerien trader I had been looking for and we went up to the fifth floor to see his new inventory. He opened his storage bin to reveal a small room filled with old and new pots from Ghana, Nigeria, and Niger. He also had brought sacks of dried medicinal herbs, some old farming tools, a few weapons, and a col-

lection of old brass and copper rings. We used a flashlight to look more closely at
the objects. Many of the terra cotta figures had broken during transport. We talked
about medicinal herbs. Even though I did not want to purchase anything, I bought
a few copper and brass rings out of respect for our trading relationship. Having
known many traders over the years, I knew it would be insulting to inspect a
trader's goods and then refuse to buy something. Satisfied, the trader then closed
his storage bin and we got on the freight elevator, which serendipitously stopped on
the third floor. The group of dignitaries got on and we all descended—very
slowly—to the ground floor. The dignitaries looked as though they had thoroughly
enjoyed their visit. They talked animatedly about The Warehouse. My friend and I
followed the contingent of dignitaries to their car where a driver awaited them. A
crowd of traders flocked around them. Some offered them "wood." Others offered
business cards. One trader promised to find a rare object. Standing tall beside his
car, Ambassador Holbrook collected quite a pile of cards. He treated everyone
respectfully. He then invited the president of the African Art Traders Association to
lunch. The president got into the sedan and they left. Back in The Warehouse the
visit generated a great deal of discussion. My friend, the Nigerian trader, had talked
briefly to Ambassador Holbrook. He said that the dignitaries had behaved respect-
fully and had honored the African community with their visit. At the same time, he
noticed that they had not bought anything and that disturbed him. I encountered
the woman who had offered to introduce me to the dignitaries.

"Well, did they buy anything?"

"I don't think so. No one seemed to have carried away an object."

She shook her head. "See what I told you," she said.

Among people who "know" about African art in New York City, The Ware-
house is considered an interesting place to visit, but not a place to buy "authentic"
African art. Curators and gallery owners say that the stalls and storage bins are
filled with tourist art. One person who collects West African art said, "The place is
great, but it's filled with fakes. If you look very carefully, you might find a real
gem." Put another way, The Warehouse is a kind of cultural curiosity. Who would
think that a six-story storage facility in Chelsea, Manhattan would be filled with
West African traders who had stocked it to the gills with "African art"?

And so, from within the space of African art, which is, in part, framed by Kan-
tian and Hegelian notions of taste and authenticity, The Warehouse is a fascinating
place to see, but not a good place to purchase art. This notion may well have
shaped the observations and behaviors of the ambassadorial visitors. From within
the space of West African "wood" (and "mud"), which is framed both by the his-
tory and traditions of Islam and long distance trade by a history of fleeting cross-
cultural encounters, The Warehouse is a place where one engages in commerce,
the sale of "wood" and "mud." For West African traders, commerce, following the
dictates of Islam, is usually not deemed separate from social relations. When peo-
ple visit an African vendor at a market or an art trader at The Warehouse, they

should buy something, even if it is a small purchase. In this way, social relations are established and mutual face is maintained. Here, we have a classic case of a mismatch of intentions that generates misunderstandings and disrespect. "They came to visit, but they didn't buy anything." In this case, the mismatch of intentions resulted in few, if any, economic consequences.

Spaces of Collecting African Art

More often than not, things are not what they seem when one collects African art today. Manipulated objects are sometimes marketed as fine art. Skilled artisans can play with patina. They can also quickly age "wood" to make it look like an antique (see Steiner 1995:159–162). Old broken pieces of terra cotta are easy to come by in West Africa. These can be recombined to mold figurines that resemble 1,000-year-old excavated objects. These pieces are then presented to buyers as "old" and of "museum quality," when they are, in fact, decorative objects. Museum curators spend an increasing portion of their time talking to investors who want to know the value of the piece of (African) art they have purchased. Given the flood of "wood" floating in the African art market, vetting objects has become serious business. Before a Sotheby's tribal art auction, experts are called in to authenticate pieces. In some cases objects have to be removed from the auction list.

When one collects African art in the contemporary market, the intersection of spaces—of meaning—becomes a rather complex affair. From the standpoint of curators, connoisseurs, and high-end gallery owners, one usually collects fine African art from reputable dealers—men and women who have established reputations based on the authenticity of their objects. High-end dealers and connoisseurs buy from other high-end dealers or from reputable collectors who choose to sell their objects. This group attends such auctions as Sotheby's annual tribal arts auction in New York City, where bidding can sometimes increase the price of an object. They also flock to the annual New York tribal antiquities show. They may also buy objects at special auctions like the one in Paris in June 2001 that sold the famed Hubert Goldet collection (Moonan 2001). On increasingly rare occasions, they buy objects from African traders hoping to find a diamond in the rough, which is, as Steiner (1995) suggests, a conceit that African art traders fully understand and manipulate.

The collector's orientation to the objects has been shaped, in part, by a Kantian-Hegelian aesthetic that focuses on the ageless, transcendental nature of the object—qualities that imbue the object with legitimacy and value. For this group, value is important, but it is not the solitary force that drives buying and selling. There is a second group of collectors for whom investment value is the solitary force that compels buying and selling. Like all people interested in fine arts, these collectors pay great attention to prices paid for works of (African) art. They would know, for example, that the May 2001 Sotheby's tribal art auction generated $6.8

million in sales. They buy objects at Sotheby's auctions, estate sales, and at high-end galleries. They may also be on the client lists of West African traders. These collectors look to buy low and sell high. Sometimes they buy "art" that is, in fact, "wood" or "mud," in which case they have bought high and, if they so choose, will have to sell low.

Experience, ideology, and identity politics drives a third group of African art collectors to buy objects. These people may include African Americans inspired by some variety or version of Afrocentrism. A carved object from Africa becomes more than a work of plastic art; it is an emblem of pride. This group of collectors pays a wide variety of prices for African objects ranging from finely crafted decorative pieces to mass-produced tourist art. Some of the mass-produced objects can even be found in such discount stores as Marshalls and T. J. Maxx (see figure 5). Each group, then, brings a different set of aesthetic, economic, and ideological expectations and meaning into an encounter with an African trader. Even so, they are all seeking, in one way or another, an enriching authenticity.

Figure 5. African art for sale at Marshalls in Rehobeth Beach, Delaware, summer 2001. Photo by Paul Stoller.

The fourth group, of course, is composed of "kinship" based networks of African traders. This group is highly diverse. Long-term traders are highly knowledgeable. They take their better pieces to reputable art restorers. They may take their "important pieces" to well-known African art experts to seek their endorsement. These traders reserve their best objects for customers willing to pay good prices for "quality" objects. Even so, many of them believe, to paraphrase Errington (1998), that "authentic" primitive art has died. Accordingly, the bulk of

what they offer are decorative and mass-produced objects—"wood" and "mud" that can be bought easily and cheaply for quick, profitable sale. Sales bring in much needed cash. They use some of this cash, as has been already mentioned, to pay off debts to "brother" traders or to reinvest in inventory. Much of the cash is sent home to support large families that have become dependant on a steady flow of foreign exchange. Using this foreign income, elders and children can remain in the rural areas of West Africa where food is expensive and jobs are scarce (see Stoller 2001; Stoller and McConatha 2001). The income also empowers other family members to establish small rural or urban enterprises (see Stoller 1999). Put another way, selling "wood" and "mud" enables West African art traders to meet many of their social and cultural obligations, which means that their kinspeople honor them—especially when they return home (see Rouch 1956, 1967; Stoller 1999, 2002). The crossroads of African art is, then, a series of places where space—and meaning—is continuously negotiated and renegotiated. Given the ephemeral nature of these ephemeral "nonspaces" (Augé 1995), is it any wonder that the people who fleetingly inhabit them are filled with transitory misunderstandings and residual antipathies?

The Space of Anthropology

Where might anthropologists fit into these ever-changing spaces? Like any curiosity seeker, we can easily dive into the transnational currents of a place like the annual New York tribal antiquities show. Engaging in participant observation, we can observe the blending of people and the intercourse of meaning that constitutes a transnational space. We can conduct informal and formal interviews and compile economic, demographic, and sociological data. What can we learn when an African trader goes to the New York tribal antiquities show at Seventh Regent Armory on Park Avenue and 67th Street and convinces a seemingly well-heeled investor to look at the "wood" stacked in his van? That small slice of interaction compels much intellectual rumination about issues central to our comprehension of contemporary social life in North America. It triggers reflection about how art has been constituted and how global flows, which have brought to North America "wood" and "mud," have undermined the legitimacy of "authenticity." This observation prompts a discussion of Baudrillard's notion of the hyperreal, in which the power of copies overwhelms that of the original. The fast, high-octane world of copies—of the mimetic faculty—fuels the double-barreled engines of mobile, informal economies (see Baudrillard 1983; Taussig 1993; Stoller 2002).

In these fast-paced, contemporary worlds it becomes increasingly difficult to "read" objects. Can "wood" or "mud" become art? These considerations, of course, trigger reflections about the changing world of aesthetic legitimacy and the volatility of markets (see Steiner 1994; Marcus and Myers 1995; Marcus 1998; Myers 2002). They also touch on the sociology of art in contemporary worlds.

Connoisseurs, curators, and high-end gallery owners may have aesthetic as well as economic motives for maintaining an art for art's sake ethos, an ethos based, in part, on deep-seated notions of sublimity and transcendentalism. Investors, mid- to low-level collectors, and boutique owners may have economic and ideological motives for entering African art markets. As for the African art traders, many of them have a sophisticated comprehension of the aesthetic, economic, and political forces that drive the markets they attempt—often with great success—to exploit. In the end, the art that they sell has only a fleeting value. It is a material investment that enables many of them to meet their considerable economic and social obligations. These obligations have evolved historically—from Islam and from the history of long distance trading in West Africa.

It is fair to say that this anthropological trail is one filled with stimulating complexities. Anthropological spaces, of course, have always been complex—or perhaps more complex than we have been willing to admit or express (see Marcus 1998; Taylor 2002). As readers of Erving Goffman's work know, even the most miniscule of everyday interactions is laced with nuanced social negotiations and multilaminated cultural innuendoes. Social scientists have gleefully isolated rules for linguistic and social behavior to make sense of interactional chaos, and yet, as Goffman (1981) demonstrates in his later work, especially *Forms of Talk*, actors regularly violate rule-governed behavior. Goffman's work celebrates complexity within a relatively homogeneous cultural frame. His books analyze the private and public micro-behaviors of mostly mainstream Americans.

Twenty years after the publication of *Forms of Talk*, the United States, as the 2000 census indicates, is a much more diverse nation. Some 11 percent of Americans are foreign born; 20 percent of Americans speak a foreign language at home. In some urban areas, like New York City, these percentages are significantly higher, which means that cultural hybridity—the intercourse of universes of meaning and intent—increasingly characterizes our public encounters. This hybridity, in turn, makes the ethnographic enterprise exceedingly difficult; it renders the narrowly focused anthropological study as an anachronistic illusion. What's an anthropologist to do?

There are several strategies. One can focus on the past. This tack has yielded a rich ethnohistorical literature—especially on colonialism—but does little to shape anthropological investigations of present or future social configurations. One can advance the cause of anthropology as science by pummeling postmodernists, or one can advance the cause of anthropology as a humanistic enterprise by castigating positivists. Considering the ethnographic particularities of the anthropological trail I have attempted to describe in this article, this debate, which has taken up far too much space in anthropological journals, seems rather superfluous.

In a recent book, *Global Ethnography* (Burawoy et al. 2000), a group of Berkeley sociologists present a series of case studies that underscore the importance of empirically grounded ethnographic research in contemporary social worlds. They

argue that social theorists have been so far removed from ground-level social reality that they often overlook important dimensions of global processes. Although the authors seem to be ignorant of what has transpired in (urban) anthropology during the past fifteen years, they do make an important point: to understand contemporary worlds scholars must opt for dwelling rather than travel, for theory shaped by data rather than vignette. Considering how global and local forces interact to effect immigration, informal economies, transnational trade networks, and local-level politics, anthropologists (as George Marcus [1998] underscores in his book *Ethnography Through Thick and Thin*) have already begun to take up this challenge. It is a challenge that will not only make anthropology socially and politically relevant, but intellectually exciting as well.

Questions for Discussion

1. What does Stoller mean when he discusses "paths of wood" in this article?

2. As art objects, are there material differences between the carvings sold at the tribal art show and the contemporary "wood" sold by Africans at The Warehouse?

3. What differences in meaning and value do these two types of art have for American consumers?

4. Curators, dealers, and collectors are key players in the art world that involves traditional African art. What role do these players perform in conferring value on African art?

Acknowledgments

The research on which the present article is based has been ongoing since September 1999 and has been generously funded by the National Science Foundation. I would also like to thank David Buchanan and Jenny Skerl (past and present deans of West Chester University's College of Arts and Sciences) and Edmundo Morales and Anthony Zumpetta (past and present chairs of West Chester University's Department of Anthropology and Sociology) for giving me time off from teaching to pursue my research in New York City. Jasmin Tahmaseb McConatha, Christine Mullen Kreamer, and David Napier have read various versions of the manuscript. I thank them for their comments and advice. I am also grateful to *AQ*'s three anonymous reviewers whose suggestions have improved this article. My greatest gratitude goes to the scores of West African traders who have been graciously patient with my ongoing presence in their midst.

References

Amselle, Jean-Loup. 1971. "Parenté et commerce chez les Kookoro," in *Development of Indigenous Trade and Markets in West Africa*, ed. C. Meillassoux, pp. 253–266. London: Oxford University Press.

Appadurai, Arjun. 1996. *Modernity at Large: Cultural Dimensions of Globalization*. Minneapolis: University of Minnesota Press.

Appiah, Kwame Anthony. 1992. *In My Father's House: Africa in the Philosophy of Culture*. London: Oxford University Press.

Augé, Marc. 1995. *Non-Places: An Introduction to an Anthropology of Supermodernity*. London and New York: Verso.

Basch, Linda, Christina Szanton-Blanc, and Nina Glick-Shiller. 1993. *Nations Unbound: Transnational Projects, Postcolonial Predicaments, and Deterritorialized Nation-States*. New York: Gordon and Breach.

Baudrillard, Jean. 1983. *Simulations*. New York: Semiotext(e).

Bhabha, Homi. 1994. *The Location of Culture*. New York: Routledge.

Burawoy, Michael, Joseph A. Blum, Sheba George, Zsuzsa Gille, Teresa Gowan, Lynne Haney, Maren Klawiter, Steve H. Lopez, Seán Ó Riain, and Millie Thayer. 2000. *Global Ethnography: Forces, Connections, and Imaginations in a Postmodern World*. Berkeley: University of California Press.

Castells, Manuel. 1996. *The Rise of Network Society*. Malden, MA: Blackwell.

———. 1997. *The Power of Identity*. Malden, MA: Blackwell.

———. 1998. *The End of the Millennium*. Malden, MA: Blackwell.

Clifford, James. 1988. *The Predicament of Culture: Twentieth-Century Ethnography, Literature, and Art*. Cambridge: Harvard University Press.

———. 1996. *Routes: Travel and Translation in the Late Twentieth Century*. Cambridge: Harvard University Press.

Curtin, Phillip. 1975. *Economic Change in Precolonial Africa: Senegambia in the Era of the Slave Trade*. Madison: University of Wisconsin Press.

Early, Gerald. 1997. "Dreaming of a Black Christmas." *Harper's Magazine* 294:55–62.

Errington, Shelly. 1998. *The Death of Authentic Primitive Art and Other Tales of Progress*. Berkeley: University of California Press.

Foner, Nancy. 2000. *From Ellis Island to JFK: New York's Two Great Waves of Immigration*. New Haven: Yale University Press.

———, ed. 2001. *New Immigrants in New York*. Rev. ed. New York: Columbia University Press.

Glick-Shiller, Nina and Georges Fouron. 2001. *Georges Woke Up Laughing: Long Distance Nationalism and the Search for Home*. Durham: Duke University Press.

Goffman, Erving. 1981. *Forms of Talk*. Philadelphia: University of Pennsylvania Press.

Harvey, David. 1989. *The Condition of Postmodernity*. London: Blackwell.

Hegel, G. F. W. 1975. *Aesthetics: Lectures on Fine Art*. Oxford: Clarendon Press.

Hopkins, A. G. 1973. *An Economic History of West Africa*. New York: Columbia University Press.

Howes, David, ed. 1991. *The Varieties of Sensory Experience: A Sourcebook in the Anthropology of the Senses*. Toronto: University of Toronto Press.

Jameson, Frederick. 1991. *Postmodernism, or the Cultural Logic of Late Capitalism*. Durham: Duke University Press.

Janson, H. W. 1962. *History of Art: A Survey of the Major Visual Arts from the Dawn of History to the Present Day.* New York: Abrams.

Kant, Immanuel. [1790] 1966. *The Critique of Judgment.* New York: Hafner Publishing Company.

Kantner, Rosabeth Moss and Todd L. Pittinsky. 1996. "Globalization: New Worlds for Social Inquiry." *Berkeley Journal of Sociology* 40:1–21.

Mahler, Sarah. 1995. *American Dreaming: Immigrant Life on the Margins.* Princeton: Princeton University Press.

Marcus, George E. 1998. *Ethnography Through Thick and Thin.* Princeton: Princeton University Press.

Marcus, George E. and Fred R. Myers. 1995. "The Traffic in Art and Culture: An Introduction," in *The Traffic in Culture: Refiguring Art and Anthropology,* ed. George E. Marcus and Fred R. Myers, pp. 1–55. Berkeley: University of California Press.

Margolis, Maxine. 1994. *Little Brazil: An Ethnography of Brazilians in New York City.* Princeton: Princeton University Press.

Meillassoux, Claude. 1991. *The Anthropology of Slavery.* Chicago: The University of Chicago Press.

Mennan, Moustapha. 1986. *Islamic Economics: Theory and Practice.* Boulder: Westview Press.

Mollenkopf, John and Manual Castells, eds. 1991. *Dual City: Restructuring New York.* New York: Russell Sage Foundation.

Moonan, Wendy. 2001. "Antiques for Sale: African Art in Abundance." *The New York Times* (June 22).

Morris, Brian. 1987. *The Anthropology of Religion: An Introduction.* London: Cambridge University Press.

Myers, Fred R. 2002. *Painting Culture: The Making of an Aboriginal High Art.* Durham: Duke University Press.

Plattner, Stuart. 1996. *High Art Down Home: An Economic Ethnography of a Local Art Market.* Chicago: University of Chicago Press.

Portes, Alejandro and Alex Stepick. 1994. *City on the Edge.* Berkeley: University of California Press.

Price, Sally. 1989. *Primitive Art in Civilized Places.* Chicago: University of Chicago Press.

Rouch, Jean. 1956. "Migrations au Ghana." *Journal de la Société des Africanistes* 26(1–2):33–196.

———. 1967. *Jaguar.* Paris: Films de la Pléiade.

Sassen, Saskia. 1991. *The Global City: New York, London, Tokyo.* Princeton: Princeton University Press.

———. 1994. *Cities in a World Economy.* Thousand Oaks, CA: Pine Forge/Sage.

———. 1996. "Whose City Is It? Globalization and the Formation of New Claims." *Public Culture* 8:205–223.

Steiner, Christopher B. 1994. *African Art in Transit.* Cambridge: Cambridge University Press.

———. 1995. "The Art of the Trade: On the Creation of Authenticity in the African Art Market," in *The Traffic in Culture: Refiguring Art and Anthropology,* ed. George E. Marcus and Fred R. Myers, pp. 151–166. Berkeley: University of California Press.

Stoller, Paul. 1989. *The Taste of Ethnographic Things: The Senses in Anthropology.* Philadelphia: University of Pennsylvania Press.

———. 1997. *Sensuous Scholarship.* Philadelphia: University of Pennsylvania Press.

———. 1999. *Jaguar: A Story of Africans in America.* Chicago: University of Chicago Press.

———. 2001. "West African: Trading Places in New York," in *New Immigrants in New York,* ed. Nancy Foner, pp. 229–249. Rev. ed. New York: Columbia University Press.

———. 2002. *Money Has No Smell: The Africanization of New York City.* Chicago: University of Chicago Press.

Stoller, Paul and Jasmin Tahmaseb McConatha. 2001. "City Life: West African Communities in New York City." *Journal of Contemporary Ethnography* 26(4):651–678.

Synnott, Anthony. 1993. *The Body Social: Symbolism, Self, and Society.* New York: Routledge.

Taussig, Michael. 1993. *Mimesis and Alterity: A Particular History of the Senses.* New York: Routledge.

Taylor, Mark. 2002. *The Moment of Complexity: Emerging Network Culture.* Chicago: University of Chicago Press.

Torgovnick, Marianna. 1990. *Gone Primitive: Savage Intellects, Modern Lives.* Chicago: University of Chicago Press.

Vogel, Susan Mullin. 1997. *Baule: African Art, Western Eyes.* New Haven: Yale University Press.

Wilde, A. D. 1995. "Mainstreaming Kwanzaa." *The Public Interest* 119:68–80.

5

Tourism, Aesthetics, and Global Flows along the Swahili Coast

Sidney L. Kasfir

For centuries the facts of trade, war, and migration have influenced the performance of African expressive culture—music, dance, the production of artifacts, clothing and adornment, and even the rituals of comportment and speaking. On the east coast of Africa from Somalia to Mozambique, coastal incursions from the Indian Ocean, some friendly and others hostile, began two millennia ago with the publication by an unknown author of an early navigator's guide known as *Periplus of the Erythrean Sea* (Huntingford 1980). It has continued up to the latest militant attack on a Mombasa tourist hotel and charter plane in late 2002. In this case, the weaponry used is thought to have been moved down the coast by *dhow* from Somalia. International tourism and terrorism are the most recent of these successive invasions of the Swahili coast. Both are two readily acknowledged results of the process of globalization. The urgent need to recognize and understand these global flows has finally outweighed the reluctance of anthropologists and art historians to allow the tourist into some of their investigations (Gewertz and Errington 1991; Kasfir 1992, 1999; Steiner 1994, 1999; Phillips and Steiner 1999).

This article brings together two strands of cultural history: (1) a long-standing Swahili coast mercantilism seen in the context of a very permeable ocean frontier and (2) the much more recent experience of modernity. These strands engage in a kind of mutual dialogue that engages both global and local outcomes. The broad topic I explore is the aesthetics of the Swahili coast as a tourist "destination" in the late twentieth and early twenty-first centuries. As an art historian, I am particularly interested in the effects of this latest invasion of foreigners on material culture, on the personal sense of embodiment it offers, and on the production of identities through the artists who engage in its manufacture. A second aim of this article is to bring together two very different discourses on nomadism, one from pastoralist and

environmental studies, the other from the conceptual framework of postcolonial art and artists.

A key feature of this interaction is that the traders, mercenaries, colonizers, and conquerors who breached this African shore were motivated by trade and the extraction of highly desirable goods—ivory and ebony, slaves, mangrove poles, exotic animals, spices, and fruits. Now, tourists in the tourist trade are extracting experiences as well as souvenir goods. Each wave of migrants, conquerors, or fortune-seekers—whether Shirazi, Omani, Hadhrami, Portuguese, or British—has added its own sociopolitical structures and cultural practices into the mix, blending their practices with those of local people living along the stretch of shore that has come to be known as the "Swahili coast."

The history of this interaction is long and complex. It can be traced in every medium of expression from language to adornment to architecture. In this article, I focus on the second half of the twentieth century, which was dominated first by British colonialism and then by postcolonial states as different as Kenya and Tanzania. Everywhere in Africa during the last century there has been a desire for, and simultaneously a resistance to, modernity. On the Swahili coast these tendencies have been refracted through the social and religious practices of Islam both during and after colonial rule. This inherent volatility has fractured into shifting alliances and rivalries that have nonetheless remained loosely knit together in the stone-town mercantile and trading class, the Swahili *waungwana* (the town-based, mercantile class claiming Arab or Shirazi ancestry).

My observations come from four research trips to the Kenya coast undertaken during the early to late 1990s. They are focused on two places: (1) Mombasa, together with the beaches and settlements along its north coast, especially Mtwapa and Kikambala (which coincidentally was the site of the 2002 terrorist attack on an Israeli-owned hotel), and (2) the island of Lamu near the border with Somalia. I first visited the Kenya coast, and also Zanzibar, as a very young person many years earlier, and while I cannot claim this visit as "research," nevertheless I do retain a vivid memory of what these places were like in the early postcolonial period and how both compare with the present. I mention this earlier visit because to study tourism reflexively, in some ways, one must be a participant as well as an observer.

I will narrate my own cultural encounters along these shores through two sets of subjects: the Swahili furniture-making workshops on Lamu, and a contingent of Maasai and Samburu males of the warrior age-grade (*lmurran*) who have encamped seasonally in Mtwapa since the early 1980s, where they continue to sell spears and beadwork to tourists. These two groups at Lamu and Mtwapa, respectively, neither know nor interact with each other. They are linked only through their connections to tourism. Both raise important issues about authenticity, tradition, and the cultural politics of identity as they are understood by foreign tourists. Both cases raise questions about cultural mediation by an array of producers, traders, and guides. Perhaps most importantly they demonstrate how aesthetics, material culture, and

their various discourses shape the representation of African cultures to spectators in the West and Asia.

East Africa as a Tourist Destination

Before the advent of airplanes, most long-distance travelers arrived in East Africa by European ship or Indian Ocean *dhow.* Thus, the Swahili coast port cities have been the sites of cultural encounters for many centuries. Mombasa and Zanzibar have each had distinctive identities in Western popular literature and more recently in films. Edward Bruner (2001:881), following Arjun Appadurai (1988), has noted that there is a tendency—whether in the popular imagination or in ethnography—to pair certain places with specific recurrent topics. Mombasa is most frequently associated with the eve of British colonialism in East Africa and in having ushered in modernity with the building of the Uganda railway, which brought goods from the coast to the interior. These themes are recounted in both the popular book *The Lunatic Express* (Miller 1971) and more recently in the Hollywood film *The Ghost and the Darkness* (Paramount Studio 1996), which actually brought together the Swahili and Maasai in a single setting. Zanzibar, on the other hand, evokes the romance of social revolution, whether it be the British suppression of the slave trade in 1876 or the Maoist-inspired overthrow of the sultanate nearly a century later.

But overriding these site-specific themes, colonial (and for Hollywood pseudo-colonial) accounts by outsiders about both destinations are overlain with a strong veneer of orientalism that has focused on the Zanzibar sultanate or other aristocratic forms of power, such as slavery, the seclusion of women, the trade in exotic goods (such as ivory or cloves), and the coralstone towns with their thick-walled privacy that Europeans can not easily penetrate. Hotel owners and tour operators have used this imagery, embedded within the larger picture of a fisherman's paradise and beach resort, to create localized distinctions in a bid to attract tourist patronage.

We should also consider the perceptions of the Swahili themselves, especially since they were affected by British colonial attempts at social engineering and exist in constant interaction with the perceptions of outsiders. In his study of the Mombasa Old Town Swahili, Marc Swartz (1991:36) notes that until the 1960s, "Zanzibar was Mombasa's Paris," a role model to be emulated in cultural matters. But the British strengthened this regional pecking order. After dismantling the slave trade, the British appointed "men of good family"—mostly former slave owners—to administrative posts in the coastal province government. British administrators particularly favored "Zanzibar Arabs" of Omani descent, an ethnic category that they recognized as "nonnative." They offered them tax breaks, rice rations, and a place in the bureaucracy of indirect rule. Twelve tribes waungwana, who were classified as "Swahili Arabs" by the British, tried to get the same privileged "nonnative" status, but failed in this effort for most of the colonial period (Swartz

1991:44–46). Publicly, this humiliation was inscribed in the "white-brown-black" racial hierarchy of colonial rule. It gives a sharp edge to long-standing Swahili attempts to distance themselves culturally from obvious "natives" who live in the interior, such as the Maasai and Samburu.

The competing, and nowadays dominant, image in East African travelers' narratives is that of the primeval, untamed landscape dominated by wild animals. This imagery is played out in the broad savannahs of the Great Rift Valley in Kenya and Tanzania and accompanied by the "disappearing," yet noble, warrior-herdsman: Maasai in the south and Samburu, Turkana, or Pokot in the north. The Rift Valley and its game parks and reserves are geographically far removed from the coast. They appeal to a different type of travelers' sensibility and, thus, have tended to remain separate destinations from the coast. Beginning with the big game hunting of Teddy Roosevelt and others in the early twentieth century, the hunting safari for the wealthy client has gradually developed into the East African camera safari package. These packages cost anywhere from a few thousand dollars for the standard eleven days to more than $1,000 per person per day with companies like Abercrombie and Kent, who provide every possible luxury from champagne breakfasts in the bush to hot air ballooning.

In this competition for travelers' patronage, the Swahili coast hotel and tour operators do not rely on foreigners' interest in Swahili urban stone-town culture or its archaeological sites, such as Gedi or Kilwa, but on the more bankable middlebrow taste for the Indian Ocean's warm water, coral reefs, and white sand beaches. In other words, they are creating a Caribbean rather than a European model of tourism. Beginning with the tourist boom on the East African coast in the 1980s, airlines such as Lufthansa sold all-inclusive round-trip air and beach hotel packages to Mombasa similar to those from U.S. cities to Caribbean island resorts. On these tours the tourist spends very little time away from the beach and the hotel and barely encounters the local culture other than during optional forays to restaurants and souvenir stalls.

The Coastal Invasion of Warriors

It was perhaps inevitable that when tourist revenues began to vacillate due to global and regional factors, a few enterprising operators began to find ways to offer "two experiences in one." They could not release lions and elephants onto the coastal beaches, but they could transfer a piece of the pastoralist culture there in a gesture of staged authenticity. A Mtwapa-based north coast business called Kenya Marineland, which specializes in chartered deep-sea fishing trips, built a small "Maasai village" just inside its entrance. They invited Maasai (and later Samburu) warriors to be present on the premises when customers returned from their chartered excursions. There was already a well-known tourism prototype for this arrangement on the outskirts of Nairobi. There the government-sponsored Bomas

of Kenya organization maintains a group of model mini-villages on the same site as its main auditorium, which is used for dance performances (see Bruner 2001:886). As for the Maasai and Samburu lmurran, a few of them had already worked intermittently in game park lodges on the Maasai Mara Reserve or Samburu Reserve, or at the Mayers Ranch in the Rift Valley (Bruner and Kirshenblatt-Gimblett 1994) where they had performed group dances for tourists. Before the 1980s the warriors viewed these casual encounters with tourists as something of a lark. But by the mid-1980s, a succession of severe droughts that began in 1976 left many pastoralists in Kenya with sharply reduced herds. Maasai warriors and their Samburu cousins, unencumbered by wives or animals, began drifting around the countryside in pairs looking either for work or diversion; some ended up at Mtwapa on the coast.

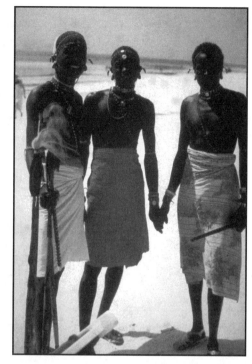

Figure 1. Three Samburu lmurran, Lkurorro age set, on a Mombasa beach with miniaturized tourist spears for sale, 1980s. Photo by K. Lenaronkoito.

Here a bachelor warrior settlement gradually developed in the 1980s in a warren of concrete rented rooms of the type found in African cities everywhere. It was (and still is) a kind of cattle camp without cattle on the coast road close to both Kenya Marineland and the north coast beaches where major resort hotels are located. The settlement grew by word of mouth as Samburu lmurran, some of them sons of blacksmith families, brought beadwork and spears to sell on the beaches. They dressed identically to the way they dressed at home in the northern Rift Valley, barechested, in waist-to-knee *shuka* (wrappers) and sandals, with elaborate beadwork and decorated, plaited, and ochred hair. Their predominant body type is tall, slender, and to the European eye, "aristocratic." Their comportment, along with their looks, set them apart immediately from aggressively friendly "beach boy" hawkers. They seemed reserved, distant, and echoed the Samburu standard of behavior for males, which disdains open displays of emotion.

The combined effect on Western tourists was that of a kind of warrior artifact, in which the focus of the tourists' interest was on them, not on the goods they hap-

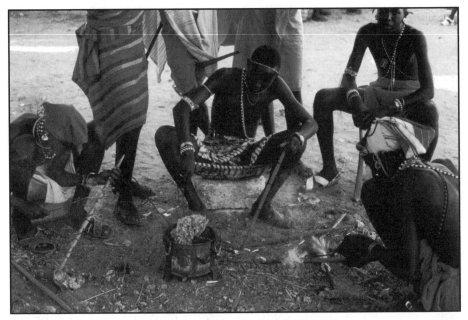

Figure 2. Samburu lmurran burning designs on tourist spear shafts, Mtwapa, 1991. Photo by S. Kasfir.

pened to be selling. It is this embodied warrior artifact that is my major concern here, and not so much the beadwork or spears themselves. Tourist perceptions of the warrior with his decorations and weapons as both image and artifact blur the boundaries of what is conventionally considered "performance" and "material culture." On display in Mombasa, far from his home district, the warrior becomes a representation, a simulacrum of the pastoralist life not readily visible to the tourist at the coast.

Nonetheless male tourists, especially Germans, Swiss, and Italians, want souvenir spears in order to acquire a piece of this Samburu-constructed masculinity, which is focused on warriorhood. (Because they rarely interact with Samburu in their home environment, tourists are generally unaware that Kalashnikov rifles and other firearms have gradually been replacing spears as the primary symbol of masculinity in the cattle raiding that is endemic to the Kenya-Somalia and Kenya-Uganda borderlands.)

Women tourists rarely show any interest in spears, but like the men are often attracted to the warriors themselves. The result, depending on the warrior's personal level of interest, may be an assignation and sometimes a brief affair, something that also happens between women tourists and so-called beach boys. I will return to this strand of interaction, but for now it is only important to notice that

Figure 3. Samburu selling spear to tourists, Bamburi Beach, 1991. Photo by S. Kasfir.

Samburu or Maasai male sexuality is a prominent part of the Swahili coast tourist equation. Sexuality rarely, if ever, figures in tourist encounters in their home districts or in the game reserves. The warrior himself, of course, is not collectible—though temporary liaisons with women tourists are attempts at precisely that—instead he is "captured" as a souvenir by acquiring weaponry, beadwork, and posed tourist snapshots, or in images sold as postcards and glossy picture books in the game lodges and in tourist hotels. In more adventurous cases, he is invited to Germany or Switzerland for a few weeks or months at the tourist's expense, to be displayed to friends and rivals as a living souvenir of having "been there."

Ethnic Competition, Staged and Offstage

But if Samburu warriors and European tourists ostensibly share certain mutual affinities, the same can not be said for Samburu interaction with the local Swahili culture. Swahili have feelings of racial and cultural superiority toward the up-country *washenzi* (people who lack civilization or "pedigree"). And the Maasai-Samburu have feelings of revulsion toward those who are polluted by eating fish or crustaceans (a very strong dietary prohibition for them), and they also have a deeply ingrained sense of superiority over those who are not "people of cattle."

Thus, an invisible wall separates their interactions at nearly every level. Both refer condescendingly to those they feel superior to as "Africans," as if they themselves are not. They know, and want to know, very little about each other, even though they share the same public spaces at the coast.

Swahili and Arab merchants still recollect the Maasai dominance over the Rift Valley trade routes during the nineteenth century. This dominance forced their ivory and slave caravans to pay duty in ivory tusks to the Maasai, who could then resell or trade them at the coast. For this reason, they also know that no Maasai were ever enslaved. In other words, the merchants' feelings of cultural superiority were partly mitigated by the Samburu's and Maasai's nonslave ancestry, as well as the knowledge that in the nineteenth century (and even in the colonial period) a Maasai or Samburu warrior unimpressed by a stranger's status and position might not hesitate to run him through with his spear. For their part, the Samburu regard the coast as a dangerous place, abundantly supplied with AIDS and malaria, neither of which posed a threat in the Samburu district back in the 1980s when they began coming to Mombasa. They consider coastal people as unclean because the two communities do not follow the same prohibitions about food and sexuality. At the same time, the warriors at the coast recognize and act on the pragmatic importance of learning to speak Swahili. For that matter, they even learn a smattering of German and Italian to smooth the way for transactions to take place.

The operators of large beach hotels, many of whom are Europeans, and the owners of the curio shops, nearly all of whom are Asians or Arabs, maintain a strictly business relationship with the Maasai and Samburu warriors. They understand how to use the exoticism and panache of the warrior image to attract clientele, but do not enter into personal relationships with them, as the tourists frequently hope to do. One large curio and gem shop in the business district of Mombasa hired a beaded and ochred warrior just to stand outside and attract attention.

On the beaches the problem is a complex one for hotel owners because tourists constantly complain about hawkers, who approach them on the beach to sell souvenirs. The solution has generally been to severely limit warriors' access to the beach, which they need since they do not own shops where they can sell their spears. A compromise that has worked for some hotels has been to grant access to the beach for only certain hours and places. In return a small group of ten or twelve warriors agree to dance at the after-dinner entertainment that the hotel sponsors. In other agreements, the beach is still off-limits but warriors are allowed to bring out their spears and beadwork on the hotel terrace after their dance is over. In the early 1990s, when most of my fieldwork was carried out, there were three or four warrior dance groups who had made this kind of informal contract.

For tourists, Maasai-Samburu dancing is a huge departure from the other hotel dance troupes at the coast that contain both men and women. These troupes feature the type of dances and drumming that foreign audiences recognize as "African" from touring national troupes or television specials they have seen. The

Maasai-Samburu have no drums, no graceful hip movement, and no footwork at all, just one man after another leaping straight up into the air with arms at his sides or holding a fighting club, to the accompaniment of guttural sounds that are meant to imitate bulls (figure 4). Given their expectations, many tourists are understandably disappointed. But at the same time, they realize they are watching an unmediated performance, with nothing added or subtracted because it happens to occur at a beach hotel in front of strangers.

The point of these remarks is to establish that the Maasai and Samburu are very unforgiving in their colonization of these coastal spaces. They remain almost totally unassimilated, interacting only when they have to. At the same time they are highly visible wherever they go, obeying a body aesthetic, with its bare-limbed display of young male perfection, that contrasts with the

Figure 4. Samburu lmurran of Lmooli age set dancing at a wedding, Samburu district, 2001. Photo by S. Kasfir.

self-conscious and sunburned flesh of middle-aged European tourists in their varying states of undress. The warrior demeanor also contrasts starkly with the many-layered privacy of the Arabs and waungwana. Swahili merchants also wrap themselves in their cultural superiority and draw their own line in the sand. Their wives and daughters, covered in black *buibuis* from head to ankle, reinforce the image of inaccessibility. It is the tourists who occupy an uncertain space relative to the Samburu and the Swahili. Some tourists, especially women, are cloaked in their romantic preconceptions of warrior sexuality on the one hand, and of Swahili and Arab inscrutability on the other. But they are willing to suspend their own identities during the encounter. This suspension seems an implicit requirement for being a "good traveler" in the old-fashioned sense.

All of this also points to the fact that tourism itself is a modern form of nomadism, made possible by the globalizing effects of air travel. Despite the boundary-maintaining havens of luxury hotels and package tours, tourists are vulnerable to some of the same effects of displacement experienced by less affluent migrants,

namely a destabilization of identity caused by unfamiliar cultural encounters. How else can one explain the sudden willingness of older European female tourists to enter into relationships, however fleeting, with lmurran who are half their age and a world apart in cultural assumptions about romantic entanglement?

While the Samburu themselves are semi-nomadic by tradition, practicing a form of seasonal transhumance, those who come to the coast to trade leave the most important accoutrements of that nomadism, their livestock, behind. In doing so, they are propelled into an equally destabilizing cultural encounter, not so radically different from that of the tourist. Their response, however, is in every sense opposite, attempting to limit and set the terms of these encounters with strangers and at the same time remain uncompromisingly Samburu. If flexibility, or a kind of relaxed cultural relativism, is the Western value most effectively brought into play when facing the exotic, the result is to reinforce the cultural certainties of the Samburu warrior that he is worthy of such attention, which in turn creates a stage for warrior theater. Subtly, these lmurran have moved from one form of nomadism to another, the first defined by adaptive subsistence patterns and the second by the global flow of tourism. In doing so they did not have to become transnationals, but only had to make the journey from the sparsely populated open spaces of Lorroki to the town culture of the coast. In discussing contemporary African artists, Nigerian-born curator Okwui Enwezor has remarked to me that this kind of urban migration is comparable to the displacement from home to foreign metropolis. In certain ways—particularly linguistic—it is not as complex, yet the spatial and temporal dimensions are radically redrawn.

Modernity and Authenticity in Lamu

My second example of the Indian Ocean coastal tourist invasion is actually offshore, on the island of Lamu in the northern section of the Swahili coast near the Kenyan border with Somalia. This border has been unstable since the early 1960s when both countries laid claim to Kenya's Northern Frontier District. One result is that the narrow coast road north of Malindi, which leads to Lamu, is controlled as much by *shifta* (Somali bandits) as by the Kenyan government. The traditional access by dhow from Mombasa has dwindled along with the dhow trade itself. The island's remoteness from the Nairobi-centered safari routes and the lack of safe road access from Malindi kept tourists away from Lamu until small six- and eight-seater planes began flying to a tiny, mainland airstrip opposite the island.

On my first visit more than thirty years ago there was no real provision for tourists other than the original Petley's Inn, which served government resthouse fare and had two or three guest rooms in addition to an alleged male brothel upstairs. Today, there are a few hotels, mainly on the beaches outside town and on

neighboring Shela, besides the "modernized" Petley's and some bed-and-breakfasts set up in private homes. Aside from the district commissioner's Land Rover, no vehicles are allowed in Lamu Town, so the town retains the unhurried tempo of life of an earlier period. Tourists think of Lamu as an authentic "find" with its narrow streets, fishing boats, and imposing coralstone houses with their carved doors. Unlike Mombasa, where the Swahili are outnumbered by more recent arrivals, here they are highly visible and (the men at least) can be seen going about their daily pursuits almost as if the tourists were not there.

Because nearly all tourists arrive and leave on small planes, they rarely purchase the most important local forms of material culture—the carved furniture, door posts, and lintels. (An antiquities law enacted in the 1960s prohibited the export of the old doors and frames after many had already disappeared via dhow shipments.) In theory, new furniture can be shipped out by dhow to Mombasa and then freighted overseas from there, but in 1992 the price of shipping a single chair had risen to about $400, eliminating all but the most dedicated tourist buyers. At that time, there were three active furniture-making workshops, whose clientele were mainly traditional customers, particularly the waungwana families of the town, purchasing pieces for their daughters' dowries.

By local custom, a bride's family should provide as many furnishings for the house as possible—ideally, a bedroom set, a sitting room set, and kitchen utensils, as well as gold and silver jewelry and a small carved chest to hold it. (This is a great expense, and often the bride's relatives are asked to help out.) A second, less wealthy class of young Lamu brides-to-be want furnishings that correspond to their perceptions of "Kenyan modern," with mirror inlays, plastic panels, and hand-painted headboards. But since mothers and

Figure 5. Nineteenth-century furnishings in a women's *ndani,* House Museum, Lamu, 1987. Photo by S. Kasfir.

other female relatives of the bride help her choose what to order, the final choice is more apt to lean toward conservative designs.

Besides these customary uses, there are some nontraditional uses of traditionally styled furniture. At least one luxury hotel group, Block Hotels, who until recently owned both the Nyali Beach north of Mombasa and the legendary Norfolk Hotel in Nairobi, commissioned traditional style Lamu furniture for display in their public rooms, invoking the orientalism theme (figure 5). (The Nyali Beach also has a Swahili Arab "greeter" dressed in a white turban and *khanzu* who welcomes guests as they come in to register, figure 6.) In this case, there is a reversal of expected consumption patterns: the five-star hotel as an upholder of traditional forms and perpetuator of the Arab myth.

Figure 6. Swahili "greeter" and neotraditional furniture from Lamu workshop, Nyali Beach Hotel, Mombasa, 2001. Photo by D. Turgelsky.

There were other surprises as well. The late Saidi Abdul-Rahman, master furniture-maker and owner of Lamu Crafts, was much more of a traditionalist than his father, who still runs a separate workshop in another part of town. His father makes mostly Formica-veneer and plastic-upholstered furniture for people who can not afford to buy items with the older style of carved mahogany. Saidi, on the other hand, largely made replicas of old styles, or variations of them, in the same expensive hardwoods as the originals. Sometimes he would bring a chair from the Lamu Museum to copy (figure 7). When I asked why he preferred to work in those styles he shrugged and said, "they are still beautiful, even if they are old." One of his innovations took the design of a single chair and expanded

it into a four-seater design. He then modified the caning so that there was a continuous, almost hammock-like back and seat—"a chair to relax in." The main difference in technique between reproductions and traditional chairs is their modern, lathe-turned legs. (Only dhow builders still use the old method of shaping the mast by a rope-pulled hand lathe.)

Modern innovations coexist with consciously Swahili cultural practices, just as they do for other Kenyans who are trying to relate their past to the present. Saidi, for example, revived the old practice of chair-caning by women. In the past, the wives of furniture-makers caned because it was similar to weaving, a craft practiced by women. More recently, a diminishing cadre of old men have been doing most of the caning. With a great deal of persuasion, Saidi trained about six young women, who worked modestly swathed in their buibuis (figure 8). He also had

Figure 7. Nineteenth century nobleman's chair in a private house, Lamu, 1991. Photo by S. Kasfir.

at least six male apprentices learning joinery and woodcarving, most of whom planned to set up their own businesses in Lamu, in Mombasa, or in Dar es Salaam. Like most Lamu men, these artisans were avid soccer fans and their musical tastes ranged from a Mombasa-based *oud* player to Bob Marley. Saidi had an extensive tape and video collection in his home above his workshop on Lamu's main street, where he lived with his wife and four children—the oldest of whom was in secondary school in the early 1990s when he simultaneously began his apprenticeship.

Into the Global Mix

The most self-consciously modern local inhabitants in both Mombasa and Lamu are the young men involved in entrepreneurial tour guiding. These are the so-called "beach boys" who solicit tourist business in face-to-face encounters. Along

Figure 8. Young veiled Swahili woman caning a chair, furniture workshop, Lamu, 1991. Photo by S. Kasfir.

the coast north and south of Mombasa, a few are Swahili and other coastal ethnic groups. In Lamu they are mainly from nonpatrician Swahili families. Their personal styles vary. Some wear polo shirts, well-pressed slacks, and penny loafers, while others dress like California surfers, and still others adopt a dreadlocked Rasta look. But they all speak good English and have smatterings of German and Italian. All purport to offer the visitor a personal experience of the authentic Swahili culture.

In Lamu this experience typically means a walking and shopping tour of the town to purchase silversmiths' earrings and small carved signs that say *Karibu* and *Jambo sana*. They end the tour by bringing the tourist home to enjoy a real Swahili family meal. The pièce de résistance is an all-day combination dhow trip, fishing excursion, and beach cookout. For adventurous tourists it could even include sleeping on the beach afterward.

Mark Horton and John Middleton (2000:197–198) reserve their deepest scorn for such persons and the "culturally illiterate foreigners" who patronize them, referring to mass tourism as "the most threatening of all late twentieth-century forms of globalization." Judith Schlehe (2001a, 2001b) has a rather different view. As an anthropologist she sees these tourist-beach boy liaisons in Indonesia (particularly the older woman tourist and younger local man) as "globalization from below"—an opportunity for the vector of globalization to work in a reverse direc-

tion for the benefit of the poor local through his partnership with the much wealthier tourist. In both Kenya and Bali the guide frequently uses the tourist's financial support to begin a small tourist-related business that develops out of some initial romantic involvement.

I prefer to see the beach boys within a longer historical time frame. As an emergent, and in some ways postmodern, Swahili coast subclass, they are following in a long-established pattern of Swahili mercantilism. To better their standing and renegotiate identity they enter into exchanges with foreigners. What makes these encounters different from those of the past is only the fact that this time the sought-after commodity is the encounter itself and the economic benefits that may emerge from subsequent patronage.

Some cultural theorists would surely argue that the combination of globalized travel

Figure 9. Swahili furniture workshop apprentice cutting design into wood, Lamu, 1991. Photo by S. Kasfir.

and our concurrent everyday experience of a virtual world through technology compels us to accept that for most Westerners, the "map" now replaces the "territory" it once stood for (cf. Baudrillard 1983). In such a case, the claim that beach boys are ignorant representatives of Swahili civilization is largely reduced to curmudgeonly grumbling. Or, following a more strictly ethnographic turn, we could note that just as there are many kinds of people who choose to self-identify as Swahili, there are many kinds of tourists as well. Frederick Errington and Deborah Gewertz (1989) noted that for Oceania a distinction between tourists (in the sense of typical cruise-ship clients) and travelers (in the sense of authenticity seekers) is important for discussions of what tourists want from a destination. Each category can also be broken down further to include the so-called post-tourists, as an extension of the former, and adventure tourists, trekkers, or eco-tourists as a variation on the latter.

The same is true in Africa, where there is not much in common between the singles or couples on the beach hotel package tour and the young backpackers who wind up traveling north on the Turkana Bus or at places like Lamu, which for a time in the 1980s became the African version of Katmandu. But in my experience it simply is not the case that most tourists in East Africa are "culturally illiterate." For every package holiday tourist looking only for a mild sexual adventure and a tan, there is another looking for the real (or "disappearing") Africa. As in Papua New Guinea (Errington and Gewertz 1989), this second group keeps detailed diaries and competes to see who can get to the most out-of-the-way places and find the most authentic artifacts at the lowest prices. Older and wealthier tourists are less concerned about authenticity, but care more about comfort than the moral superiority that comes from enduring hardships on the tour. But this concern for comfort does not mean they pay no attention to where they are. (In this respect safari clients, who are usually both well-off and well-educated, differ as a group from beach hotel tourists.)

It is, however, the case that both tourists and travelers of all ages and wealth are apt to succumb to the perennial East African stereotyped expectations, whether of orientalism or glorious, ochred, and spear-carrying warriorhood. Since neither the Swahili (other than beach boys) nor the Samburu-Maasai are very forthcoming about their private lives to strangers, such stereotypes remain undisturbed. It is one of the perennial ironies of tourism that the firm resistance to modernity that both stereotypes imply can only be experienced by the spectator with the help of such modern underpinnings as long-distance air travel, air-conditioned hotels, and cultural brokers ready to bridge the gaps.

Conclusion

I began with the intention of looking at recent Swahili coast tourism in the light of its mercantile past, as a familiar lens through which we might view the local points of engagement. Two strands of this interaction directly involve the Swahili: (1) the support of Lamu furniture-making workshops by five-star hotels as part of an orientalizing strategy meant to turn the Swahili coast into a distinctive destination in global competition with other beach resorts and (2) the young male entrepreneurs ("beach boys") who offer themselves as tour guides. The important point here is that the cultural mediations are being achieved from two directions: European-owned hotels and a younger generation of Swahili entrepreneurs. Neither group possesses more than superficial cultural knowledge, thereby ensuring that Swahili culture remains resistant to penetration by strangers despite the permeability of its landscape.

Further, these cultural mediations produce different sets of aesthetic criteria. On the one hand, the hotels need "modern" furnishings, but want them to have a

sense of the coast about them. They do not want to look like the Lamu House Museum, so they prefer furniture with just the recognition of "traditional" shape, technique, and material. Beach boys, on the other hand, are a part of "modern" coast life. Their cultural mediations work in the opposite direction. They make the tourist aware that Swahili culture is not all dhows and buibuis, or that underneath the buibui there may be a T-shirt with a risqué logo. Certain constituencies, both traditionalists and those with purist sensibilities, will inevitably find these aesthetic changes loathsome. But they stand as evidence that both Lamu and the beaches around Mombasa are more than UNESCO-designated historic landmarks. For better or worse, they are in the global flow.

The enclave of Maasai and Samburu warriors at the coast presents a different scenario. Their response to drought and their resulting need for tourist dollars offers other insights into how a sense of cultural superiority—not unlike that of the Swahili—can shield a community from exposure to an overeager tourist gaze. The Samburu case also makes it clear that the traveler's pursuit of an authentic cultural experience unspoiled by modernity, as well as the pursuit of sun and unscripted fun, both focus on embodied practices as much as on things. The body itself—young, beautiful, and on public display—becomes a sought-after artifact and its possession is enabled through either temporary, sexual liaisons or is captured through photography. By the same token, bodily practice can be made accessible through its weaponry or ornaments, both of which may be purchased as souvenirs.

These points of contact establish the tourist experience vis-à-vis the Samburu warrior as a form of collecting. Such collecting may be once removed when the miniaturized tourist spear replaces the real one, or even twice removed when the photograph of the spear-carrying warrior replaces the artifact altogether. Each represent the original artifact, either the real spear or the real warrior. These simulacra still provide the documentation that the tourist experience requires: "I was there. I saw him, looking like this."

But as in the Swahili case, the lack of knowledge of what meanings these "documents" may hold in a Samburu warrior's life ensures that the tourist or traveler can only fall back on the cultural stereotypes available in tourist brochures and photographic essays. Everyone is satisfied. The tourist comes away with memorable souvenirs of the encounter, the beach hotel draws customers, and the Samburu are able to keep their cultural knowledge to themselves. Globalization, as Clifford Geertz (2000:254–255) observed, shutting off all but a few dimensions of interaction, produces situations in which a "working misunderstanding" becomes a kind of best-case scenario.

Questions for Discussion

1. Kasfir argues that East Africans have been engaged with the wider world for centuries and that many of these interactions involved objects. What kinds

of interactions is she talking about? How are they similar and different from international tourism today?

2. In this article we see examples of tourists interacting with Africans from the Maasai tribe and with Swahili people on the Kenyan coast. How are tourists' interactions different in each of these cases?

3. Who are the key players in shaping what tourists understand about their interactions with Africans in Kenya? How do they shape tourist understandings?

Acknowledgements

This article was adapted from a paper originally published as "Tourist Aesthetics in the Global Flow: Orientalism and 'Warrior Theatre' on the Swahili Coast," *Visual Anthropology* 17(3–4):319–343, 2004, special issue: Confronting World Art, ed. Eric Venbrux and Pamela Rosi.

References

Appadurai, Arjun. 1988. "Putting Hierarchy in its Place." *Cultural Anthropology* 3(1):37–50.

Baudrillard, Jean. 1983. "The Precession of Simulacra," in *Simulations*, trans. Paul Foss, Paul Patton, and Philip Beitchman. New York: Semiotext(e).

Bruner, Edward M. 2001. "The Maasai and the Lion King: Authenticity, Nationalism, and Globalization in African Tourism." *American Ethnologist* 28(4):881–908.

Bruner, Edward M. and Barbara Kirshenblatt-Gimblett. 1994. "Maasai on the Lawn: Tourist Realism in East Africa." *Cultural Anthropology* 9(2):435–470.

Errington, Frederick and Deborah Gewertz. 1989. "Tourism and Anthropology in a Post-Modern World." *Oceania* 60:37–54

Geertz, Clifford. 2000. *Available Light*. Princeton: Princeton University Press.

Gewertz, Deborah B. and Frederick K. Errington. 1991. *Twisted Histories, Altered Contexts: Representing the Chambri in the World System*. Cambridge: Cambridge University Press.

Horton, Mark and John Middleton. 2000. *The Swahili: The Social Landscape of a Mercantile Society*. Oxford: Blackwell Publishers.

Huntingford, G. W. B. 1980. *The Periplus of the Erythrean Sea*. Second Series, No. 151. London: Hakluyt Society.

Kasfir, Sidney Littlefield. 1992. "African Art and Authenticity: A Text with a Shadow." *African Arts* 25(2):41–53, 96–97.

———. 1999. "Samburu Souvenirs: Representations of a Land in Amber," in *Unpacking Culture: Art and Commodity in Colonial and Postcolonial Worlds*, ed. Ruth B. Phillips and Christopher B. Steiner, pp. 67–83, 359–360. Berkeley: University of California Press.

Miller, Charles. 1971. *The Lunatic Express: An Entertainment in Imperialism*. New York: Macmillan.

Paramount Studio. 1996. *The Ghost and the Darkness*. Directed by Stephen Hopkins. DVD released 2002.

Phillips, Ruth B. and Christopher B. Steiner, eds. 1999. *Unpacking Culture: Art and Commodity in Colonial and Postcolonial Worlds*. Berkeley: University of California Press.

Schlehe, Judith. 2001a. Income Opportunities in Tourist Contact Zones: Street Guides and Travelers. Paper presented at the Third EUROSEAS Conference, London, September.

———. 2001b. "Street Guides und Beachboys in Indonesien: Gigolos oder Kleinunternehmer?" *Beiträge zur feministischen Theorie und Praxis* 58:127–137.

Steiner, Christopher B. 1994. *African Art in Transit.* Cambridge: Cambridge University Press.

———. 1999. "Authenticity, Repetition, and the Aesthetics of Seriality: The Work of Tourist Art in the Age of Mechanical Reproduction," in *Unpacking Culture: Art and Commodity in Colonial and Postcolonial Worlds,* ed. Ruth B. Phillips and Christopher B. Steiner, pp. 87–103. Berkeley: University of California Press.

Swartz, Marc J. 1991. *The Way the World Is: Cultural Processes and Social Relations among the Mombasa Swahili.* Berkeley: University of California Press.

• • • • • • • • • *Section Three* • •

Creating
New Traditions in
Contemporary Art

*M*any factors help shape traditions in contemporary art. The two articles in this section focus on the creation of new traditions, considering how other actors—besides the artist—or cultural brokers in their respective art worlds help to shape the traditions of weavings and cloth paintings for external consumption. Sharon W. Tiffany analyzes the meanings attached to woven Zapotec rugs by various intermediaries' narratives as these objects make their way along their cross-cultural trajectories from Mexican producers to U.S. consumers. Helle Bundgaard addresses the competing art worlds of elite art specialists and low-caste painters of miniature, cloth paintings called *patta chitra* in coastal Orissa, India. Lower status painters are concerned with the practice, which contrasts with the religious and text-oriented concerns of self-appointed, literate supervisors of the art tradition.

In article 6, Tiffany deals with narratives about Zapotec textile art to potential consumers in North America. (These may be compared to the backstage negotiations of contemporary Papua New Guinea textile artist Wendy Choulai in article 10.) In this public arena, Tiffany explores the ways that Zapotec carpets, particularly those woven by her host family in the Oaxaca village of Teotitlán del Valle, move across geopolitical, social, and cultural boundaries as commodities in a postindustrial consumer society. She proposes that these textiles should be regarded as texts because en route to market destinations they accumulate various "stories" that speak to their aesthetics, repertoire of designs, and attributes of authenticity. For example, they are hand-loomed, colored, and processed with natural dyes, and are individually designed by a native artist. Because these narratives are fabricated in this way by artisans, vendors, consumers, and cultural brokers, the narratives contribute to how a Zapotec textile's value is negotiated as both art and craft, thereby distinguishing its quality from "knock-off" mass-manufactured products.

Particularly instructive is Tiffany's account of her own role in brokering Zapotec carpets as "fine" art when she learned to craft repertoires of stories to accommodate the interests and attention span of her various audiences. Tiffany observed—as does Carol Hermer in article 16—that people construct their own ideas of what art objects mean to them. With Zapotec textiles, consumers, who are mostly women, often fashion their own narratives of embodied experiences associated with the carpets they own. Framed in a New Age discourse of spirituality and nostalgia for earth-connectedness, women frequently described their Zapotec weavings to Tiffany as having "positive energy," "power," or simply "aura." With such qualities, it made sense that women often used their rugs as yoga mats for meditation and achieving desired harmony of mind. But as Zapotec weavers know from long experience, consumer tastes come and go inexplicably. Consequently, in the highly competitive market for handcrafted goods, weavers must continually keep ahead of the game of gauging consumer tastes and offering them new desir-

able products. Yet, as Tiffany also argues, Zapotec textiles have more than economic worth to Zapotec weavers; they are also expressions of individual creativity and ethnic identity.

In article 7, Helle Bundgaard makes the case for a more nuanced understanding of what an art world is. Rather than taking it as a monolithic concept, she argues it is better to speak of "art-worlds," that is, in the plural form. Bundgaard's example concerns the aesthetic values that come into play with regard to the cloth paintings known as patta chitra. She shows that what may be conceived of erroneously as a *singular* art world in fact has several cultural subdivisions. Most notably she distinguishes between a literate elite claiming expert knowledge of the art tradition and the low-caste painters, whose actual practices and pragmatic concerns the elite remain largely unaware. What is true for the Orissan patta chitra art world must certainly be true for art worlds of a larger scale, including those like Tiffany's that spans large parts of the globe. In other words, all art worlds, regardless of scale, may include a diversity of opinions and judgments.

In her discussion of the concept of an art world, Bundgaard makes clear that art worlds—for lack of objective criteria—have the power to define whether something is judged real art or not. Thus, it matters who is entitled to speak on behalf of a particular art world. Bundgaard acknowledges the power relations within art worlds, which seem to give the institutionally supported arts specialists a decisive say. But she also notices that these specialist interpreters do not necessarily have "absolute discursive authority" because the artists themselves may disagree and take another view.

The assessments of the painters, in the case of patta chitra, indeed differ considerably from those of the intellectuals that form the regional art elite. The artists are mainly concerned with the skilful execution of the paintings, the practice of art itself. Furthermore, they tend to be pragmatic in their response to the demands of consumers (e.g., in making stylistic changes) because the paintings are their way of earning an income. The formation of a Crafts Council in the 1980s, in addition to national prizes, gave the elite an opportunity to put their mark on what they saw as retaining "authentic" arts and crafts. Their "policing of standards," to borrow Nick Stanley's phrase (article 15), was based on the unfounded assumption (reminiscent of Herder and the Grimm Brothers in nineteenth century Germany) that survivals of an ancient and distinctively Indian painting tradition connected with Sanskrit scriptures could still be found in rural areas. This connection with religious texts did not exist for the illiterate painters. But some of the painters, who felt they had to live up to the demands of elitists' cultural activism, were prepared to accept the suggestion nevertheless. Bundgaard gives an example of one prize-winning painter who placed himself in the invented "sketchbook tradition." As she discusses, this man's collection of religious texts was little more than a showpiece for upholding the authenticity of the imagery he used in his painting. The practitioners' understanding of patta chitra art remained a world apart from that of the self-proclaimed connoisseurs.

6

"Frame that Rug!"
Narratives of Zapotec Textiles as Art and Ethnic Commodity in the Global Marketplace

Sharon W. Tiffany

apotec weavers in the village of Teotitlán del Valle in the Oaxaca Valley of southern Mexico are no strangers to the cultural politics of representing themselves and their textiles for local, regional, and international markets. Completion of the Pan American Highway in the late 1940s marked the beginning of expanded opportunities for this cottage industry. By the 1960s and 1970s, most village families relied on weaving as a primary source of household income. This shift in domestic economic strategy was, in part, a response to increased tourism and an international demand for handcrafted commodities. Since the 1990s, women's textile production, particularly the work of weaving on the free-standing wooden treadle loom, has assumed greater economic importance as transnational husbands, brothers, sons, and to a lesser extent, daughters, circulate in and out of village households as migratory workers (Stephen and Barco 1991; Stephen 1993; Ziff and Stevens 1994; Grimes 1998; Cohen 2001).

This article explores representations of Zapotec textiles as texts and as negotiated sites of contested values and meanings. My discussion follows the movement of these textiles as border-crossers to ask how these objects take on diverse meanings along their complex journey from Mexican weaver to North American consumer. Transnational artisans, like their crafted goods, circulate among symbolic, cultural, and political domains. Moreover, border crossing transforms the indigenous migrant as well as the indigenous commodity. The textile on the loom in a village household is different from the craft object displayed in a store in Tijuana or in the United States. The textile as tourist art in postindustrial consumer culture, in turn, differs from the unique possession that decorates the floor or wall of a cus-

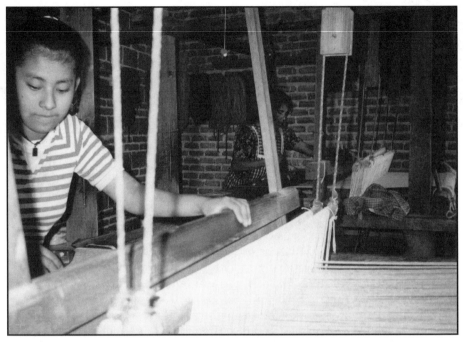

Figure 1. A mother and her teenage daughter weave together at home, 1998. Photo by Sharon W. Tiffany.

tomer's home. Embedded in the social relations of production and consumption, as indigenous commodities Zapotec textiles thus constitute "multisited" texts of contested narratives, each representing different sites and perspectives.

In the discussion that follows, I explore these textiles as a source of information. I consider how they comprise a self-contained nexus of meanings, symbols, and visual understandings. Brian Spooner's (1986:198) analysis of Turkmen Oriental carpets highlights the crucial role of information that travels across cultural boundaries with a similar group of handcrafted goods:

> The carpet business involves not just the supply of carpets, as in the case of other commodities, but also the supply of information about them. . . . The information . . . suffers reinterpretation with each transaction. The dealer's interest is primarily economic. The lore he acquires with his wares is often purveyed incidentally. On the other hand, the connoisseur, who is the public arbiter of authenticity scarcely controls the sources of the information on which he bases his judgment.

Following Spooner, I suggest that additional narratives provided by artisans, vendors, consumers, collectors, and academics, among others, may also accompany an Oriental carpet or Zapotec textile as it moves across social and cultural boundaries.

Representing Zapotec Textiles

The story of Zapotec textiles begins at the site of production in Teotitlán del Valle, an indigenous village of some 5,000 residents. Conveniently located about 26 kilometers south of the state capital of Oaxaca City, the village is just four kilometers off the Oaxaca-Mitla tourist route of the Pan American Highway. Advantageously situated as a tourist attraction for both groups and independent travelers, Teotitecos (residents of Teotitlán del Valle) are cited in guidebooks as artisans famous for their "beautiful rugs" (e.g., Noble et al. 2002:774–775; Baird and Bairstow 2003:440).

Other tourist attractions in the village, in addition to the textile stores that line the main street, include the outdoor textile market and a well maintained museum that displays a few pre-Hispanic artifacts discovered in the area. Most of the museum space is given over to life-size dioramas of local textile production reminiscent of the ethnological section in Mexico City's National Museum of Anthropology. Nearby is Teotitlán's elegant, eighteenth-century Spanish colonial church, built with stones from the pre-Hispanic site on which the current structure now stands.

Upon entering a weaver's home, the visitor may observe a completed textile cut from the loom by its warp threads. The weaving is then dampened and brushed to remove lint and dust, and its warp selvages finished by either rolling or by braiding them between the palms of the hands and knotted. The weaving is then carefully folded and wrapped in heavy-duty plastic for its journey to a site of consumption near to or across the border. A government-issued *carta-factura* (factory invoice) enables the independent artisan (or exporter) to ship handmade Mexican textiles duty-free to the United States and Canada under provisions of the 1994 North American Free Trade Agreement (NAFTA). The treaty, which provides for the phasing out of protective tariffs among the three signatory countries, instigated the Zapatista rebellion in Oaxaca's southern neighbor state of Chiapas on January 1, 1994, the day that NAFTA formally went into effect (Collier and Quaratiello 1999).

Once it crosses the border, the textile begins its transformation into the "ideal craft object"—a product that "is arguably authentic, precisely the right balance of the understandable and the palatably mysterious, and of course, attractive" (Goertzen 2001:242). Part of the transformative process of the craft object is its mediations in a nexus of unequal exchange relations with traders, vendors, curators, tourists, anthropologists, and others (Graburn 1976, 1999). One aspect of the buyer-seller transaction is the anthropologist's role in "brokering crafts" (Causey 2000:168). This role involves processing and supplying information about indigenous, handmade weavings as authentic crafted goods to prospective Euro-American storeowners and consumers who are unfamiliar with Mexico's varied textile traditions.

Representing Authenticity in the Global Market

"Appropriation" and "commodification," key words in the postmodern vocabulary of art and anthropology, pose contentious issues about three other terms in this anthropological subfield: "authenticity," "art," and "craft." Objects produced by Cultural Others are consigned to categories of "art," "tourist art," "crafts," or sentimentalized "kitsch" according to Western constructions of aesthetic values. Today, however, the hierarchy of boundaries between artifact and art are in the process of deconstruction simultaneously in the work of indigenous groups and artists of the periphery and by the forces of postindustrial consumer demand for exotic commodities (Nash 1993; Phillips 1995; Phillips and Steiner 1999).

Postmodern analyses suggest the multiplicity of cultural traditions, authenticities, narratives, and markets constitute commercial exchanges between artists and buyers in the "global cultural ecumene" (Appadurai and Breckenridge 1988; Hart 1995; Marcus and Myers 1995). Much of the literature on these issues has focused on cultural constructions of Native American and Middle American craft objects and places. These cultural constructions include mutual appropriations of indigenous designs by other ethnic groups, as well as by members of consumer cultures (e.g., Howes 1996; Mullin 2001; M'Closkey 2002).

Zapotecs, like the Hopi discussed in Zena Pearlstone's (2001) provocative work on *katsinas*, have also been objects of the Euro-American gaze for the last 500 years. Alert to new ideas and changing consumer tastes, Zapotec, Native American, and Otavalo artisans (among New World indigenous peoples) have "transgressed cultural boundaries" by engaging in "reciprocal appropriations" (Berlo 1991:449–453) from numerous sources (Wade 1985; Meisch 2002; Wood 2003). I suggest that Janet Berlo's (1991) use of the term "appropriation" may be seen in the context of the Oxford English Dictionary (1989) definition: "To take possession of for one's own, to take to oneself" (see also Clifford 1988:221). Similarly, in their study of Hispanic Chimayó weaving in northern New Mexico, Helen Lucero and Suzanne Baizerman (1999:ix) argue that a "weaving tradition is an open-ended phenomenon, a renewable resource, a reflection of its changing social context." In short, the processes of artistic borrowing, adapting, and integrating elements from other weaving traditions is both complex and reciprocal (see Wood 2001b). "Appropriation," in the context of Zapotec and Native American weaving traditions, is not simply an "add-on"; it has a long and vibrant history.

Zapotec textile tradition adapts and incorporates ideas and designs from many sources: Mesoamerican motifs, carvings, and paintings; Native American designs; and Spanish colonial motifs. Contemporary "landscapes" (*paisajes*), or depictions of rural village life, are popular and difficult to weave well. These textiles may be woven imitations or creatively inventive versions of works by artists associated with the Western world of "high art," including Matisse, Miró, Picasso, and Escher, among others. These depictions, which take great skill, are typically woven for foreign con-

sumers. The Zapotec weavers who create these textiles typically have no idea who Escher or Picasso are and evince little curiosity about these Western artists.

Paintings of indigenous peoples by the Mexican muralist Diego Rivera have been mainstays of Teotiteco pictorial textiles for decades. Recently, the cultural commodification of Mexican painter Frida Kahlo as "cult heroine" (Lindauer 1999) has been visually depicted in Zapotec weavings. Rivera's paintings of Kahlo, in addition to Kahlo's well-known self-portraits, are inspirations for exceptionally talented Zapotec weavers who specialize in complex pictorials.

Anthropologists and art historians remind us that the exchange of fibers, cloth, materials, and designs among different cultural groups is as old as

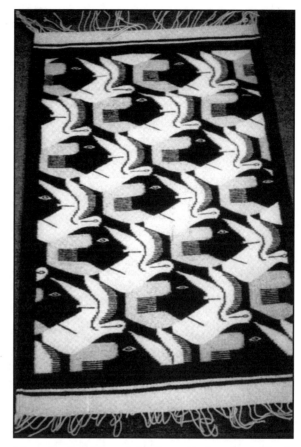

Figure 2. A "fish and bird" textile based on M. C. Escher's drawing, 29 inches by 45 inches. Photo by Sharon W. Tiffany.

human history (Clifford 1988:189–214; Berlo 1991:449–479; McCafferty and McCafferty 1994; Anawalt 2000:205–216). Today, however, the identity politics of representing indigenous craft objects has shifted from local, interethnic appropriations and discourses to the international marketplace. Like their Native American counterparts, Zapotec weavers are confronted with the economic challenges of the mass market assimilation of indigenous motifs, as well as contentious issues of authenticity and cultural property (Stephen 1991b; Cohen 1998; Wood 2001a; M'Closkey 2002).

The production, circulation, and exchange of objects as "knockoff" textiles (a form of generic, mass market art) has flooded postindustrial cultures of consumption. Foreign distributors contract piecework to Mexican, Hispanic, or South Asian weav-

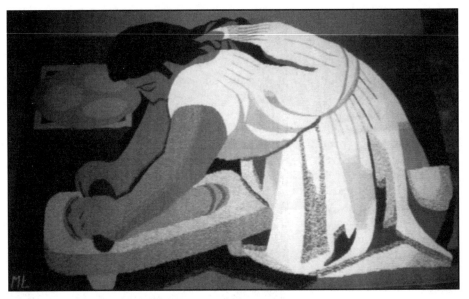

Figure 3. La Molinera (Indian Woman Grinding Corn), based on Diego Rivera's painting, 41 inches by 55 inches. Photo by Sharon W. Tiffany.

ers who replicate or rework indigenous New World motifs, often with differing combinations of colors and fibers (Stephen 1993:41–51; Wood 2000a, 2000b; M'Closkey 2002:192–204). The generic art market produces a plethora of machine-woven and handcrafted products that vaguely resemble Native American, Southwest, and New World motifs. These goods include handbags, backpacks, pillow covers, table runners, dining table place mats, coasters, blankets, rugs, jewelry, and clothing. Moreover, indigenous weavers, "as active agents of their own artistic styles" (Berlo 1991:453), may subsequently "reappropriate" generic art motifs or goods and incorporate them into their repertoires. Table runners and place mats in muted, desert tones have been in high demand for the past several years. Weavers say that these items sell well during economic slumps because they are smaller, less expensive, and functional.

As James Clifford (1988:235–236) notes, "Art collecting and culture collecting now take place within a changing field of counterdiscourses, syncretisms, and reappropriations originating both outside and inside 'the West.'" For example, I may purchase "Zapotec" car floor mats with *grecas* (geometric, or "stepped fret" motifs) from the Minnesota Public Radio's Wireless Holiday mail-order catalog in order to "bring a touch of class into my car and brighten my commute." I may clean my reading glasses with Kleenex™ Expressions™ tissues packaged in the "Old West" style "inspired by the beautiful colors and intricate patterns of blankets woven by Native Americans." Or, I may choose the generic "Zapotec" style wallpaper option

provided by the Microsoft Windows XP system on my computer. According to an in-flight magazine called *American Way,* my consumption options also include shopping for Zapotec textiles and other "exotic products" on the Web: "From Andean alpaca sweaters to Kashmir rugs, a few clicks of the mouse bring it all to you." Offering convenience and speed, collecting culture at a distance is an ideal shopping solution for the busy, postmodern consumer.

Zapotec Textiles in the Culture of Production

In the summer of 1997, I arranged to stay in the modest home of an independent weaving family in Teotitlán del Valle. I had met Antonia and her husband, Luís, six months earlier in the main plaza (*zócalo*) of Oaxaca City, where they had rented vending space to sell their textiles and brightly painted, handcarved wood figures (*alebrijes*) accepted on consignment from other indigenous producers in the Oaxaca Valley (see Chibnik 2003).

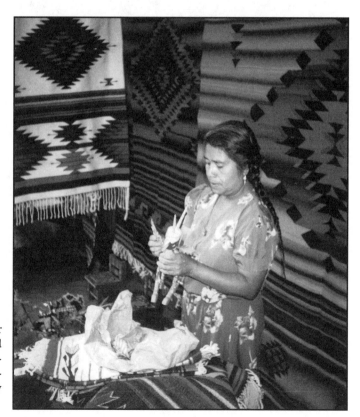

Figure 4. A vendor sets up *alebrijes* (wood carvings) at her textile stall, Oaxaca market, 1998. Photo by Sharon W. Tiffany.

Antonia and her husband lived near the separate households of Luís's two married brothers and three married sisters. Luís, unlike his two brothers, did not have a history of circular migration to the United States. Luís's mother, a widow in her early sixties, continued to weave in order to "stay busy" and assist with household expenses and chores in her youngest son's household. An elderly widowed "aunt" (*tía*), related to Luís's deceased father, lived nearby in a separate household with her son, daughter-in-law, and two young grandchildren. I often awoke to the sound of the older woman's loom at the first light of dawn.

My research on women's work histories quickly drew me into the domestic world of textile production. My ignorance of the basics of weaving was so profound that I did not know the difference between warp and woof threads. During

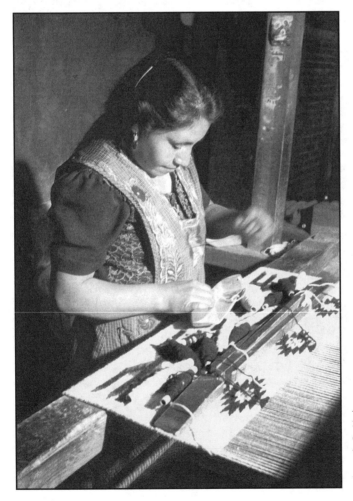

Figure 5. This Teotiteco mother of four young children weaves only when time permits, 1999. Photo by Sharon W. Tiffany.

subsequent research trips, I regularly visited fourteen different village households linked to Antonia and Luís by a variety of familial and ritual-kinship connections. I enjoyed talking to various household members as they wove, carded, spun thread, and processed vegetal (plant derived) or synthetic (aniline) dyes. While I observed families at work, or accompanied them to the mountains to collect bark, nuts, leaves, and firewood, I asked hundreds of questions about looms, weaving techniques, color processing, design, sources of inspiration, pricing, and vending. I made a few efforts to use the treadle loom, primarily to get the "feel" of what it was like to operate such equipment while standing on wood pedals and shifting my weight from one leg to the other. I also noted the potential for back and neck strain—problems weavers commonly mention after working at the loom for extended periods.

Textiles as Art and Ethnic Commodity

During the course of my field trips to the village and regional markets, I purchased several Zapotec textiles for research purposes. Eventually, I accepted a dozen pieces from Teotiteco weavers in order to place them on consignment with U.S. storeowners with interests in indigenous crafts and "fair trade" issues. This decision expanded my role as ethnographer to include that of activist and culture-broker among artisans, vendors, and clients. In other words, I was now engaged in the cultural production of knowledge about Zapotec textiles and a mediator of representations about indigenous lifeways and commodity production.

During my first sequence of fieldwork visits to Teotitlán del Valle, I had not concerned myself with the problematics of whether the Zapotec weavings that I placed in U.S. stores were tourist art, folk art, ethnic commodities, indigenous crafts, kitsch, or fine art. Indeed, I saw no reason to impose labels on these goods. As an anthropologist, I viewed such categories as Eurocentric constructions that served "gatekeeping" functions within academic, art, or collecting circles.

Today, Zapotec weavings are notable for their absence in major museum collections of textiles in the United States. They occupy a liminal zone within the periphery of the "minor arts," otherwise known as "crafts" (Kinzer 2003:B5). The director of the National Ornamental Metal Museum in Memphis, Tennessee, pungently pronounced that crafts are "the bastard child left out on the street corner."

Yet, in my experience, the marginalization of Zapotec textiles in the Western art world has little relevance to the everyday lives of the people who produce these commodities. What I *did* know was that individual weavers entrusted me with their work in order to expand their networks of distribution. They wanted to sell their textiles at prices that they themselves considered "fair" (*justo*).

Most of my village informants were independent weavers, rather than merchant-distributors or contract weavers who work on a piecework or "putting-out"

system (Cook 1993; Wood 2000a). Independent weaving households have sufficient capital to purchase factory-produced or hand-processed wool. They also have the skills and experience for producing their own color combinations. Some independent households specialize in using only vegetal dyes, others create unique color "recipes" that utilize various combinations of aniline and vegetal dyes (see also Ross 1986; Turok 1996; Forcey 1999).

During the last two to three decades, independent Teotiteco weavers have relied on direct sales to tourists and merchant-distributors. They have supplemented their household income with migratory work. The gradual decline in direct sales, a trend that according to some scholars (Cook and Binford 1990:87) began as early as the 1970s, however, has forced independent weavers to seek work outside the village for longer periods. Some artisans have even forged business connections with foreign or local distributors and/or storeowners as outlets for their goods. Other independent weavers occasionally accept piece-work contracts to supplement household income, but only as a last resort because of the low pay for outsourced textiles.

Weavers are keenly aware of local and global economic uncertainties. I talked with informants about their struggle to maintain a craft tradition in the global context of a "saturated market," the "boom and bust" times of the 1980s and 1990s, the events of September 11, 2001, and the 2003 Iraq War, as well as the changing nature of tourism in the Oaxaca Valley. These independent artisans, mainly men, had histories of frequent border crossing in search of wage

Figure 6. A weaver color processes her wool purchased from the village factory, Teotitlán del Valle, 1998. Photo by Sharon W. Tiffany.

work. My friends told me that only "*los ricos*" ("rich people," i.e., merchants and distributors) could make a full-time living from rugs—but not by weaving them.

Parents want their children to learn how to weave, but they also want them to receive as much formal education as possible. Many parents are veterans of circular migration between the village, Tijuana, and the United States. Above all, they want their children to learn English. As one of my informants, a man in his mid-thirties, noted, "My [seven-year-old] son is Zapotec and he must learn to weave. It is something he can experience. But who knows about the future?" Weaving clearly has a value beyond domestic production of a saleable commodity. As informants emphasized, "Weaving is what we, as Zapotecos, do. It is part of our tradition." For most Teotitecos, the linkage between weaving and ethnic identity is an important mode of representing their "Difference" to outsiders. The cultural production of indigenous identity is played out in many areas of social life for villagers (see Stephen 1991a, 1991c). Ethnic identity is, among other things, an important marketing strategy. Being Zapotec conveys a message of authenticity about weavers and their goods to potential clients.

Reading Zapotec Textiles

The topic of an indigenous Zapotec aesthetic is a complicated one for many of my weaver informants. Some have a vocabulary for assigning meanings to designs, but many appear not to have given this topic much thought until I attempted to elicit responses from them. A few weavers (only men)—in their modest, almost self-effacing way—spoke to me about technique and their experience in creating specialty textiles.

Two of my male informants (both in their early forties) seemed surprised, yet pleased, when I called them *artistas* (artists) rather than *artesanos* (artisans). Indeed, I have never heard a Teotiteco weaver use the word "artist" to refer to him- or herself or to other weavers. In this particular instance, both weavers work almost exclusively on producing exceptional pieces (usually commissioned). Other family members produce what are commonly referred to as "standard" or "commercial" textiles for household income.

Teotiteco weavers willingly admit that they do not understand why some textiles sell well and others do not. They do recognize, however, that foreign tastes quickly change. For most weavers, a textile that sells is a "good" one. Textiles of similar size, design, and range of colors will be produced; but they will not be replicated given the vagaries of hand-processed dyes, the quality and color tones of undyed wool, and whether the wool is machine- or hand-carded. In short, there is no guarantee that a similar textile will sell, despite its artistic merit and quality of techniques.

"High-end" pieces are different from "commercial" textiles. Weavers recognize that they invest considerable work and capital in a specialty weaving, and that

they have to be "patient" with respect to the time it may take to sell it. According to informants, it is a matter of either finding a client who understands the creativity needed and the amount of work involved in making a specialty weaving, or waiting for better economic times that will bring tourists back to the Oaxaca Valley.

Occasionally, a weaver produces an extraordinary textile simply because he or she wants to create it. Juliana's 83-year-old father, Gustavo, weaves larger pieces—typically six feet wide by eight feet long—on a loom with three pairs of treadles. Gustavo specializes in "greca" and "*caracol*" (a "bisected" conch shell that shows its labyrinthine interior) motifs. The "caracol" is based on a pre-Hispanic, stone-carved motif that is in the village church (see also Stanton 1999:33–35, plates 6–8).

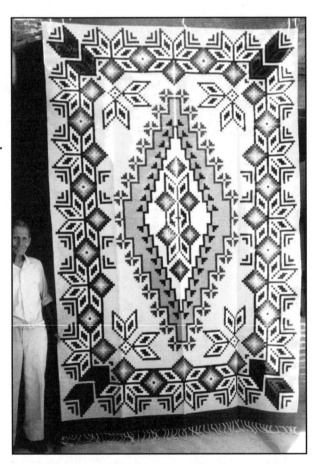

Gustavo, who wove his first textile at the age of ten, works only with hand-carded, natural, undyed warp and weft wool that his wife prepares. In the past, he consigned most of his carpets to his daughter, an excellent weaver-artist in her own right, who sold them for him when she rented stall space in the main plaza of Oaxaca City during holidays. There she displayed her own textiles, those produced by her father and brother, as well as the work of her husband and two teenaged daughters. One of Gustavo's masterpieces is now part of my research collection.

Many weavers keep books or catalogs of Southwestern and Zapotec textiles as sources of ideas. Weavers also treasure photographs of carpets that they themselves have made.

Figure 7. An elderly Teotiteco weaver displays his latest work with Zapotec and Native American-inspired motifs, 73 inches by 115 inches, 2002. Photo by Sharon W. Tiffany.

Artisans, or their relatives, typically obtain these valuable reference books and cameras during migratory trips across the border. Some weavers maintain personal notebooks of designs and ideas. Pedro, a contract worker who depends on his brother-in-law for occasional income from piecework, specializes in elaborate reworkings of what textile experts call the "serrated concentric diamond" motif (Sayer 2002:57). This design is also referred to as "el diamante," the Zapotec "sun" (Stanton 1999:42), or "lozenge" (Sayer 2002:60). Pedro has two notebooks filled with color pencil sketches and notes on thread counts for varying sizes of interconnected "diamonds" centered down the middle of his rugs. Pedro's "concentric diamond"

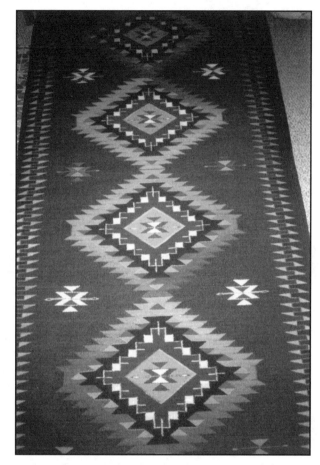

Figure 8. A classic Zapotec "diamond" or "sun" motif, with a "pine tree" border, 38 inches by 81 inches, Teotitlán del Valle, 1997. Photo by Sharon W. Tiffany.

motifs are based in part on the historic "*Saltillo*" style of colonial Mexican textiles—a style that influenced Zapotec, Navaho, and Chimayó textiles (Kent 1985:61–66; Lucero and Baizerman 1999:17–25; Stanton 1999:39–43).

Some enterprising Teotiteco weavers have reintroduced historical motifs, such as the nineteenth-century Saltillo-style *sarape*, which was possibly influenced by Oriental carpet designs introduced by traders to both Zapotecs and Navahos (Jett 1993; Stanton 1999:38–46, plates 11–13; Sayer 2002:54–59). Once the textile is publicly displayed, copies quickly follow. Upon the publication of Andra Fischgrund Stanton's *Zapotec Weavers of Teotitlán* (1999), for example, several textiles based on the book's color plates appeared in the village and regional markets, as well as

in Oaxaca City galleries. A weaver-artist assumes that such replication will take place, but nonetheless takes pride in the quality of color tones, technique, and overall aesthetic effect of an exceptionally well-made textile.

Zapotec Textiles in Cultures of Consumption

My brokering role became more complicated when I agreed to organize gallery exhibits and to make presentations about my fieldwork at three local college campuses. Frequent queries from friends and colleagues about the artisans, weaving techniques, looms, and color processing motivated me to produce a series of simple catalogs containing my annotated fieldwork photos of weavers, their families, and their homes, as well as various stages of textile production. Gallery visitors and lecture audiences in such commodity cultures, of course, are also prospective consumers of handcrafted goods.

My ethnographic experiences with members of a commodity culture and their exotic goods have taught me the importance of knowing one's audience. Euro-American clients want a culturally authentic product *and* an accompanying narrative. Indeed, clients with little or no firsthand knowledge of textiles in general, or of Zapotec textiles in particular, are often hesitant to purchase a weaving without a convincing narrative of indigenous culture as a social marker of the craft object's authenticity. Audiences demand a lively story, preferably with visual aids. They want a story that typically requires the details and insights that only a "professional stranger" with insider knowledge, such as an anthropologist, photographer, writer, or collector, is likely to provide. After some trial and error, I constructed a presentation entitled Zapotec Culture and Weaving for my socially aware and often well-traveled audiences. My longer, ethnographically dense narratives were reserved for colleagues at conferences and university students in lecture halls.

My storytelling repertory includes several topics. Color processing is a favorite subject. I focus on the variety of vegetal materials (bark, leaves, nuts, fruits, and lichen) used to make colorants: the pulp of the indigenous *zapote* fruit for deep brown; bougainvillea flower petals for pink; or the parasitic yellow-orange "vines" (*bejucos*), related to the Morning Glory family, that produce a deep, clear yellow. In addition, I discuss pre-Hispanic uses and trade of cochineal red, which is derived from crushed insect larvae that feed on certain species of cactus, and indigo blue, which is derived from leaves harvested in the Isthmus of Tehuantepec region of Oaxaca state (see also Ross 1986; Turok 1996; Forcey 1999:47–65; Stanton 1999:7–14).

Photographs, slides, transparencies, and videos are important visual accompaniments to my storytelling. Usually, I show pictures of Teotiteco families collecting colorants in the pine-forested, mountain watershed behind the village. Textbook explanations are enlivened with personal anecdotes of "life with a Zapotec fam-

ily"—photographs of dyed skeins of wool drying on a clothes line next to my laundry in a household compound are always popular with an audience.

I draw my ethnographic narratives about a Zapotec aesthetic of color, design, and technique from what weavers themselves tell me. Furthermore, my interpretations of Zapotec expressive forms are grounded by slides of stone-carved, geometrical motifs that grace the walls of pre-Hispanic Zapotec structures at Mitla, Lambityeco, Yagul, and Dainzú (González Licón 1990; Winter 1992).

My narratives about an ancient weaving technology elicit attentive responses from audiences. I describe and show slides of the freestanding treadle loom used in the village. Zapotec weavers use a medieval technology, the horizontal treadle loom, which first appeared in Europe around 1000 CE (Anawalt 1979:177; Sayer 1988:41). I spice up my commentaries with interesting historical tidbits. For example, Archbishop Don Juan López de Zárate is said to have introduced the European treadle loom, carding tools, and sheep to the village sometime between 1536 and 1538 (Stephen 1991a:107; Stanton 1999:31; see also Anawalt 1979). I enjoy talking about the multipurpose functions of a village loom: to store things; to provide a roost for chickens and shade for dogs; to provide a temporary tethering post for a goat.

Western nostalgia for "Difference" within the parameters of the "Familiar" is an important element in marketing handcrafted objects. These stories emphasize representations of the Familiar to a Western audience: a domestic, agrarian, and traditional setting where the indigenous commodity is created. A "good" story also notes the distinctive Otherness of handcrafted Zapotec textiles. In other words, representations of Zapotec textiles as tourist art must be effectively contrasted with mass-produced goods associated with consumer cultures (Graburn 1976:21; Steiner 1999:98–103).

Audiences quickly grow impatient with academic discussions of how Zapotec commodity production and aesthetic expression are connected to domains of authoritative, Eurocentric knowledge systems. They rarely become excited hearing how such authoritative systems of knowledge construct a hierarchy of meanings about indigenous textiles that range from craft to art. And inevitably, the craft-mediator's stories mire in the problematic challenge of representing "Zapotec culture" and weavers' varied narratives about their work to Americans with busy schedules.

Audience expectations may also constrain anthropological narratives of indigenous worlds. For many members of consumer cultures, the appeal of indigenous cultures is likely to be their representations as "imagined communities"—that are timeless, bounded, and homogeneous (Anderson 1991). Thus, Euro-American audiences may not necessarily be receptive to ethnographic narratives of transnational artisans or translocal textiles in the international marketplace. For example, the anthropologist's stories about Teotiteco cross-border experiences may collide with Euro-American assumptions about the lives of weavers. Equally unsettling are stories of Zapotecs flipping burgers in fast-food outlets, bagging groceries, bending

over tomatoes in the fields, and of living with a constant fear of the *migra* (immigration authorities) and police (Chavez 1992). Such narratives are a break with Western assumptions inspired by *National Geographic* images and texts of "traditional" peoples living according to time honored rules of custom in societies untouched by the outside world.

Zapotec Textiles as Embodied Texts

American women frequently express the special feelings they have about Zapotec textiles in their homes. Several informants have told me, for instance, that their carpets emit a "power" or "aura"—something akin to the Polynesian concept of *mana*. Others note that their Zapotec textiles radiate "emotion" or "positive energy." Frequently, a woman will say that her rug's "power" or "energy helps me start the day in a positive way." Others say that a textile "makes me feel energized and ready to take on the world." In short, women's narratives about their Zapotec textiles consistently emphasize bodily and emotional responses.

My informants creatively interpret Zapotec craft objects as embodied texts framed in a New Age vocabulary of spiritualism and nostalgia. For them, possession of a handwoven textile dipped in vegetal dyes symbolizes a connection with earthbound or agrarian cultures. Informants often use their Zapotec weavings as yoga mats for exercises and meditation. The rug-as-yoga-mat is a material representation of the artisan's "rooted" world of tradition—a world lost to socially alienated members of postindustrial consumer cultures. The Zapotec textile represents a postmodern vehicle for achieving a harmony of mind and body, attributed to indigenous lifeways, through meditation or yoga. The client, thus, transforms her possession by inscribing individualized meanings to it. In turn, the textile—perceived by its owner as something greater than a mere commodity in the global marketplace—transforms its possessor.

Women in their fifties and older often claim that their textile "makes a wonderful conversation piece." Phrased in postmodernist vocabulary, the Zapotec textile is a discursive device for facilitating social interactions. A textile's story, revealed through its muted earth tones with Zapotec "mountains and pyramids" and "star" designs, or its vivid hues with the dazzling "Zapotec sun" or "lightning bolt" pattern, reminds the possessor, and others, of her social and spiritual place in the world.

In her research of African tourist art, Bennetta Jules-Rosette (1984:235–236) states that an ethnographic good crafted by an Other assumes different functions and meanings for the buyer:

> Because there are no conventional aesthetic standards for these works, the consumers are hesitant about their quality and are persuaded by secondary explanations presented by middlemen, vendors, and experienced collectors. This

point in the exchange system might be termed the crisis in quality for tourist art. This crisis in quality is magnified when the tourist consumer returns home with a piece for which there is no existing cultural and artistic context.

To assist a client in overcoming this "crisis in quality" for tourist art, the craft-broker affirms the authenticity of the textiles as both indigenous and handcrafted, as aesthetically pleasing, as technically superb, and as unique. This representation of authenticity allows consumers to fashion personalized and meaningful stories about themselves and their craft objects.

Zapotec Textiles and the Stories They Tell

A Zapotec textile has many stories embedded in the threads of its warp and woof. These narratives accumulate varied meanings and representations as the object crosses social and economic borders. Along the way, a history of exchange transactions and multiple mediations is created by weavers, clients, vendors, collectors, curators, academics, and others. As Igor Kopytoff (1986) suggests, with each new set of hands it takes on a new social biography and a new narrative.

These textiles give value to the social relations of production within the household that created them. For Teotitecos, the social and economic act of weaving is linked to ethnicity as well as to relations of kinship and community. Teotiteco weavers further represent the authenticity of their textiles with claims to historical precedence, product quality, artistic creativity, and entrepreneurship. Weavers understand the importance of authenticity as a marketing strategy in the competitive sector of handcrafted goods in the global economy.

A Zapotec textile, like a Navaho or Oriental rug, is an object crafted by the Other and consumed for its difference. Buyers of exotic goods in postindustrial societies invent and reinvent the authenticity of Zapotec textiles to serve their possessors' individualized needs for "self-fashioning" and social display. These creative, personalized readings of a textile enhance its social and emotional value for the owner, who views her Zapotec textile as both art *and* craft.

Textiles possess rich histories of cultural uses: They are "entangled objects" (Thomas 1991), embedded in scripts of ethnicity and identity in a postmodern world. They are exotic, yet familiar commodities produced for an international market. And they are expressions of individual creativity and aesthetic design. Zapotec textile production is part of the political economy of inequality and class divisions at the village, regional, and national levels of Mexican society. As Zapotec migrant workers know all too well, they also document an international economy of inequality. Zapotec textiles are also distinctive commodities linked to the cultural politics of global mass culture, collectibles, marketing strategies, and fickle consumer demand for the "ideal craft object."

Questions for Discussion

1. Why does the author assume the role of "cultural broker," mediating exchange relations between the buyers and sellers of Zapotec textiles, in the context of her professional work as an anthropologist?

2. What are some of the sources of creativity that Zapotec weavers make use of and appropriate in designing their textiles to attract diverse outlets for their work?

3. Why and how have Zapotec textiles become the subject of multiple meanings and varied understandings for Western consumers?

4. What are the qualities that Western consumers desire when purchasing a Zapotec carpet?

5. How do local weavers accommodate changing consumer tastes and global economic uncertainties?

6. What does the author mean by referring to Zapotec textiles as "embodied texts"?

Acknowledgments

I am deeply indebted to the people of Teotitlán del Valle for their generosity, time, and hospitality, which made my research possible. This article is based on ten months of fieldwork conducted during 1998–1999, with shorter, four-month intervals each year between 1996–1997 and 2000–2001. In order to protect the privacy of individual informants, I have used pseudonyms for all personal names.

References

Anawalt, Patricia. 1979. "The Ramifications of Treadle Loom Introduction in 16th Century Mexico," in *Looms and Their Products,* ed. Irene Emery and Patricia Fiske, pp. 170–187. Irene Emery Roundtable on Museum Textiles, 1977 Proceedings. Washington, DC: The Textile Museum.

———. 2000. "Textile Research from the Mesoamerican Perspective," in *Beyond Cloth and Cordage: Archaeological Textile Research in the Americas,* ed. Penelope Ballard Drooker and Laurie D. Webster, pp. 205–228. Salt Lake City: University of Utah Press.

Anderson, Benedict. 1991. *Imagined Communities: Reflections on the Origin and Spread of Nationalism.* Rev. ed. London: Verso.

Appadurai, Arjun and Carol Breckenridge. 1988. "Why Public Culture?" *Public Culture* 1(1):5–9.

Baird, David and Lynne Bairstow. 2003. *Frommer's Mexico 2004.* Hoboken, New Jersey: Wiley Publishing.

Berlo, Janet Catherine. 1991. "Beyond *Bricolage*: Women and Aesthetic Strategies in Latin American Textiles," in *Textile Traditions of Mesoamerica and the Andes: An Anthology,* ed. Margot Blum Schevill, Janet Catherine Berlo, and Edward B. Dwyer, pp. 437–479. Reprint ed., 1996. Austin: University of Texas Press.

Causey, Andrew. 2000. "The Hard Sell: Anthropologists as Brokers of Crafts in the Global Marketplace," in *Artisans and Cooperatives: Developing Alternative Trade for the Global Economy,* ed. Kimberly M. Grimes and B. Lynne Milgram, pp. 159–174. Tucson: University of Arizona Press.

Chavez, Leo R. 1992. *Shadowed Lives: Undocumented Immigrants in American Society.* 2nd ed. Fort Worth: Harcourt Brace College Publishers.

Chibnik, Michael. 2003. *Crafting Tradition: The Making and Marketing of Oaxacan Wood Carvings.* Austin: University of Texas Press.

Clifford, James, ed. 1988. *The Predicament of Culture: Twentieth-Century Ethnography, Literature, and Art.* Cambridge: Harvard University Press.

Cohen, Jeffrey H. 1998. "Craft Production and the Challenge of the Global Market: An Artisans' Cooperative in Oaxaca, Mexico." *Human Organization* 57(1):74–82.

———. 2001. "Transnational Migration in Rural Oaxaca, Mexico: Dependency, Development, and the Household." *American Anthropologist* 103(4):954–967.

Collier, George A. with Elizabeth Lowery Quaratiello. 1999. *Basta! Land and the Zapatista Rebellion in Chiapas.* Rev. ed. Chicago: Institute for Food and Development Policy, Food First Books.

Cook, Scott. 1993. "Craft Commodity Production, Market Diversity, and Differential Rewards in Mexican Capitalism Today," in *Crafts in the World Market: The Impact of Global Exchange on Middle American Artisans,* ed. June Nash, pp. 59–83. Albany: State University of New York Press.

Cook, Scott and Leigh Binford. 1990. *Obliging Need: Rural Petty Industry in Mexican Capitalism.* Austin: University of Texas Press.

Forcey, John M. 1999. *The Colors of Casa Cruz: An Intimate Look at the Art and Skill of Fidel Cruz, Award Winning Textile Weaver.* Oaxaca, Mexico: Impresos Árbol de Vida.

Goertzen, Chris. 2001. "Crafts, Tourism, and Traditional Life in Chiapas, Mexico: A Tale Related by a Pillowcase," in *Selling the Indian: Commercializing and Appropriating American Indian Cultures,* ed. Carter Jones Meyer and Diana Royer, pp. 236–269. Tucson: University of Arizona Press.

González Licón, Ernesto. 1990. *Los Zapotecas y Mixtecos: Tres Mil Años de Civilización Precolombina.* Mexico City: Consejo Nacional para la Cultura y las Artes.

Graburn, Nelson H. H. 1976. "Introduction: Arts of the Fourth World," in *Ethnic and Tourist Arts: Cultural Expressions from the Fourth World,* ed. Nelson H. H. Graburn, pp. 1–32. Berkeley: University of California Press.

———. 1999. "Epilogue: Ethnic and Tourist Arts Revisited," in *Unpacking Culture: Art and Commodity in Colonial and Postcolonial Worlds,* ed. Ruth B. Phillips and Christopher B. Steiner, pp. 335–353. Berkeley: University of California Press.

Grimes, Kimberly M. 1998. *Crossing Borders: Changing Social Identities in Southern Mexico.* Tucson: University of Arizona Press.

Hart, Lynn M. 1995. "Three Walls: Regional Aesthetics and the International Art World," in *The Traffic in Culture: Refiguring Art and Anthropology,* ed. George E. Marcus and Fred R. Myers, pp. 127–150. Berkeley: University of California Press.

Howes, David. 1996. "Introduction: Commodities and Cultural Borders," in *Cross-Cultural Consumption: Global Markets, Local Realities,* ed. David Howes, pp. 1–16. New York: Routledge.

Jett, Stephen C. 1993. "Oriental Carpets and the 'Storm Pattern' Navaho Rug Design," in *Why Museums Collect: Papers in Honor of Joe Ben Wheat,* ed. Meliha S. Duran and David T. Kirkpatrick, pp. 103–125. Albuquerque: Archaeological Society of New Mexico.

Jules-Rosette, Bennetta. 1984. *The Messages of Tourist Art: An African Semiotic System in Comparative Perspective*. New York: Plenum Press.

Kent, Kate Peck. 1985. *Navaho Weaving: Three Centuries of Change*. Santa Fe: School of American Research Press.

Kinzer, Stephen. 2003. "The Luster of Glass Joins Art's Mainstream." *New York Times* (April 28), pp. B1, B5.

Kopytoff, Igor. 1986. "The Cultural Biography of Things: Commoditization as Process," in *The Social Life of Things: Commodities in Cultural Perspective*, ed. Arjun Appadurai, pp. 64–91. Cambridge: Cambridge University Press.

Lindauer, Margaret A. 1999. *Devouring Frida: The Art History and Popular Celebrity of Frida Kahlo*. Middletown, CT: Wesleyan University Press.

Lucero, Helen R. and Suzanne Baizerman. 1999. *Chimayó Weaving: The Transformation of a Tradition*. Albuquerque: University of New Mexico Press.

Marcus, George E. and Fred R. Myers. 1995. "The Traffic in Art and Culture: An Introduction," in *The Traffic in Culture: Refiguring Art and Anthropology*, ed. George E. Marcus and Fred R. Myers, pp. 1–51. Berkeley: University of California Press.

McCafferty, Sharisse D. and Geoffrey G. McCafferty. 1994. "Engendering Tomb 7 at Monte Albán: Respinning an Old Yarn." *Current Anthropology* 35(2):143–166.

M'Closkey, Kathy. 2002. *Swept Under the Rug: A Hidden History of Navajo Weaving*. Albuquerque: University of New Mexico Press.

Meisch, Lynn A. 2002. *Andean Entrepreneurs: Otavalo Merchants and Musicians in the Global Arena*. Austin: University of Texas Press.

Mullin, Molly H. 2001. *Culture in the Marketplace: Gender, Art, and Value in the American Southwest*. Durham: Duke University Press.

Nash, June. 1993. "Introduction: Traditional Arts and Changing Markets in Middle America," in *Crafts in the World Market: The Impact of Global Exchange on Middle American Artisans*, ed. June Nash, pp. 1–22. Albany: State University of New York Press.

Noble, John, Susan Forsyth, Allison Wright, Andrew Dean Nystrom, Morgan Konn, and Ben Greensfelder. 2002. *Lonely Planet Mexico*. 8th ed. Melbourne: Lonely Planet Publications.

Oxford English Dictionary. 1989. *Oxford English Dictionary*. 2nd ed. London: Oxford University Press.

Pearlstone, Zena. 2001. "Contemporary Katsina," in *Katsina: Commodified and Appropriated Images of Hopi Supernaturals*, ed. Zena Pearlstone, pp. 38–127. Los Angeles: UCLA Fowler Museum of Cultural History.

Phillips, Ruth B. 1995. "Why Not Tourist Art? Significant Silences in Native American Museum Representations," in *After Colonialism: Imperial Histories and Postcolonial Displacements*, ed. Gyan Prakash, pp. 98–125. Princeton: Princeton University Press.

Phillips, Ruth B. and Christopher B. Steiner. 1999. "Art, Authenticity, and the Baggage of Cultural Encounter," in *Unpacking Culture: Art and Commodity in Colonial and Postcolonial Worlds*, ed. Ruth B. Phillips and Christopher B. Steiner, pp. 3–19. Berkeley: University of California Press.

Ross, Gary N. 1986. "The Bug in the Rug." *Natural History* 95(March): 66–73.

Sayer, Chloë. 1988. *Mexican Textile Techniques*. United Kingdom: Shire Publications.

———. 2002. *Textiles from Mexico*. Seattle: University of Washington Press.

Spooner, Brian. 1986. "Weavers and Dealers: The Authenticity of an Oriental Carpet," in *The Social Life of Things: Commodities in Cultural Perspective*, ed. Arjun Appadurai, pp. 195–235. Cambridge: Cambridge University Press.

Stanton, Andra Fischgrund. 1999. *Zapotec Weavers of Teotitlán*. Santa Fe: Museum of New Mexico Press.

Steiner, Christopher B. 1999. "Authenticity, Repetition, and the Aesthetics of Seriality: The Work of Tourist Art in the Age of Mechanical Reproduction," in *Unpacking Culture: Art and Commodity in Colonial and Postcolonial Worlds,* ed. Ruth B. Phillips and Christopher B. Steiner, pp. 87–103. Berkeley: University of California Press.

Stephen, Lynn. 1991a. *Zapotec Women*. Austin: University of Texas Press.

———. 1991b. "Export Markets and Their Effects on Indigenous Craft Production: The Case of the Weavers of Teotitlán del Valle, Mexico," in *Textile Traditions of Mesoamerica and the Andes: An Anthology,* ed. Margot Blum Schevill, Janet Catherine Berlo, and Edward B. Dwyer, pp. 381–402. Reprint ed., 1996. Austin: University of Texas Press.

———. 1991c. "Culture as a Resource: Four Cases of Self-Managed Indigenous Craft Production in Latin America." *Economic Development and Culture Change* 40(1):101–130.

———. 1993. "Weaving in the Fast Lane: Class, Ethnicity, and Gender in Zapotec Craft Commercialization," in *Crafts in the World Market: The Impact of Global Exchange on Middle American Artisans,* ed. June Nash, pp. 25–57. Albany: State University of New York Press.

Stephen, Lynn and Julia Barco. 1991. *Mayordomía: Ritual, Gender, and Cultural Identity in a Zapotec Community.* Northeastern University, Network Northeastern. 20 min. Austin: University of Texas Press.

Thomas, Nicholas. 1991. *Entangled Objects: Exchange, Material Culture, and Colonialism in the Pacific.* Cambridge: Harvard University Press.

Turok, Marta. 1996. "De Fibras, Gusanos y Caracoles," in *Artes de México: Textiles de Oaxaca*, #35, pp. 62–69 (trans. Lorna Scott Fox, pp. 91–94). Mexico City: Artes de México y del Mundo.

Wade, Edwin L. 1985. "The Ethnic Art Market in the American Southwest 1880–1980," in *Objects and Others: Essays on Museums and Material Culture,* ed. George W. Stocking, pp. 167–191. Madison: University of Wisconsin Press.

Winter, Marcus. 1992. *Oaxaca: The Archaeological Record.* 2nd ed. Mexico City: Editorial Minutiae Mexicana.

Wood, W. Warner. 2000a. "Flexible Production, Households, and Fieldwork: Multisited Zapotec Weavers in the Era of Late Capitalism." *Ethnology* 39(2):133–148.

———. 2000b. "Stories from the Field, Handicraft Production, and Mexican National Patrimony: A Lesson in Translocality from B. Traven." *Ethnology* 39(3):183–203.

———. 2001a. "Rapport Is Overrated: Southwestern Ethnic Art Dealers and Ethnographers in the 'Field.'" *Qualitative Inquiry* 7(4):484–503.

———. 2001b. *The Zapotec Textile Resource Page* [online]. Available: http://www.nhm.org/research/anthropology/Zapotec/index.html. Accessed January 9, 2005.

———. 2003. "Oaxacan Textiles: [Fake] Indian Art, and the Mexican [Invasion] of the Land of Enchantment." *Cuadernos del Sur* 9(19):19–33.

Ziff, Trisha and Sylvia Stevens. 1994. *Oaxacalifornia*. Faction Films and Citron Nueve Producciones. 58 min. Berkeley: University of California Extension Center for Media.

Contending Indian Art-Worlds

Patta Chitra Paintings in Orissa

Helle Bundgaard

This article argues that the notion of a singular art world will have to give way to that of "art-worlds," the point being, as Fred Myers (1994:13) has suggested, "to imagine conditions of cultural heterogeneity, rather than those of consensus, as the common situation of cultural interpretation." The argument is based on a detailed analysis of the contending practice and discourse of two of the several groups involved in a traditional craft in coastal Orissa, India: the paintings called *patta chitra*. More specifically, the article explores the relation between the pragmatic concerns of patta chitra painters regarding their work on the one hand and the Indian elite's priorities on the other. A central issue is the way painters, as agents, seek to influence the reality in which they live. The specific case of a painter, who contextually reframed Sanskrit extracts in order to secure his position as an acknowledged artist, illustrates the creative aspect of agency.

The Art-World

The concept of an "art-world" was introduced into philosophical aesthetics by the philosopher Arthur C. Danto (1964). His ideas were taken up by an American philosopher of aesthetics, George Dickie (1969, 1974), who developed them in a sociological direction establishing the institutional theory of art. Dickie's *Art and the Aesthetic* (1974) is considered the canonical version of the institutional theory of art (Yanal 1994:ix). (Because of his philosophically centered interests, Danto, however, considers this theory alien to his work [see Danto 1981:viii].) Dickie argues

Reprinted from Bundgaard, Helle. 1999. "Contending Indian Art Worlds." *Journal of Material Culture* 4(3):321–337.

that the members of an art-world—artists, critics, dealers, and collectors—have the power to decide whether a work will be circulated as art. An artwork, thus, has no inherent quality entitling it to be art. It is consensus within the art-world, rather than a common historical interpretation, that is required for an object to be a work of art (Gell 1996:19). For anthropologists, the institutional theory has the merit of allowing us to abandon the aesthetic notion of artworks (Yanal 1994:ix–x; Gell 1996:35), favoring a sociological analysis. Thus, the artistic quality of a work is found in the relation that exists between the object and its "art-world" rather than within the object itself (Becker 1982:146).

This theory, however, presents certain problems. Alfred Gell (1996:37) criticized the institutional theory for not being sufficiently clear about the criteria that determine whether an object will be selected as artistically "interesting." Another problem is the inherent circularity of the theory. Artworks are defined through the evaluations of an art-world, which itself is defined by the exchange of evaluations of artworks by members of the art-world. The identification of artworks, thus, must precede the identification of the art-world (Gell, pers. comm.). A third area where the theory is found wanting is its disregard for power relations between the individual members and groups that make up the art-world. This limitation might be a consequence of philosophers' tendency to build their arguments around purely hypothetical examples. In contrast, an empirically based notion is likely to reveal the necessity of considering this aspect of power relations as a crucial constituent of any art-world.

Influenced by Danto's and Dickie's approaches to art, sociologist Howard S. Becker (1982:151) explored the implications of the art-world concept using a social organizational analysis. Becker has pointed out that many interested parties in an art-world commonly see some people as being more entitled to speak on behalf of the art-world than others. Becker indicates the role that official institutions might play in establishing who can speak for his or her art-world, but he does not explore this issue further despite the importance of his point. A possible explanation for why some people are entitled to speak could be that we are dealing with a discursive strategy, a Foucauldian "statement," or, to use Herbert Dreyfus and Paul Rabinow's (1982:48) well-chosen term, a "serious speech act," the existence of which has the following precondition:

> If we analyze those who are accorded the right to speak on any particular occasion this involves criteria of competence and knowledge in relation to institutions, pedagogic norms, and legal systems. These allow particular subjects to practice and extend their knowledge claims. In other words . . . statements cannot come from anyone. . . . Institutional sites (the academic department, the seminar-room, the finds-processing laboratory, the museum, and the library) all provide supports for the making of serious speech acts and differentiate hierarchically between those who may and may not make them (the professor, the lecturer, curator, the student, and the man or woman in the street). (Tilley 1990:292)

As the statement suggests, it should come as no surprise that certain people are more entitled to speak on behalf of the art-world than others. In contrast to every-

day utterances, their statements—the so-called "serious speech acts"—carry weight empowered by their institutional backing. If not supported by an institutional site that legitimizes what they say and write, these entitled speakers of art-worlds are often supported by a community of experts. It does not follow, however, that the entitled speakers enjoy absolute discursive authority. The advice offered by art specialists regarding what constitutes good art is not necessarily accepted as valid by local producers, who often have their own agendas and standards. Thus, there is no single set of wise persons who can tell us what constitutes genuine arts or crafts, which was the criterion raised against Danto's claims by J. C. Faris (1988) in his discussion of the ART/artifact exhibition in New York.

In his book *African Art in Transit,* Christopher B. Steiner (1994) discussed the transnational supply, distribution, and exchange of African art objects. He showed how African traders mediated distinct cultural knowledge about the (art) objects to village-based owners, to contemporary artisans, and to Western collectors, among others. Far from being atypical, what Steiner shows transnationally is true of all cultural relations. As Myers (1994:12) suggests in his discussion of the Aboriginal acrylic painting art-world: "Its 'interculturality' . . . represents conditions of cultural heterogeneity that, far from being unusual, should probably be viewed as *the theoretically basic social condition*" (emphasis added). It should perhaps be added that art-worlds do not have to be international to contain "interculturality." This is evident in the particular art-worlds discussed here, a mini cosmos of Steiner's larger, transnational system.

Patta Chitra in Orissa

The particular art-worlds considered here are the art-worlds of the Orissan cloth paintings called patta chitra. The patta chitra art-worlds are characterized by two discursive formations; we shall consider the one that centers around aesthetic values. (For a discussion of the other, the economic-oriented formation, see Bundgaard 1999.)

Following Christopher Tilley (1990:299), a discursive formation can be seen as "a historically specific and socially contingent ordering of discourse." Far from being neat and regular it contains contradictions—it is, in Michel Foucault's (1991:155) words, a "space of multiple dissensions." As crucial as this formation is, of course, some of the situated practices of local painters are strategic responses to the previously mentioned discursive formation.

A Glimpse of the Paintings

Patta chitra paintings have been produced in Puri district, Orissa, for centuries. The earliest existing example is likely to be one made in 1670 (Starza-Majewski

1993a:42). This painting illustrates the Hindu Jagannatha temple in Puri and is now the property of the Victoria and Albert Museum (for a detailed description of the painting, see Starza-Majewski 1993a, 1993b). The dominant theme in patta chitras has been Jagannatha, a form of Visnu, as well as his siblings Balabhadra and Subhadra either on their own, in the temple complex, or possibly with illustrations of important religious sites in Puri. Characteristically, the color scheme consists of only a few colors—mainly primary colors such as red, yellow, and blue, in addition to black, orange, or green (Archer 1979:111; Starza-Majewski 1993a:40). During the past century the paintings have undergone some thematic and stylistic changes as well as a change in color scheme. Although the number of themes used in patta chitras are increasing, the most popular are still Jagannatha, Krishnaleela, and Ramleela. (For an extremely useful description and analysis of Orissan *Ramayana* illustrations, see Williams 1996.)

The most fundamental stylistic change in the patta paintings was introduced in the early 1960s when the State Handicraft Design Centre in Bhubaneswar developed a chronologically ordered design with a linear narrative form, the purpose of which was to make the paintings more accessible. Some years ago, Nelson Graburn (1976:15) suggested that the ability of an art object to be understood by consumers was one of the key characteristics necessary for objects produced for the mass market. This shift in design in Orissa follows this pattern. Despite these changes, the Orissan patta chitras present a relatively static form when compared to Kalighat paintings (Archer 1971:4–5) or Bengal scroll paintings (Singh 1996), both of which commonly refer to current social events.

For centuries the caste of traditional painters, *Chitrakaras*, has been intimately connected with the pilgrim center of Puri, selling their paintings and crafts to pilgrims from all over India who visit the Jagannatha temple. Some have also found patrons in the Puri *rajas* or other wealthy people; and, of course, the temples themselves have supported their work. It is, however, only since independence that outsiders, other than middlemen and potential customers, have begun to advise craftsmen directly about the execution of their paintings—advice that is supported and empowered by the institutions the advisors represent. It is the relationship between the elite discourse on patta paintings on the one hand and the practices of patta painters in Puri district on the other that is the central concern of this article. (The concept of discourse is used here in the Foucauldian [1991] sense of a practice that shapes thoughts and actions. Implicit in this notion are connotations of power and possible contestation.)

The majority of the contemporary patta paintings are intended as trade objects for the regional, national, and, occasionally, international markets. They continuously undergo different evaluations rooted in quite separate and distinct regimes of value (Appadurai 1986; Kopytoff 1986). Far from being "empty vessels" (Danto's [1988:23] terminology for objects that have never been thick with religious significance), these paintings are "spirited" (Steiner 1994:160) by tourists, government

officials, and, as we shall see, art specialists as authentic handicrafts embodying Sanskrit principles.

Painters' Practice: Producing and Assessing Patta Chitras

Skill in making patta chitras is acquired through practice. An apprentice works under his *guru,* follows his example, and takes note of his criticisms. The government offers two-year training courses in patta painting, just enough time to acquire some idea of the work. Students who wish to master the skill of patta chitra have to apprentice to a guru after the completion of the course. Apart from the practice itself, apprentices are given a few rules of thumb: a figure from head to feet should be on a straight line, the length from waist to head should be equal to the length from feet to waist, and proportions must be made in accordance with body proportions in general. In order to get a clearer idea of painters' priorities toward their work, let us consider some examples of their assessment of other painters' work.

One painter from Puri district described what he does when he considers the quality of a patta chitra:

> A painting must be studied carefully to know whether it is good or not. Which things are put where? In which position is the hand kept? Which are the actual things which should be held? Which hand should hold what? Has the deity been painted the correct color?

Such considerations seem to be the basis for the majority of painters' evaluations of their work. When asked to comment on a painting depicting Ganesha, three painters independently noticed the lack of a tooth (figure 1). To protect their privacy I will use pseudonyms rather than the real names of painters and art specialists in what follows. On examining the painting Bhagavan Maharana from the village Danda Sahi said, "This is dancing Ganesha. He holds an axe (*pharsa*), he holds a sweet (*ladu*), and a rosary (*japa*) is also present, but there is no tooth in his hand. The craftsman has made a mistake (*bhul*)." Some days later his neighbor, Ganesha Maharana, commented on the same painting, "A tooth which should have been here has not been made. That means that the work has been completed too quickly . . . [however] . . . it is not bad (*gote prakara*)." In Raghurajpur, Prafulla Mahapatra liked the painting in general but noted, "The pose is beautiful (*sundara*), but the gesture (*mudra*) is wrong. Our Ganesha holds a tooth but there is no tooth in the hand, the hand makes a gesture." Bhagavan's brother Jayakrushna Maharana did not remark on the missing tooth, but mentioned other things, which to his eye was lacking: "Dots (*topi mara*) are not there, moreover a border (*dhadhi bhida*) has not been made, the nails have not been painted white. Everything else is fine."

These comments, and in particular the repeated use of the concept of bhul, which indicates a mistake, suggest that the painters have a mental set of conventions. It is these conventions to which they refer when looking at a patta chitra. They

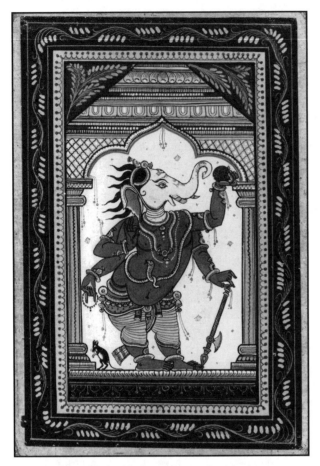

Figure 1. Patta chitra painting, *Dancing Ganesha.*

look at the details in the painting in order to know whether the painting as a whole conforms to existing conventions.

It is important to paint the proper figures and items. But equally, if not more important, are the proportions and lines. The lines in particular, as well as the poses, of *Rama's Meeting with Bharata* were noted by painters most frequently (figure 2). Seeing the painting, the Chitrakara Prafulla Mahapatra was reminded of his youth when a Polish-American woman named Halina Zealey (1953) had praised the artist's handwork, particularly pointing out how his lines were unbroken, implying that he painted in one stroke:

I could do so fine work then

and the lines were well built (*sudhala*). The way this craftsman has drawn his lines is sudhala, for which I thank him in my heart. . . . Obviously one can only work according to the ability god has bestowed on one. The person who has made this painting, his way of drawing lines is extremely good (*ati sundara*). The decoration he has done likewise is not bad (*amadhya heini*).

Another Chitrakara from Puri similarly noted the lines, saying that "The 'lining' is good and so is the sketch. Good colors have been given and the ornaments are well done. . . . His lines are very good (*khub bhala*)." This painting was generally thought to be excellent. Independently of each other, several painters nevertheless noted how Rama's waist was too narrow when compared with his broad chest. One also found that Rama's legs and arms were too long compared to his body.

Painters frequently appeal to everyday experience when guiding their students and when considering another painter's work. A Chitrakara described how his father taught him to paint using practical examples: "My father always said: Before you try to paint Krishna holding Radha's waist, you first hold someone's waist to see how it looks and how much of the hand will be visible." Poses must look "natural (*prakruta*)," by which painters mean that they should be physically plausible. Moreover, the proportions of figures should be made according to the proportions of human bodies.

The appearance of daily life was the basis of another painter's criticism of a painting of Krishna and Jashoda milking a cow (figure 3): "It is good, the work is good. The main thing is that the knee is not done in a proper way. How is a cow milked? One milks sitting like this." He then proceeded to illustrate how one sits when milking a cow, an embodied experience that can be expressed in words only inadequately.

Figure 2. Patta chitra painting, *Rama's Meeting with Bharata.*

It is characteristic that when talking about specific patta chitras local painters engage in a process of assessment rather than exegesis. Interpretation of meaning does not take place and is certainly not part of the ordinary process of evaluation (see O'Hanlon 1993). In this respect painters' commentaries are strikingly different from those of the majority of art specialists. Painters consider lines, poses, proportions, colors, and iconographic codes pragmatically. They offer a step-by-step eval-

Figure 3. Patta chitra painting, *Krishna and Jashoda Milking a Cow.*

uation of a painting. Apart from this, the evaluations, expressed in a detailed and descriptive language, are concerned with the credibility and accuracy of an image measured against painters' own experiences in daily life.

In contrast to previously published observations (Williams 1988:14), I thus argue that painters compare figures "with referents in the real world." They are, moreover, concerned with the degree to which a painting can be said to replicate ideal models and, of course, the skill with which a painting has been executed. At an immediate level, the former observation suggests an ideology of replication. This interpretation, however, would be an oversimplification of a much more complex phenomenon. As such, it would certainly present a clear, but hardly a very accurate, picture of what is going on. Although painters in the tourist industry also replicate preexisting images, many nevertheless participate in the process of innovation typical of a market characterized by competition (Layton 1981:211, 216).

With very few exceptions painters have a markedly pragmatic relationship with their work. To paint is to (try to) earn a living. One consequence of this attitude is that customers are likely to get whatever they fancy as long as they pay and so long as their requirements are within the ability of the painter. Such pragmatism was reflected in one painter's response to me when I asked him what he thought of

an art specialist's rejection of a railway station as a potential patta motif. "Nobody pays me unless I work, if a customer wants a railway station, will I make one or not? Do you think he will be pleased if I tell him he can have a Ganesha painting? You see, we need money to be able to eat." To the specialist's mind, however, the railway motif would spoil the purity of the Odissi style.

Another consequence of this pragmatism is that painters, particularly younger painters, will be looking out for new possible ways of depicting the traditional motifs. It should be noted that here we are not talking about radical shifts in imagery but subtle interventions, such as the depiction of a garland with what painters generally term "shade," which is commonly found, for example, in popular calendar images.

We shall now turn to another of the patta art-worlds, namely the art specialists who, among other things, bestow awards on selected painters, have a say in the selection of candidates for government posts as patta instructors, and more generally participate in an elite discourse that seeks to define and confine traditional crafts and their characteristics.

Timeless Tradition and Textual Knowledge

In Orissa a number of institutions, government as well as private, are involved in different ways in the production of local crafts. The representatives of these institutions and their ideas of what constitutes good crafts illustrate some of the distinct and occasionally opposed demands facing contemporary patta chitra painters. One of these institutions is engaged in a critical discourse concerned with the aesthetics and traditional aspects of production (for a discussion of other institutions' involvement with patta chitras, see Bundgaard 1999).

Orissa's Craft Council is a voluntary, unpaid organization that exists primarily for idealistic motives. A group of intellectuals, employed in academic institutions elsewhere, founded the Crafts Council in the late 1980s in order to improve what they saw as a general deterioration in the quality of Orissan handicrafts. The decline was seen as caused by market demands and, supposedly, an increasing concern with money among craftsmen. One of the aims of the Council was to influence their adjustment to the market to ensure a proper continuation of the tradition. Let us have a closer look at the viewpoint of one of the initiators, who can be seen as representing not only the Crafts Council but also the dominant position of the regional art elite.

The perspective of Dr. P. Mohanty puts him in line with earlier orientalist figures such as George Birdwood and A. K. Coomaraswamy (see Coomaraswamy 1909:99; Birdwood 1980; Guha-Thakurta 1992:164–165, 146–184; Bundgaard 1996b, 1999). He described himself as a traditionalist, something that is indicated in his comment to me when we first met:

> The basic thing, tell me, why have you come from London to study patta chitra? Because [he answered himself] . . . you have not come here to study calendar prints or laminated modern photographs—it [patta painting] is a craft that has a traditional value, it has a peculiarity; that is why you have come. So those particular things which attracted you from the very beginning, if they are gradually lost, then what happens?

During interviews in the autumn of 1992 and winter 1994, Mohanty expressed his concern about the patta chitra paintings that have become a tourist commodity, stressing the importance of maintaining traditional values. He described how Orissan crafts are famous due to their continuity with the past and reasoned that recent introductions, such as certain new themes, colors, and in particular luminous colors, should be eradicated to prevent the painting tradition from losing its connection with history. He was of the opinion that this kind of modernization, if allowed to continue, would change the tradition to such an extent that in 20 years' time there would be nothing worthy of the name patta chitra.

Mohanty illustrated his point by describing how a painter recently painted a railway station using perspective. He found both the motif and the attempt at perspective unacceptable because those elements spoiled the purity of the Orissi style. That Mohanty employs a narrowly defined notion of purity was apparent when he related how he had rejected what to his mind was an otherwise excellent work submitted for a national award competition:

> Once there was a palm leaf illustration submitted by an artist depicting *Raga mala*. It was made beautifully in black and white. However, on the cover he had painted a number of musical instruments, including a harmonium and a tabla. I objected to that, because a harmonium can never go with the ancient conception of Raga paintings. Had he illustrated *ghazals* (Persian lyric poems) it would have been OK.

When I remarked that some people might argue that no harm had been done, as harmonia nowadays are commonly used as accompaniment to raga singers, Mohanty countered:

> I don't blame the artist, he is not properly educated. . . . You know from your study that the guru *sisya* (teacher's apprentice) tradition has gone, so has the sketchbook tradition, as [Dr. Mishra] calls it. The most important thing, however, is that gurus are not proper gurus—they don't have the knowledge of scriptures.

Here we have a typical example of a classical elite hypostatization: the idea that proper painter gurus possess knowledge of scriptures—an assumption that has little or no evidence. It is highly unlikely that noneducated, low-caste painters should ever have such a knowledge (for further discussion, see Bundgaard 1996b, 1999).

As we shall see this assumption can have surprising consequences for the work of painters. It should be noted how Mohanty has adopted the idea of a "sketchbook tradition" from another specialist and member of the Crafts Council. This scholar's

claim that something like a sketchbook tradition once existed (whether actually true or not) is an example of a "serious speech act" (Dreyfus and Rabinow 1982:48) that is passed on to others, studied, and repeated and, thus, significantly influences the object of study, namely the patta paintings and their makers. Mohanty was of the opinion that the State Handicraft Training Centre ought to ensure that trainees were not only taught to paint but also coached in mythology, Hindu religion, Orissan art and architecture, and, perhaps most strikingly, Sanskrit *slokas* (stanzas describing the appearance of a deity).

Far from being an unusual example, the specialist's concern with scriptures and Sanskrit knowledge is common among the elites in the Indian art-worlds. The late Pupul Jayakar (1989:98), an acknowledged authority on Indian arts and crafts, noted in her widely known book, *The Earthly Mother*, how the understanding of the rural arts has been obscured by "the general belief that these arts are the product of illiterate people . . . without access to India's storehouses of myth, legend and symbol." Jayakar stresses that this assumption is "far from correct" and mentions that "sanctuaries of religion, art and literature had sprung into existence in villages from the earliest times when religious teachers, poets, painters, musicians and epic performers sought refuge in the countryside." According to Jayakar (1989:106), it was these sanctuaries that made "possible the survival of archaic myth and history." She goes on to suggest that

> the rural arts . . . are unique, for here coalesce a comprehension and knowledge of Sanskrit learning and culture, its vocabulary and iconography, *Tantric* ritual and magic, and the distortions and robust vitality inherent in the rural perceptions of the visual arts.

This is just another example that signifies a particular crafts discourse and illustrates the kind of elite hypostatization to which I have referred previously. We have learned that India has a store of myths, legends, and symbols; that villages are sanctuaries of religion, art, and literature; and most remarkably that a comprehension and knowledge of Sanskrit learning and culture is inherent in the rural perceptions of the visual arts.

Jayakar assumes that through religion, art, and literature the rural painters have a comprehension and knowledge of Sanskrit learning. But Mohanty, as we have seen, was concerned with an apparent lack of knowledge of scriptures among the contemporary craftsmen. Readers have already had a hint that painters' practices are indeed far from these elite assumptions and concerns. Do these distant, elitist concerns have an effect among the patta painters? If so, what effect?

For the majority of painters the concerns of the elite are perceived as remote, indeed as of another world. Their general attitude is that the art elite have a job to do that is of no concern to the painters (see Bundgaard 1999, chapter 9). A few, however, take the elite more seriously, something that can have paradoxical effects.

Scriptural Scraps:
Mimicry, Mockery, or an Indication of Agency?

The patta chitra painter Prafulla Mahapatra is widely known for his skill and for his collection of Sanskrit slokas, which is arranged in an impressive, large book (*grantha*). The main part of the slokas, or more precisely *dhyanas* (the visualization of a particular aspect of the divinity described in a sloka), are accompanied by illustrative sketches. The book also contains detailed notes on *Mahabharata*, which are not accompanied by sketches. The book is used as an *aide-mémoire* when working or when guiding apprentices, but it also serves other purposes, such as indicating to customers, art specialists, and researchers that Prafulla is one of the few painters who still keeps a sketchbook—thus continuing the so-called "sketchbook tradition." They emphasize that the paintings of his household are made in accordance with Sanskrit slokas. The aim of the collection has partly been fulfilled, as indicated by the fact that the noted art historian Joanna Williams (1996:60) refers to it as an example of one of two existing notebooks. The collection also enables customers to choose among different sketches when making an order. Painters occasionally come to Prafulla to get advice about the appearance of a deity or to hear his interpretation of Hindu mythology and the epics.

Ganesha Maharana, a painter from a neighboring village, was aware of the collection's value as signifying tradition for the benefit of visitors, tourists, and scholars. There were also, however, other reasons why he thought all painters ought to have a similar book:

> The book has everything about the colors needed, the weapons needed for the hands and other things too. . . . Actually everybody should have it, but the fact is that the idea of keeping such a book for our sons and their sons has not come to our minds. Even if we know how to make such a book, it needs time and knowledge of slokas and *sastras* (a treatise, in this case, on arts). We can make drawings but we do not have the slokas which conform precisely to the image.

The last part of the statement is particularly interesting. Ganesha says that for painters, the painting comes before the slokas, which painters "do not have." The need for slokas, reflected in Prafulla Mahapatra's collection and book, is thus likely to have been imposed on the painters by the elite discourse characterized by hypostatizations, the continuing existence of which depends on their seclusion from the painters' actual practice. Some might feel slightly uneasy with this last interpretation—after all, we have just been confronted with an example of a painter who not only possesses Sanskrit slokas but clearly also uses them. But we must look more closely at an example of one of the slokas from Prafulla's collection to explore his interpretation of it.

Being unschooled in Sanskrit, Prafulla does not understand many of the slokas he has collected. (Actually, the language of his slokas is a mix of Sanskrit and Oriya.) Some of the slokas are so complicated that he does not understand a single

word. Others are easier but still not fully comprehensible. Like other dhyanas, the Hanuman dhyana presented below was recited by Prafulla only with difficulty and he relied heavily on the sketch when interpreting the text.

> I constantly pray to the God Hanumana, the son of Mrut and the [devout] servant of Shri Rama; who is surrounded by great warriors like Angada; who has a fearsome appearance; who is as bright as millions of suns; whose eyes seem to be burning like those of the God of Death; who shouts very loudly and bearing a mountain in his hands runs after Ravana saying "You wretch, stand on the battlefield [and fight]."

Looking at the sketch rather than the text, Prafulla explained:

> The story of the birth of Hanumana is there. The day Hanumana saw Rama he got his power. He was so powerful that nobody could match him either in heaven or on the earth. Not even the sun and the moon were so powerful as him. Ravana and other demons feared him when they saw him. But though he has that power, he is powerless without Rama. Now look at the figure, he has a mountain in one hand, and a mace (*gada*) in the other and he is enormous.

This is a clear example of how Prafulla's explanation builds on the story of Rama as he knows it rather than the text he reads aloud. Generally the painter's explanation of the slokas in his collection was based on the sketches rather than the texts (see also Bundgaard 1999). Prafulla only partially understands the slokas he has copied in his book, and in several cases only a few words. His explanations are mainly founded on his knowledge of the *puranas* and the sketches that help to remind him of the various details. The above example illustrates that it is the collection of slokas and not their meaning that is of importance to the painter. What are we to make of this collection? In order to answer that question we shall have a closer look at the origin of his collection of texts.

In 1991 Prafulla explained to me why he had made his collection:

> In 1965 [the ex-president of India] Sarvapalli Radhakrishna gave me a national award. I became famous but felt ashamed. People in general must have thought that I felt honored, but actually I felt ashamed. Because I felt like this, I was obliged to collect various things from many places.

What the painter is saying is that the award made him anxious because he felt he could not live up to what he thought was demanded of the elite: a profound knowledge of Sanskrit slokas. In other words, he felt inadequate because he was not familiar with Sanskrit. That was when he first thought of making a collection of textual fragments to make up for his supposed lack of knowledge. It is tempting to conclude that the painter, with his collection of what to him are largely incomprehensible slokas, has done his best to live up to his perception of the demands of the art-world: the need to have profound knowledge of Sanskrit slokas. In other words, a pathetic mimicry. But is this a satisfactory explanation?

Alternatively, the collection could perhaps be seen as the painter's materialized mockery of what to him are completely alien requirements of the elite. Another possibility is to see the collection of slokas and dhyanas as a concrete result of the painter's agency. The national award and its implications—that the recipient's work presents an ideal for other painters to follow—was cause for concern for the painter, who felt he could not live up to what he conceived of as the expectations of the elite. He was caught between expectations that knowledge of Sanskrit was evident in the regional and national art discourses on the one hand and the realities of local practice on the other.

In an attempt to bridge these two incompatible discourses the painter created his collection—an example of what Marshall Sahlins (1993:14) in a different context termed a "working misunderstanding." The point is that it was never the painter's intention to use the textual fragments as texts to be read and understood. The painter's investment paid off. Although the collection has not bridged the two worlds, it has certainly contributed to the painter's status as a "man of renown" among fellow painters; among local, regional, and international art specialists, as reflected in the numerous awards the painter has received and by the number of invitations to represent India and one of its craft traditions abroad; and last but not least among scholars, as reflected in their references to the painter and his work (see, for example, Das 1982; Bundgaard 1996a, 1996b, 1999; Williams 1996).

Intercultural Art-Worlds

The collection of slokas has been subject to a number of possible interpretations: a mimicry, mockery, or expression of agency. The point is, of course, that this collection has been created as a (Braudrillardian) floating signifier (see Veber 1996:170) and, thus, offers numerous and divergent readings. As such the painter's book is a brilliant signifier of the contending patta chitra art-worlds and their often incompatible priorities and interests. The process that resulted in the collection, its use, and reception show the complexity of the concerns and interactions that are always bound to circumscribe a specific kind of material culture and thus are an important constituent of art-worlds.

The encounters between local painters and art specialists—a complex field of interactions that is the very real reality of the lives of many of India's artisans—present "interface" situations (Long 1992:6) in which these contending art-worlds meet and not uncommonly clash. This complex reality explodes the very notion of "art-world" into a plurality of worlds connected only by a common interest in a specific object or category of objects. This fact is precisely what has led me to suggest as an alternative to the concept of a singular art-world that of *art-worlds*, implying an acknowledgement of the inherent discursive formations and the strategic practices arising in response to them. Rather than an exception, to my mind the

intercultural condition of the patta chitra art-worlds is likely to prove to be representative of all art-worlds.

Questions for Discussion

1. How much do contemporary patta chitra paintings resemble the form and styles of older examples of this art tradition?

2. To what extent are contemporary patta chitra painters free to paint what they wish? To what extent are they constrained not to be innovative?

3. What is the source of these constraints?

4. What role do sophisticated "experts" play in shaping the form and subject matter of contemporary patta chitra paintings?

References

Appadurai, Arjun. 1986. "Introduction: Commodities and the Politics of Value," in *The Social Life of Things: Commodities in Cultural Perspective*, ed. Arjun Appadurai, pp. 3–63. Cambridge: Cambridge University Press.

Archer, Mildred. 1979. *Indian Popular Painting in the India Office Library*. London: Her Majesty's Stationary Office.

Archer, W. G. 1971. *Kalighat Paintings*. London: Victoria and Albert Museum/Her Majesty's Stationary Office.

Becker, Howard S. 1982. *Art Worlds*. London: University of California Press.

Birdwood, George C. M. 1980. *The Industrial Arts of India*. London: Chapman and Hall.

Bundgaard, Helle. 1996a. "Local Discourses on Orissan Paintings." *South Asia Research* 16(2):111–130.

———. 1996b. "Handicraft Awards and their Changing Significance: A Case Study from Orissa, India." *Folk* 38:107–124.

———. 1999. *Indian Art Worlds in Contention: Local, Regional and National Discourses on Orissan Patta Paintings*. Surrey: Curzon.

Coomaraswamy, Ananda K. 1909. *The Indian Craftsman*. London: Probstain & Co.

Danto, Arthur C. 1964. "The Artworld." *The Journal of Philosophy* 63:571–584.

———. 1981. *The Transfiguration of the Commonplace: A Philosophy of Art*. Cambridge: Harvard University Press.

———. 1988. "Artifact and Art," in *ART/artifact: African Art in Anthropology Collections*, ed. Arthur C. Danto, R. M. Gramly, Mary Lou Hultgren, Enid Schildkrout, and Jeanne Zeidler, pp. 18–32. New York: The Center for African Art and Prestel-Verlag.

Das, J. P. 1982. *Puri Paintings: The Chitrakara and His Work*. New Delhi: Arnold Heinemann.

Dickie, George. 1969. "Defining Art." *American Philosophical Quarterly* 6:253–256.

———. 1974. *Art and the Aesthetic*. Ithaca, NY: Cornell University Press.

Dreyfus, Herbert and Paul Rabinow. 1982. *Michel Foucault: Beyond Structuralism and Hermeneutics*. London: Harvester Wheatsheaf.

Faris, J. C. 1988. "ART/artifact: On the Museum and Anthropology." *Current Anthropology* 29(5):775–779.

Foucault, Michel. [1972] 1991. *The Archaeology of Knowledge.* London: Routledge.

Gell, Alfred. 1996. "Vogel's Net." *Journal of Material Culture* 1:15–38.

Graburn, Nelson H. H., ed. 1976. *Ethnic and Tourist Arts: Cultural Expressions from the Fourth World.* Berkeley: University of California Press.

Guha-Thakurta, T. 1992. *The Making of a New "Indian" Art. Artists, Aesthetics and Nationalism in Bengal 1850–1920.* Cambridge: Cambridge University Press.

Jayakar, Pupul. 1989. *The Earth Mother.* New Delhi: Penguin Books.

Kopytoff, Igor. 1986. "The Cultural Biography of Things: Commoditization as Process," in *The Social Life of Things: Commodities in Cultural Perspective,* ed. Arjun Appadurai, pp. 64–91. Cambridge: Cambridge University Press.

Layton, Robert. 1981. *The Anthropology of Art.* London: Granada Publishing.

Long, Norman. 1992. "Introduction," in *Battlefields of Knowledge: The Interlocking of Theory and Practice in Social Research and Development,* ed. Norman Long and Ann Long, pp. 3–16. London: Routledge.

Myers, Fred R. 1994. "Beyond the Intentional Fallacy: Art Criticism and the Ethnography of Aboriginal Acrylic Painting." *Visual Anthropology Review* 10(1):10–43.

O'Hanlon, Michael. 1993. "Unstable Images and Second Skins: Artifacts, Exegesis and Assessments in the New Guinea Highlands." *Man* (n.s.) 27:587–608.

Sahlins, Marshall. 1993. "Goodbye to Tristes Tropes: Ethnography in the Context of Modern World History." *Journal of Modern History* 65:1–25.

Singh, K. 1996. "Changing the Tune. Bengali *Pata* Painting's Encounter with the Modern." *India International Centre Quarterly,* Summer:60–78.

Starza-Majewski, Olek M. 1993a. "The Jagannatha Temple at Puri: Its Architecture, Art and Cult," in *Studies in South Asian Culture,* vol. XV, ed. Janice Stargart, pp. 1–161. Leiden: E. J. Brill.

———. 1993b. "A Seventeenth Century Ritual Pata from the Jagannath Temple." *South Asian Studies* 9:47–60.

Steiner, Christopher B. 1994. *African Art in Transit.* Cambridge: Cambridge University Press.

Tilley, C. 1990. "Michel Foucault: Towards an Archaeology of Archaeology," in *Reading Material Culture: Structuralism, Hermeneutics and Post-Structuralism,* ed. Christopher Tilly, pp. 281–347. Oxford: Blackwell.

Veber, H. 1996. "External Inducement and Non-Westernization in the uses of Ashéninka Cushma." *Journal of Material Culture* 1(2):155–182.

Williams, Joanna G. 1988. "Criticizing the Visual Arts in India: A Preliminary Example." *The Journal of Asian Studies* 47:3–28.

———. 1996. *The Two-Headed Deer: Illustrations of the Ramayana in Orissa.* Berkeley: University of California Press.

Yanal, R. J., ed. 1994. *Institutions of Art: Reconsidering George Dickie's Philosophy.* Philadelphia: The Pennsylvania State University Press.

Zealey, Halina. 1953. Indigenous Arts of Orissa. Unpublished report sent to the American Friends Service Committee.

• • • • • • • • *Section Four* • •

Engaging Tradition
in Contemporary
Aboriginal Art

he following articles show that engaging tradition in the production of contemporary Aboriginal art is a complex matter. In article 8, Fred R. Myers carefully elaborates that the signifying practices of acrylic painting are, like Aboriginal culture more generally, a matter of "unsettled business" because they are continually being reconstructed. This dynamic situation allows individual artists scope for the re-creation of both indigenous and personal identity, factors that are increasingly favored by the global art world. In article 9, Eric Venbrux takes a different approach. He appreciates the indigenous agency of Aboriginal artists, but seeks to clarify the conditions of artistic production, particularly how these artists engage with "tradition." He argues that this engagement of the artists is guided and that culture is objectified in the context of the arts and crafts industry in the Aboriginal society of the Tiwi islanders with whom he has worked.

Fred Myers considers the acrylic paintings of Australian Aboriginal artists, who must work to assert their identity within a commercialized system, directed at external consumption. As Myers notes, the meanings of these works can not be controlled "in the emerging intercultural space where concerns about 'authenticity' and 'tradition' have defining power." However, he also makes it clear that, even within the indigenous domain, there was always an indeterminacy of meanings and interpretation because disagreements were the normal state of affairs. His important theoretical point is that "signs do not just have a meaning, they are made to have meanings, in actual practice to be given signifieds." Myers then goes on to paint a picture of ongoing "interpretive struggle." This struggle underscores his point that culture should not be reified as something fixed and stable, but should be seen as "unsettled business." To theorize this, Myers proposes that a paradigmatic shift is needed in the conception of culture so that the actual process of "culture-making" is emphasized.

Over the years, acrylic paintings produced by the Aborigines in Central Australia have become highly valued and quite successful in the global art world. Despite this success, the status of the paintings was "unsettling" since they were difficult to categorize: Were they traditional or not? And what about their "authenticity"? For a long time, Western hegemonic ideas of tradition have been the yardstick for judging Aboriginal culture. But the dominance of this mode of thinking is now shifting with the quest to understand how the acrylic paintings are contributing to Aboriginal people's empowerment within Australia and "the significance of indigeneity" for contemporary Australia. Myers predicts that this field of cultural production will develop further as it is prompted both by critical art discourses and from increasingly knowledgeable audiences, which Aboriginal artists address through their feats of "self-production" that are successfully re-creating an indigenous presence in the contemporary world.

Myers concludes his article with a rich example of this dynamic process by interpreting themes that appear in the work of Pintupi painter Linda Syddick. Focusing on two paintings dealing with the death of her father and her recovery from this loss through adoption by her second father, Myers recognizes that her artistic genius lies in the hybrid sources of her iconography. She uses a traditional story inherited from her father as well as references to Jesus Christ and E.T. Her ability to make them both have very specific personal and universal meaning is striking. By making her paintings resonate with traditional Pintupi claims to land, Christian messages of loss and redemption, and Steven Spielberg's theme of diaspora, Myers proposes that Syddick has managed to renew her Aboriginal identity while expressing her many personal sorrows, all within a contemporary Australian context.

In article 9, Eric Venbrux discusses the extent to which such "cultural renewal" is guided by the arts and crafts industry of Bathurst and Melville Islands. The role forced on young Tiwi Aboriginal people to retain their "culture" through art production for the external market goes hand in hand with a tale of cultural loss. This emphasis on loss, particularly the presumed need to "reclaim traditional imagery" by resorting to museum collections kept elsewhere, suggests to younger Tiwi artists that there has been a rupture with the past. But for older generations, where cultural traditions, including art, have continued to be an integral part of lived experience, this rupture with tradition is not perceived. The government-supported arts and crafts industry, intertwined with a development-oriented heritage politics, employs the rhetoric of "cultural empowerment." But because it operates on the local level, it may instead instill feelings of alienation in the workforce—particularly among younger artists.

Responding to the overarching art world's definition of "Tiwi style," Tiwi artists are encouraged to produce neotraditional art in art centers, which necessarily entails an objectification of Aboriginal culture. Although most younger artists do not attend the annual *Kulama* ceremony—unanimously considered of crucial importance to the maintenance of Tiwi culture—they nevertheless adopt its imagery in their art for external consumption. Likewise, ritual paraphernalia and other artifacts with a history of cross-cultural transaction as ethnographic objects are also depicted.

A younger generation of Tiwi artists thus engage their people's traditions in the intercultural space of canonical high art. This art, under the aegis of the industry and external advisers, seems no less subject to a civilizing mission than the government and missionary interventions of the past. Yet, according to Venbrux, it was by embracing and displaying Aboriginal art that the Australian nation-state and its citizens could demonstrate their "postcolonial virtue." As a result, in spite of what they had to give up for the sake of "cultural recovery," local Aboriginal artists, including the Tiwi (under discussion), "managed to create new meaning, to launch identity claims, and to reconnect with significant others in living memory."

The Unsettled Business of Tradition, Indigenous Being, and Acrylic Painting

Fred R. Myers

This paper is dedicated to the memory of Tjupurrula, painter of *Straightening Spears.*

Prologue

*L*et me begin with an anecdote of something that took place in New York a few years ago. My university was hosting an Aboriginal musician and artist, who usually lived in Europe but who also performed in Australia. Jenyuwari was the child of an unusual mixed marriage—Aboriginal father, Dutch mother. He found many of the conditions of living in Australia intolerable. I learned he had grown up mostly in cities, but he has painted acrylic dot paintings. He told me he was authorized to do so by his belated initiation into his father's cultural traditions. All of this was even more surprising because his father had taught himself to read, left his remote community of origin, went to Canberra, and became a lawyer. (Most Aboriginal artists who work in dot paintings remain in or near their rural communities of origin.)

As an anthropologist, whose research has been conducted mostly in the remotest areas, I have had the privilege of learning about indigenous cultural traditions where they are greatest. Thus, I am wary of inquiring too much about anyone's knowledge or experience. I did not want to appear overly curious, inquisitive, or intrusive. As my visitor continued talking I thought it might be polite to let him know I was familiar with many features of Western Desert sociality. This acknowledgement became a prompt for more conversation. It turned out we had some vocabulary in common.

This man had had an incredibly interesting life, and I was intrigued as to how he had made his way so far in the world. What I wondered, of course, was how much he knew and what his relationship was to the forms of Aboriginality that were familiar to me. How was I to behave toward him, seated as we were under the presumption of an essentially Euro-American event—he the artist and I just another New Yorker to him.

What did his history mean to him? I struggled to hear the tones of Western Desert language in the English translations of his experiences as a child, rather as one hears the shapes of indigenous knowledge in Sally Morgan's (1987) story, *My Place*. I remember the story of his grandfather and his grandfather's funeral. His grandfather, he told me, lived to nearly 200 years! What was I to make of this? I'm largely a rationalist and I don't believe anyone has lived to this age, but would I question this attribution of greater health to his indigenous forbears? I wondered what it meant for him to say this. He remembered the funeral. When his grandfather died, "warriors" arrived from out of the desert, armed and impressive in their demeanor. I imagined the approach of the formation of men bearing spears point downward, the custom for "sorry business." Was this what he had seen? Was his translation really what this custom literally represented?

To me, it was very moving—an expression of identification, an attempt to translate some deep experiences into a language that might communicate its value to listeners and perhaps to himself. What kind of currency is contained in these statements? What mythopoesis is taking place with "tradition"? That is to say, what kind of new mythologizing was going on here?

Introduction

What stakes might be involved in claims of "indigenous tradition"? In 1973, when I began research in Australia, James Urry, who was teaching at the Australian National University, made it a point of honor to ban the words "tradition" and "traditional" from anthropological usage. He insisted that there must be more productive frameworks to apply to the problem of cultural processes. The Yayayi community, where I lived and started my research with Pintupi-speaking people, was typically represented as "traditionally oriented," if not "tribal," and by then only rarely as "full-blood"—in contrast to the other principal category of Aboriginal presence, "the half-caste." I recite these categories as a reminder of the field of meanings—or, as I would prefer to say, the field of cultural production—in which such concepts and categories must be understood. My doctoral dissertation (Myers 1976), "To Have and To Hold," was subtitled "A Study of Persistence and Change in Pintupi Social Life" and not, as it might unthinkingly have been, "Tradition and Change."

My own ethnography could be positioned in relation to claims about "the resonance of tradition" because I stressed a dimension of cultural continuity, the past

in the present in Pintupi social life. When he visited New York several years ago, David Trigger took me to task for what he thought was too great an emphasis on this cultural continuity, and I realize very well that what I perceived in Pintupi communities does not automatically extend to communities where the relations with settlers, the state, and the missions had been more brutal.

Recognizing the many eloquent works on "tradition" written by Bob Tonkinson (1999), Francesca Merlan (1991, 1998), and Beth Povinelli (1993), I want to engage with a line of thought begun by Jeremy Beckett (1988) when he wrote about the making of Aboriginalities in distinctive institutions. This step away from culture as context toward culture as it is produced can be extended. This article draws principally on what I have learned since my first book (Myers 1986) through an ongoing study of the circulation of culture, of acrylic painting in Central Australia, and the processes through which it became "fine art." Here, my previous experience with Pintupi people underlies my study of this as an indigenous project that extends into a broader space, one of "business." It leads me to the question of what makes something or someone "Aboriginal"? What are the boundaries of Aboriginality?

Culture-Making

How should we think about cultural continuities without reifying culture? This is a fundamental question for an anthropology that engages with the present. If we are not only antiquarians concerned with unearthing the truth of an original Aboriginal alterity (however alluring that may be), attention to what is happening directs us to Aboriginal cultural production, to the production of Aboriginal cultures. This is a production in which the idea of tradition—an objectification of culture—has become significantly a part. Of course, for indigenous peoples of the fourth world, tradition is particularly fraught with tension. Tradition has been used as a vehicle for dividing Aboriginal people, empowering some but not others. The claim of its possession is a claim of survival, persistence, and connection to a past. It is in fact because such a seemingly innocuous concept can have such serious real world consequences for indigenous people that it is worth thinking our way through it once again.

The Australian Institute of Aboriginal and Torres Straits Islander Studies returned to the question of tradition at the conference Indigenous Tradition in 2001. The conference was a response to a *zeitgeist* in which the disintegration of communities designated as "traditional" has become epidemic. It was a time in which Noel Pearson (2000) questioned whether drinking practices and violence should be accepted under the sign of "tradition" (or "Aboriginal way") when the status of native title rights to land, designs, and knowledge figured prominently in public debate and policy questions about Aboriginal futures. Thinking about a "cultural future" (as Eric Michaels [1994] called it) is not as easily imagined as the

once-promising frameworks of self-determination conceived of it. Although the topic seems self-evident at first, it is a minefield.

So, what about "culture"? Looking at culture as the context for rendering the world intelligible is not the same as conceiving it within history. We should have always recognized that even supposedly "traditionally oriented" people did not just "have" a culture. They certainly had a set of interpretive practices and resources. But however much the observer may gain entry to a world by "learning" the meaning of a sign, in actual practice signs do not just have a meaning; they are made to have meanings, in practice to be given signifieds. How else do children or initiates acquire them but through the practices of those who have the authority to define the signifieds? It is not, as Ruth Benedict's (1934) idea of culture once implied, that people cannot think outside their culture. It is more the question of how their attempts at signification will be received by others and whether these significations will be ruled out as meaningless by those with the authority to do so.

What conception of culture might be required by an account of acrylic painting? A concept of culture that emphasizes the "universe of meanings within which signs operate," or "a system of symbols and signs," has the capacity to explain different assumptions that Aboriginal painters might bring to interaction. Such notions of culture might help make indigenous intentions intelligible, but they do not provide for the space of negotiation. For example, my friend Uta Uta Tjangala's insistence that a painting is a sacred object might coexist oddly with his willingness to sell it as a commodity for $400,000 and then eventually agree on $35. "Culture" has tended to become reified in the anthropological salvage project, as anthropologists tried to understand the many different ways in which people have made sense of the world. This concept was especially important or meaningful for the American national cultural project (asserting the dominance of nurture over nature, the idea of a New World, asserting the possibility of immigrants becoming assimilated rather than being racially determined). The claim that there could be many different ways of cultural being led to the conclusion that there was a bounded—even exclusive—culture.

But such cultures were never what people saw—not according to the accounts of American anthropologists Paul Radin or Edward Sapir during the early twentieth century. What they saw through the medium of indigenous life histories and autobiographies were people making sense of things, negotiating meanings, and trying out new ways of thinking and being. Sapir (1938) famously knew that one informant, Two Crows, denied everything that another Dakota informant claimed to be the case. This is the import of Carlo Ginzburg's (1980) extraordinary portrait of the sixteenth-century heretic Menocchio in *The Cheese and the Worms*. Menocchio was burned at the stake for the personal cosmology he had created through the application of his newly gained literacy. It is also the point of Clifford Geertz's (1973) depiction of Cohen in "Thick Description."

Deploying the old concept of culture, one was guided to discern implicit assumptions, whatever their theoretical inadequacies. Those of us in the early con-

text of self-determination articulated the ways in which cultural models mediated indigenous experience. We sought the ways in which local models of "authority" constructed indigenous relationships with the government and other bosses along the lines of those organized internally, such as in my delineation of *kanyininpa* (looking after) and local notions of personhood. Recognition of such assumptions may be vital to the project of those—like Noel Pearson (2000) and Peter Sutton (2001)—who have suggested the necessity of examining the implications of different cultural formations for the contemporary situation. But it has been more difficult to recognize that such models were not an invariant structure, that they might have circulated with other alternatives, since their application depended on the interpretive authority of particular actors.

That such a stew might be the cauldron of culture in Aboriginal communities is an important step, however much it might challenge the current folk view of "traditional culture" shared by many stakeholders in the definition of Aboriginal social life. From the point of view that I wish to advocate, culture is not static. My perspective is more like that offered by Geertz in "Thick Description," or even in the situational analysis of the Manchester School (such as Epstein 1967 and Van Velsen 1967). One imagines a range of possibilities—what might be called an "arena" (Turner 1974)—in which a field of meanings are brought to bear by potentially competing actors, and any stability is sustained not by inertia but by authority and hegemony.

People have widely different perceptions of what is said, and what things mean. Far from tradition simply ruling, they have their own minds and disparate perceptions are not so much an occasion for conformity as for temporary consensus building. Indeed, the Western Desert society I knew was one in which the mandate for the regulation of consciousness was not very strictly enforced. When did it matter? I vividly remember my surprise after leaving a meeting with my self-appointed brother Pinta Pinta Tjapanangka, who was aptly named "Butterfly" because of his lack of focus. Discussions had taken place at the meeting, but upon leaving Pinta Pinta Tjapanangka turned to me and asked what had been said.

Such has been my empirical warrant for recommending that we not think of signs as having a meaning, but rather of signifiers being made to have a signified in social action, in fields of power. Young initiates may have no comprehension of the signs in ritual, or may even be misguided until they are addressed by the authoritative claims of elders. Even then, as we know, there is often serious disagreement rather than consensus. This is not a marginal state but the basic condition.

My engagement over the past several years with understanding a history of acrylic painting has led me fully into the messy thicket of "traditionalism." From the beginning, the ambiguous status of Papunya Tula's acrylic painting—as art or artifact, as tourist souvenir or fine art, as ethnographic object or painterly achievement—has pressed itself upon every analyst. Produced largely for nonlocal and non-Aboriginal buyers, are the paintings an authentic expression? Of what? Tradi-

tional culture? Traditional painters? Or are they "a product of non-Aboriginal culture" (Willis 1993)? The onetime Papunya Tula art adviser Peter Fannin felt obliged to hedge his bets with the category "fine art-ethnology." Similarly, Vincent Megaw (1982) made this the centerpiece of his thoughtful article. The problem of authenticity pressed itself on the producers themselves, so much so that they insisted to me in 1979, "These are not just pretty pictures. We don't just make these up. They come from the Dreaming" (Myers 1988).

Like other anthropologists in the 1970s and 1980s (Morphy 1977, 1983, 1992; Anderson and Dussart 1988; Dussart 1988, 1993, 1999), I have recognized many linkages between contemporary Pintupi cultural production and that of the past. For example, the painters at Yayayi imagined the circulation of their paintings and the relations this involved with whites to be subsumed within a single cultural model (see Myers 1980a, 1980b, 1986), and not intrinsically limited by the supposed boundary of white and black. I have conceived of such productions of value as a project of "objectification" (see also Sansom 1980), an analytical term drawn partially from theories of exchange that allowed me to generalize from the cultural specificity of Pintupi practices. As I have written elsewhere, the painters conceived of their activities as "giving" or "making visible" their indigenous forms of value to Canberra—expecting recognition of their identity and a return in value (Myers 2002). Exceeding the standard rendering of the "gift" as a moment of reciprocity, this kind of "giving" is a temporary production of one's identity for an Other. Such externalizations of identity into visible form, individually or collectively, represent a kind of social practice that the painters aimed toward their new exchange partners, constituting themselves as an autonomous presence in the process.

But Aboriginal understanding of what the paintings mean has not simply been an internal matter, nor could any of us control the meanings in the emerging intercultural space where concerns about "authenticity" and "tradition" have defining power. If acrylic paintings are not really produced for local consumption, for ritual use specifically, their status as "authentic" primitive art (Price 1989; Errington 1998) would be problematic for the collectors who regard them as less vitally linked to the life-world of those who make them. Yet, the Aboriginal producers do regard acrylic paintings as authentic. They are at once commodities and what Annette Weiner (1992) taught us to recognize as "inalienable." What's the problem here? Is it the truth of indigenous meaning and intention? Or rather do we need a framework more suited to comprehend such processes of interpretive contest? You can feel the pressure in accounts to overcome the slippage in our concepts.

Acrylic paintings have been challenged as "nontraditional"—extended into the field of art from ritual and other legacies of sign-making. Surely, we might have said that since there is no concept of art, these paintings are not authentic, not traditional. It is something else. Well, it is nonetheless grounded in the subjective horizon of Pintupi painters, a directing of their signifying practice towards new participants. (We often see cases where we can argue that there is no indigenous

term for art; see, for example, Perkins [article 13]. Or perhaps we want to argue that there is such a term, as Sutton [1988], Morphy [1998], and others have done.)

Even more, it has been pointed out that the painters were criticized by other Aboriginal people for breaking their rules (Johnson 1990; Kimber 1995), as if these rules were everlastingly definitive and unchanging. But, it seems to me that the Pintupi men I knew were never absolutely sure whether an action did break the rules according to someone else, and they knew that every ritual step was dangerous precisely because someone might claim it was inappropriate. Is it surprising that they thought everyone died from sorcery in punishment for overstepping their rights?

Can we open the boundaries of this culture concept? The meanings and practices of ritual performance, design, and mythical narrative are not a cause—the absolute determinants—of contemporary form. Rather, they are only part of the field of its contemporary production. For some, perhaps a man like Jenyuwari, their claim is—as Pintupi painters also sometimes said—that the designs had been held by those who went before: tradition, surely. The emphasis may be on repetition, or continuity and survival, but who is to say that a sign grasped first for its indexicality may not itself grasp other signifieds? Who is to say that the only authentic participation in "Aboriginal cultural traditions" is only that which starts from birth? Who is to say that engagement with the tradition of signs is not to be part of the culture itself, or—better—a form of participation in a cultural community?

To find common ground between the so-called traditional and the contemporary as equal instances of culture-making is not to claim a simple continuity. Rather the point is to insist on interpretive struggle and ambiguity, as regimes of value are constantly brought into new relationships. This line of thinking about culture-making has its roots in the tradition of Pacific studies of intercultural practice, emanating from Peter Lawrence's (1964) work on "cargo cults" through to Marshall Sahlins (1981) and Nicholas Thomas (1991), who have emphasized cultural construction and agency in the face of a world system. To this legacy of cultural study, however, has to be added a concern with the power of the outside "gaze" to define the legitimacy or authenticity of local cultures, of claims to native title. This concern with "tradition" is not, as Tonkinson (1997, 1999) shows, so much a fact as it is part of the interpretive struggle itself. Indeed, it is centrally a condition for the production of Aboriginality.

Such concerns with "genuine" culture or "genuine" traditions echoes a concern with authenticity intrinsic to the modern art-culture system (Kristeller 1965; Clifford 1988)—and from this convergence, my story continues. In my analysis, I pursue the unsettled situation of acrylic paintings as forms of commodity and also sacred value. I do so in terms of the organization of distinctive regimes of value that distinguish "market" and "culture" as distinctive spheres of human activity, and I attempt to regulate the relationships between them. These relationships are a significant site of culture-making around the significance of indigeneity.

Linda Syddick: Tradition and Beyond

It should be obvious that acrylic painting presents a difficult problem for interpretation. It is "fine art-ethnology," sort of one and sort of the other. It is "traditional" and not really so. These distinctions show up quite clearly in the history of interpretive activity—or criticism—awaiting authority. Interpretation of acrylic painting has tended either to be (1) iconographic and referential (explaining mostly what Dreaming stories and landscape features are signified) or to be (2) formalist, asking what colors and organizations of the color plane attract us. When criticism has pressed further, with some exceptions, and more often in the past few years, it has suggested that the painting is expressive of agency or asserts an indigenous presence, identity, or some other characteristic. Vivien Johnson (1994) has pointed out how Clifford Possum's paintings addressed a knowable white audience, attempting to reproduce an aspect of the Dreaming. And John von Sturmer (1989) has brilliantly written about the expression of self-realization in the work of Jarinyanu David Downs. My position (Myers 1994) has been that acrylic paintings are only beginning to create their own critical culture, that they are not transparent, not reducible to a preexisting iconographic repertoire. But they are not simply open signifiers, waiting to find a signified. They are complex constructions that are finding an audience, making viewers. Otherwise, would these paintings be anything more than endless, if pleasurable and compelling, repetition? Are they something new in this new media, however much they are also something old?

The paintings are not just transpositions of indigenous design onto a new media. They are transpositions of signifying practice, and only in grasping that do we grasp their particularity as well as their hybrid entanglements. The problem for criticism, surely, lies in its capacity to engage with what may be new or different sensibilities—a problem exacerbated by the intercultural, but also valorized way in which the art world attends to difference, creativity, and innovation.

Much of Western Desert painting concerns places—particularly the places made in the activities of ancestral figures. But what is largely ignored is that, as Nancy Munn (1970) has shown, places are meaningful as tokens of social relationship, acquiring value by virtue of their participation in the transmission of identity (Myers 1986, 1993). That is, place enters into the life-world of subjects already objectified as a location of a Dreaming event and known as such in ritual and mythological practice, acquiring meaning in those practices. Moreover, rather than using this association simply to demonstrate a generalized Aboriginal form of placedness, constructed—so to speak—out of a contrast with the West, such meanings should be considered in historically specific ways, as in the deployment of such constructions in Aboriginal image-making.

Let me explore the work of a single painter in order to consider these issues concretely and in greater depth. Rather than picking someone like Uta Uta Tjangala, who is an exemplar of the historical cultural tradition, I have found consider-

ing someone whose affiliations are more complex helps us to interrogate the question of "tradition." The paintings by a Pintupi woman known as Linda Syddick, or to me initially as Tjungkaya Napaltjarri, do not fall neatly into aesthetic categories. The awkwardness of her placement marks the unsettled situation of acrylic painting, since "tradition" is always already unsettled. That Linda Syddick's Christian paintings signal her Aboriginality through the use of dots seems almost a gimmick until one looks more deeply into her deployment not of iconography or paint schemes but of the practice of painting.

On Longing:
A Contemporary Aboriginal Painter in Australia

Because of her development of Christian themes and interest in Western popular culture, Syddick's paintings challenge the critical conceits of what might be deemed "authentic" Western Desert painting. Such authenticity has largely been understood as transmitting an understanding of the Dreaming and "placedness." Syddick's work makes it clear that critical understandings of "place" in Aboriginal painting remain as limited in terms of understanding the activity as were the former category of "primitive art."

Linda Syddick's work shows what and how a place signifies, both in its relationship to local Aboriginal identities and also to an engagement with wider themes of disruption and loss. These latter feelings are often implicitly coded as a social formation within the meanings of "place" itself. The activity of painting, which she traces as coming from her adoptive father, was enabled by his giving her the right to paint his place, an activity of recuperating identity. In grasping this sense of her activity we are better able to perceive Linda's artistry—as perhaps the first "modern" Pintupi artist—in conveying this complex understanding of place, loss, and identity. Her paintings are not only an example of this sort of construction, but they also—as good art should—offer us Linda Syddick's insight into it.

Tjungkaya Napaltjarri

Linda Syddick was the daughter of one of my principal informants and close friend, Shorty Lungkarta Tjungurrayi (figure 1). Shorty was a wonderful man and a gifted painter who helped me to understand much of what I came to know about Pintupi social life and culture. He died in 1987. I understood that one of his daughters, Tjungkaya, had been born in the bush, but she seemed to have turned her back on the traditions embraced by Shorty by moving to Alice Springs.

In 1981, Shorty's wife Napulu told me a story of the killing of her first husband, Riinytja Tjungurrayi, by a revenge expedition (*warrmala*), long ago when she

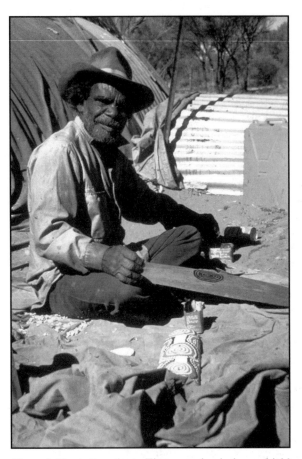

Figure 1. Shorty Lungkarta Tjungurrayi painting a shield in his camp at Yinyilingki, Northern Territory, 1979. Photo by Fred Myers.

still lived "in the bush." Napulu's husband was speared by the killers and thrown into the fire.

In the commotion, Napulu escaped with her small daughter, Tjungkaya, crawling off away from the camp. This must have occurred in the early 1940s in the Gibson Desert. I knew Tjungkaya in the early 1970s, when she and her husband Musty Syddick lived near Shorty at Yayayi, a Pintupi community in the Northern Territory. I knew her as a tall and hearty woman who lived with a part-Aboriginal initiated Arrernte man—somewhat outside the local community with long stays in the fringe camp of Morris Soak in Alice Springs. During the early 1970s, I never would have envisioned her as a painter. Imagine my surprise at seeing two paintings by Linda Syddick in the Gondwana Gallery in Alice Springs in early July 1991! The two paintings were set up as a series and, I was told, they represented "her story." The first painting (figure 2) shows "her father being speared and put on the fire, while she and her mother are hiding near the fire." The second painting (figure 3) represents "spears—men spearing the clouds and washing away the blood." That is, they cause it to rain and cleanse the earth.

I was greatly affected by seeing these paintings, for personal reasons more than aesthetic ones. Tjungkaya was not Shorty's biological daughter, but adopted by him when he married Napulu. I had also heard of Tjungkaya's biological father in Shorty's life history accounts of his experiences as a young man who had hoped to have Napulu for a wife. I was also interested to discover that Linda had made a

Figure 2. Linda Syddick, *Father's Body Thrown in Fire*, 1991. © 2003, Artists Rights Society (ARS), New York/VISCOPY Sydney 2001. Photo by Fred Myers.

Figure 3. Linda Syddick, *The Cleansing Rain*, 1991. © 2003, Artists Rights Society (ARS), New York/VISCOPY Sydney 2001. Photo by Fred Myers.

name for herself as a painter of Christian religious images, such as *The Ascension* and *The Last Supper* (figure 4 and figure 5, respectively), and had won the Blake Prize for Religious Art. Apparently, the painting of the Ascension draws on the fact that "men of high degree (Aboriginal shamans) were buried with their arms and legs tied up," which is how Linda paints Jesus in this markedly syncretistic image. Initially, I thought of her work as interesting in a number of ways, as an introduction of historical narrative into Pintupi painting, informative as an indication of how Pintupi people might experience over time the loss of a parent through violence, and as an insight into the process of becoming Christian through the use of some of the iconography of Pintupi painting to tell Christian stories. Initially, not recognizing any deeper, specific links in the image, I thought her second painting referred to her state of mind, a Christian sort of grace. How little I understood the interpenetration of cultural signifiers and signifieds.

It was when I returned in 1996 that I gained a deeper understanding of these images, both as "artistic communication" and as evidence of the way in which place and its representations might convey significance for Pintupi. When I strolled with an elderly Aboriginal painter friend into the gallery where Linda's paintings were sold, I was recognized by the dealer (Roslyn Premont), who said she wanted to talk to me about Linda. There was interest in doing an exhibition of her work, she said, but Linda was troubled. Actually, I realized, she "had trouble" in the

Figure 4. Linda Syddick, *The Ascension*, 1991. © 2003, Artists Rights Society (ARS), New York/VISCOPY Sydney 2001. Photo by Fred Myers.

Aboriginal sense: someone had accused her of doing wrong, as a woman, in painting Tingarri stories. These are part of a class of Dreaming stories that are associated with the travels of ancestral beings who were instructing postinitiatory novices. The dealer thought Tjungkaya might want to talk to me; I assume Tjungkaya's interest arose because she knew me to have been very close with her father and because she thought me unusually suited, for a white person, to understand her predicament. The dealer rang Linda on the telephone, calling Taree where Linda was living in South Australia with her current husband, a white man who had met her when serving as a dentist for the Aboriginal health service in Alice Springs.

I spoke to her in Pintupi and to her husband in English. She had a story, she said, about Emu men who were "perishing" (dying of thirst) at Walukirritjinya, so they got some "clever men" to fashion spears (*kularta*) and to use a "mirror," throwing spears into the sky to bring a cleansing rain. This was, I realized, a story associ-

ated with Shorty Lungkarta. It is a Tingarri story, part of their cycle of activities, but the key to understanding its significance is that it involved Emu ancestral beings at a place called Walukir-ritjinya. This is a place that I knew to be closely identified in almost everyone's mind with Shorty Lungkarta. His father had died there, and Shorty had been ceremonially in control of its stories and ritual. I had not

Figure 5. Linda Syddick, *The Last Supper,* 1991. © 2003, Artists Rights Society (ARS), New York/VISCOPY Sydney 2001. Photo by Fred Myers.

known about the Emu beings as part of the story, but I had seen Shorty paint versions of this story numerous times. Following his own logic of authenticity, the husband wanted to know what the "mirror" was, and Tjungkaya told me it was a *tjakulu,* that is, a pearl shell—an item often associated with rain in Aboriginal understandings. As Tjungkaya talked, I realized that this story was the second of the ones I had seen in her paintings a few years before: this one was identified with Shorty and Shorty's place or country, while the first, of the spearing and fire, was of her first father, Riinytja.

The issue for her, and for her husband, concerned her right to paint. Her own country, she told me (as I knew), was near Kiwirrkura, considerably further to the west, where she was born and from where her mother came as well. She told me that before he died, Shorty Lungkarta had told her she could paint his country, the Tingarri there. Linda's husband suspected that the jealousy of a sister had been the basis for recriminations of wrongdoing, but Linda was unquestionably concerned by it and insistent on the right to paint Shorty's country, insistent on what this meant about their relationship. The emotional tone made me realize something about the paired paintings I had seen, a pair that Tjungkaya had insistently told the dealer should be a set, not separated. If the cleansing rain represents Shorty Lungkarta, then his being her father was indexed not just in the painting's iconography, but also in the transmission to her of the right to paint his country. It represents a settling of the upset of the first loss, signified by the fire. Iconographically,

this occurs at another level of mediation: water soothes the fire, cleanses, makes things grow, cools the pain. The activity of painting, which comes from Shorty and is enabled by his giving to her the right to paint his place, is an activity of having a place and of recuperating identity. In this way, Linda's paintings represent a powerful, symbolic formulation of "loss," "estrangement," and "redemption."

I had the extraordinary fortune at this same time of meeting Allison French, the curator of the government art gallery in Alice Springs, who had written a grant proposal for Linda Syddick to obtain funding for her painting. In order to write the submission, French had asked Linda and her husband to make a tape answering the questions she thought were important for the proposal. In short, she needed to know, what did Linda want? After listening to Linda's response, Allison felt that she really did not understand much of what Linda had said because most of it was in "language" (Pintupi), but she felt it was somehow important. So she asked me if I would listen to it and see if I understood.

Beginning in somewhat labored English, Linda talked about how her father, Shorty Lungkarta, taught her his country, his Dreaming, and told her—his eldest daughter—that she would paint these when he was dead. Thus, she paints Tingarri stories, the stories of the carpetsnake (known as *kuniya*, probably referring to a place called Lampintjanya, which Shorty often painted), and "God's word" (*Katutjaku wangka*). What the tape was supposed to elicit was what she wanted to do with the grant—and she said she wanted money "for my property, for *ngurra* (that is, "country," "camp," or "home") here" (in South Australia where she was living at the time). Then she said she was getting tired of talking.

When her husband took up the microphone, he reported that Linda was "singing to her painting," apparently wanting Allison to know that something authentic was going on—rather than an inauthentic money-making scheme. "Singing" would indicate to him that the painting was traditional, associated with ceremonies. He recorded what she was singing, saying it was "men's stories." But, as I realized as the singing went on, what she was singing was the class of song/story known as *yawalyu* and sometimes identified in English as "love magic." She tells Allison this, addressing her in Pintupi and English: "Did you understand my word (what I said)?" And then she sings more songs. She seemed to me to be redefining the relationship between herself and Allison, reconstituting who she was, portraying herself more and more as Pintupi by shifting to that language. Instead of being the supplicant by responding to questions in English, she offered herself as knowledgeable, autonomous.

Her comments were intended for Allison. She says, "You, Allison, you are woman alone" (single). "This story is bringing man, making him 'see' you" (bringing you to his thoughts). She sings verse after verse and narrates the event in it—initially with an emphasis on a woman singing to bring a man, because "she doesn't want to be alone." Increasingly, however, Linda's narration turns to feelings of "sadness" (*ngaltu*) in the songs—not just of the longing to overcome separation and desire, of

"love magic" premised on the desire to be recognized by certain others. The narration describes a man's sadness at his distance from a daughter. In the account she is giving on the tape, she describes the man of the story as having moved away "*yuntaltjirratja*"—wishing for his daughter. These were also probably the feelings that Linda was concerned with herself, having moved to South Australia with her current husband after the sequential deaths of her children. Her loss, or losses, have been crushing—a father to violence, three children at an early age, two husbands.

Addressing Allison initially as a woman without a man, she establishes a common human ground, but one that she controls as the possessor of ritual and its knowledge. While her husband wanted to emphasize Linda's authenticity (referring to the songs), she first centers herself and defines a relationship with Allison, whom she addresses directly, "You [are] white woman; you can't sing *inma* (ritual), can you?" This shows something important in her possession. Second, she defines herself as an Aboriginal. Finally, she invokes "sadness." "Tired," as she says, of responding in the terms initially established by Allison (about the grant, about publishing), Linda shifts the ground of the communication. This seemed apparent as the tone of the tape shifts.

Linda's concern with "loss" and "salvation" is palpable. It is the story of the loss of her first father and her life being cleansed and

Figure 6. Linda Syddick, *ET Returning Home*, 1994. © 2003, Artists Rights Society (ARS), New York/VISCOPY Sydney 2001. Collection of the Museum and Art Gallery of the Northern Territory.

repaired by her second father, Shorty, who gave her—in his adoption and in the transmission of his country—a new life. Unexpectedly, it is also the story of the substantial body of paintings she did of E.T., the extraterrestrial figure in Steven Spielberg's film of that name: the alien estranged from home (figure 6). She has watched this Hollywood film absorbedly, more than twenty times. "Linda is fascinated by this movie," her dealer Ros Premont (1993) has written. "Her empathy was sparked by E.T. longing to return home." These are the feelings—homesickness, pining—of grief, of loss, which Central Desert Aborigines articulate in song and ceremony. These are feelings signified in and through "places"—as Walukirritjinya and its story of bringing the rain does for Linda. And this is the story of Christianity, offering similarly a salvation from her loss and estrangement—the loss of her children, of her father, and to some extent now of her culture.

As Pintupi learn to experience the environment, places such as Walukirritjinya are already objectified. Shorty Lungkarta gave Linda the right to paint it, and his act of doing so is central to her. The specific iconography of the place, the story elements of its fashioning in the Dreaming, which are already socially objectified and define it as a token of identity and exchange, takes on a doubled use that is part of its aesthetic function (to borrow a usage from Roman Jakobson [1960]). Jakobson described the aesthetic function of any communicative event as one oriented to the message for its own sake. It is not only the possession of the place and the right to paint that establishes an identity, but also the specific imagery of the spearing of the clouds and the cleansing water poetically reverses the loss of her first father in the fire. Herein, at least in part, lies Linda's artistry in conveying this complex understanding of place, loss, and identity.

Longing

It is difficult to ignore the larger themes—of how place signifies "at homeness" or wholeness—in narratives of uprootedness, displacement, and loss. This connection is invoked through the E.T. paintings, and it is a theme about place one also finds expressed in the formulation of diaspora cultures. Linda seems to have found something of value in E.T., something paralleled by the longing of the Jewish Diaspora for the place (Zion) tied to ancestors, continually evoked and kept alive in ritual (such as the Passover seder). *E.T.* is one of several films—a list that also includes *Schindler's List*—by Spielberg, a filmmaker whose attention to Jewish themes of exile and return has been pointed out by many critics. Undoubtedly, the Pintupi construction of place is not built on separation from a homeland in the same way, but in an uncanny and perspicacious manner, Linda has picked up on Spielberg's concerns in her art. Rather, Linda's painting suggests that separation/ longing/recognition are fundamentally encoded or activated in the transmission of relations to place.

It should be no surprise that Linda Syddick can formulate this relationship of place in her art. The sensibility of this complexity is central to Aboriginal communications about place. In 1983, when the hearing for the Mongrel Downs land claim—on which I worked—was held, the Aboriginal land commissioner visited some sites with the claimants. That night, the claimants performed an enactment of a Tingarri sequence to demonstrate their rights to the area. In this performance a stone curlew bird led them as they passed through the region and created the country by their actions. The Tingarri ancestors were known in this region near Lake Hazlett as Wirntiki. The main performer, Allen Wintu Tjakamarra, was understood to have been conceived from the essence of the Wirntiki, and therefore was its real life embodiment. The men chose to perform the sequence in which the stone curlew passes with the novices under his supervision through a raging (ceremonial) fire. He looks back sadly to the country from which he came, his own country, and calls out "goodbye my country; I will see you no more."

Linda Syddick's paintings extend and discern in painting practice a particular formulation of identity, loss, and replacement that must have had long standing in Western Desert life. Distilling this cultural formation, she articulates a more general longing—one we can now see to have been imagined more concretely in practices we regarded narrowly as love magic. Her painting of loss, redemption, and longing is a reflection of states of being and an economy of desire defined by Pintupi understandings of "sorrow"—*yalurrpa*—as the loss of an object fundamental to one's identity.

Circulating Discourses of Art: Blurred Genres

The concern about "tradition," of course, comes from somewhere. The anthropology of indigenous Australia is partially constrained by the legal concepts and processes of land claims. Legitimate claims rely on being cast as "authentic tradition." This makes anthropology and its interpretive practices complicit with a production of Aboriginal cultures that continues to stitch culture and tradition into some kind of wearable garb. In this respect, while the interest of scholars of and from the diasporic world has valorized hybridity and dislocation in cultural theory, those of us working with indigenous communities have a different problem. I was well aware that my first ethnography—according to Eric Michaels (1994), the "last" of the ethnographies—would have an impact on land claims. This puts constraints on how deconstructed your concept of culture can be.

The irony of Aboriginal acrylic painting condenses these debates. It acquires value (in the market) ostensibly through its incarnation of tradition. And the recent and ongoing debates or scandals about its authenticity ("dots for dollars") exemplifies the power of this. Yet, I want to argue its real power and lasting value is that it appears to be of "tradition" while violating it. This ambiguity constitutes its unsettlement.

But this work must be seen as addressed to a present, whatever it brings from a past. Writing about "multiculturalism," Terence Turner (1993:17) has argued that the current global cultural conjuncture has made for "the steady proliferation of new cultural identities along with the increasing assertion of established ones." Along these lines, the principal discourse of Aboriginal painters emphasizes their works as vehicles of self-production and collective empowerment. Such interpretations almost surely represent an engagement with emerging theoretical discourses in the arts themselves that emphasize, in the framework of multiculturalism, "the self-definition, production, and assertion of cultural groups and identities in general." Yet, as Fiona Foley has claimed it should (Isaacs 1990), Aboriginal painting does so from its own particular histories and conceptions of collectivity and power. These differences, or particularities, are what make this work of interest to the art world—both contributing to its development of a general theory of such cultural activity as "art" and drawing on it for a historical frame. Linda Syddick's painting could be seen as instantiating the capacity for self-creation within a particular history—having both transcultural and specific meaning.

Blackfella/Whitefella

Whatever they might be understood to "say," the entry of acrylic paintings into the category of "fine art" has produced a counterweight of suspicion in Australia, where the rough edges of the fit between Aboriginal acrylics and "fine art" generate a concern about "commoditization" and evoke the constitutive opposition of art and money in Western theory. In her essay "Culture Wars," Marcia Langton (2003) has seen the scandal mongering as part of an ongoing and intensifying culture war in Australia, whose base lies in white anxieties, anxieties about the entry of indigenous culture and values into the broader society. This resistance to the rise of Aboriginal regimes of value can be palpable, but so has been the ever-increasing visibility of Aboriginal cultural production. In August 2000, the Art Gallery of New South Wales and Papunya Tula Artists opened a retrospective exhibition in Sydney, Papunya Tula: Genesis and Genius, focusing on the past 30 years of work. It received major critical attention and publicity. Curated by an indigenous curator, Hetti Perkins, the exhibition included approximately 150 paintings (from 50 artists) from the entire period of the movement, including almost all of the most celebrated examples of Papunya art that had been sold for record prices. This exhibition announced definitively the recognition of Aboriginal fine art. For my friend Bobby West Tjupurrula, the retrospective was an occasion for pride, especially in his father's painting.

Even so, at a Radio National interview (August 18, 2000) occasioned by the opening, Michael Cathcart's questions to me carried a probing nuance. Was this really fine art, or was it just a kind of sentimental recognition of Aboriginal culture? "Fred Myers," he asked, "what's your take on this? Is it fair to see this kind of art as

part of a worldwide phenomenon in art, or do we need to see it within a purely Aboriginal context?" Pressing further, the question revealed a concern for the "authenticity" of current Western Desert art.

These probings so paralleled the suspicions circulating in the scandals of the previous several months that most of us understood them to be phrasing that point of view. The next day at the symposium, Marcia Langton made the fundamental response: viewers of Aboriginal art expect that looking at the work itself will reveal its value and meanings. But, she told the audience, responding to the paintings requires work—the work of scholarship, research, and attention, just as we cannot understand Renaissance art merely by looking. Indeed, she said, her own understanding of Western Desert culture was not something she simply knew because of her Aboriginal identity, but was acquired over a long period. How could it be otherwise? Or do we think that Aboriginal paintings are somehow transparent? A simple recognition of "hybridity" is not enough to grasp the internal life of culture. This lies not in reified notions of culture, or even of culture-mixing, but in specific histories of culture-making.

At the end of the events opening this retrospective, a Western Desert Aboriginal rock and roll group, the Warumpi Band, played in the art gallery's main hall, a space usually restricted to the serious gatherings associated with fine art. The words of their celebrated song "Blackfella/Whitefella" were an anthem to the mixed crowd, black and white, pressed together in the new combination objectified in the acrylic paintings:

> Blackfella, whitefella,
> It doesn't matter what your color
> As long as you're a true fella
> As long as you're a real fella

It isn't color, it is the recognition of the reality of Aboriginal lives that matters—recognizing the emerging conditions of cultural production. And then the refrain, "Are you the one who's gonna stand up and be counted?" Here is an invitation that—like the paintings—finds new combinations of white and black. Songs with the specificity of the Western Desert and the Arnhem Land locations of band members, such as "Kintorelakutu" (back to Kintore) and "My Island Home" (Elcho Island), now circulate as part of a more abstract currency for young Australians, white and black, in ways similar to the circulation of Western Desert acrylic paintings for other identities inside and outside of Australia.

Conclusion

At this point, then, I have learned to recognize that the men who attended the funeral of Jenyuwari's grandfather can reasonably be understood as "warriors"—

bearers of social value—and to see in this resignification the everyday work of culture. Similarly, if we are to regard acrylic painting in the frame of "culture-making," we will need a more action-based approach. That this is not an unusual situation is evident if one peruses the works of art criticism with the "acceptance" of cubism or if one considers the processes of ritual socialization or evangelization in cases like the "Balgo Business" of the Western Desert: where forms are put forward and acquire their subjects, hail them, and produce new meanings. The concept of social drama (Turner 1974), or even of tournaments of value (Appadurai 1986), recognizes these reshiftings of cultural hierarchies as part of cultural life, not something added on "by change." It is the recognition of the fields of cultural production that would take us away from the idea of people "having" a culture (or is it they are "had" by the culture?) and move us toward the idea of people making their culture, and remaking it through the "unsettled business" of acrylic painting, which is neither ritual business nor fully commerce.

I want to end with my conclusion from the lecture I gave at the Art Gallery of New South Wales, which was celebrating Papunya Tula's retrospective, where I tried to explain why the circulation of these paintings has been so promising and so problematic. They help us as well to rethink tradition in a contemporary context. The hopes of the Yarnangu painters at Papunya, Yayayi, Yinyilingki, and beyond for new levels of connection and recognition, the expectation of renewed value for their own cultural forms, these are all part of what the paintings have achieved. Equivalence has not been easy to work out, but in the long view, it is clear that the original insistence on the power of their paintings has been borne out. The effects of the painting movement have been remarkable, far beyond what my early literal translations had imagined. I understood what the painters said, of course, but I would never have anticipated the effects they have had in producing a recognition of their value and power across cultural boundaries. They have contributed to the accomplishment of land tenure security, of establishing significant identity for those whose Dreamings they are, and they have made a kind of Aboriginality knowable to those who view them. In this way, they have evidenced the power they were said "traditionally" to have.

Questions for Discussion

1. In what sense is acrylic dot painting in the deserts of Central Australia "unfinished business"? In what sense is it a business at all?

2. What is Myers's view about whether these acrylic paintings are traditional or not?

3. In what ways are the acrylic paintings discussed by Myers no longer just an art tradition from the desert Aboriginals?

4. How has this art tradition become symbolic of the greater Australian community, including white Australians?

Acknowledgements

This article was written as a keynote speech for the Australian Institute of Aboriginal and Torres Strait Islander Studies Conference 2001: The Power of Knowledge, the Resonance of Tradition, Canberra, Australia, September 18–20, 2001. It is published here with permission of the organizers. It was also adapted from a paper originally published as "Unsettled Business: Acrylic Painting, Tradition, and Indigenous Being," *Visual Anthropology* 17(3–4):247–271, 2004, special issue: Confronting World Art, ed. Eric Venbrux and Pamela Rosi. Thanks to Allison French, Ros Premont, and Tjungkaya Napaltjarri for helping me to understand the contemporary world of Western Desert painting. I would like to thank Dick Kimber for his comments and Faye Ginsburg for her suggestions in reading this essay. The essay draws on material and analyses more fully explored in my book (Myers 2002) *Painting Culture: The Making of an Aboriginal High Art.*

References

Anderson, Christopher and Françoise Dussart. 1988. "Dreaming in Acrylic: Western Desert Art," in *Dreamings: The Art of Aboriginal Australia*, ed. Peter Sutton, pp. 89–142. New York: George Braziller and Asia Society Galleries.

Appadurai, Arjun. 1986. "Introduction: Commodities and the Politics of Value," in *The Social Life of Things: Commodities in Cultural Perspective*, ed. Arjun Appadurai, pp. 3–63. Cambridge: Cambridge University Press.

Beckett, Jeremy. 1988. "Aboriginality, Citizenship and Nation State." *Social Analysis* 24 (Special Issue: Aborigines and the State in Australia):3–18.

Benedict, Ruth. 1934. *Patterns of Culture.* Boston: Houghton Mifflin.

Clifford, James. 1988. "On Collecting Art and Culture," in *The Predicament of Culture: Twentieth-Century Ethnography, Literature, and Art*, ed. James Clifford, pp. 215–251. Cambridge: Harvard University Press.

Dussart, Françoise. 1988. "Women's Acrylic Paintings from Yuendumu," in *The Inspired Dream: Life as Art in Aboriginal Australia*, ed. Margie K. C. West, pp. 35–40. Brisbane: Queensland Art Gallery.

———. 1993. *La Peinture des Aborigènes d'Australie.* Marseille: Éditions Parenthèses.

———. 1999. "What an Acrylic Can Mean: The Meta-Ritualistic Resonances of a Central Desert Painting," in *Art from the Land: Dialogues with the Kluge-Ruhe Collection of Australian Aboriginal Art*, ed. Margo Boles and Howard Morphy, pp. 193–218. Charlottesville and Seattle: University of Virginia and the University of Washington Press.

Epstein, A. L., ed. 1967. *The Craft of Social Anthropology.* London: Tavistock.

Errington, Shelly. 1998. *The Death of Authentic Primitive Art and Other Tales of Progress.* Berkeley: University of California Press.

Geertz, Clifford. 1973. "Thick Description: Toward an Interpretive Theory of Culture," in *The Interpretation of Cultures: Selected Essays*, pp. 3–32. New York: Basic Books.

Ginzburg, Carlo. 1980. *The Cheese and The Worms: The Cosmos of a Sixteenth-Century Miller.* Trans. John and Anne Tedeschi. Baltimore: Johns Hopkins University Press.

Isaacs, Jennifer. 1990. "Fiona Foley on Aboriginality in Art, Life and Landscape." *Art Monthly Australia* (Special Issue: The Land, the City: The Emergence of Urban Aboriginal Art, ed. Wally Caruana and Jennifer Isaacs):10–12. Canberra: Arts Centre, Australian National University.

Jakobson, Roman. 1960. "Closing Statement: Linguistics and Poetics," in *Style in Language*, ed. Thomas Sebeok, pp. 53–82. The Hague: Mouton Publishers.

Johnson, Vivien. 1990. "The Origins and Development of Western Desert Art," in *The Painted Dream: Contemporary Aboriginal Paintings from the Tim and Vivien Johnson Collection*, pp. 9–20. Auckland: Auckland City Art Gallery.

———. 1994. *The Art of Clifford Possum Tjapaltjarri.* East Roseville, NSW: Craftsmen House.

Kimber, R. G. 1995. "Politics of the Secret in Contemporary Western Desert Art." *Oceania Monograph* 45 (Politics of the Secret, ed. Christopher Anderson): 123–142. Sydney: University of Sydney.

Kristeller, Paul Oskar. [1951] 1965. "The Modern System of the Arts," in *Renaissance Thought and the Arts: Collected Essays*. Princeton: Princeton University Press.

Langton, Marcia. 2003. "Culture Wars," in *Blacklines: Contemporary Critical Writings by Indigenous Australians*, ed. M. Grossman, pp. 81–91. Melbourne: Melbourne University Press.

Lawrence, Peter. 1964. *Road Belong Cargo: A Study of the Cargo Movement in the Southern Madang District, New Guinea.* Melbourne: Melbourne University Press.

Megaw, J. V. S. 1982. "Western Desert Acrylic Painting—Artefact or Art?" *Art History* 5:205–218.

Merlan, Francesca. 1991. "The Limits of Cultural Constructionism: The Case of Coronation Hill." *Oceania* 61(4):341–352.

———. 1998. *Caging the Rainbow: Places, Politics, and Aborigines in a North Australian Town.* Honolulu: University of Hawai'i Press.

Michaels, Eric. 1994. "Towards a Cultural Future: Francis Jupurrurla Makes TV at Yuendumu," in *Bad Aboriginal Art: Tradition, Media, and Technological Horizons*, pp. 99–110. Minneapolis: University of Minnesota Press.

Morgan, Sally. 1987. *My Place.* Fremantle, WA: Fremantle Arts Press.

Morphy, Howard. 1977. Too Many Meanings: An Analysis of the Artistic System of the Yolngu of North-east Arnhem Land. Doctoral diss., Australian National University.

———. 1983. "'Now You Understand'—An Analysis of the Way Yolngu Have Used Sacred Knowledge to Retain their Autonomy," in *Aborigines, Land and Land Rights*, ed. Nicolas Peterson and Marcia Langton, pp. 110–145. Canberra: Australian Institute of Aboriginal Studies.

———. 1992. *Ancestral Connections: Art and an Aboriginal System of Knowledge.* Chicago: University of Chicago Press.

———. 1998. *Aboriginal Art.* London: Phaidon.

Munn, Nancy. 1970. "The Transformation of Subjects into Objects in Walbiri and Pitjantjatjara Myth," in *Australian Aboriginal Anthropology*, ed. Ronald Berndt, pp. 141–163. Nedlands, WA: University of Western Australia Press.

Myers, Fred. 1976. To Have and To Hold: A Study of Persistence and Change in Pintupi Social Life. Doctoral diss., Bryn Mawr College.

———. 1980a. "The Cultural Basis of Politics in Pintupi Life." *Mankind* 12:197–214.

———. 1980b. "A Broken Code: Pintupi Political Theory and Contemporary Social Life." *Mankind* 12:311–326.

————. 1986. *Pintupi Country, Pintupi Self: Sentiment, Place, and Politics among Western Desert Aborigines.* Canberra and Washington, DC: AIAS and Smithsonian Institution Press.

————. 1988. "Burning the Truck and Holding the Country: Forms of Property, Time, and the Negotiation of Identity among Pintupi Aborigines," in *Hunter-Gatherers, II: Property, Power and Ideology,* ed. David Riches, Tim Ingold, and James Woodburn, pp. 52–74. London: Berg Publishing.

————. 1993. "Place, Identity, and Exchange: The Transformation of Nurturance to Social Reproduction over the Life-Cycle in a Kin-Based Society." *Oceania Monograph* 43 (Exchanging Products, Producing Exchange, ed. Jane Fajans): 33–57. Sydney: University of Sydney.

————. 1994. "Beyond the Intentional Fallacy: Art Criticism and the Ethnography of Australian Aboriginal Acrylic Painting." *Visual Anthropology Review* 10(1):10–43.

————. 2002. *Painting Culture: The Making of an Aboriginal High Art.* Durham: Duke University Press.

Pearson, Noel. 2000. *Our Right to Take Responsibility.* Cairns: Noel Pearson and Associates.

Povinelli, Elizabeth A. 1993. *Labor's Lot: The Power, History and Culture of Aboriginal Action.* Chicago: University of Chicago Press.

Premont, Roslyn. 1993. "Tjankiya (Linda Syddick) Napaltjarri," in *Australian Perspecta 1993,* ed. Victoria Lynn. Sydney: Art Gallery of NSW.

Price, Sally. 1989. *Primitive Art in Civilized Places.* Chicago: University of Chicago Press.

Sahlins, Marshall. 1981. *Mythical Histories and Metaphorical Realities.* Ann Arbor: University of Michigan Press.

Sansom, Basil. 1980. *The Camp at Wallaby Cross: Aboriginal Fringe Dwellers in Darwin.* Canberra: Aboriginal Studies Press.

Sapir, Edward. 1938. "Why Cultural Anthropology Needs the Psychiatrist." *Psychiatry* 1:7–12.

Sutton, Peter. 1988. "The Morphology of Feeling," in *Dreamings: The Art of Aboriginal Australia,* ed. Peter Sutton, pp. 59–88. New York: George Braziller and Asia Society Galleries.

————. 2001. "The Politics of Suffering: Indigenous Policy in Australia Since the 1970s." *Anthropological Forum* 11(2):125–173.

Thomas, Nicholas. 1991. *Entangled Objects: Exchange, Material Culture and Colonialism in the Pacific.* Cambridge: Harvard University Press.

Tonkinson, Robert. 1997. "Anthropology and Aboriginal Tradition: The Hindmarsh Island Bridge Affair and the Politics of Interpretation." *Oceania* 68(1):1–26.

————. 1999. "The Pragmatics and Politics of Aboriginal Tradition and Identity in Australia." *Journal de la Société des Océanistes* 109(2):133–147.

Turner, Terence S. 1993. "Anthropology and Multiculturalism: What is Anthropology That Multiculturalists Should Be Mindful of It?" *Cultural Anthropology* 8(3):1–19.

Turner, Victor. 1974. *Dramas, Fields and Metaphors.* Ithaca: Cornell University Press.

Van Velsen, Jaap. 1967. "The Extended Case Method and Situational Analysis," in *The Craft of Social Anthropology,* ed. A. L. Epstein, pp. 129–149. London: Tavistock.

von Sturmer, John. 1989. "Aborigines, Representation, Necrophilia." *Art and Text* 32:127–139.

Weiner, Annette B. 1992. *Inalienable Possessions: The Paradox of Keeping-While-Giving.* Berkeley: University of California Press.

Willis, Anne-Marie. 1993. *Illusions of Identity: The Art of Nation.* Sydney: Hale and Iremonger.

9

The Postcolonial Virtue of Aboriginal Art from Bathurst and Melville Islands

Eric Venbrux

More than anything else, it seems, Aboriginal art reflects worth, morality, and modern success in contemporary Australia. After an international "breakthrough" in the late 1980s, Aboriginal art became embedded in civil religion Down Under. Rhetorically, the omnipresence of visual art produced by Aborigines demonstrates the nation's postcolonial virtue. It suggests that mainstream Australia and the institutions of the state have come to terms with past wrongs to the indigenous population. It has become a symbolic reconciliation to removing the taint of colonial vice.

This article considers the implications of the success of Aboriginal art for its local producers in one of the most remote parts of Australia. What does it mean to be an artist in a so-called "traditionally oriented" Aboriginal community producing for the world market? What happens when young Aboriginal people are stimulated to produce fine art suitable for an external market in order to boost their self-esteem? Aboriginal people are constantly being told with dread about the loss of their "culture." In dealing with these questions I focus on the case of Tiwi artists from Bathurst and Melville Islands in north Australia.

First, I discuss the postcolonial virtue of Aboriginal art in relation to Australian national identity. The next section examines certain notions of "culture" that have currency in Australia today, especially those ideas that surround the government-supported Aboriginal arts and crafts industry. Drawing on these notions I explore the problem of cultural empowerment. Then, I turn to a discussion of art production in the local context of Tiwi sociocultural life. Finally, I assess the impact of these messages of cultural loss on the understandings of local artists, who produce neotraditional art for external consumption.

The Art of Being a Worthy Citizen

Writing in the early days of Aboriginal art promotion, anthropologist A. P. Elkin (1956:10) stressed the emancipatory role that a recognition and appreciation of their art could play for Aborigines, namely to be seen as "much higher on the human scale than previously thought." He envisioned that Aborigines, then at the point of being granted civil rights, "can and will become worthy Australian citizens" (Elkin 1964:354–355).

One high point in the "discovery narrative" (Errington 1998) of Aboriginal art was the display of a set of seventeen Tiwi grave posts in the Art Gallery of New South Wales in Sydney in 1959. The exhibition aroused controversy when an Australian art critic argued that the proper place for these Aboriginal works was not an art museum but the museum for natural history. This first-ever exhibition of Aboriginal works in a major art institution counts as a landmark in the history of Aboriginal art (Jones 1988:175). Undoubtedly, the debate about art that ensued enriched the meaning of the event, which is now generally considered a decisive turning point in the framing of Aboriginal works: ethnographic artifacts had finally found recognition as fine art. We should, however, note that these objects were nevertheless still viewed as "primitive art," a fact usually forgotten in these celebratory tales of how white Australians came to appreciate Aboriginal art.

During the twentieth century, European perceptions of Aboriginal art(ifacts) changed most radically from a sign of hard primitivism to canonical high art (Jones 1988). In terms of interest and recognition by the international art world, it seems that Aboriginal artists surpassed the non-Aboriginal ones (Mundine 2002). The latter took a backseat, so to speak, hoping to gain wider recognition by following in the train of successes (from an Australian perspective) of Aboriginal artists in arty hot spots like New York, Paris, and Venice.

"Only Aboriginal art, it seemed, could position the Australian local in the global, and paradoxically, make an Australian art of global significance" (McLean 1998:119). Howard Morphy (1998:417–420, 2001) makes clear that Aboriginal art has eroded the established categories of art in Australia. Moreover, he is of the opinion that the modern success of Aboriginal art owes a great deal to Aboriginal agency:

> Aboriginal art is now being incorporated in the general discourse over Australian art. It is collected by the same institutions, exhibited within the same gallery structure, written about in the same journals as other Australian art. This has come about through the Aboriginal struggle to make their art part of the Australian agenda; incorporation should not be interpreted as the appropriation of Aboriginal art by a white Australian institutional structure. (1998:417)

It is precisely because of the respect accorded to high art in the modern world that art serves fourth world peoples, such as Australian Aborigines, as a political tool (MacClancy 1997).

As George Marcus and Fred Myers (1995:11) point out, "Art continues to be the space in which difference, identity, and cultural value are being produced and contested." Aborigines use this space, but have to do so within an infrastructure and art world that is not of their own making. There can be no doubt that art has been effectively used by Aborigines in their political struggles, especially in making clear to the outside world their attachments to the land, cultural values, and indigenous identity. Since Yolngu Aborigines from Yirrkala in northeast Arnhem Land presented a petition framed on bark paintings to the Australian Parliament in 1963, art has been intertwined with the fight for the recognition of Aboriginal land rights. Furthermore, in the nationwide solidarity of Aborigines that emerged, emphasis has been placed on Aboriginality as a postcolonial, pan-Aboriginal identity (McLean 1998:104–105). Art became a powerful medium to express Aboriginality by increasing the visibility of Aborigines. At the same time, the notion of Aboriginality laid the foundation for the market success of the art. For first world consumers the trademark of Aboriginality appeared to be an important reason to buy the art (1998:108). The art in turn drew attention to what Aborigines, in the outback as well as in the urban centers, had to say.

Aboriginal art also had a profound effect on the issue of national identity. As Tony Bennett (1995), Morphy (1998), and others have argued, the 1988 celebration of the bicentennial of European invasion became a turning point in the way Australians imagined their national identity. Aborigines protested. The slogan ran: "Mourn 88, don't celebrate!" Arts coordinator Djon Mundine at Ramingining (Arnhem Land) organized "the Aboriginal Memorial," a set of 200 hollow log coffins made by Aboriginal artists (now in the National Gallery of Australia, Canberra). Prime Minister Bob Hawke accepted a petition on a painting in the Northern Territory and promised Aborigines a treaty. His successor Paul Keating made a point of Australia breaking with its colonial past and eventually becoming a republic. The nation would have to reorient itself—politically, economically, and culturally—to the Asia-Pacific region. In order to become an integral part of the region, and to find connections with the suddenly booming economies in Southeast Asia, Australia needed to restyle its own identity.

In the search for "authenticity" within its Asia-Pacific neighborhood, the idea that Australia possessed "the oldest living culture[s] in the world" was an asset. It was also a common point of reference for the Australian multicultural society. Simultaneously, the imagery served the (economically important) tourist industry to promote Australia's uniqueness as a destination in the global marketplace. It is important to note, as Myers (2001:224) points out, that "the new interest in Aboriginal art as part of national culture was not the sentiment of a majority of Australians," but that the purchases were mainly made by "members of the professional managerial class." All over Australia one could see the distinctive art of the remote outback of the Western Desert, which had none of the overt political messages of urban Aborigines. These acrylic dot paintings became a positive sign that Australia

was getting rid of its guilty conscience about the colonial past and injustice to indigenous people. The point I am getting at is that by displaying and embracing Aboriginal art, made by "the first Australians," non-Aborigines could now be "worthy Australian citizens."

Such is the postcolonial virtue of Aboriginal art that it has come to be seen as essentially "good," both in an artistic and a moral sense (cf. Jensen 2002). "Bad" Aboriginal art is anathema in Australian art writing (Michaels 1994; McDonald 1998). The recognition as fine art, however, allowed dealers in the 1990s to brand Aboriginal art with their own value judgments, while a now conservative government increasingly sought to expose production to market forces (Myers 2001:226; Altman 2005). The new creed in the creation of Australian nationhood bears the name of "reconciliation." On national Sorry Day, for example, Australians say sorry to indigenous people for past wrongs (concerning the stolen generations—children taken away from their families by state agencies—in particular). The opening and concluding ceremonies at the 2000 Olympic Games in Sydney could be cited as another example. Aborigines drew attention to many, initially contentious, issues by means of their art. Indigenous art, says Colin Mercer (1997:viii), "stands as a productive medium for exchange and dialogue between the oldest and one of the newest societies on Earth." Cultural continuities with a long-distant past, as well as spiritual attachments to the land, are expressed in the contemporary art of Aborigines from remote areas, particularly north and central Australia. Hence, the art of these "traditionally oriented" Aborigines has been accorded important symbolic value in both the present political struggle of the Aboriginal elite and Australian nation-making (see also Lattas 1993; Tonkinson 1999).

Guided Cultural Renewal

A feature of Australia's modernity is the use of Aboriginal art in the creation of a distinctive, national identity and accompanying myth of an atemporal tradition (always was and always will be). The "acquisition of an indigenous past" (Byrne 1996) follows the old European model of the use of folk art to these ends (Svašek 1997:12–13). Likewise, as Barbara Kirshenblatt-Gimblett (1998:140) reminds us, "Australia and New Zealand have tended to identify their uniqueness as tourist destinations with the indigenous and to identify culture with the places from which the settlers came." The acceptance of the Anglo-European notion of (high) culture—"one which emphasizes finished artifacts and fixed types of social products apart from the processes of their social reproduction" (Merlan 1989:105)—provides Aborigines with an arena for contestation, mainly in terms of difference, but also sets limits to the agency of local Aboriginal artists in the outback.

Francesca Merlan (1998:234) argues "that earlier devaluation has been replaced by a situation in which Aborigines are being brought to a recognition of a

divide between their past and the present that is stimulated precisely by intensified national effort to maintain and reconstitute Aboriginality." The efforts for Aboriginal "cultural renewal" have been stepped up in the era of reconciliation. According to Merlan, it has been an ongoing concern of the state since the adoption of the policy of Aboriginal "self-determination" in the 1970s. She speaks of a "social technology" forcing indigenous people to "mimic" representations of their past (Merlan 1998:231–240). We might thus ask if "there is loss of control over communal identity as the group is called upon to fulfill the constructions of its identity created by those in authority" (Morris 1989:3). Peter Sutton (2001:136) describes "the fine art trade in outback Dreaming pictures" as "being largely a cottage industry organized by non-Indigenous administrators and entrepreneurs at the point of production as well as of distribution." But he does so in a context in which he wants to draw attention to the harsh realities of life in Aboriginal communities in the outback during the past few decades.

Government support of the Aboriginal arts and crafts industry is intended to offer "the means through which indigenous Australians can be both economically empowered and culturally powerful" (Mercer 1997:viii). Besides their expectation that art production can become a major source of income and will help decrease the dependency on government subsidies and social benefits in Aboriginal communities in the outback, policy makers identified a need for "cultural recovery and maintenance" to safeguard "the fundamental resources" on which the industry is based (ATSIC 1997:18–20). What happens when young Aboriginal people are encouraged to produce art suitable for an external market while continuously being told there is a dread of a loss of "culture"? What does it mean to be an artist living in a so-called "traditionally oriented" Aboriginal community producing for the world market?

Closer to home than the overarching bureaucracy and the dominant art institutions are the white adult educators, arts advisers, or coordinators hired to assist local Aborigines to become artists. Frequently, the coordinators find themselves caught in the crossfire between the demands of bureaucracy and those of members of the Aboriginal community. Given their responsibility to facilitate fine art production and to take care of its marketing, arts coordinators are also important mediators between local artists and the art world. They can be in a position to act as gatekeepers, making the selections of artists and works based on, among other things, their understanding of opportunities in the art market.

Much is done in Australia to promote Aboriginal art, in all its diversity, and there seem to be ample venues for showing the art. The industry, however, is also rapidly expanding and becoming increasingly rationalized. The reception and market success is to a large extent beyond the control of the artists. The making of art can be understood as a form of cultural production, as Myers (1995) has shown with regard to acrylic paintings from the Western Desert, by an art world that involves multiple discourses and actors (see also Bundgaard, article 7). These

actors include the artists, exhibition-makers, art dealers, anthropologists, art critics, and consumers. Whereas these discourses take place within the contexts of a global capitalist system and an unequal distribution of power the influence of indigenous artists should not be exaggerated.

Art Production in Bathurst and Melville Islands

I now want to turn to the example of the art production for external consumption by the Tiwi from north Australia. In contrast to Pamela Rosi's (1998a, 1998b, 2002) Papua New Guinean case concerning the engagement of urban Papuan artists in the construction of a national art style, nonurban Aboriginal producers of contemporary art are encouraged to deliver works that express regional variation and differentiation in terms of art provinces. Tiwi art also found recognition as a regional Aboriginal art style (Caruana 1993:84–93). Now Tiwi artists are expected to work in this style.

The Tiwi from Bathurst and Melville Islands in north Australia have produced artifacts and art for external consumption since the beginning of the twentieth century (Venbrux 2000, 2001, 2002). They responded to the changing conditions of life and shifts in the expectations of European consumers. The Tiwi artistic system puts a premium on creativity and individual originality (Goodale and Koss 1971). Moreover, the Tiwi are used to make art for ceremonial purposes in exchange for money, substituting the earlier means of payment with significant artifacts. Their works were and are also evaluated according to aesthetic criteria (Hart and Pilling 1960:48; Venbrux 1995:185). The three major townships on the islands each have an art center where fine art is made for the external market. There has been artistic competition between the three independent centers, but recently they formed the Tiwi Art Network, aiming to promote their art jointly. A special marketing officer promotes their art nationally and internationally. She also has to facilitate access to sales over the Internet (see Tiwiart.com 2002a).

The production of art appears to fit in well with the local lifestyle. During my fieldwork (in 1988–1989 and three return visits in the 1990s) young Tiwi people clearly expressed that they did not like jobs in which they were "bossed around." At the Munupi Arts Centre in Pirlangimpi (Melville Island) the Tiwi artists came and went as they pleased. They left because of other commitments or to pursue other interests, and attendance followed the rhythm of local social life. One artist who soon returned to the center from working elsewhere told me that she had found the work "boring," adding that there was hardly anyone there. Social reasons and being able to discuss the artwork at hand with others attracted her to the center. She did not stand alone in these desires.

There appeared to be other incentives related to the ebb and flow of cash in the community. At Nguiu (Bathurst Island), where artists delivered their work to the

so-called keeping place (where it was kept for sale), the production of sculptures of "mythological bird" ancestors peaked at times when the makers were short of money. The artist immediately received two-thirds of the estimated price to the eventual consumer of the object. It took little time to make the bird sculptures because the artists then refrained from refined carving and finished them with a bold decoration of painted natural ochres. These works of art, locally known as "beer birds," strongly appealed to consumers in the "primitive art" market. (The label does not relate so much to the sculptures as to the "selfish" destination of the money thus obtained for them.)

It is not that the artists (and other Tiwi) failed to take pride in their work. Quite to the contrary. The usual response was a lot of praise for the work, especially from close relatives and friends of the artist. Negative criticism of locally produced art was rarely voiced openly, except during appropriate occasions in connection with carved and painted grave posts commissioned for the final mortuary rites by those who had to pay up (see Venbrux 1995:189, 207). One could say that the commoditization of art (Kopytoff 1986) is a long standing cultural practice in the Tiwi Islands, not something that was first introduced under the influence of an external market.

When commissioned to make grave posts, or in the position to perform as a ritual worker or dancer, the first thing people discuss with the person offering the commission is the

Figure 1. The late Romuald Puruntatameri in the process of painting a grave post in front of his house in Pirlang-impi, Melville Island. The carved and painted post he made as a ritual worker formed one of ten unique posts later placed around a grave out bush at the conclusion of a cycle of mortuary rites, 1989. Photo by Eric Venbrux.

amount of money that could possibly be made. When other close relatives are com-missioned this also happens to be the main topic for discussion. After the ritual payments, the topic becomes what the various people had actually received in pay-ment. Worth and appreciation are thus expressed in terms of payment (often nego-tiated beforehand). Both the payment and receipt of large sums of money involve prestige. With regard to sales of art to the external market things are little different.

The news that someone had earned a substantial sum for a piece spread like fire. When one woman told me she had learned that her sister elsewhere on Melville Island got $5,000 (Australian dollars) for a painting, she implied that it was time for a visit. Often owing to what Nicolas Peterson (1993) calls "demand sharing," money earned was soon redistributed. The demands of those entitled to ask built a pressure on artists who were successful in market sales to produce ever more works. In a social field in which everyone is related to everyone else in one way or another, kinship counts heavily but does not suffice to express the quality of a relationship. With limited resources—whether material or immaterial—one constantly has to make decisions in regard to social investments. An artist, for instance, explained to me, "I always give my [classificatory] grandfather cigarettes so I have something to cry for when he dies." It is not so much about the cigarettes, money, or whatever, but the giving of substance to social relations. As among Aboriginal fringe dwellers in Darwin, "assessment of worth is done by running appraisal" (Sansom 1980:73). In a broad sense, such exchanges define the current state of social affairs.

When artists felt "ripped off" by market sales, their personal worth was at stake. A prominent senior artist, for example, who had been commissioned to make a large sculpture of a human figure for $200 became furious when he was not paid more than that. His sculptures had recently been auctioned at Sotheby's for thousands of dollars without any returns to him of the resale value. He directed his aggression at the arts coordinator who had helped to construct the deal for the commission on behalf of a distant collector. The artist felt that it looked like he was not considered "important." In his view, what now seemed like a low payment for the commission was a disgrace. He felt shamed.

Stuart Plattner (1998:482–487), in his study of local artists in the United States, deals with the question of why these artists keep on producing art when almost no one buys their work. They fail to make a living from their art, but the work has its rewards for them. Plattner describes these artists as "identity producers" who thrive on the "psychic income" resulting from their work.

The local Australian Aboriginal artists I know are lucky to find patrons in an increasingly secure market. Besides, most of the Tiwi artists working at the two art centers on Melville Island obtain a basic income from the government-supported Community Development and Education Program (CDEP). They consider the revenue from their art production as an extra. Nevertheless, what Tiwi artists and artists in St. Louis, Missouri, have in common is that both of them can be consid-ered "identity producers" in their own ways.

Figure 2. Pedro Wonaeamirri's work in the Darwin mall. His designs on the ceramic tiles are inspired by ceremonial paintings on grave posts (see figure 1) and on the bodies of relatives in the past, 2002. Photo by Eric Venbrux.

A broad distinction can be made between the production of Tiwi art for the internal market (ritual context) and the external market (for sale to outsiders). In reality, both markets intersect to a certain extent. Visual and performing arts enable Tiwi participating in the seasonal and mortuary rites to launch "identity claims" (see Venbrux 1995). Increasingly, it has been only a select group of members from the oldest generations who possess the skills and knowledge to make more than general statements in the song language and by means of dance movement, decorative design, and so forth. The rhetorical statements, which could not be challenged directly, fit in with an ongoing social discourse. They used to have implications for one's position vis-à-vis others in a web of partially negotiable kinship relations. The subtleties in this juggling with identity, entirely for internal consumption, are lost to the audience of (mainly) younger people. Until the early 1990s, the commissioning and making of grave posts for final mortuary rites also provided an arena in which prestige could be obtained. Not only the quality, size, and number of posts, but also the amount of money involved, formed an index of prestige.

The younger generation of Tiwi artists often had secondary schooling and were more or less formally trained on the job since the 1980s. For them, the politics of iden-

tity in relation to the visual arts had another horizon of reference. They make art for a national and international audience beyond the islands. In part, their work at the art centers takes stock of the pictorial tradition of geometrical design. However, it involves new media and techniques as well as figurative references to personal clan associations (drawings of eagles, crocodiles, buffaloes, and so forth) or ceremonies and ceremonial objects (grave posts, bangles, and barbed spears). The works these artists produce for the fine art market tend to be categorized as contemporary Aboriginal art, but at the same time they have to be recognizably "traditional," that is, in the Tiwi "style."

The subject matter of the art produced is predominantly "traditional," signaling difference. Australian rules football is tremendously popular in the islands today, and has been for more than half a century. Yet, this Tiwi tradition is less likely to be represented in the art for external consumption.

These identity markers are an objectification of culture. For example, the Munupi artists in Pirlangimpi did not personally attend the seasonal Kulama ritual, which was performed locally by members of an older generation at the end of the wet season. Nevertheless, the ceremony was by far the favorite subject matter of their paintings at that time of the year. Even though they refused to take part in the ritual by request of the elders, the Kulama continued to have significance for them. Through the agency of the local arts coordinator, one artist acted as a spokesperson in a plea for national legislation on indigenous cultural and intellectual property rights. She said that her circular design of the Kulama was something she would like to see protected.

Another Munupi artist opted for the imagery of grave posts as something distinctively Tiwi that should be protected also (Jopson 1998). In September 1998, when I was on Melville Island, the two artists were preparing to address a meeting of the United Nations in Geneva on the issue of indigenous cultural and intellectual property rights later that month. On the basis of the argument that no "tribal artists" from Australia would otherwise be represented, the arts coordinator did manage to arrange for them to attend (Lyne Helms, pers. comm.). The imagery of distinctive Tiwi artifacts, namely grave posts and barbed spears, also appears on the Tiwi flag, designed in 1995. They have become emblems of a communal Tiwi identity.

The fact that Aborigines have entered the international political and art scenes gives the state bureaucracy both worries and satisfaction. On the one hand, with their "uniquely Australian and indigenous cultural product" Aborigines are supposed to improve "Australia's international cultural profile" (Mercer 1997:viii–ix). On the other hand, the plight of Aborigines could put a stain on the country's postcolonial reputation with all of the resultant economic and political repercussions.

Mountford's Legacy: Neotraditional Tiwi Art

One of the major tropes concerning Aboriginal art is the concept of the (timeless) Dreaming or Dreamtime. As James Bennett (1993:39) notes, "What often is

not understood is the degree to which the popular ascendancy of painting from both Central Australia and Arnhem Land has influenced people's perceptions of Aboriginal art as a whole." Although the Dreamtime appears less significant in Tiwi ceremonial life than that of Aborigines on the mainland of Australia (Bennett 1993:39; Venbrux 1995:232), Tiwi art—now enshrined in state galleries—is commonly discussed in relation to the Dreamtime (see Kupka 1972; Allen 1976; Sutton 1988; O'Ferrall 1990; Caruana 1993; Holmes 1995; Sotheby's 1997, 2001). One critic recently remarked: "There is a truth to this art that derives from the Dreamtime stories, images, and vision, and we are drawn to these works because of their timeless ethos, their profound vision, and their aesthetic power" (Berrin 1999:73). These understandings might in part explain its modern success.

Works relating to the Dreamtime are sought-after representations in contemporary Aboriginal art (cf. Verghis 2001). Other work containing the imagery of ceremonial artifacts is also desirable because of their association with the Dreamtime. An objectification and reification of the Aboriginal past, perceived as ancient and unchanging on the one hand, and a display of progress by means of modern techniques and media on the other, constitute the category of contemporary Aboriginal art. These patterns correspond with Australian heritage politics, in which the past no longer tends "to be preserved *from* development," but rather becomes an aid *to* development (Bennett 1995:146). It also exemplifies the artificial gap between the past and the present (Merlan 1998) that Aborigines are faced with in the arts and crafts industry.

Let us now consider how Tiwi art became connected to Dreamtime creation myths in the context of the development of a local arts and crafts industry.

In April 1954 a scientific expedition, led by the ethnologist Charles P. Mountford (1956:417), went to Melville Island, north of the Australian coast. Mountford reports in *National Geographic*:

> In one sense, in that April of 1954, we were traveling backward in time as we moved forward in space. . . . There, in the little-known land of the Tiwi, we would see man living as much as he did 50,000 years ago.
>
> The Tiwi, one of the few archaic peoples left on earth, have no agriculture, no permanent homes, no pottery, and no domestic animals except the dog. Only yesterday they had no tools except the crudest of stone axes, specimens of which can be found discarded all over the island. Their weapons are spears and sticks. It is a marvel that their culture has survived with so little change.

In 1954 when Mountford came to the government settlement of Snake Bay, presently Milikapiti, he looked at Tiwi art from an Arnhem Land perspective. He did so with the romantic notion of a timeless, "primitive isolate." He argued that "We were still able to study Tiwi culture largely as it had existed since the Stone Age" (1956:423). Thus, the leader of this expedition characterized Tiwi society by means of material culture in a way that is reminiscent of Lewis Henry Morgan's model of cultural evolution, using precisely the criteria that would put the Tiwi in the cate-

gory of "savages." The idea of contemporary ancestors gave him reason to study Aboriginal art, "for in no other country is it possible to study the art of a living Stone Age people, to watch them at work, to observe the techniques they use, or to learn from the artists themselves the meaning of the motifs they employ" (Mountford 1962:207). Mountford tried to find the meaning of the motifs in creation myths in the same way he had used such myths to interpret the bark paintings from Arnhem Land during an expedition in 1948.

Almost immediately, however, he confronted a problem with the paintings of the Tiwi. There was an "almost total absence in those designs of any reference to the myths and totemic localities" (Mountford 1958:110; cf. Spencer 1914:425). In addition, Mountford (1958:179) readily admits, "I did not witness, nor did I hear of any specific Tiwi ceremony that commemorated the myths of the creation period." Given the situation, all he could do was commission Tiwi artists Tjamalampua and Malumarinita to paint "their myths and stories" (1958:19–22) so that the resulting works would illustrate or illuminate the oral narratives. Deriving their imagery from the decorated Tiwi bark baskets or containers, the artists began to produce paintings on flattened sheets of bark, much like the ones from Arnhem Land. The two-dimensional bark paintings had to represent mythological themes. Some of the paintings, however, resembled the designs on ceremonial grave posts and bark baskets. Mountford decided to call these latter designs "secular paintings" (1958:160) in contrast to the ones representing myths that had actually been made at his explicit request.

From the mid-1950s to the mid-1970s, Tiwi artists responded to the demands of collectors to produce carvings and paintings that went with a mythological story. Collectors vigorously competed to get hold of works that became available at Snake Bay (Holmes 1995:79–81). There seemed to be an increasing demand for Aboriginal handicrafts. This growing demand coincided with a renewed arts and crafts movement and widespread popularity of cottage industries. At the Bathurst Island Mission (presently Nguiu), the missionaries were led to believe that an indigenous arts and crafts industry could not only be profitable, but would also be of use in maintaining and training people's manual skills and craftsmanship. Moreover, they saw it as a way of instilling a European work ethic (Venbrux 2000:70).

In 1969 the lay missionary and art teacher Madeleine Clear laid the foundation for an arts and crafts industry on Bathurst Island. At the instigation of Bishop O'Loughlin, who had shown her Inuit woodblock prints, she taught or inspired Tiwi male adolescents to make lino and woodblock prints. Two Tiwi youths, Bede Tungatalum and Giovanni Tipungwuti, founded their own company called Tiwi Designs. They produced designs of animals and birds. Next, the carved designs were carried over on silk screen to be printed on fabric (Clear 1977; Venbrux 2000). In 1974, the arts adviser Diana Conroy showed Tungatalum and Tipungwuti reproductions of the bark paintings collected by Mountford on Melville Island in 1954. Encouraged and inspired by these photos, the two artists started to produce

geometric designs that were printed allover on cotton fabrics (McCulloch 1999:183). The fabrics of Tiwi Designs continue to be made for sale to tourists and a national and international market. In the islands the materials gained popularity as loincloths, skirts, and payments in mortuary rituals.

About 1987, adult educator Sister Celine Auton gave drawing lessons to female adolescents at Pirlangimpi. This developed into the Munupi Arts Centre (founded in 1988), which has become famous for its fine art, notably gouaches with a wide array of bright colors. About the same time, adult educator Anne Marchant set up a sewing class at Milikapiti (Snake Bay), added a silk-screen print workshop, and a small museum with artifacts. Marchant put reproductions from Mountford's (1956) *National Geographic* article on the wall in order to encourage Tiwi youths to make the artifacts and designs in the old fashioned style again. The initiative resulted in the Jilamara Arts Centre (founded in 1989). The two centers, each working in its own distinctive style, cater to different market niches.

Recently, three Tiwi artists went to the South Australian Museum in Adelaide in order to study Mountford's collection of Melville Island art. They did so during the course of a project, funded by the Australia Council for the Arts, to reclaim "traditional Tiwi imagery" (Burbidge 2000:17). The artists—Pedro Wonaeamirri, Janice Murray, and Maryanne Mungatopi—are members of the Jilamara Arts and Crafts Association at Milikapiti, Melville Island:

> Maintaining the traditions of Tiwi art is one of the strong motivating forces behind the members of Jilamara. . . . The artists from Jilamara pride themselves on using only ironwood for carvings and natural ochres for painting. There is constant referral back to the older designs documented in the 1950s by Charles Mountford or housed in collections around Australia. (Tiwiart.com 2002b)

Thus, the Tiwi art repertoire has been extended enormously, but the artists in all three locations take their inspiration mainly from the past as they now see it. Time and again, they have creatively adopted new elements in an effort to "keep the culture strong" and to meet the demand for "traditional" imagery in their art.

Innovation and experimentation was already part of the dynamic Tiwi art tradition. The "development" of fine art for external consumption in the local arts and crafts industry has now become a tradition in itself. Neotraditional art has to be in the Tiwi style, but the idea of the threat of a loss of "culture" and a constant need for "renewal" has also made inroads into the local consciousness. It entails an objectification of culture as the Tiwi increasingly experience the past as if it were a foreign country.

Pedro Wonaeamirri told me that he felt "empty" when he remembered his grandmother, who had taken him to the Kulama ceremony in 1989, and other artists of her generation. Because of the painful memories he went to live in the other Melville Island community. The place where he used to live looked and felt empty too, he said. Together with John Wilson, Leon Puruntatameri, and others, Pedro

painted inside the local museum since it was a comfortable place to work. Not only did the gallery have air-conditioning, but they were also surrounded by artifacts made by elders, a number of whom they had known as children. For Pedro, the artifacts embodied a history of social relations and distinctive, personal identities. In his own art he seeks to reconnect to people, preferably by depicting body paintings, and not so much the beings of the Dreamtime. He is one of the most successful younger Tiwi artists.

Pedro's work finds great acclaim in the Australian art world. His name is mentioned in one breath with Kitty Kantilla, a prominent senior Tiwi artist, as far as artistic relevance in that art world is concerned. Kitty started to make two-dimensional art after the death of her husband in 1988. She produces art for his remembrance and as such these works are concerned with the past on a more personal level. Furthermore, like several other artists, she is inspired by and seeks to use the designs of her father. Young artists trained in the art centers also make references to clan affiliations and ceremonial paraphernalia in their imagery. On the one hand, the artists struggle with feelings of loss, emphasizing the idea of a rupture with the past. On the other hand, artistic activities create a space for reflection and "self-production" (Myers 1995) in view of a wider audience.

The art in the islands has always been dynamic, and its cultural vitality rests on making connections with significant others expressed in the visual and performing arts. Also, in the production of fine art at the Tiwi art centers process, in this sense, takes precedence over form (cf. Price and Price 1999:300–301). Outside recognition and market success can help to establish an artist's importance in the Tiwi domain. In spite of the prestigious destinations of their work, the invitations, and commissions, the respect of their fellow Tiwi is what really matters. And that means for these artists that they are socially embedded and accorded their "worth" as persons.

Conclusion

Some have argued that the promotion of Aboriginal art is "a form of soft neo-colonialism" (Fry and Willis 1989:116). Others have pointed out the "self-conscious planning and policy concerns on the part of the state" (Myers 2001:211). The counterargument strongly emphasizes Aboriginal volunteerism and agency in bringing their art to the world (Morphy 1998:329–330, 368). In my view it is necessary to go beyond the dichotomy of structure and agency in the discourse over contemporary Aboriginal art. When Australia redefined its national identity, Aboriginal art gained postcolonial virtue. Assisted by the government, the Aboriginal arts and crafts industry was supposed to improve the economic status of Aborigines in the outback as well as make them "culturally powerful." An odd side effect of the current government's policy is that economic "success is penalized"

(Altman 2005:14) because it means a withdrawal of financial support. Precisely because of their peripheral and liminal position—including their poverty, as in the romanticized image of the Western artist—the work of Aboriginal artists from the outback received important symbolic value. Cultural continuities with a distant past, together with the spiritual attachments to the land that are present in the art, could then be appropriated on a symbolic level by embracing, obtaining, and displaying the art.

Market demands and cultural policies require Aboriginal artists in the remote areas of Australia to reproduce external representations of their past, the "traditional," in their art. This has coincided with Aboriginal assertions of their cultural values and ideology. In the Tiwi case, artists have had to work within the bounds of a Tiwi "style." Ironically, the encouragement to "reclaim traditional Tiwi imagery" has created feelings of loss and led to an objectification of their culture. Simultaneously, these artists have managed to create new meaning, to launch identity claims, and to reconnect with significant others in living memory as well as the artistic process that mattered in the everyday and ceremonial life of previous generations.

Questions for Discussion

1. What are the different roles that art has played among the Tiwi? Do these roles continue to influence them?

2. Which of these roles seems most unexpected if we use other non-Western societies as a guide?

3. What role has the Australian government played in shaping the significance and meaning of Tiwi art today?

4. How do new art objects differ in form and meaning from "traditional" Tiwi carving and basketry from a few generations ago?

Acknowledgments

My research has been made possible by the Netherlands Foundation for the Advancement of Tropical Research (WOTRO) and the Netherlands Royal Academy of Arts and Sciences (KNAW). An earlier version of this paper was presented to the working session Postcolonial Virtue, Worth, Morality, and Modern Success in the Western Pacific, organized by Bruce Knauft and Joel Robbins, at the annual meeting of the Association for Social Anthropology in Oceania (ASAO) in Miami, Florida, in February 2001. I thank the organizers and the participants for their comments. I am also indebted to Jane Goodale, Rob Welsch, Jon Altman, and Markus Schindlbeck for their helpful suggestions and comments. A special thank you must go to Pamela Rosi for the stimulating discussions we had comparing the

situation of urban Papuan artists (see Rosi, article 11) with the one of Aboriginal artists in remote Australia. My chief debt, of course, is to the Tiwi from Bathurst and Melville Islands.

References

Aboriginal and Torres Strait Islander Commission (ATSIC). 1997. *National Aboriginal and Torres Strait Islander Cultural Industry Strategy.* Canberra: Author.

Allen, Louis A. 1976. *Time Before Morning.* Adelaide: Rigby.

Altman, Jon. 2005. "Brokering Aboriginal Art: A Critical Perspective on Marketing, Institutions, and the State." Kenneth Myer lecture in Arts and Entertainment Management, Deakin University, Geelong, Victoria.

Bennett, James. 1993. "Narrative and Decoration in Tiwi Painting: Tiwi Representations of the Purukuparli Story." *Art Bulletin of Victoria* 33:39–47.

Bennett, Tony. 1995. *The Birth of the Museum: History, Theory, Politics.* London: Routledge.

Berrin, Kathleen. 1999. "Spirit Country: Contemporary Australian Aboriginal Art." *The World of Tribal Arts* (Summer/Autumn):64–73.

Burbidge, Madeleine. 2000. "Task of the Tiwi: Reclaiming Traditional Heritage." *Arts Yarn Up* 9:16–17.

Byrne, Denis. 1996. "Deep Nation: Australia's Acquisition of an Indigenous Past." *Aboriginal History* 20:82–107.

Caruana, Wally. 1993. *Aboriginal Art.* London: Thames and Hudson.

Clear, Madeleine. 1977. "Thinking Printing." *Teachers' Forum* 11:2–3.

Elkin, A. P. 1956. "Foreword," in *Australian Aboriginal Decorative Art,* ed. F. McCarthy, pp. 9–10. Sydney: Australian Museum.

———. 1964. *The Australian Aborigines.* New York: The Natural History Library.

Errington, Shelly. 1998. *The Death of Authentic Primitive Art and Other Tales of Progress.* Berkeley: University of California Press.

Fry, Tony and Anne-Marie Willis. 1989. "Aboriginal Art: Symptom or Success?" *Art in America* 7(July):108–117, 159–160, 163.

Goodale, Jane C. and Joan D. Koss. 1971. "The Cultural Context of Creativity Among Tiwi," in *Anthropology and Art: Readings in Cross-Cultural Aesthetics,* ed. C. M. Otten, pp. 182–200. New York: Natural History Press.

Hart, C. W. M. and Arnold R. Pilling. 1960. *The Tiwi of North Australia.* New York: Holt, Rinehart and Winston.

Holmes, Sandra Le Brun. 1995. *The Goddess and the Moon Man: The Sacred Art of the Tiwi Aborigines.* Roseville East, NSW: Craftman House.

Jensen, Joli. 2002. *Is Art Good for Us?: Beliefs About High Culture in American Life.* Latham, MD: Rowan and Littlefield.

Jones, Philip. 1988. "Perceptions of Aboriginal Art: A History," in *Dreamings: The Art of Aboriginal Australia,* ed. P. Sutton, pp. 143–179. New York: Viking.

Jopson, Debra. 1998. "Culture Clash: Sweeping Guidelines to Protect Copyright of Aboriginal Heritage are Being Drafted." *Sydney Morning Herald* (April 20).

Kirshenblatt-Gimblett, Barbara. 1998. *Destination Culture: Tourism, Museums, and Heritage.* Berkeley: University of California Press.

Kopytoff, Igor. 1986. "A Cultural Biography of Things: Commoditization as Process," in *The Social Life of Things: Commodities in Cultural Perspective,* ed. Arjun Appadurai, pp. 64–91. Cambridge: Cambridge University Press.

Kupka, Karel. 1972. *Peintres Aborigènes d'Australie.* Paris: Société des Océanistes.

Lattas, Andrew. 1993. "Essentialism, Memory, and Resistance: Aboriginality and the Politics of Authenticity." *Oceania* 63:240–267.

MacClancy, Jeremy. 1997. "Anthropology, Art, and Contest," in *Contesting Art: Art, Politics, and Identity in the Modern World,* ed. J. MacClancy, pp. 1–25. Oxford: Berg.

Marcus, George E. and Fred R. Myers. 1995. "The Traffic in Art and Culture: An Introduction," in *The Traffic in Culture: Refiguring Art and Anthropology,* ed. George E. Marcus and Fred R. Myers, pp. 1–51. Berkeley: University of California Press.

McCulloch, Susan. 1999. *Contemporary Aboriginal Art: A Guide to the Rebirth of an Ancient Culture.* Honolulu: University of Hawai'i Press.

McDonald, Michelle. 1998. "The Problem of Criticism: Emily Kame Kngwarreye." *Art Monthly Australia* 108(April):20–21.

McLean, Ian. 1998. *White Aborigines: Identity Politics in Australian Art.* Cambridge: Cambridge University Press.

Mercer, Colin. 1997. *Creative Country. Review of the ATSIC Arts and Crafts Industry Support Strategy (ACISS). Final Report.* Canberra: ATSIC.

Merlan, Francesca. 1989. "The Objectification of 'Culture': An Aspect of Current Political Process in Aboriginal Affairs." *Anthropological Forum* 6(1):105–116.

———. 1998. *Caging the Rainbow: Places, Politics, and Aborigines in a North Australian Town.* Honolulu: Hawai'i University Press.

Michaels, Eric. 1994. *Bad Aboriginal Art: Tradition, Media, and Technological Horizons.* Minneapolis: University of Minnesota Press.

Morphy, Howard. 1998. *Aboriginal Art.* London: Phaidon Press.

———. 2001. "Seeing Aboriginal Art in the Gallery." *Humanities Research* 8(1):37–58.

Morris, Barry. 1989. *Domesticating Resistance: The Dhan-Gadi Aborigines and the Australian State.* Oxford: Berg.

Mountford, Charles P. 1956. "Expedition to the Land of the Tiwi." *National Geographic Magazine* 59:417–440.

———. 1958. *The Tiwi, Their Art, Myth, and Ceremony.* London: Phoenix House.

———. 1962. "The Aboriginal Art of Australia," in *Oceania and Australia. The Art of the South Seas,* ed. A. Bühler, T. Barrow, and C. P. Mountford, pp. 207–225. London: Methuen.

Mundine, Djon. 2002. "Between Two Worlds." *Art Monthly Australia* 150(June):25–26.

Myers, Fred R. 1995. "Representing Culture: The Production of Discourse(s) for Aboriginal Acrylic Paintings," in *The Traffic in Culture: Refiguring Art and Anthropology,* ed. George E. Marcus and Fred R. Myers, pp. 55–95. Berkeley: University of California Press.

———. 2001. "The Wizards of Oz: Nation, State, and the Production of Aboriginal Fine Art," in *The Empire of Things: Regimes of Value and Material Culture,* ed. F. R. Myers, pp. 207–231. Santa Fe: School of American Research Press.

O'Ferrall, Michael. 1990. *Keeping of the Secrets: Aboriginal Art from Arnhem Land in the Collection of the Art Gallery of Western Australia.* Perth: The Art Gallery of Western Australia.

Peterson, Nicolas. 1993. "Demand Sharing: Reciprocity and the Pressure for Generosity Among Hunter-Gatherers." *American Anthropologist* 95:860–874.

Plattner, Stuart. 1998. "A Most Ingenious Paradox: The Market for Contemporary Fine Art." *American Anthropologist* 100:482–493.

Price, Sally and Richard Price. 1999. *Maroon Arts: Cultural Vitality in the African Diaspora*. Boston: Beacon Press.

Rosi, Pamela. 1998a. "Cultural Creator or New *Bisnisman*: Conflicts of Being a Contemporary Artist in Papua New Guinea," in *Modern Papua New Guinea*, ed. Laura Zimmer-Tamakoshi, pp. 31–54. Kirksville: Thomas Jefferson University Press.

———. 1998b. *Nation-Making and Cultural Tensions: Contemporary Art from Papua New Guinea*. Chestnut Hill, MA: Pine Manor College.

———. 2002. "'National Treasures' or 'Rubbish Men': The Disputed Value of Contemporary Papua New Guinea (PNG) Artists and Their Work." *Zeitschrift für Ethnologie* 127(2):241–267.

Sansom, Basil. 1980. *The Camp at Wallaby Cross: Aboriginal Fringe Dwellers in Darwin*. Canberra: Australian Institute of Aboriginal Studies.

Sotheby's. 1997. *Aboriginal and Tribal Art* (Catalog Sale AU619, Sydney, November). Woollahra, NSW: Sotheby's.

———. 2001. *Aboriginal Art* (Catalog Sale AU0648, Melbourne, July 9). Armadale, VIC: Sotheby's.

Spencer, W. Baldwin. 1914. *Native Tribes of the Northern Territory*. London: Macmillan.

Sutton, Peter. 1988. "A Morphology of Feeling," in *Dreamings. The Art of Aboriginal Australia*, ed. Peter Sutton, pp. 59–88. New York: Viking.

———. 2001. "The Politics of Suffering: Indigenous Policy in Australia Since the 1970s." *Anthropological Forum* 11(2):125–173.

Svašek, Maruška. 1997. "Visual Art, Myth, and Power." *Focaal* 29:7–23.

Tiwiart.com [online]. 2002a. Available: http://www.tiwiart.com.

———. 2002b. Available: http://www.tiwiart.com/jilamara/centre/centre.htm.

Tonkinson, Robert. 1999. "The Pragmatics and Politics of Aboriginal Tradition and Identity in Australia." *Journal de la Société des Océanistes* 109:133–147.

Venbrux, Eric. 1995. *A Death in the Tiwi Islands: Conflict, Ritual, and Social Life in an Australian Aboriginal Community*. Cambridge: Cambridge University Press.

———. 2000. "Cross with the Totem Pole: Tiwi Material Culture in Missionary Discourse and Practice," in *Anthropologists and the Missionary Endeavour*, ed. A. Borsboom and J. Kommers, pp. 59–80. Saarbrücken: Verlag für Entwicklungspolitik.

———. 2001. "On the Pre-Museum History of Baldwin Spencer's Collection of Tiwi Artifacts," in *Academic Anthropology and the Museum. Back to the Future*, ed. M. Bouquet, pp. 55–74. Oxford: Berghahn.

———. 2002. "The Craft of the Spider Woman: A History of Bark Baskets in the Tiwi Islands," in *Pacific Art: Persistence, Change, and Meaning*, ed. Anita Herle, Nick Stanley, Karen Stevenson, and Robert L. Welsch, pp. 324–336. Honolulu: University of Hawai'i Press.

Verghis, Sharon. 2001. "Dash It—Dots Are Not the Only Aboriginal Art." *Sydney Morning Herald* (May 11).

Moving Away from Tradition in Contemporary Papua New Guinea Art

\mathcal{T} he three articles in this section call attention to two important issues that engage scholars studying the contemporary arts of Papua New Guinea (PNG): Why does their hybridity make it difficult to assign their forms into conventional categories for classifying and marketing art? And why are their styles and identities contested, raising issues about their authenticity and value in local and global art worlds?

Jacquelyn A. Lewis-Harris compares the experiences of two artists who introduced new art forms to their traditional communities and tried to accommodate these works both to customary modes of production and copyright and to their individual professional interests. Pamela Sheffield Rosi focuses on artists who work in modern media and techniques, and who were trained at PNG's new art institutions. She explores why their new artworks have been disputed as images of national culture and identity—for example, as compared to contemporary Aboriginal art discussed in the previous section. Eric K. Silverman elaborates on why the Sepik art forms he discusses are "mixed genres" that operate in "contact zones" where people, things, and ideas commingle dynamically. He argues that art forms in border zones are typically "blurred" and it is this quality that makes them authentic.

Saun Anti and Wendi Choulai, the artists discussed by Lewis-Harris, came from different areas within PNG. Anti was a traditional carver from a village in the Middle Sepik and a senior member of the men's *haus tambaran* (men's spirit house). But as Anti told Lewis-Harris, he had begun to carve in a new style following dreams from ancestral spirits who instructed him to do so. Despite this traditional rationale, Anti's carving style was rejected by members of his men's cult community. Lewis-Harris suggests two reasons for this fact: First, fundamentalist Christian missionaries were converting villagers from their beliefs in the powers of the tambaran, subsequently cult members saw Anti's new art as yet another attack on the tambaran's authority. Second, senior cult members believed that Anti's new carving style endangered their sales of traditional carvings to tourists since the sale of these carvings depended on a recognized village style. Squeezed by fears of spiritual reprisals and censure from the tambaran society, Anti retreated to the outskirts of his village where he lived a marginal existence until his death.

Choulai posed a different challenge to traditional orthodoxy when she began to negotiate traditional rules of copyright for her own personal creative purposes. Choulai was the first woman to receive honors in textile design from the National Arts School (NAS). Expatriate teachers told her to seek inspiration for her work from the designs of her Solien Besena people of the Central Province. But Choulai resisted these instructions because such suggestions ignored indigenous rules of copyright that required payments to traditional owners for the use of their motifs. Caught in this predicament, she borrowed the designs of other groups or created her own designs from patterns in PNG landscapes.

Choulai was determined, however, to link her work with her family's clan designs and began negotiations aimed at obtaining permission from senior family members and to arrange compensation. Moving to Australia, she decided to call a Solien Besena dance performance and hold it at the Asia Pacific Triennial. This performance was part of a traditional ceremony that allowed her to complete her grandmother's funerary ceremonies, to repay family debts, to display Solien Besena culture at an international venue, and to showcase her "modern" silk dance skirts. Lewis-Harris called these festivities an "artistic coup on several levels." But it also cost her $10,000 in compensation payments and brought Choulai considerable distress, as she often needed to smooth out family conflicts. Choulai's hybrid work thus draws attention to the difficulties of classifying contemporary PNG art as either traditional or modern because the contexts of personal and communal identity are all aspects of her artistic expression.

Rosi's article examines the reasons why contemporary urban artists connected with the NAS have had difficulties exhibiting their contemporary art and why it has been so difficult for it to be recognized as a significant aspect of PNG national culture and identity. She points out that the impetus for introducing professional art training in PNG was linked to independence when Australia set up the Creative Arts Centre in Port Moresby in 1972 (renamed the NAS in 1976). Through the NAS the Australian government provided funding for student scholarships, exhibitions, and a production workshop to provide artists with commissioned work. But despite this support, other factors, discussed by Rosi, hindered artists from selling their work. These factors include: (1) obligations to relatives that competed with the demands of a professional career, (2) the absence of galleries in PNG, therefore artists did not have a venue in which to sell their work, (3) the disinterest most Papua New Guineans showed in buying new art, (4) the lack of state financial support to help artists exhibit their work, and (5) critical responses from Western curators and viewers that devalued these new PNG art forms and styles.

While impediments have always hindered the marketing of contemporary PNG art, Rosi describes how they worsened during the mid-1980s when the PNG economy experienced a series of deep fiscal crises resulting in massive cuts in the NAS budget. Exhibitions were eliminated, the workshop closed, and the NAS was amalgamated with the University of Papua New Guinea, leaving artists to seek venues and resources elsewhere. Today, the global art world has minimal exposure to contemporary PNG art because most Western curators show little interest in exhibiting it and potential buyers at home and abroad are hesitant to acquire it as these new artworks often do not conform to their ideas of what PNG art should be about.

The arts of the traditional Iatmul carvers from the Sepik River discussed by Silverman confound the categories of Western art classification because their styles and meanings engage the dynamics of PNG's modernizing society. Silverman compares the objects made for the tourist trade along the Sepik River with the "fine art" sculptures commissioned for the New Guinea Sculpture Garden at Stanford

University in California. He argues that both of these art forms incorporate features of the Other—a situation typical of culture contact and exchange. Because tourist art is motivated by money, it is conventionally said to lack aesthetic merit or significant cultural meaning. Silverman's research, however, documents that this is not the case. Sepik tourist art is intended for display and artists strive for particular aesthetic effects to enhance particular perspectives. Moreover, tourist art is meaningful for the artists because it incorporates motifs that send messages about the artists' individual, village, regional, national, and religious identity.

Many symbols are also multivocal, linking traditional and modern referents. For example, a crocodile, which traditionally signified powerful totemic spirits, is now "an ubiquitous emblem of Iatmul ethnicity." Given this complexity, Silverman describes Eastern Iatmul tourist art as "a complex self-representation, a wide-ranging conversation between tradition and modernity. These works communicate subtle, often elegant, messages that are muted by traditional categories and notions of authenticity."

The Sepik carvings in their lush setting of Stanford's sculpture garden are, as Silverman describes, "breathtaking." Forms play with themes of light and shadow, and carvings "beautifully wind around the natural contours of the wood." The intent of the project was to provide the carvers with an art space where they could (1) express their artistic creativity outside village conventions and (2) be positioned in the Western category of artistic "genius" equivalent to Rodin, whose sculptures adorn other areas of the Stanford campus. To make this connection, the Sepik carvers created two works in wood and pumice (a new medium) that resembled *The Thinker* and *The Gates of Hell*. Yet, by carving these objects, the sculptures ironically came to embody features of tourist art and subvert the category of "high art." Why is this so?

According to Silverman, although the garden setting and the sculptures represented the ideals of aesthetic beauty and dazzling creativity, by imitating Rodin the carvers introduced features of inauthentic reproduction that cannot be associated with the creation of genuine "high art." Moreover, although the artists were asked to innovate on clan-specific motifs, they appeared restrained and created essentially variations on traditional forms. Ironically, Sepik tourist art made for money stimulated more innovation than art created specifically for an art space, where village carvers were brought and asked to let their creative imaginations run free.

Silverman's point is that both Sepik tourist art and the New Guinea Sculpture Garden art rupture conventional artistic categories. Their importance lies in resisting dominant bounded categorizations of authenticity, which seem particularly inappropriate in contact zones where "objects are always in taxonomic motion."

10

Gender, Location, and Tradition

A Comparison of Two
Papua New Guinean Contemporary Artists

Jacquelyn A. Lewis-Harris

The emerging world-art world is epitomized in the contemporary art scene of Papua New Guinea (PNG). This art phenomenon is fairly recent, having begun in the late 1960s. It encompasses art forms based on older "traditional" forms as well as the newer syncretic styles influenced by foreign media and techniques. For scholars these works are intellectually contentious because they challenge both Western and indigenous notions of art. By not fitting either into art historical or anthropological descriptive categories, such artworks not only contest definitions of fine arts and crafts, but they confound customary understandings of group identity as well.

Several writers have argued that in the years surrounding independence in 1975 these syncretic forms of art played a central role in shaping—if not creating—a national identity (see, e.g., Narokobi 1980, 1990; Otto 1997; Iamo and Simet 1998). During the early years after independence both village-based and urban artists were encouraged to create contemporary art with a nationalist theme. But by the 1990s it was clear that the financial success of this new art movement would be dependent on international art venues, and this new Papua New Guinean art world would be market driven and influenced by foreign curatorial dictates (Simons and Stevenson 1990; Choulai 1997; Raabe 1999).

Two types of contemporary art became prominent in PNG, the "arts gallery" faction and the "neotraditional" group (Simons and Stevenson 1990). "Arts gallery" works use foreign media and styles that resemble the work of artists in Australia, the United States, and New Zealand. The artists who create these syncretic works are either graduates of government high schools, technology colleges, universities, or the National Arts School, or from a select group of self-taught artists. "Neotraditional" artists produce a variety of objects, all of which relate to the

materials and forms of functional village art forms or traditional ritual objects. Some of these objects are contemporary reproductions of old ceremonial objects, such as masks, drums, or carved figures that depict spirits, totemic emblems, or mythological characters; others are extensions or revised versions of important traditional forms, such as the larger or more complex carved figures so commonly produced along the Sepik River today. Yet another class of objects consists of the creation of new designs within prescribed traditional techniques and forms, including such items as string bags (*bilums*) now made with colorful acrylic yarn, basketry woven as platters, trays, or clothes hampers, textiles, and ceramics. The majority of neotraditional art is sold in the international artifact and handcraft market, and only a small portion is produced for domestic consumption.

The evolution of contemporary art in PNG raises several issues and questions. Can contemporary art continue to represent the nation if it is created for the foreign art world market? Can contemporary artists truly represent their heritage and personal concepts of cultural inclusion while successfully participating in international art world markets? This article explores these questions by contrasting the lives of two contemporary PNG artists. To do so I consider the influences on their art and personal identities that have come from their different social worlds.

Art in Two Worlds: Concrete or Rainforest

During my six-year stay in PNG (1981–1987), I worked with Saun Anti and Wendi Choulai while employed by the United Nations Development Program and the PNG government. Subsequently, I maintained a long friendship with Wendi Choulai until her death in 2001.

Saun Anti is a senior male artist who was raised within the fairly traditional culture of the Western Iatmul people of the Middle Sepik River. Anti (figure 1) was an initiated Iatmul elder and came from a highly structured men's house society that still maintains many of its original customs and traditional art forms. This area of PNG is fairly remote and has few opportunities for growing cash crops or other sources of income. The region has come to depend on the preservation of the traditional forms of its ceremonies and arts as a way of attracting much desired tourist income. To be initiated into the men's house (or *haus tambaran*) society Anti had undergone the painful scarification and bloody cutting of the skin on his back and chest to leave dramatic scars. Life as a member of the men's cult was governed by strict rules of behavior and organized into several age grades within the cult. The men's house itself was an imposing structure that commanded a dominant place in the village. In some parts of the Sepik region this architecture reflects the men's physical well-being and symbolically represents the body of the ancestral mother (Thomas 1995; Silverman 2001). With rare exceptions, women were not allowed to enter the house or participate in the (its) secret ceremonies, as their feminine power would pollute and negate the rituals.

Figure 1. Saun Anti and his sculptures in front of his exile house.

Wendi Choulai (figure 2), in contrast, was a younger female artist of mixed heritage who largely grew up in Port Moresby, the nation's capital and largest city. She did, however, have prolonged stays in her mother's village along the Central Province coast near Brown River. Her upbringing was influenced by a combination of Malay Chinese, Solien Besena, Motu-Koita, and Australian cultural patterns. During her childhood in the 1950s many of the cultural traditions were still essentially intact, but undergoing significant changes in the face of foreign influences and Motu-Koita cultural dominance. The Motu-Koita people are the customary landowners of Port Moresby and have had the longest period of sustained contact with the West, benefiting economically, politically, and socially from these encounters.

Inspiring or Meddling Ancestors in the Middle Sepik Region?

Traditionally, the Sepik River is one of the most important art producing regions in PNG. Its intricate designs and carving styles appealed to the early explorers and collectors from the 1880s onward, and it remains one of the most prolific

Figure 2. Wendi Choulai.

art producing and art exporting regions in New Guinea. Internationally, nearly all museums that have holdings of Melanesian or New Guinea art will have examples of art from the Sepik.

The cultures of the Sepik River area can generally be divided culturally and geographically into three subregions: the Upper, Middle, and Lower Sepik. Of these the Middle Sepik is the most important and is currently the home of many art exporting businesses, some of which are owned by private companies, others are under the direction of Catholic missions or occasionally developed as government-run enterprises. Some of the best known carving villages are Korogo, Palimbei, Kanganaman, Mindimbit, and Tambanam in the Middle Sepik.

By the 1980s Saun Anti had become a highly regarded carver from Indabu village, which was an artistically conservative Iatmul village. In 1986, it was in economic decline. Many of the young men were working outside of the region, and the remaining population were dependent on subsistence farming and what income they could get from tourist-related activities. The haus tambaran was modest in size and still in use. Ceremonially important art was carved in the prescribed forms dictated by its use in the haus tambaran men's society. The styles and motifs of the pieces were closely associated with land ownership, the society's power, and clan and ethnic identity (Thomas 1995; Silverman 2001; Wassmann 2001). Silverman (1999:55) reported among Eastern Iatmul that:

> Sacred objects do not represent totemic spirits; they *are* spirits. An ornamented art object is a "body" (*mbange*) animated by the totem's "soul" (*kaiek*). The wooden carving is akin to "bones" (*awa*); decoration is skin (*tsiimbe*). Totemic entities (*tsaginda*) signify the mystical power and fertility of a specific descent group.

For example, during earlier times when intertribal warfare was commonplace, victorious warriors not only took the heads of their fiercest competitors, but they also removed the best sacred art and burned the remaining structures and ceremonial objects. Thus, they had performed one of the most serious offenses against a people: capturing their spirit, power, and identity through their art (Bateson 1958).

When I met Saun Anti, he was more than 60 years old, a senior member of the haus tambaran, and a respected traditional carver. He had been initiated and was privy to much of his clan's ritual knowledge. He specialized in carving particularly ancestral figures that were used during men's initiation rituals. These pieces were used as mnemonic markers of important cultural tenets. As Nicholas Thomas (1995:51) noted:

> Initiation at each phase generally takes the form of some kind of terror or ordeal. After which novices are shown the secret sacred objects or musical instruments associated with the grade. Through most of its stages, the cult is closely connected with a ceremonial house erected either specifically for Tambaran rites or used in a longer-term way as a men's house.

Anti also taught initiation chants and oral history related to these works of art. He had instructed all of his relatives in the appropriate style of haus tambaran sculpture, and had become a high-ranking member of the tambaran society. He was an old timekeeper of traditional customs, who worked to maintain the power and influence of the haus tambaran within his society.

Several Christian religions had come to his village. Roman Catholicism, Seventh Day Adventists, and the Lighthouse Pentecostal group were the most important. Each had become a direct threat to the haus tambaran society, and at the time of my last visit they seemed to have developed a tenuous balance of power. Anti had refrained from joining any Christian group, preferring the haus tambaran, although his wife and children were Seventh Day Adventists. His family split apart as a result of his unorthodox carving activities and religious differences. His sons and their families remained in the main village, but his wife moved back and forth between his current residence at the farthest edge of the community's boundaries, where he lived as an exile, and their former house in the village.

When Anti began to receive dream visions from the ancestors, these spirits directed him to revive an old style that he called the "time before" technique (figures 3 and 4). This Melanesian pidgin phrase refers to the era of the ancestors. According to him, this was a style used some five or six generations earlier. Thus, no one had a memory or physical evidence of its existence or what it actually looked like. Anti explained that the spirits of his deceased clan members had commanded him to carve these figures. In his dreams they came out of the river and explained their role in forming the course of the river, shaping the land, and the water's connection to his clan forefathers.

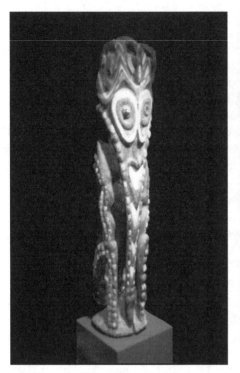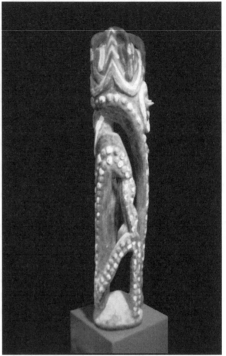

Figure 3. Saun Anti, crocodile/man ances- *Figure 4.* Saun Anti, crocodile/man ances-
tral figure (front). Photo by J. Lewis-Harris. tral figure (side). Photo by J. Lewis-Harris.

Jürg Wassmann's (2001:49) research among the neighboring Nyaura, who
refer to the Indabu people as Palimbei *nimba*, helps to clarify Anti's reference to the
ancestral links to the river and its water.

> When the Nyaura visualize the area where they live in terms of space, the cen-
> tral feature is the Sepik River. In the central section of the river live the Nyaura
> nimba (from Sotmeli to Korogo), the Palimbei nimba (from Sotmeli to Kanga-
> nanmun), and the Woliagwi nimba (from Kararau to Tambunum). These three
> groups feel that there are cultural, linguistic, and historical bonds among them.
> The space surrounding this middle section is divided into regions marked off to
> form individual districts (known as *ndimba*, "enclosures") inhabited by specific
> people. Each of these districts is occupied by *mumungi* ("aliens" or "ignorant
> people"). To these must be added, as mythological regions, the area "under the
> water" (*ngungu ndimba*) and that of the stars (*singut ndimba*).

Anti's carving muse came from those spirits residing in the ngungu ndimba.
His portrayal of these and other spirits as tied to his ancestors had direct bearing on
land rights in the region and the sacred and secret knowledge associated with these

rights. As a result, he met fierce resistance from both the members of the haus tam-baran as well as from others in the community. Introduction of foreign materials and forms was not unknown among the Iatmul (Bateson 1958; Silverman 2001), but reintroduction of new forms was another matter. These new "old" images were a direct threat to the waning power of the haus tambaran. Anti's work seemed to have threatened the cult's spiritual power and authority because he was reintroduc-ing an "old" form that was not sanctioned by current tambaran members. He insisted that they were legitimate forms of important spirits, and his insistence that these forms had been given to him by clan ancestral spirits reflected the traditional method in which new forms were introduced to the tambaran. Silverman (1999:57) confirmed that men in Tambanam village had on occasion received supernatural inspiration: "If a man sees the totemic spirit of a carving in a dream he must not sell the object but place it inside the cult house."

In the past, it was even considered auspicious when an initiated senior member carved a form that he had dreamed. Such forms were thought to be spiritually inspired. So why was Anti's work rejected? Was it due to its direct ties to land own-ership and a new narrative about the migration of the tambaran in the region? Were the carvings potentially dangerous to the community's well-being? As I was a foreign woman who was only able to interview Anti with my uninitiated foreign husband, I will never know the full story. But it did appear that the weakened state of the tambaran cult, combined with Christianity and the economic pressures of the world art and artifact trade, led to contentious community opinions in which visions were disdained by the young and were questioned by less knowledgeable members of the tambaran cult.

The intrusion of the global art world in the form of the international market also influenced the customary carving style within the tambaran cult itself by authenticating specific forms that the carvers, and the tourists, had come to recog-nize as "their" distinctive style of art (Gewertz and Errington 1991). Silverman (1999:59) has also noted that:

> Iatmul tourist art, to a degree greater than traditional art, conforms to styles that are largely indigenous to individual villages. . . . Local carvers too, recog-nize that tourist art symbolizes village identity . . . Sepik tourist art moreover, is an index of Sepik ethnicity.

Even though these phenomena applied more to art made for the tourist market, it also affected the aesthetic of the tambaran cult. The same carvers who produced tourist art were often the carvers who produced sacred art for the haus tambaran.

Anti's defiance not only threatened and challenged the spiritual status quo, it also introduced another form of competition in a highly competitive art market. His work was viewed as a unique style that might become more popular than their version of the established "traditional" style. The other carvers had some reconfir-mation of their fear in 1986, when the government artifact buyer bought all of

Anti's carvings during a buying trip. She bought a small selection of the work of the other carvers. It is ironic that their rejection of his carving from the tambaran was what actually forced him to sell his work in the market as a means of support.

At one point Anti had even tried to stop carving in this style, but he was plagued by multiple visits and threats from the ngungu ndimba ancestral spirits. He showed me where one of the crocodile related spirits had come out of the river during a daytime visit and commanded him to carve an image of the spirit. He told me that he had no choice but to carve the sculpture as the spirit threatened to harm members of his family. Facing stern reprimands and censure from the initiated men, and threats from the spirits, Anti eventually retreated to the outskirts of the village where he continued to carve in his unique style until his death in the early 1990s.

From Port Moresby to Melbourne

The Papua New Guinean contemporary art movement of the "arts gallery" type is a fairly recent phenomenon, having been established only some four decades ago. Many of the artists studied art at Sogeri High School (the fledgling Institute of Papua New Guinea Studies), Goroka Teachers College, or the National Arts School, where they refined their own distinctive art styles. Other artists developed independently in their villages, often under the tutelage of expatriate advisors. The most important of these mentors was Tom Craig at the National Arts School and Ulli and Georgina Beier at the Institute of Papua New Guinea Studies (Beier 1974; Rosi 1994). Both groups of artists were strongly influenced by a few expatriate-sponsored art exhibitions and by the tourist art market (Simons and Stevenson 1990).

One of the major hurdles these contemporary artists have faced concerns the use of traditional designs and motifs in new artworks. As we have seen, Saun Anti paid a high price for introducing a style of carving not sanctioned by his community. In the urban setting contemporary artists confronted somewhat different concerns when they modified old designs and introduced new styles since both practices created (or faced similar) controversy. The serendipitous use of traditional designs and motifs by uninitiated artists presented the possibility of provoking even stronger sanctions and punishment for violations of what has now come to be known as indigenous copyright. Indeed, in recent years, anthropologists have begun to recognize and discuss that in nearly every part of PNG there are unwritten concepts of group copyright over designs used both in ceremonial and utilitarian art (Bateson 1958; Choulai 1996, 1997; Silverman 2001; Dark 2002). Furthermore, as they have also begun to understand, traditional ideas of group copyright do not map easily onto Western concepts that are vested in individual ownership. Reconciling indigenous and international systems is therefore problematic (Silverman 1999; Totu 2002).

This is the art world in which Wendi Choulai had lived and worked since the mid-1980s. Concerns over traditional copyright overshadowed and influenced her entire artistic career. As the first Solien Besena female to attend the National Arts School, she came under close scrutiny both from her clan and from other relatives. Coming from a clan that had bought or negotiated for the use of the majority of its designs had made her sensitive to the issue of traditional copyright. She stated that:

> Despite the abundance of traditional motifs in PNG, I would no sooner fish or even travel through another tribe's traditional land than I would use their designs. It is not only my fear of compensation payment but also an identification with my own Papuan clan and respect for PNG custom that prevents me from doing so. . . . Within PNG there is great importance and pride placed on the cultural group because it gives you an immense sense of belonging. (Choulai and Lewis-Harris 1999)

Although she resided in Port Moresby, her artistic roots were in the Solien Besena culture, an offshoot of the dominant Motu-Koita group. Choulai was the first female to graduate with honors in textile design from the National Arts School. After receiving her diploma in 1986, she immediately introduced contemporary Solien Besena painting and textile design to the PNG art scene (Rosi 1994:222–224, 238). While still at art school, she opened PNG Textiles, a workshop and studio, to train and employ squatter settlement-based artists. Her company arranged contracts to provide art and textiles for the International Travel Lodge hotel and Air Niuguini, the national airline. She represented PNG in several overseas art venues, including the Commonwealth Arts Festival in Edinburgh, Scotland, and the World Crafts Council Meeting in Jakarta, Indonesia. For both of these venues, she developed a performance piece, blending her textiles and paintings into an exciting educational presentation on traditional design and costumes.

As part of her early National Arts School projects, Choulai was strongly encouraged by her teachers to incorporate designs from different areas of PNG, something that showed their naïve understanding of traditional copyright rules and traditions. Speaking of her instructors during the early 1980s, Choulai and Lewis-Harris (1999:214) observed:

> The National Arts School of PNG employs foreign contract lecturers . . . they have no knowledge or training in traditional culture. In an effort to have us diversify our designs, the artistic projects largely ignore traditional "customs"; for example, the reproducing of women's tapa designs by non-initiates. By not acknowledging the traditional copyright principles, the images will be used elsewhere and thereby create conflict with the sensitivities inherent in the Melanesian culture.

Both her family and her friends warned her that she should not use designs belonging to other groups. She was caught in a double bind—to complete her course work she was poised between her expatriate instructor's direction and con-

cerns about having to ask permission to use her mother's clan designs. To solve this dilemma, she began to develop designs that were based on her own personal environment, both rural and urban. She also began to incorporate the motifs of African, South American, Asian, and Pacific cultures, remarking:

> I am outside those cultures and feel free to use these universal symbols in a decorative way. When representing PNG I use the markings of the land, a strong binding element for Papua New Guineans. My designs represent images of the Hiritano Highway that connects Port Moresby to my family's traditional land. Images include the patterns of the mud along the highway in the wet season. Other designs represent fish, so important to our survival, pigs, snakes, feathers and the geometric designs of our gardens. The dance ceremonies also are an inspiration as they embody so much rhythm, color, jewelry, and dress. (Choulai and Lewis-Harris 1999:216)

Her first love was subject matter connected to her family, clan, and their land. She and her sister researched their family designs and art forms, condensing them into large sketchbooks illustrated by Choulai.

Her 1987 textile and painting exhibit at the Mila Mala Market gallery in Port Moresby was the art event of the year. It showcased her work as well as PNG textile artists Ostin Harupa and Demitrius Lakore. This exhibit featured Choulai's large "shadow people" paintings on canvas and other found materials, such as copra sacking. The "shadow people" paintings were a commentary on the personality split experienced by contemporary Papua New Guineans residing in the city. The person in the painting is the public figure, while the shadow represents the village person. Thus, the shadow often wears fiber skirts and headdresses, while the public figure might be dressed in a suit or a dress (figure 5). Her smaller paintings and drawings reflected her use of abstracted tattoo patterns, landscape features from her mother's clan area and details of the Port Moresby urban environment. Designer clothing constructed of her hand-printed textiles complimented the painting and drawings. Her inclusion of fashion in the gallery was a reaction to her family's insistence that her new art be functional, promote the textile business, and make money.

One of her most creative works was her "Tru Kai rice" dance skirt. It was made from shredded, 100-kilo plastic rice sacks. The resulting fibers were incorporated into the traditional "grass skirt" form but woven to display the "Tru Kai" logo on the front of the skirt. The skirt was a political commentary on her people's reliance on imported rice, the use of the rice as a valuable and a status symbol in women's bride price, and the equation of women's value to expensive imported rice. Unlike Saun Anti, Choulai's work was embraced by the majority of her community, sometimes with dire results. Distant relatives felt compelled to "borrow" her work permanently. The "Tru Kai rice" piece became one of these borrowed pieces. The skirt disappeared right after its debut to the public and even though she needed it for important overseas venues, it never resurfaced.

The issue of traditional copyright arose once again when Choulai decided to use her clan designs in Mila Mala Market gallery's paintings and textiles. She discussed reciprocity with the senior members of her clan and formed numerous alliances to receive the rights to use the designs. This process was a long and arduous one in which she had to raise funds to pay for the incorporated designs. She called numerous meetings to negotiate appropriate reciprocity and to prove her worthiness to numerous family members, both distant and close. A good example of this effort was the process of designing and constructing what she called a "modern" dance skirt (figure 6). Among her people,

Figure 5. Wendi Choulai, *Shadow People.* Acrylic painting on copra sacking.

women did not make their own dance skirts. Men obtained skirts from their trade partners and had total control over the distribution of the skirts. To design a contemporary skirt, Choulai had to negotiate with male elders and the more conservative, senior women in her family. The estimated cost of these negotiations was close to US$1,500 in cash and trade goods. After several months, she was allowed to make her own version of these skirts in hand-painted silk, cotton, and other printed materials. The silk dance skirt emulated the traditional sago fiber skirts and was inspired by the designs and color combinations from several types of skirts used by Solien Besena women. This was the first skirt ever made by a woman from her group.

Figure 6. Wendi Choulai, *Modern dance skirt.*

In 1989 Choulai moved to Melbourne, Australia. There, the very process of her creative work and the use of clan designs became embroiled in an international event. Soon after arriving in Australia, she was invited to create a work for the Asia Pacific Triennial in Brisbane. She decided to stage a *Gumo Roho*, a traditional dance that would honor the spirit of her grandmother. This dance ceremony served multiple purposes. It would help her to complete the funerary cycle and repay portions of the family for past reciprocity. For the first time, it would also centerpiece the Gumo Roho dance and the culture of Solien Besena at an international art exhibit. Finally, it would provide a showcase for her "modern" silk skirts.

But putting on this dance ceremony would prove to be a very complicated matter in which art took a backseat to the whole process. Several of Choulai's relatives had previously moved to the Brisbane area and had established their own dance groups. One cousin's group featured a mix of Hiri Besena and Motu-Koita dance styles. Another cousin's group specialized in Solien Besena dances. When Choulai contacted them to enlist their help with the exhibit, old family animosities arose. There were disagreements over the ownership of dances and costumes, and, thus, about who should participate in the dance and what their contribution might be. Following the advice of senior members of the Australian-based members of her clan, Choulai held several meetings and feasts. These events helped to ease some of the stress and smoothed out disagreements by allowing clan members to express

their concerns and claim their rights to the dance ceremony. In addition to the participation of the Brisbane-based dancers, Choulai eventually brought in five traditional dancers from PNG through an Australian government art grant. A year and US$10,000 later, the dance was held as an opening act in the Asia Pacific Triennial. Her exhibit in the Queensland Art Galleries featured the dance itself, as well as drawings, paintings, textiles, and a video recording of the Gumo Roho dance. This exhibit was well received by the general Australian audience. It was an inspirational achievement for Pacific Island communities, and became a source of great pride for the Papuan community in Australia. This multimedia presentation was an artistic coup on several levels. Choulai was the first PNG artist to blend traditional art forms with contemporary paintings, drawings, and textiles at the Asia Pacific Triennial, which is an important Western art world venue.

Trials and Travail in the International Art Market

The art and artifact markets have profoundly shaped Choulai and Anti's creativity, their income, and relationships with their families and greater community. While Anti was fortunate enough to have his work purchased by a government handcrafts officer, Choulai eventually had to establish her own retail outlet to sell her products. Anti's work was more easily marketed to artifact dealers and tribal art collectors because it was more akin to their aesthetic parameters. But Choulai's paintings, drawings, and "art textiles" fell into a problematic market categorization—part contemporary art, part traditional, and part fine handcrafts. Her marketing woes mirrored the dilemma of so many urban-based Pacific and contemporary PNG artists.

Solomon Islands cultural officer Victor Totu (2002:341) expressed this concern well:

> One of the best answers to economic exploitation by the dominant culture is for the artist to join the entrepreneurs to gain knowledge of the business side and to become involved in marketing. The danger with this is that it requires involvement with a new set of values that may directly or indirectly affect the form of art produced. The artist is then condemned as "non-traditional" by the fine-art market because of his increased sophistication in the ways of the dominant culture, or because the art he produces reflects new experiences as well as traditional forms.

Choulai often encountered this problem, prompting her to form three separate collections. She developed a commercial textile portfolio, a gallery quality portfolio of paintings, drawings, and prints, and a private collection based on clan designs and traditional art forms. Her commercial textiles sold well, both locally and internationally, but she was troubled when European and Australian buyers wanted her work to be more tribal or "New Guinean." She was particularly offended by one

Melbourne client, who suggested that she would sell more textile designs if they were more "primitive." Like other contemporary Pacific and PNG artists, much of her work has a tenuous position within art world markets.

Challenges to Academic Understandings of "Contemporary Art"

Saun Anti and Wendi Choulai have developed distinctive contemporary art forms despite their involvement in societies with highly communal social structures—albeit a heterogeneous one—as we have seen above. Both artists paid a high price for their individuality: Saun Anti was banished from his village and Wendi Choulai left her home country after enduring emotional and financial duress. Both posed a threat to their community's current construct of traditional forms, and by extension to their group identity. In our discussions Choulai argued that it was more than this. It was the promotion of a dominant Central Province clan that was able to establish and showcase their culture in Australia.

Within the broader discussion of contemporary art in the Pacific region, Choulai and Anti's works do not fit very neatly. Academics had previously defined contemporary PNG art either as artworks produced with nontraditional media (Simons 1990) or as art that was not an outgrowth of traditional art (Rosi 1998a, 1998b). Eva Raabe (1999:23) has suggested that most contemporary art in the Pacific should be seen as a reaction to foreign influences. She went on to add that:

> Contemporary art often develops from the need to express the cultural identity
> of ethnic minorities or migrants in countries like Australia and New Zealand,
> or it develops as a tool to shape new national identity in decolonized states like
> Papua New Guinea.

Choulai's work falls outside this sense of contemporary art because her work was highly personal, growing out of a need to illustrate and glorify her clan's culture. She has intentionally used both traditional and nontraditional media in her art, intellectually toying with the parameters and descriptors found in art historical commentaries. Choulai was well-versed in the academic discussions on current art trends and theory. Her Australian work—if analyzed through a cultural anthropological approach—could be classified as an expression of cultural identity by an ethnic minority. But she would have disagreed with such an interpretation of her work.

Saun Anti's work, although contemporary, was the result of his own personal visions of ancient traditions and cultural landscapes in his mind's eye. It might be argued that community pressure in reaction to foreign influence was a catalyst for Anti's psychological state, and that this state, in turn, spurred on his visions. But such an interpretation does not negate the fact that he created new forms that can only be seen as contemporary PNG art.

Both of these artists' approaches challenge art historical and anthropological arguments in relation to the development of contemporary PNG art. Marsha Berman (1990:59), for example, argued that the term "contemporary art" does not adequately describe these types of work.

> The term "contemporary" means to exist together at the present time. However, "contemporary" within the framework of conventional Western art terminology connotes avant-garde or modern. In order to avoid misunderstanding, I will introduce the term "contemporaneous art" to denote all the art forms existing together at the present time. The "new art" and traditional art are both contemporaneous art forms.

In a 2001 conversation with Choulai she agreed with Berman's concept, as she thought that it was a concise description of her dance skirts and her other art related to traditional ceremonies, while her "new art" acrylic paintings, textiles, and drawings would best be classified as contemporary art.

Curators, Collectors, and Art Historians

Western art collectors, anthropologists, and curators have had difficulty in classifying—and thus understanding—where this art fits in their taxonomy (Simons 1990; Raabe 1999; Rosi 2002; Stevenson 2002). Pamela Rosi (2002, see article 11) noted that contemporary PNG art forms have been devalued because they are considered too Westernized, economically driven, and appealing primarily to the tourist "gaze." Choulai and other contemporary PNG artists echoed this sentiment. They often complained that they had no real market for their art, as collectors and curators preferred the more traditional, ethnographic art and did not know how to "take" their work. The writings of Marcus Schindlbeck (2002), Susan Cochrane (1997), and Eva Raabe (1999) document the cultural bias and ignorance of the collecting population. They attribute this situation to the European idea of ethnographic authenticity, which they view as a remnant of the colonial era. According to this classification, the collector holds older, traditional work at the highest standard, using it as a model by which to judge and appreciate all other Pacific art.

During my own experiences wholesaling contemporary Middle Sepik art, I was told by a well-known European art dealer that most work made after 1960 was "crap," and not worth collecting. This value-laden approach reinforces the exotic stereotypes that are so readily associated with Pacific cultures and art forms. Michael Mel (1999:17) offered a similar view when discussing this affect on the desirability of contemporary Pacific art in his article on the Asia Pacific Triennial in Brisbane:

> Much has been written and recorded in various forms by Europeans about the Asia-Pacific region in terms of it being seen as exotic, different, new, and strange. These representations have held a strong place in the minds of Europe-

ans. Inevitably these "boxes" of representation helped to contain and limit the meaning of images and experiences in art and culture of the region. Most often the activities from the region are deemed to be historical or traditional.

Another aspect of the contemporary art market conundrum concerns the curators, art historians, and anthropologists who are key to the promotion and interpretation of PNG art. Rosi's research on the marketing of Papua New Guinean contemporary art acknowledged the impact of the scholar's validation of authenticity. She found that "authenticity" was a serious issue, impacting the aesthetic and cultural value—and hence desirability—of contemporary PNG art to domestic and foreign consumers (Rosi 1998a, 1998b, 2002). Scholars are not immune from the stereotyped attitudes and opinions attributed to the collecting public. In the late 1980s, art historians, curators, and anthropologists were still debating the definition and merit of Pacific contemporary art. Summarizing a discussion that arose in 1989 at the meeting of the Pacific Arts Association in Honolulu, Karen Stevenson observed that several scholars questioned the authenticity of contemporary Pacific art and most frequently placed it into the "tourist art" category. She also noted, however, that "this pigeonholing was countered by a number of papers focusing on contemporary issues, moving beyond notions of degradation and tourist art to a validation of contemporary art forms" (Stevenson 2002:404).

Part of this dissension arises from the various perceptions of what contemporary Pacific and PNG art represents and where it should be exhibited. As noted, some scholars included all currently produced art forms as being contemporaneous, not "contemporary art." Others defined it by the type of media used or by how disconnected it was from traditional cultural forms. The most commonly held definition views contemporary art as a product of national identity and the introduction of new media and techniques. Underlying these definitions is the classification of this contemporary art. Should it be shown in anthropological museums where material culture is categorized in an evolutionary sequence of primitive, barbaric, and civilized (Dark 2002), or should it be selected on the basis of individual merit and be included in museums of modern art? Harrie Leyten and Bibi Damen (1993:11) argue that non-Western contemporary art has been relegated primarily to anthropological museums due to biased aesthetic selectivity:

> Until now, most museums of modern art have observed a linear, succinct philosophy or conception of art and thus have been wary of other visions of art . . . many museums of modern art prescribed a sort of universal definition of art and consequently determined who corresponded to it and who did not. Artists falling outside of this frame of reference were not considered interesting enough for these museums and consequently fled to other kinds of museums, such as the anthropological museum.

Art museums that offered a platform for this art isolated it and made it a part of the Western hierarchical construct in which non-Western art played a subordi-

nate role (Lopez 1993), thus belittling its value rather than enhancing it. Curators who have attempted to exhibit contemporary Pacific and PNG art in nonanthropological venues recognized these aesthetic limitations and tried to modify their affect through installation design and presentation. Caroline Turner (1993) and Susan Cochrane Simons (1990) confirm their hesitant use of Western concepts of art and aesthetics in the selection of works for their exhibitions, while noting the need to curate the works on their own cultural merit. Michael Mel (1999:17) described this approach as "walking a very fine line," acknowledging that the prescribed "boxes" of representation were defined by a linear European aesthetic.

Anthropological museums provide a modicum of exhibition freedom, but carry the risk of associating contemporary art with the exotic stereotypes of the past. Gradually, contemporary art has been accessioned into these collections but it is often exhibited as part of the cultural evolution paradigm. A notable break from this exhibition philosophy was shown in the recent Nijmeegs Volkenkundig Museum's successful exhibit of contemporary Papua New Guinean art, *Mak Bilong Ol*. Organized by Pamela Rosi and Jacquelyn Lewis-Harris, this show was installed and exhibited like any other contemporary fine arts exhibit. There were no overt connections to the works' ethnic sources, and no artifacts or archival photographs injected into the display. The exotic element was not stressed, thus leaving the audience to examine the art without induced prejudices (Vulum and Boden 2002).

Conclusion

A comparison of Anti and Choulai's experiences illustrate another facet of the emerging world-art world experience from two Papua New Guinean perspectives. The context of their life experiences can be viewed as a microcosm of the greater Pacific experience. As Vanya Taule'alo (1999:16) noted in an article in *Australia Art Monthly*:

> Contemporary Pacific art is reflecting and will continue to reflect a new diversity in the thinking of Pacific artists. At one end of the spectrum we have those who uphold sacred traditions and at the other end, those no longer living or not born in the homeland who are further removed from that cultural context.

As a holder of sacred traditions and a senior haus tambaran member of high standing, Saun Anti placed himself in a tenuous position within his community by creating his sculptures. They posed a possible threat to the power of the tambaran cult, which was closely linked to the definition of cultural identity and land ownership. His actions were also seen as a potential threat to the community's spiritual power because of the close relationship between art and ritual.

Choulai's introduction of the new dance skirt and her organization of the first Australian based Gumo Roho challenged old gender roles and the balance of

power among her PNG-based relatives and her family members living in Australia. On one level, her success made her more beholden to her clan, as she was expected to share the perceived profits. On another level, the international art market had a strong influence on her designs and subject matter because she had to compete in that market to be successful and meet the monetary demands of her clan.

Unlike Anti, she was reasonably successful in negotiating her way through multiple conflicts while representing her cultural heritage. She saw her work in light of a series of nested identities, such as those that Nelson Graburn (1976) has discussed. These activities were not achieved without a cost to her emotional and financial well-being, as she died of cancer at the age of forty-seven. In certain respects, Choulai's position was more stressful and complicated as she was forced to respond to clan, national, and international concerns—all of which had some vested interest in her work. She was a woman torn between two worlds: the world of "tradition," reciprocity, and initiation and the sophisticated, cosmopolitan world-art world of the international artist.

These two artistic careers present a glimpse of the dilemmas embodied in the definition and classification of contemporary PNG art. Their experiences represent two ends of a continuum that parallel the lives of many other contemporary artists in PNG and other Pacific Island countries as these developing traditions become involved in an emerging world-art world.

Questions for Discussion

1. How did art play a role in the formation of a Papua New Guinea national identity? Was this role as relevant in the rural villages as in the city?

2. What role does gender play in the definition of an artist's status and importance within their society and culture?

3. Is traditional copyright important in the rural and urban settings? How does it affect the production of art in each area?

4. Examining the lives of both artists discussed here, define the societal and psychological pressures placed on each and how these pressures influenced their art.

Acknowledgements

This article was adapted from a paper originally published as "Not Without a Cost: Contemporary PNG Art in the 21st Century," *Visual Anthropology* 17(3–4):273–292, 2004, special issue: Confronting World Art, ed. Eric Venbrux and Pamela Rosi.

References

Bateson, Gregory. 1958. *Naven.* Stanford: Stanford University Press.

Beier, Georgina. 1974. *Modern Images from Niugini.* Queensland: Jacaranda.

Berman, Marsha. 1990. "*Samting Tru* or *Samting Nating*?" in *Luk Luk Gen! Look Again!: Contemporary Art from Papua New Guinea,* ed. Susan Cochrane Simons and Hugh Stevenson, pp. 59–63. Townsville: Perc Tucker Regional Gallery.

Choulai, Wendi. 1996. "Art and Ritual Aina Asi A Mavaru Kavamu." *Artlink* 16(4).

———. 1997. Indigenous Oceanic Design in Today's Market: A Personal Perspective. Masters Thesis, Royal Melbourne Institute of Technology.

Choulai, Wendi and Jacquelyn A. Lewis-Harris. 1999. "Women and the Fiber Arts in Papua New Guinea," in *Art and Performance in Oceania,* ed. Barry Craig, Bernie Kernot, and Christopher Anderson, pp. 211–217. Sydney: Crawford House Press.

Cochrane, Susan. 1997. *Contemporary Art in Papua New Guinea.* Sydney: Crawford House Press.

Dark, Philip. 2002. "Persistence, Change, and Meaning in Pacific Art: A Retrospective View with an Eye Toward the Future," in *Pacific Art: Persistence, Change, and Meaning,* ed. Anita Herle, Nick Stanley, Karen Stevenson, and Robert L. Welsch, pp. 13–39. Honolulu: University of Hawai'i Press.

Gewertz, Deborah B. and Frederick K. Errington. 1991. *Twisted Histories, Altered Contexts: Representing the Chambri in the World System.* Cambridge: Cambridge University Press.

Graburn, Nelson H. H., ed. 1976. *Ethnic and Tourist Arts: Cultural Expressions from the Fourth World.* Berkeley: University of California Press.

Iamo, Wari and Jacob Simet. 1998. "Cultural Diversity and Identity in Papua New Guinea: A Second Look," in *From Beijing to Port Moresby,* ed. Virginia R. Dominquez and David Wu, pp. 189–204. Amsterdam: Gordon and Breach Publishers.

Leyten, Harrie and Bibi Damen. 1993. *Art, Anthropology and the Modes of Re-Presentation: Museums and Contemporary Non-Western Art.* Amsterdam: Royal Tropical Institute.

Lopez, Sebastian. 1993. "The 'Other' in the Land of the Globetrotters," in *Art, Anthropology and the Modes of Re-Presentation: Museums and Contemporary Non-Western Art,* ed. Harrie Leyten and Bibi Damen, pp. 45–58. Amsterdam: Royal Tropical Institute.

Mel, Michael. 1999. "Encountering *Ples namel* (Our Place)." *Australia Art Monthly* 121(July):17–20.

Narokobi, Bernard. 1980. *The Melanesian Way.* Boroko: Institute of Papua New Guinea Studies.

———. 1990. "Transformations in Art and Society," in *Luk Luk Gen! Look Again!: Contemporary Art from Papua New Guinea,* ed. Susan Cochrane Simons and Hugh Stevenson, pp. 17–21. Townsville: Perc Tucker Regional Gallery.

Otto, Ton. 1997. "After the 'Tidal Wave': Bernard Narokobi and the Creation of a Melanesian Way," in *Narratives of Nation in the South Pacific,* ed. Ton Otto and Nicholas Thomas, pp. 33–64. Amsterdam: Harwood Academic Publishers.

Raabe, Eva. 1999. "Understanding Pacific Identity and Individual Creativity: Two Paintings from Papua New Guinea." *Australia Art Monthly* 121(July):21–23.

Rosi, Pamela. 1994. "Bung Wantaim": The Role of the National Arts School in Creating National Culture and Identity in Papua New Guinea, PhD diss., Bryn Mawr College.

———. 1998a. *Nation-Making and Cultural Tensions: Contemporary Art from Papua New Guinea.* Chestnut Hill, MA: Pine Manor College.

————. 1998b. "Cultural Creator or New Bisnisman?: Conflicts of Being a Contemporary Artist in Papua New Guinea," in *Modern Papua New Guinea,* ed. Laura Zimmer-Tamakoshi, pp. 31–54. Kirksville: Thomas Jefferson University Press.

————. 2002. "'National Treasures' or 'Rubbish Men': The Disputed Value of Contemporary Papua New Guinea (PNG) Artists and Their Work." *Zeitschrift für Ethnologie* 127:241–267.

Schindlbeck, Markus. 2002. "Contemporary Maori Art and Berlin's Ethnological Museum," in *Pacific Art: Persistence, Change, and Meaning,* ed. Anita Herle, Nick Stanley, Karen Stevenson, and Robert L. Welsch, pp. 342–352. Honolulu: University of Hawai'i Press.

Silverman, Eric. 1999. "Tourist Art as the Crafting of Identity in the Sepik River (Papua New Guinea)," in *Unpacking Culture: Art and Commodity in Colonial and Postcolonial Worlds,* ed. Ruth B. Phillips and Christopher B. Steiner, pp. 51–66. Berkeley: University of California Press.

————. 2001. "From Totemic Space to Cyberspace," in *Emplaced Myth,* ed. Alan Rumsey and James Weiner, pp. 189–214. Honolulu: University of Hawai'i Press.

Simons, Susan Cochrane. 1990. "Commercial Orientation in Papua New Guinean Art," in *Luk Luk Gen! Look Again!: Contemporary Art from Papua New Guinea,* ed. Susan Cochrane Simons and Hugh Stevenson, pp. 39–44. Townsville: Perc Tucker Regional Gallery.

Simons, Susan Cochrane and Hugh Stevenson, eds. 1990. *Luk Luk Gen! Look Again!: Contemporary Art From Papua New Guinea.* Townsville: Perc Tucker Regional Gallery.

Stevenson, Karen. 2002. "The Island of the Urban: Contemporary Pacific Art in New Zealand," in *Pacific Art: Persistence, Change, and Meaning,* ed. Anita Herle, Nick Stanley, Karen Stevenson, and Robert L. Welsch, pp. 404–414. Honolulu: University of Hawai'i Press.

Taule'alo, Vanya. 1999. "*Ua sii le Matalaga*: Creating New Patterns in Pacific Art." *Australia Art Monthly* 121(July):13–16.

Thomas, Nicholas. 1995. *Oceanic Art.* London: Thames and Hudson.

Totu, Victor. 2002. "The Impact of the Commercial Development of Art on Traditional Culture in the Solomon Islands," in *Pacific Art: Persistence, Change, and Meaning,* ed. Anita Herle, Nick Stanley, Karen Stevenson, and Robert L. Welsch, pp. 338–341. Honolulu: University of Hawai'i Press.

Turner, Caroline. 1993. "Introduction: From Extraregionalism to Intraregionalism?" in *The First Asia-Pacific Triennial of Contemporary Art,* pp. 8–9. Brisbane: Queensland Art Gallery.

Vulum, Sam and Ian Boden. 2002. "Review of *Mak Bilong Ol.*" *The PNG National Weekender* (March 22), p. 3.

Wassmann, Jürg. 2001. "The Politics of Religious Secrecy," in *Emplaced Myth: Space, Narrative, and Knowledge in Aboriginal Australia and Papua New Guinea,* ed. Alan Rumsey and James Weiner, pp. 43–70. Honolulu: University of Hawai'i Press.

11

The Disputed Value of Contemporary Papua New Guinea Artists and Their Work

Pamela Sheffield Rosi

*I*n today's lucrative global "traffic in art and culture" (Marcus and Myers 1995), the Western art world recognizes the traditional village arts of Papua New Guinea (PNG) to be "masterpieces" of aesthetic power and meaning—attributes that ensure high market value and desirability. In contrast, the contemporary arts of PNG, made by urban artists in response to modernization and national independence, have received little attention or critical acclaim, even within PNG. Contemporary PNG artists—many of whom have invested in professional training to further their hopes for fame and professional success—find themselves in the distressing position of being professionally adrift, their artwork devalued or unnoticed (Rosi 1994, 1998a).

This is an ironic situation. Government leaders Michael Somare (1979:xv) and Bernard Narokobi (1990:20) have proclaimed new artists to be "national treasures," whose work embodies a sense of national spirit to aid the task of PNG's nation-making. Yet the artists themselves dismiss these official statements as "*maus wara* (meaningless talk)." From their perspective, the state has failed to support their work and treats them as "rubbish men" whose contributions to national development are peripheral (Rosi 1994).

When I visited him in Port Moresby in November 2000, Martin Morububuna, one of PNG's best known artists, ruefully commented to me:

> Look around at how I am living in this run-down flat, which my family shares with two others. This is where I have to work with all these people—even the dogs. We artists only hear from the government or the National Cultural Council when they need something special.

Morububuna's bitter reflections on his own impoverished condition, which he blames on the government and not his own agency, illustrate the uncertain value

that contemporary PNG artists and their work appear to have in modern PNG society (Rosi 1998a). Unlike traditional forms of art, which are described as a significant (*samting tru*) component of village life, this new art is often categorized as decoration without meaning or social function. From a traditional perspective, such newer artworks are logically considered as *samting nating* since they lack worth or substance (Berman 1990). Such ambiguities about the value of new art in PNG invite exploration.

This article considers why these new artists and new art forms are controversial and lack the prestige accorded traditional PNG art both at home and in the global market. For the past eighteen years I have worked as an anthropologist with contemporary PNG artists. Research for my doctoral dissertation was carried out in 1986 at the PNG National Arts School (NAS). Since then, I have curated four exhibitions of contemporary PNG art in the United States and one in the Netherlands. My most recent visit to PNG was in 2004. As many of the artists I work with in PNG know subjectively, the modern road to individual success is not easy to achieve or sustain. The artists I know yearn for fame and fortune, but most are still hoping and waiting. I draw on these diverse experiences with PNG artists to explore the key notions of ambiguity, controversy, uncertain value, and modern success.

This article consists of three sections. First, I consider the factors that have contributed to the establishment of a modern art system. Of particular interest is the vacillating role the PNG government has played in promoting new artists and art forms to showcase national identity and pride.

Second, I examine the hardships and conflicts that confronted new urban artists—primarily men—as they struggled with competing obligations to sustain their jobs and find recognition for their imagery in domestic and foreign markets. Sometimes, the distresses of these social problems find an expressive outlet in the subjects and iconography of an artist's imagery. Clearly, the achievement of modern success necessitates that both male and female artists develop strong emotional stamina to cope with painful doubts about self-worth and lifestyle.

Third, I explore the challenges that artists face in marketing their art in PNG and in the international art world. Besides problems with production and marketing, these challenges include the question of authenticity, which has been debated by Western critics. Authenticity is an important issue because whether an artwork is deemed authentic or not impacts the aesthetic and cultural value—and hence desirability—of contemporary PNG art for domestic and foreign consumers. By drawing on comparative material about the marketing of Australian Aboriginal art, it becomes clear that it takes more than talent to become a contemporary PNG artist. It takes a productive art system.

Structuring a Modern Art Environment

Contemporary PNG art did not emerge from traditional art forms, but was developed as a way to speed up national development and modernization. The first roots of this were stimulated in the 1950s while PNG was still an Australian territory. Australian teachers in the territory's primary schools taught realist drawing as a way of helping children interpret book illustrations, posters, and billboards—basic skills necessary for modern visual literacy (Stevenson 1990:23). The major reason for developing contemporary art, however, was Australia's decision—under pressure from the United Nations—to grant the territory independence much sooner than had been anticipated.

Beyond the rush to form a national government and to instigate an economic and educational development plan, the administration recognized that new art forms were needed to establish a modern communications industry. Such new art forms would also contribute to the construction of a new national culture in PNG's fragmented, village-based society (Craig 1971, 1982; Rosi 1998b). As several scholars have described, aesthetic forms can contribute to the symbolic processes of nation-making. These processes include constructing the imagery of an imagined national community (Anderson 1983; Cohen 1985; Foster 1995a); composing narratives of nationhood (Bhabha 1990; Facey 1995); modeling nationalist norms of gender and sexuality (Zimmer-Tamakoshi 1993); and stimulating sentiments of nationalism.

At the time, the territory had hundreds of local ethnic identities but almost no sense of any national consciousness or subjective feeling of being Papua New Guinean—as opposed to being Simbu, a Hagener, or a Motu. Such feelings of collective national consciousness and pride could be stirred by symbolically charged objects, events, or performances. These symbolic forms include the familiar repertoire of anthems, flags, historic commemorations, architecture, food, and representations of a sacred national heritage (Herzfeld 1982; Keesing and Tonkinson 1982; Hobsbawm and Ranger 1983; Handler 1988). Both the colonial administration and the newly independent government of PNG recognized the need for national symbols and new buildings like the National Parliament House and the National Museum and Art Gallery, which were used to fulfill this function (Rosi 1991). Nevertheless, in any multicultural, national society with competing interests, national symbols like the new PNG Parliament House can be politically contested (Narokobi 1983; Lindstrom 1994; Rosi 1994; Foster 1995a).

The initial institutionalization of art and the training of PNG's first contemporary artists were due largely to the efforts of two expatriate art teachers, Georgina Beier and Tom Craig. Beier began to teach illiterate migrants at the University of Papua New Guinea (UPNG) in 1967. Three of her students, Timothy Akis, Ruke Fame, and Mathias Kauage, later became PNG's best known village artists (Beier 1974). Tom Craig was head of the Department of Visual Arts at Goroka Teachers College when he was appointed to be the first director of the Creative Arts Centre after it was jointly funded by the central government and UPNG.

Figure 1. Jakupa, *Tom Craig makes Jakupa an Artist,* 1983. Acrylic painting. Presented to Tom Craig as a farewell gift upon his departure from the National Arts School. Photo by Pamela Rosi, courtesy of Tom Craig.

In 1972, the center opened in Port Moresby with a small number of staff and resident students. Despite limited facilities, the institution adopted a philosophy of education that shaped the ethos and basic goals of the school for several years. As a way of involving students directly in commissioned work, teachers emphasized the applied arts and urged students to design things with a "PNG look." They accomplished this look by restyling traditional motifs for new contexts, or making objects to represent old and new aspects of national life. This work included designing book covers, textiles, uniforms, architectural facades, murals, and graphic productions—particularly posters and advertisements as visual aids for economic, political, and cultural development, or for promoting modern health care (NAS 1982; Rosi 1994; Foster 1995b).

The school further attempted to instill feelings of national consciousness and good citizenship in its students. During classes students were urged to take pride in their work and reminded that they were assisting national progress (NAS 1978). This educational ideology of fostering virtuous citizenship and national unity was glossed by the pidgin concept of *bung wantaim,* which had the meaning of "coming together" or being united in diversity (Rosi 1994). Theoretically, these ideas have roots in Émile Durkheim's (1956) work on collective consciousness and education

and Victor Turner's (1969) ideas about *communitas*, which focus on the importance of group spirit and allegiance.

To help develop and represent national sentiments and collective identity, students were recruited from all parts of the country. Each student was encouraged to learn about, share, and draw inspiration from his or her own cultural traditions. While learning to experiment with new Western media, they were also encouraged to draw on indigenous traditions (*pasin bilong tambuna*) and represent them in their imagery. As a result, new art forms were hybrid expressions that linked the traditional and modern concerns of PNG's changing society.

To foster cross-cultural friendships ("being *wantoks*") and national pride, as well as part of an effort to prevent regional animosities from erupting at the center, staff organized social events and mounted exhibitions where students worked collaboratively to promote their work. When students traveled overseas to attend cultural festivals or art shows, they were designated PNG cultural ambassadors, which became a source of great pride.

Whatever pride may have come from acting as a national ambassador, this honor was also a source of frustration later when, as some artists complained to me, they received little public attention in return for their public work. Village painter Jakupa Ako, now deceased, was a good example of this neglect. He was the first PNG artist to be awarded an OBE (Order of the British Empire) for national service. Yet, his sole government remuneration for this national decoration was to receive free residency in a dingy room at the center where he could live and work (Rosi 1994:269).

In 1972, the Creative Arts Centre was already a microcosm of the tensions associated with urban life, migration, and social modernization—including for men the provocative changing roles of women (Rosi and Zimmer-Tamakoshi 1993; Zimmer-Tamakoshi 1993). Because disruptions and conflicts were facts of life at the center, bung wantaim was not just an abstract ideology of virtue. It was a necessity to assuage social divisions and the numerous cultural conflicts associated with development.

In 1974, a grant from Australia to expand the development of national culture under a minister of culture and a National Cultural Council, enabled the center to enlarge its curriculum, student body (including the first women), and studio facilities. But this expansion also created sharp conflicts over the direction of educational policies. Georgina Beier, head of textiles, believed that if national art education was to reflect Melanesian values, students of the center should work in their villages and be sent for advanced training to third world countries sharing similar problems of modernization and postcolonialism.

Tom Craig, pressured by students and their parents, countered Beier's desires and argued that students should be trained in Port Moresby so as to have direct access to commissions and places for marketing their work. He also proposed the introduction of diplomas and the eventual incorporation of the center into the university. These moves would enable students to gain advanced professional training

and higher occupational status in the national prestige economy (Beier 1974; Rosi 1994). Board members supported Craig. The center was renamed the National Arts School and soon after a program of diploma courses was offered to qualified secondary school students. Village artists maintained a limited connection to the school through shows of their work in the school's new gallery. Adequate funding now allowed the school to function well and to mount a regular program of exhibitions, concerts, and theater performances. In 1981, the large government commission to design and construct the embellishment program for the national parliament building brought the establishment of a special production workshop and national recognition of the school's work.

There was a general consensus that this was the high point of success for the NAS, and yet none of its artists were invited to the opening ceremonies for the parliament building, which was attended by national and commonwealth dignitaries. Upon completion of the project, the work of the NAS declined as staff, programs, and funding were cut in response to a growing crisis in the national budget. In 1986, when I began my research at the NAS, these problems were already evident, including a decreasing number of exhibitions. Both staff and students were also dismayed by the recently released Manpower Act, which ranked art very low in its listing of national priorities for development. There was also resentment for the Department of Culture and Tourism's administration of the school when complaints from the school were ignored. But the most traumatic blow to school esprit

Figure 2. The Papua New Guinea Parliament House designed by Cecil Hogan. Photo by Pamela Rosi.

was the violence that occurred at the end of the year. Sparked by the death of High-land leader Iambaki Okuk, city riots spread to the school and Highland students destroyed 30,000 kina worth of music equipment. In response, the school director cancelled graduation, and students reacted by striking to protest the unfairness of everyone being punished for the drunken acts of a few.

In 1987 and 1988, program cuts continued as the national fiscal crisis deep-ened with the shutdown of the Ok Tedi and Bougainville mines due to local vio-lence, escalating in the Solomon Islands into bitter civil war. Left with a threadbare budget, the NAS had to abandon its exhibition program, forcing artists to seek other venues. Successive administrative reorganizations paralyzed all leadership as the NAS was shuffled between the Departments of Culture and Tourism, Aviation, and the new National Tourist Corporation. At the end of 1989, the government vacillated again, announcing that the NAS would be affiliated to the UPNG. The director of the NAS was strongly opposed to this move fearing the loss of the school's autonomy. Others in the community also protested because it would cut ties to village artists and put an end to the school's policy of preventing status divi-sions among artists. After just six weeks, the government reversed its position and the NAS was reassigned to the tourist corporation. Angry students went on strike and displayed placards on national television that declared, "We are like a football being kicked around" (Rosi 1994:280). Further protests in the press pressured the government to reverse its position again. In April 1990, the NAS was officially affiliated to the university as the Faculty of Creative Arts (Rosi 1994:284).

Affiliation with the UPNG during the past decade did not automatically revi-talize the art faculty or bring increased economic support to PNG artists. Instead, the faculty was affected by the government's sharply decreased funding of the uni-versity's budget due to the military costs of the Bougainville civil war, the devalua-tion of the kina in 1995, and a declining economy. The last of these has led to widespread unemployment, a sharp increase in violent urban crime, and social and political insubordination, all worsened by the government's inability to deliver essential public services. In the mid-1990s, student activists at the university orga-nized rallies to protest government policies. These rallies often ended in violence and looting. Tensions arising from student participation in this civil unrest fueled state actions to cut back on university education, and on one occasion it led the government to close the university for several months.

In November 2000, when I was back in Port Moresby, evidence of the univer-sity budget cuts was clearly visible. The new creative arts and humanities building stood in unmowed grounds, and the condition of the former NAS was decrepit, its buildings rotting. As I learned from arts faculty members, the situation worsened. The new university chancellor had announced that the science and humanities fac-ulties would be merged, and the Faculty of Creative Arts would loose all administra-tive autonomy. The number of new art students annually admitted to the university would be limited to ten, a decision that would result in further downsizing.

Other Impediments to Artistic Success

Martin Morububuna and other artists blame the government for their unsuccessful careers, but there are other problems of modernization that have hampered their reaching artistic success. Lack of state support contributes to the difficulties of becoming a successful artist, but so do other problems of daily life. The most important of these is the difficulty of "managing the wantok system" (Rosi 1998a:43). In order to work, contemporary artists require the resources of an urban location. But at the same time, many are rural migrants who want to retain ties to their villages and clansmen. They do this in several ways: by sending remittances to fulfill kinship obligations, by participating in local ceremonies, by contributing to school fees, and by investing in modern village businesses, such as coffee growing or trade stores. In town, artists are also expected to host village relatives and unemployed kin. Balancing the continual demands of this "wantok system" with the artist's personal needs and the requirements of a modern career inevitably creates tensions and conflicts.

For example, Akis, Kauage (who was also awarded an OBE), and Jakupa, the first village artists associated with the Creative Arts Centre, each made a lot of money by local standards, using it to lift their personal and economic status. Aided by their wives, they did this in two ways. They invested in the village prestige economy by rearing pigs, running trade stores, or growing coffee. They also purchased highly desired Western goods—particularly cars or a house in town. But, as Georgina Beier (1974:15) suggested, this wealth also produced burdensome social obligations to fellow clansmen and was quickly spent.

> To be in possession of a house brings liabilities. It will be impossible for Kauage to refuse accommodation to wantoks. . . . He will become responsible for housing some of the homeless bachelors of his village. He is already responsible for a large proportion of Chimbu drunks. . . . As a successful town dweller, Kauage is expected to share his wealth with his countrymen. . . . He is meeting his social obligations.

Unless an artist is educated, has secure employment, and moves regularly in the elite circles now emerging in PNG (Gewertz and Errington 1999), he or she must satisfy their kin obligations for very practical reasons. These are the people who will offer assistance in times of trouble, and in addition they can deploy powerful sanctions if they feel slighted.

A film made in 1974 by the Institute of Papua New Guinea Studies documented the participation of village artists Kauage, Akis, and Jakupa in village gift exchanges and in financing local coffee production. But this film failed to note that, in the politics of village exchanges where the cash economy has penetrated, dissatisfaction and jealousy can lead to accusations of sorcery—the politics of retribution. Artist friends told me privately that they believed—contrary to modern

medical diagnoses—that both the premature death of Akis and the sudden death of Jakupa, on a Christmas visit to his village, were caused by the sorcery of jealous relatives. Jakupa had also confided to me his fears of being the target of village sorcery because he had become a "big man" with money—something he took pains to hide by putting his cash in the bank and avoiding displays of modern symbols of wealth. His humble room at the NAS, thus, had its advantages. It made him appear poor, and he had no space to accommodate relatives. But his bank savings allowed him to buy pigs—a job done by his wife—for important village *singsings* (celebrations) and other events.

A further problem has caused artists considerable distress and added to their difficulties of professional advancement. This is the loss of employment, which produces immediate financial difficulties, but it can also result in being homeless since both government and private sector jobs typically provide housing as part of the job. Since 1986, several of my artist friends have had to manage the crisis of being homeless or jobless. In 1986, Martin Morububuna was to have a solo exhibition at the NAS, but he had been evicted from his rented house and his painting business was doing badly. Homeless and with little money, he had to move in with his wantoks. There, in cramped quarters, he had nowhere to paint and no cash to buy art supplies. Without paintings, his show was cancelled and an opportunity to sell his work was lost.

Figure 3. Larry Santana, self-portrait: *Pain and Sorrow at the Six Mile Dump,* 1989. Watercolor on paper (Collection Pamela Rosi).

The well-known muralist Larry Santana lost his job and flat in 1988 when his employer went bankrupt. He and his family ended up living at the "Six Mile Dump," where he built a shack and scavenged for food discarded by Air Niugini. In 1993, he was living again in proper housing in town, but it burned down and the family lost everything. Larry pleaded for help from his homelessness on local television, and a wealthy national, who knew Santana's reputation as a PNG artist, extended him a loan and helped him to find new housing.

The pain and humiliation of being indigent, as well as the frustrating circumstances of daily life that impede fame and fortune, often find expression in an artist's work. To record his feelings of shame at hav-

ing to scavenge for food to feed his family, Santana painted a self-portrait entitled *Pain and Sorrow at the Six-Mile Dump*. Holding a paintbrush, he depicts himself with tears of blood flowing down his face—signs of his suffering (Rosi 1988:23). The trauma of losing his possessions and nearly the lives of his family to a fire is a theme expressed in several of his paintings. These images, deploying the destructive motif of fire, utilize blazing colors of red and yellow. But beyond depicting his own loss, Santana also uses fire symbolism to represent two charged national subjects: the horrors of the Bougainville civil war and the destruction of traditional culture by the forces of modernization (Rosi 1998b:21).

Martin Morububuna is another artist who uses expressive imagery to reflect the painful struggles of his life in seeking recognition for his work. A Trobriand Islander, he often depicts Trobriand myths and customs to underscore the relevance of the past for the present. A custom he frequently paints is the *kula* because he considers kula voyages to be an apt metaphor for his own life:

> I call this painting *Blue Kula* because my life as a contemporary artist is like "making kula." On these voyages we sail to make our fame . . . but at night the journey is dangerous because, in the dark, witches and hidden enemies make

Figure 4. Martin Morububuna, *Blue Kula*. Screen print (Collection Pamela Rosi).

sorcery and sudden storms threaten safety. . . . Kauage, myself, we all struggle
to get ahead . . . sometimes I think we are drowning with no one to help us out.
(Rosi 1994:417)

Morububuna shares with Larry Santana and other contemporary artists the belief
that modernization does not automatically bring progress or success. Instead, it
causes social and economic dislocation and cultural confusion. This theme of anx-
iety is symbolized in a painting I own entitled *Senis Pasin Bilong Tambuna* (Chang-
ing Traditions), whose iconography Morububuna interpreted as follows:

> Representing the dignity and values of traditional culture, this Chimbu warrior
> looks with apprehension at his wife. In her T-shirt, trade store beads, and smok-
> ing a cigarette, she symbolizes the forces of change. In this painting I am trying
> to express my feelings of anxiety. I use red to convey warning. Who is this
> woman? She is the face of the city challenging us. The light here is not
> sunshine . . . I use it to create tension. As a painter, a central theme of my work
> is change. (Rosi 1987:26)

The symbolism of this painting—unfavorably connecting women to changing
ways—suggests that gender issues are important in modern life. It also raises the

Figure 5. Martin Morububuna, *Senis Pasin Bilong Tambuna* (Changing Traditions). Acrylic
painting (Collection Pamela Rosi).

question of why so few PNG women have become contemporary artists to contribute their vision to national life. What are the reasons for this? Since the opening of the Creative Arts Centre, women have been admitted both to the NAS and the UPNG to study textile design, graphics, music, and studio arts. But many have not graduated, and very few have managed to sustain a successful career.

In 1986, when I asked female NAS faculty and students about this problem, and I also questioned employers, everyone told me that in PNG's chauvinist society the lack of male support, male aggression, and male harassment at school, on the job, or at home were all crucial factors in pressuring women to quit their art education and give up their ambitions for professional advancement (Rosi 1997). A large body of literature documents the effects of male violence on women's lives and the persistence of inequality (Toft 1985; Zimmer-Tamakoshi 1993; Macintyre 1998).

As I learned from recording women's histories in 1986 and 2000, high rates of pregnancy cause many female art students to drop out of school. Because single women face persistent harassment from male students, they often chose to have a regular boyfriend to provide protection from unwanted male advances or the threat of rape. But the price of having a boyfriend usually meant accepting sex with the frequent consequence of pregnancy. Yet, if a young woman has a supportive family or gets married, she may be able to return to school or work professionally. But for a single mother who has no help, rearing a small child alone while working is difficult. These women artists may choose, therefore, to have their mothers rear their children so that they can finish their education or remain working toward professional advancement.

Another problem is the physical violence and verbal abuse that women encounter because their boyfriends or husbands disapprove of their professional goals. Verbal and physical abuse puts strong pressure on women artists to abandon their career ambitions in all of the arts. For example, one female musician served as mistress of ceremonies for a benefit concert to aid people in the Solomons. She wore a modern dress and sang contemporary love songs for the event and was beaten up by her boyfriend, who later destroyed her clothing. This violence occurred because her provocative dress and behavior humiliated him. Warned by this incident, the young woman decided it would be wise to give up her career in contemporary music and become a journalist. This was a more acceptable career choice for a woman and less likely to incur male antagonism.

To facilitate changes in traditional gender attitudes, NAS faculty used classroom discussions to educate male students that changes in women's customary roles were necessary if PNG was to modernize and achieve national goals of democracy. But tensions over the appropriateness of this new female assertiveness and behavior were difficult to diffuse and became regular subjects of male artist's work. I will mention two examples that the PNG public are most likely to recognize because they have frequently been reproduced or copied. The first is Dus Mapun's poster poem "O Meri Wantok," with its chauvinistic message deriding the

"Western" appearance and behavior of modern PNG women (Creative Arts Centre 1972). The second is Kauage's disapproving images of "fancy women," who are depicted driving cars, piloting helicopters, parading as beauty queens, or sporting bras, high heels, and handbags (NAS 1977, 1978). These critical images contrast with representations of hardworking village women nursing babies, gardening, or carrying loaded *bilums* on their heads—symbols of their industriousness (Rosi 1997).

Male hostility towards professional or modern women also occurs in other contexts. A few women artists have attempted to operate their own businesses but met resistance from male employees. In the prevailing models of traditional and contemporary masculinity (Fife

Figure 6. Mathias Kauage, *Unmarried Couples shouldn't play around: an unmarried woman gives birth to a child and places it in a basket.* Screen print, 1977. Courtesy of PNG National Arts School.

1995), the majority of PNG men resist taking direction from women. Wendi Choulai, one of PNG's few professional textile designers, spoke out publicly about these difficulties in an effort to help educate women about the problems they need to confront. For her, achieving success as a professional woman in PNG came at considerable personal cost. It may have contributed to her untimely death in 2001 (Dunar 1988; Lewis-Harris 2001, see article 10).

While inequality and violence against women are still widespread in PNG, this situation is slowly changing as more women get secondary and tertiary educa-

Figure 7. Martin Morububuna, *Love Mother Love Child.* Acrylic painting, 2000. Photo by Pamela Rosi. Courtesy of Martin Morububuna.

tion, enter the workforce, and publicly speak out for equal rights for women in national development. On my visit to Port Moresby in November 2000, I spent time with a group of four young women artists, all recent UPNG graduates. Their self-confident attitude in their own abilities and their drive to succeed were noticeable and quite different from the pattern I had first seen in 1986.

Given the failing economy and the cutbacks in institutional support for the arts, where did this confidence come from? It was, I believe, encouraged by two important factors. These young women—married, single, and two with children—had the support to pursue their careers as professional artists from their close relatives. They had also received mentoring from German artist and anthropologist Marion Struck-Garbe, who was living in Port Moresby. She invited the women to work together at her studio, and motivated them to feel confident about their artistic talents and their identity as independent women. After being taught by male instructors at the UPNG, feeling empowered was something new to these young women. With Marion Struck-Garbe's help as a fundraiser and organizer, the group also mounted the very first exhibition of PNG women's art (Meri Artists Soim Piksa) at the Waigani Arts Center in 1998 (*The Independent* 1998; *National Woman* 1998; *Post Courier* 1998). Later that year, Struck-Garbe also arranged for their work to be exhibited at several venues in Germany, and for two of the women to study in Germany for several months.

During my visit in 2000, the confidence and pride of these young women was further enhanced when Jane Wena traveled to Brunei to represent PNG at an exhi-

bition of Asian and Pacific artists sponsored by the Asia-Pacific Economic Cooperation (APEC). She met the sultan of Brunei and had her picture taken with U.S. President Bill Clinton, which rated a front-page story in the national PNG press. The group welcomed this publicity because it drew national attention to their work celebrating women's lives and talents. But it also protested women's inequality and abuse in PNG society (Mota, pers. comm.). Their focus on activism was underscored by the title selected for one of the five exhibitions of their art held in Germany in 1998 and 1999: Behind the Fence.

Problems in the National Marketing of Contemporary PNG Art

When Ulli Beier (1980) labeled new PNG artists "outsiders in their society," he was addressing not only their emotions of alienation, but the problems they confronted in marketing their work in PNG's changing society. In a modern world of consumers, "art" had to be skillfully presented and sold if artists were to succeed. Facilitating this goal has presented a huge challenge to PNG's contemporary artists because they are dependent on the services, facilities, support, aesthetic interests, and "taste" of others. In PNG's largely village-based society, most "grassroots" people—even if they recognize new art forms—see no use in buying objects that have so little cultural value for them.

For example, young villagers are eager to purchase creatively designed T-shirts or cassettes of local rock music as desired symbols of modernity. But contemporary drawings and paintings have not acquired this value and are dismissed as only pictures ("*em piksa tasol*") (Berman 1990:61). Unlike traditional objects or designs, these new art forms are considered to be without power or sanctity. As a result, the local marketing of contemporary PNG art is largely restricted to urban venues and targeted at the educated elite or resident expatriates.

But even in town, it is difficult for new artists to sell their work because the country has few specialized art shops, galleries, or art centers where, as in Australia, native artists can sell their work to the public. Most contemporary artists live in Port Moresby and must market their artworks in other ways. First, they can work directly on commission or run their own workshops. Unfortunately, most of the latter businesses fail—either because of bad management or uncertain cash flows.

Second, artists can display their work outside hotels or at craft markets, hoping to attract tourists or expatriates. The bargaining that occurs here, however, is distasteful to elite artists who see bargaining as demeaning both to their professional status as artists and to the "spirit" of their work. Kauage, who died in 2003, was probably PNG's best known contemporary artist. Yet, he was a frequent target of criticism because the paintings he sold on the street were often carelessly executed

and also repeated the same subject matter. Elite artists also disliked Kauage's willingness to accept a "second" or "third price" from tourists wanting to get a bargain. Martin Morububuna told me in 2000 that this practice lowers the prestige market value of all contemporary art:

> Kauage and his relatives just sell art for money. They also take "second" or "third" price. I paint from my heart. When I put a price on my painting, that's what it is worth, and I keep it until I sell it. See the painting I exhibited at the Museum. I want 8,000 kina for it. You see how I am living. I could use the money, but I won't give that painting away for just anything.

Third, for elite artists the most prestigious venue to market their artwork is at an exhibition, organized by supportive patrons. Exhibition venues, however, are limited in PNG—a situation exacerbated by the ongoing crisis of the national economy. Up until 1988, artists exhibited their work regularly at the NAS and the Waigani Arts Center, organizations that covered all promotional costs. Other occasional sites included local hotels and restaurants. But in 1989, when the NAS ended all sponsorship of public exhibitions, artists were left without a single state-supported venue. The National Museum and Art Gallery was supposed to take over this function, but deep budget cuts at the museum precluded exhibitions from happening on a regular basis. Recently, the high urban crime rate in Port Moresby has also affected exhibition attendance because people are afraid to be out in dangerous places at night. Ironically, Waigani, the seat of most national government buildings, has become one of these areas. Consequently, the Waigani Arts Center, once a well-attended venue for theater and the arts, is now barely functioning.

In 1972, after the opening of the Creative Arts Centre, the faculty exerted considerable effort to promote new PNG art to local audiences. Exhibitions were well attended, but primarily by resident expatriates who had lived in Port Moresby for many years. The new art appealed to them because its combination of modern media, decorative style, and indigenous subject matter captured the dynamics of PNG's modernizing society. But with the departure of many of these expatriates after independence, and with Papua New Guineans largely disinterested in buying contemporary art, the local market became stagnant. Prices are too high for all but the wealthiest Papua New Guineans, and those with money would rather buy cars or televisions because these objects have greater social prestige (Rosi 1991; Foster 1995b). Today, the state is the largest consumer of contemporary art. But, as Martin Morububuna observed, the government gives commissions—whether it be for the prime minister's Christmas card or murals for the national airport—only when it wants something special. The chances for finding work at home are so limited that contemporary artists often seek whatever possibilities are available to promote their art abroad. Their hopes for success are tied to the belief that entering the global art market will provide many more opportunities to sell their work. But contemporary PNG art has attracted only minimal interest in world art venues.

Various critics have challenged its artistic value, undercutting efforts to raise its visibility abroad through well-publicized gallery showings and museum exhibitions.

Challenges to the Global Value and Marketing of Contemporary PNG Art

The first international promotion of contemporary PNG art began in the early 1970s when Ulli and Georgina Beier arrived in PNG from Africa. The Beiers had lived for many years in Nigeria, where both were deeply involved in the development of contemporary African literature and art. Ulli worked to develop the first group of Nigerian writers, including Wole Soyinka, while Georgina, herself a talented artist, ran workshops to develop the artistic talents of illiterate villagers (Beier 1968). Using their contacts in the global art world, they started to organize exhibitions of PNG's first village artists in Europe, Australia, and the United States (Beier 1974). They also wrote about PNG artists.

The Creative Arts Centre, and subsequently the NAS, also funded artists to exhibit and perform abroad, until budget cuts in the mid-1980s brought an end to these trips (Rosi 1994). Beginning in the 1970s, contemporary PNG artists also participated in multicultural art festivals around the Pacific, including the Pacific Festival of the Arts, which is hosted by a different country every four years. Artworks are occasionally for sale at these shows, but these festivals are primarily occasions to showcase national and ethnic identity through performances (Babadzan 1988). Several artists informed me in 2000 that they had become reluctant to contribute to these official events because all too often their artwork was "declared lost" afterwards and they received no compensation. They implied that these pieces had been sold off covertly. Such is the cynicism that accompanies the widespread bureaucratic corruption and mismanagement present in modern PNG society (Larmour 1998:22).

But while mismanagement or corruption have generated mistrust of the government's efforts to promote PNG art abroad, other problems also make it difficult for PNG artists to market their artworks in international art worlds. In this highly competitive arena, foreign gallery owners and museum directors want to mount exhibitions that will make money and attract audiences. PNG is not, however, a country that is well-known outside the Asia-Pacific Rim. Its economy only has regional importance, and international media (with the exception of Australia) pay scant attention to PNG politics. PNG has no large populations of transglobal migrants to make host countries aware of their Melanesian traditions, as has happened, for example, with Samoans living in New Zealand or on the West Coast of the United States.

Potential sponsors are, thus, reluctant to exhibit contemporary PNG art since it might not sell well or have popular appeal. This problem was personally brought

home to me when an American university museum on the West Coast cancelled an exhibition of my collection of contemporary PNG art six months into the planning process. The director informed me the reasons were financial. PNG culture was too unfamiliar in his city to attract a large local audience.

Discourses of Cultural Value:
A Comparison with Aboriginal Australian Art

Another marketing problem for PNG artists involves the concept of authenticity and whose critical judgments will determine how contemporary PNG is valued in international art circles. To consider the dynamics of this process, an instructive comparison can be made with neighboring Australian Aboriginal contemporary art, which has been discussed by Eric Venbrux (2002, article 9) and Fred Myers (1995, see article 8). As both of these scholars point out, Aboriginal art has, through a series of transformations, been given national and international recognition as "fine art." Ironically, contemporary PNG art has nearly the opposite status and has received minimal acclaim. Why is it that Australian Aboriginal arts have successfully come to be designated national treasures while contemporary PNG arts remain confined to the ambiguous margins of outsiderhood?

In analyzing the successful marketing of the acrylic paintings of Aboriginal people from Central Australia, Fred Myers discusses how several disjunctive discourses have collectively constructed their value in Australia and the international art world (Myers 1995:60–84). Aboriginal artists maintain that these paintings represent stories or mythological events of the Dreaming, thus embodying spiritual continuity with the past. Most Western art critics think about these motifs differently and see these paintings as examples of rupture with the traditional Aboriginal worldview. For example, modernist critics assimilate the paintings to formalist traditions of abstraction. Postmodernists, on the other hand, embrace their hybridity, but dismiss claims that the paintings are traditional as a marketing strategy aimed at Western tastes for the primitive "other." Despite Aboriginal views to the contrary, the paintings are not signs of cultural revitalization. Rather, they are reconfigurations of Aboriginal traditions aimed at incorporating them into global commodity production (Myers 1995).

Within Australia, Venbrux (2002) also describes how Aboriginal art's newly acquired status as "fine art" has taken on added significance in the reimaging of Australia's national identity as Australians seek to reorient their country to Southeast Asia. In authenticating this shift, the state has found it expedient to claim that Australia possesses "the oldest living culture(s) in the world." Thus, Aboriginal art has been appropriated to serve a national agenda. Aboriginal artists affirm their art represents traditional ownership rights to land and knowledge, thereby embodying ancient ancestral connections to their "country" (Myers 1995:82–83).

Whatever the merit of these differing discourses, their collective importance has been to move all Aboriginal art into the international art scene of cosmopolitan art circles. In what Myers terms "a hybrid process of cultural production" (Myers 1995:57), the inventory of articles and reviews generated by art critics and academics stirs the interest of gallery owners and museum curators. These individuals, in turn, promote exhibitions, which brings rising prices. Whatever the acrylic paintings of the Pintupi of Central Australia, or the prints, textiles, and sculptures of the Tiwi of Bathurst and Melville Islands (see Venbrux, article 9), may mean locally in their artists' home communities, this move into the international art world has been successful and lucrative.

Compared to recent Aboriginal art, new PNG artwork has attracted far less critical attention to propel its movement into cosmopolitan "high art" circles. Yet, as Myers suggests for Aboriginal acrylics, contemporary PNG art has experienced a hybrid process of cultural production. These hybrid processes have also drawn the same kinds of criticism about the art's authenticity as Aboriginal art in Australia. Does contemporary PNG art represent a "cultural renaissance" and "collective assertion of new nationalism" (Narokobi 1990)? Or would it be better to understand these artworks as PNG-based artists "making Western style art" (Lewis-Harris 2001:23)?

Since 1986, I have collected evaluations of contemporary PNG art from three sources: (1) visitors to exhibitions at the NAS and in the United States, (2) published criticism, and (3) conversations with NAS staff, students, and artists. As with discourses about Australian Aboriginal art, noted above, opinions diverge.

Reactions from Papua New Guineans (students, artists, and elite consumers) generally concur with Narokobi's (1990) view that all contemporary PNG artworks have a PNG identity that combines traditional and modern values. But there were different reactions when people were asked about style. Some older artists and elite viewers preferred the imagery of village artists because they admired its "traditional" design qualities and the "strong spirit" of village life it displayed. NAS students and younger artists, however, gave higher value to their own work because they considered its stylistic range and skilled modern techniques more progressive. The choice of preferred style usually reflected function. For example, patrons wanted the portraits they commissioned to look realistic. But style preferences can also change. As Larry Santana reported recently, all of his commissions from the PNG government for office paintings, official greeting cards, or murals now specify realistic imagery so people will "understand" them. Today, there is less interest in his symbolic imagery, but he has sold some of his new abstract images.

Western evaluations of contemporary PNG art also reflect value preferences. Most expatriate viewers I interviewed showed a strong preference for the work of village artists, whose imagery looked "exotic." These artworks appealed to their romantic notions of PNG as the land of plumed warriors. As Marianna Torgovnick (1990) and others have argued, these tastes reflect a long Western tradition of engaging the "primitive." My informants expressed this pattern in several ways. One U.S. collector of traditional PNG art regarded the "primitive" style of Akis and Jakupa as

Figure 8. Timothy Akis, *Fivepela pikinini i stap long bel bilong meri* (Pregnant with five Babies). Screen print (Collection Pamela Rosi).

evidence of their continuing connection to traditional life. It would not, in his view, be out of place to hang their art alongside the traditional pieces of his collection.

Hugh Stevenson (1990), a recognized collector of contemporary PNG art, also categorized village artists as "naïve" and argued that their thought patterns and creative spontaneity are evidence of a village "mental landscape." His views on cognitive ordering are similar to Georgina Beier's (1974), who also believed that the roots of contemporary village art lay deep in precontact Melanesian traditions. This view explains her opposition to "professional" art education for PNG students, which she and Stevenson (1990:31) saw as a "last act of cultural colonialism imposed by a well-meaning white hierarchy." Where there should be continuity with tradition, the NAS brought rupture. As another critic put it, professional training resulted in art that was not "a really meaningful comment on the Papua New Guinean way of life, or its aspirations" (Dark 1988).

In this critical discourse, contemporary PNG art is denied an authentic PNG identity because it is seen as a product of imposed Western practices, a kind of soft neocolonialism. One commentator I heard at a lecture at Boston's Museum of Fine Art on traditional Melanesia art stripped contemporary PNG art of all aesthetic merit when he categorized it as "just a step above tourist art." This label called into question whether new forms of PNG art were "art" at all.

This latter opinion is typical of critics who disdain the hybridity of contemporary PNG art and view it as a dispirited copy of Western art and, thus, not worth buying. Recent postmodern interest in global flows and the politics of culture has, however, helped to spark some interest in the new art of PNG. Consequently, a few museums and galleries in Australia, Europe, and the United States are beginning to take some interest in exhibiting or buying the new imagery.

Ethnology museums have recently become interested in displaying material evidence of the transforming worlds of the tribal peoples in their collections. Contemporary PNG art seems to suggest the course of this ongoing transformation. Nevertheless, such museums are reluctant to exhibit these new art forms. Some curators feel that the works of individual contemporary artists more appropriately belong in fine arts museums (Raabe 1992). Others hold back because they do not think that contemporary art forms have the same aesthetic merit or deep meanings as traditional village art. By thinking in this binary mode, they fail to grasp the link between customary and contemporary art that occurs, as in contemporary

Figure 9. Larry Santana and his family attending the opening reception of the exhibition Nation-Making and Cultural Tensions: Contemporary Art from Papua New Guinea, Boston, April 1988, curated by Pamela Rosi. Papua New Guinea Ambassador Nagora Brogen is on the far left; Maria Santana and her daughter Maureen are wearing traditional meri blouses and skirts fashioned from the Papua New Guinea flag (photograph provided by Pine Manor College).

Aboriginal art, by incorporating traditional designs, or through references to traditional village life, or ties to land now expressed in new or mixed media (Lewis-Harris 2001:24).

Nevertheless, when compared to the national and international attention given to Australian Aboriginal art, contemporary PNG art appears culturally insignificant. Most artists have small moments of fame when they attend exhibitions of their art, or when it attracts scholarly attention. But these moments are fleeting. Unfortunately, although creating an art world for contemporary PNG art began with promise, that promise faded with the collapse of the national economy, the departure of supportive expatriate patrons from PNG, and a prevailing attitude that artists and their work have only minimal worth in national culture. For the few remaining artists that struggle to survive, they must cope with the difficult realities of how best to allocate meager resources in their continued dreams for success, which so far have eluded them and are likely to do so for some time.

Questions for Discussion

1. Many of the artists discussed by Rosi were trained by foreigners, used non-traditional materials such as canvas and acrylic paints, and painted largely for a foreign market. Can we call their works Papua New Guinean art?

2. What rationale did the Australian colonial administration give for establishing the National Arts School in the years immediately prior to independence in Papua New Guinea?

3. How have the reasons for supporting the National Arts School and the artists who studied there changed in the years following independence? What explanations does Rosi give for this trend?

4. Why do the artists discussed in this article have difficulty making a living as artists? How similar and how different is this from what we might find in the United States?

Acknowledgments

Funding for my research at the NAS in 1986 was supported by the National Science Foundation and Bryn Mawr College. I also wish to acknowledge all the help I have received from many contemporary PNG artists, particularly Larry and Maria Santana, Martin Morububuna, Jana Wena, Joe Nalo, and the late Jakupa Ako. This paper was originally prepared for Postcolonial Virtue, Worth, Morality, and Modern Success in the Western Pacific at the 2001 annual meeting of the Association of Social Anthropologists in Oceania. I thank the organizers Bruce Knauft and Joel Robbins and the participants for their comments. I am also truly indebted to Eric Venbrux for critically reading this paper, but also for suggesting to

Fer Hoekstra, director of Nijmeegs Volkenkundig Museum, that the institution mount an exhibition of contemporary PNG art from my collection and that of Jacquelyn Lewis-Harris. The exhibition, named *Mak Bilong Ol* (Made by Us), was shown from February–May 2002. As guest curator, I greatly appreciated this opportunity to promote contemporary art from PNG in the Netherlands. Thanks also to Robert Welsch for helping to edit this article. In preparing the illustrations for this manuscript, my thanks also to Rob Williams IV for shooting the black and white photos with careful precision.

References

Anderson, Benedict. 1983. *Imagined Communities: Reflections on the Origin and Spread of Nationalism.* London: Verso Press.

Babadzan, Alain. 1988. "*Kastom* and Nation Building in the South Pacific," in *Ethnicities and Nations,* ed. R. Guidieri, F. Pellezzi, and S. Tambiah, pp. 199–228. Austin: University of Texas Press.

Beier, Georgina. 1974. *Modern Images from Niugini.* Queensland: Jacaranda Press.

Beier, Ulli. 1968. *Contemporary Art in Africa.* New York: Praeger.

———. 1980. The Artist's Struggle for Integration in Contemporary Society. Unpublished manuscript. New Guinea Collection, University of Papua New Guinea Library.

Berman, Marsha. 1990. "What is Contemporary Melanesian Art?", in *Luk Luk Gen! Look Again!: Contemporary Art from Papua New Guinea,* ed. Susan Cochrane Simons and Hugh Stevenson, pp. 59–63. Townsville: Perc Tucker Regional Gallery.

Bhabha, Homi, ed. 1990. *Nation and Narration.* New York: Rutledge Press.

Cohen, Anthony P. 1985. *The Symbolic Construction of Community.* New York: Tavistock Publications.

Craig, Tom. 1971. Draft Proposal for Establishment of the Center for Creative Arts at Waigani. Unpublished manuscript. Port Moresby, Papua New Guinea.

———. 1982. The National Arts School: The Beginning. Unpublished manuscript.

Creative Arts Centre. 1972. "O Meri Wantok," poster poem. Port Moresby: Creative Arts Centre.

Dark, Philip. 1988. "Review of The Pacific Way." *Pacific Arts Newsletter* 20:16.

Dunar, Loujaya. 1988. "In Search of a Unique PNG Design." *Art Times of PNG* (March 3), p. 6.

Durkheim, Émile. 1956. *Sociology and Education.* Glencoe: Free Press.

Facey, Ellen. 1995. "*Kastom* and Nation Making: The Politicization of Tradition on Nguna, Vanuatu," in *Nation Making: Emergent Identities in Postcolonial Melanesia,* ed. Robert J. Foster, pp. 186–207. Ann Arbor: University of Michigan Press.

Fife, Wayne. 1995. "Models for Masculinity in Colonial and Postcolonial Papua New Guinea." *The Contemporary Pacific* 7:277–302.

Foster, Robert J., ed. 1995a. *Nation Making: Emergent Identities in Postcolonial Melanesia.* Ann Arbor: University of Michigan Press.

———. 1995b. "Print Advertisements and Nation Making in Metropolitan Papua New Guinea," in *Nation Making: Emergent Identities in Postcolonial Melanesia,* ed. Robert J. Foster, pp. 151–181. Ann Arbor: University of Michigan Press.

Gewertz, Deborah B. and Frederick K. Errington. 1999. *Emerging Class in Papua New Guinea: The Telling of Difference.* Cambridge: Cambridge University Press.

Handler, Richard. 1988. *Nationalism and the Politics of Culture in Quebec.* Madison: University of Wisconsin Press.

Herzfeld, Michael. 1982. *Ours Once More: Folklore, Ideology, and the Making of Modern Greece.* Austin: University of Texas Press.

Hobsbawm, Eric and Terrence Ranger, eds. 1983. *The Invention of Tradition.* Cambridge: Cambridge University Press.

The Independent. 1998. "Women Artists Plan Exhibition" (October 30).

Keesing, Roger and Robert Tonkinson, eds. 1982. "Reinventing Traditional Culture: The Politics of *Kastom* in Island Melanesia." *Mankind* 13(4)(Special Issue).

Larmour, Peter. 1998. "State and Society in Papua New Guinea," in *Modern Papua New Guinea,* ed. Laura Zimmer-Tamakoshi. Kirksville: Thomas Jefferson University Press.

Lewis-Harris, Jacquelyn. 2001. "Our Identity lies Ahead." *Art Asia Pacific* 31:23–25.

Lindstrom, Lamont. 1994. "*Pasin Tumbuna:* Cultural Traditions and National Identity in Papua New Guinea," in *Culture, Kastom, Tradition: Developing Cultural Policy in Melanesia,* ed. M. Lindstrom and G. M. White, pp. 67–94. Suva: Institute of Pacific Studies, University of the South Pacific.

Macintyre, Margaret. 1998. "The Persistence of Inequality: Women in Papua New Guinea Since Independence," in *Modern Papua New Guinea,* ed. Laura Zimmer-Tamakoshi, pp. 211–231. Kirksville: Thomas Jefferson University Press.

Marcus, George E. and Fred R. Myers, eds. 1995. *The Traffic in Culture: Refiguring Art and Anthropology.* Berkeley: University of California Press.

Myers, Fred R. 1995. "Representing Culture: The Production of Discourse(s) for Aboriginal Acrylic Paintings," in *The Traffic in Culture: Refiguring Art and Anthropology,* ed. George E. Marcus and Fred R. Myers, pp. 55–95. Berkeley: University of California Press.

Narokobi, Bernard. 1983. *The Melanesian Way.* Boroko: Institute of Papua New Guinea Studies.

———. 1990. "Transformations in Art and Society," in *Luk Luk Gen! Look Again!: Contemporary Art from Papua New Guinea,* ed. Susan Cochrane Simons and Hugh Stevenson, pp. 17–21. Townsville: Perc Tucker Regional Gallery.

National Arts School (NAS). 1977. *Kauage.* Boroko: The National Arts School, Townsville: Perc Tucker Regional Gallery.

———. 1978. *Come and Join Us.* Boroko: Author.

———. 1982. *The Arts Applied.* Boroko: Author.

National Woman. 1998. "Artist's Tale of True Grit" (October 29).

Post Courier. 1998. "First Ever Female Art Show" (October 29).

Raabe, Eva. 1992. "Collecting Contemporary Art at the Museum für Völkerkunde." *Pacific Arts* 5:14–18.

Rosi, Pamela. 1987. *Contemporary Art of Papua New Guinea.* New Jersey: Monmouth College

———. 1988. *Contemporary Art of Papua New Guinea.* Bridgewater, MA: Anderson Gallery, Bridgewater State College.

———. 1991. "Papua New Guinea's New Parliament House: A Contested National Symbol." *The Contemporary Pacific* 3(2):289–323.

———. 1994. Bung Wantaim: The Role of the National Arts School in Creating National Culture and Identity in Papua New Guinea. PhD diss., Bryn Mawr College.

———. 1997. "O Meri Wantok" (My Countrywoman): Images of Indigenous Women in the Contemporary Arts of Papua New Guinea. Paper delivered at the Association of Social Anthropologists in Oceania Meetings, San Diego.

———. 1998a. "Cultural Creator or New Bisnis Man? Conflicts of being a Contemporary Artist in Papua New Guinea," in *Modern Papua New Guinea,* ed. Laura Zimmer-Tamakoshi, pp. 31–54. Kirksville: Thomas Jefferson University Press.

———. 1998b. *Nation-Making and Cultural Tensions: Contemporary Art from Papua New Guinea.* Boston: Pine Manor College.

Rosi, Pamela and Laura Zimmer-Tamakoshi. 1993. "Love and Marriage among the Educated Elite in Port Moresby," in *The Business of Marriage: Transformations in Oceanic Marriage,* ed. R. Marksbury, pp. 175–204. Pittsburgh: University of Pittsburgh Press.

Somare, Sir Michael. 1979. "Foreword," in *Exploring the Visual Art of Oceania,* ed. S. Mead, pp. xiii–xv. Honolulu: University of Hawai'i Press.

Stevenson, Hugh. 1990. "Structuring a New Art Environment," in *Luk Luk Gen! Look Again!: Contemporary Art from Papua New Guinea,* ed. Susan Cochrane Simons and Hugh Stevenson, pp. 23–31. Townsville: Perc Tucker Regional Gallery.

Toft, Susan, ed. 1985. *Domestic Violence in Urban Papua New Guinea.* Law Reform Commission of PNG. Monograph No. 3. Port Moresby: Law Reform Commission.

Torgovnick, Marianna. 1990. *Gone Primitive: Savage Intellects, Modern Lives.* Chicago: University of Chicago Press.

Turner, Victor. 1969. *The Ritual Process.* London: Routledge and Kegan Paul.

Venbrux, Eric. 2002. "The Post-Colonial Virtue of Aboriginal Art." *Zeitschrift für Ethnologie* 127(2):223–240.

Zimmer-Tamakoshi, Laura. 1993. "Nationalism and Sexuality in Papua New Guinea." *Pacific Studies* 16(4):61–98.

12

High Art as Tourist Art, Tourist Art as High Art

Comparing the New Guinea Sculpture Garden at Stanford University and Sepik River Tourist Art

Eric K. Silverman

In the summer of 1994, I returned to the Iatmul-speaking village of Tambunum on the Sepik River of Papua New Guinea to study, among other topics, tourist art. But I was unable to speak with my main research collaborator, Gamboromiawan. He was at Stanford University carving high art! His Stanford sculptures intentionally resemble the works of Rodin so they can compete aesthetically with Western masterpieces, which they do. But seen from another angle, the lowly tourist art crafted in the village actually conforms to the ideals of high art while the high art sculpted in Palo Alto, California, resembles tourist art.

Sepik River tourist art is not motivated by some internal, individualistic drive to lend subjective experience an outward, material expression. Rather, tourist art is motivated by money. Yet, a different motivation was at play in 1994 when men from two Sepik River societies were flown to Stanford University to carve the New Guinea Sculpture Garden. The express goal of the garden was to provide a new setting for Sepik artists, a "public art space," so carvers could express their aesthetic creativity outside of village conventions. Reigning aesthetic categories and evaluations would largely classify Sepik River tourist art as inauthentic—mere kitsch that bastardizes a formerly authentic tradition in order to cater to uninformed tourists. At the same time, the setting and intention of the sculpture garden would likely result in the creation of genuine high art, unique masterpieces that attest to the human spirit as a font of creativity.

Eric K. Silverman, "High Art as Tourist Art, Tourist Art as High Art: Comparing the New Guinea Sculpture Garden at Stanford University and Sepik River Tourist Art." *International Journal of Anthropology* 18(4), 2003 October–December. Reprinted with permission of *International Journal of Anthropology*, published by International Institute for the Study of Man in Florence, Italy.

Ironically, tourist art from the Sepik actually represents many of the ideals normally ascribed to high art. Conversely, the sculpture garden often resembles inauthentic reproductions and the shackles of tradition. Some Sepik tourist art *does* display a lack of genuine aesthetic creativity. The sculpture garden *is* a stunning, brilliant setting whose works are breathtaking. My goal in this article is not to argue *against* these claims. Instead, I identify certain ironies in these two art genres to claim that both expressions call into question conventional categories and the very idea of artistic categorization.

Theoretical Orientations

In his aptly titled collection of essays called *Routes*, James Clifford (1997a) focuses not on the center of culture, but on what Mary Pratt (1992:7) calls "contact zones." These transnational frontiers are defined by "the spatial and temporal copresence of subjects previously separated by geographic and historical disjunctures, and whose trajectories now intersect." While the "contact zone" idea does not ignore issues of domination, power, and hierarchy, it emphasizes innovation, creativity, and hybridity. Thus, both the New Guinea Sculpture Garden and Sepik River tourist art arise in, and become, "contact zones." As such, they defy conventional art-culture categories that link authenticity to taxonomic boundedness rather than to rupture and blurring. Both confound distinctions, thus "playing and subverting the dominant art-culture game" (Clifford 1991:214). They are hybrid, transnational "routes" that argue against fixed categories of art and authenticity.

Clifford (1988) argues that the dominant Western art-culture system is framed by two oppositions: (1) authentic-inauthentic and (2) masterpiece-artifact. There are, thus, four static categories: (a) authentic masterpieces (art), (b) authentic artifacts (material culture, crafts), (c) inauthentic masterpieces (fakes), and (d) inauthentic artifacts (tourist art). Although there is some movement between zones, the point of the system is to place objects into categories rather than to allow them continuous motion from one category to another. Drawing on the ideas of the "contact zone" and "routing," I propose that we reconfigure this art-culture system not as a set of new categories linked by routes, but solely as a system of routes in which objects are always in taxonomic motion. From this perspective, Sepik River tourist art and the New Guinea Sculpture Garden are authentic not because we can classify these works, but because we can not.

Traditionally, argues Deborah Root (1996:78), authentic primitive art evoked a sense of "seamlessness." The object was "fully and seamlessly inserted into a social context in such a way that permits the experience of perfect presence." Moreover, many primitive masterpieces derived their authenticity from the idea that they could have appealed to Picasso and other modernists (Torgovnick 1990; Errington 1994). If the former notion eliminates disjunctive or hybrid settings such as the

sculpture garden, the latter idea dismisses tourist art. Thus, both Sepik tourist art and the sculpture garden lack an authentic place in the conventional art-culture system. But that is precisely my point: the authenticity of these works arises from a resistance to categorization.

Sepik River Tourist Art

Tourist art communicates hybrid identities and histories (Silver 1979; Jules-Rosette 1986; Kasfir 1992; Steiner 1994). It is an anticategory. The first term, "tourist," seemingly cancels the second term, "art." Hence, touristic creations are categorized as mementoes, souvenirs, trophies, artifacts, curios, commodities, and fakes, but not genuine art. As I have argued elsewhere, however, Eastern Iatmul tourist art from this part of the Sepik River is a genuine aesthetic expression that reflects new concepts of self, ethnicity, and identity (Silverman 1999, 2000, 2001a).

These creations also reflect many of the ideals of high art. Typically, Eastern Iatmul tourist works are novel, individualized expressions. Carvers vary established themes, forms, and styles to diverge from the traditional canon, thus blurring aesthetic and politico-ritual categories. The objects are created for display, like modernist art, not for utilitarian or ritual usage. Capitalist competition fosters egocentric selfhood because carvers strive to create unique objects that reflect their identity as individuals rather than sociocentric persons whose identity is fused with others within the descent group (Silverman 2001b). Touristic carvings frequently display the artist's baptismal name, not his totemic or vernacular name. Thus, they doubly signify modern identity through literacy and Christianity. Many masks display a large face that would seem to represent the assertive dimension of personhood. This sense of identity is traditional but especially pronounced in modern settings.

Many carvings exhibit multiple faces. Some visages are obvious, while other faces become evident only when the object is viewed from a particular perspective. The message here is that contemporary Sepik identity is prismatic, partial, and never wholly actualized. Another genre of tourist art is characterized by mouths that ambiguously consume, disgorge, excrete, and birth creatures, typically the crocodile. Formerly, this creature symbolized agnatic spirits. Today, the crocodile is a ubiquitous emblem of Iatmul ethnicity, a colonial and even anthropological construct.

Tourist art expresses other levels or dimensions of identity. Unlike traditional art, it has a strong sense of village style within the Iatmul language group. But in contrast to other language groups and regions, the total corpus of Iatmul tourist art, in some 25 villages, also forms a distinct style. In addition, Iatmul tourist art expresses regional Sepik identity. Women weave "PS" into baskets, which is an acronym for the Melanesian pidgin phrase "*pikinini Sepik*" or "child of the Sepik."

Independence in 1975 created the Papua New Guinea nation-state. Today, Eastern Iatmul reproduce colorful national emblems, particularly versions of the

bird of paradise with drum, bow, and spear that appears on the reverse of modern coins. They also create endless variations of the emblem, thus expressing national identity and citizenship in a localized, individual idiom. Carvers frequently add Christian and biblical slogans. These phrases, combined with stylistic innovations, communicate four dimensions of modern personhood: citizenship, literacy, individualism, and Christianity. All told, Eastern Iatmul tourist art is a complex self-representation, a wide-ranging conversation between tradition and modernity. These works communicate subtle, often elegant, messages that are muted by traditional categories and notions of authenticity.

As Eastern Iatmul aesthetically redefine their identity, they sometimes carve objects that are unrelated to their traditional repertoire. Men borrow from non-Iatmul aesthetic traditions, yet often embellish these works with novel painting styles. They also purchase non-Iatmul masks, pots, shell ornaments, and necklaces from other villages and town markets. They peddle these items at a profit, often after some slight modifications. Men offer these objects to tourists as authentic Eastern Iatmul creations. In a sense, they are, but not in terms of conventional categories of authenticity. The taxonomic status of these objects is ambiguous. They are authentic fakes, inauthentic tradition, individualized expressions, commodities, and hybrid forms of contemporary identity.

Margaret Mead (1938, 1978) said it best. Eastern Iatmul, like other Sepik cultures, is an importing culture. They procure all of the materials used in both traditional and touristic art—including feathers, shells, putty, pigments, paints, and shoe polish—from outside the village. They rely on trading partners, town markets, and trips to distant villages. Even the wood is hauled in from the bush, or floats down the river. Aesthetically, Iatmul art has always been en route. Mead (1938:163) also brilliantly recognized a key quality of Iatmul villages: "an absorptive and retentative ability in excess of their powers of integration." The accretive disposition of Sepik cultures is augmented by the ability of objects to transgress ethno-categories (Mead 1978). Ironically, Mead identified in the pre- or just-contacted Sepik a very postmodern art-culture system!

Introducing the New Guinea Sculpture Garden

In 1994, a remarkable "contact zone" occurred in California. Under the directorship of Jim Mason, then a graduate student in anthropology, a group of Sepik River men (from the Iatmul and Kwoma ethnic groups) carved the New Guinea Sculpture Garden at Stanford University. While my goal here is to identify taxonomic ironies set in motion by the garden, I also want to underscore the extraordinary feat accomplished by Mason and the Sepik men. The garden is a fantastic artistic context. The artworks and landscaping are nothing short of breathtaking. Intellectually, the garden encourages visitors to rethink basic concepts and categories

pertaining to art, cultural differences, morality, and creativity. The sculpture garden is situated in a small, wooded grove on the Stanford campus next to a dormitory. In addition to the artworks, the garden is also horticultural. The landscaping and plants were organized by the late Wallace Ruff (at the time a retired professor of architecture who had taught for many years at the University of Technology in Papua New Guinea) and Kora Korawali, one of his students. The garden evokes the Sepik environment and the central plaza of most Sepik villages through the careful placement of Californian vegetation. The river is evoked by a bike path (Leccese 1994). The entrance to the garden is an open space, like the Sepik flood plain. But one quickly walks into a forest of sculptures and trees reminiscent of a majestic Sepik cult house.

The garden is roughly organized into four zones. Near the entrance is a large, wooden eagle atop the shoulders of an ancestress. This statue resembles the finials that often adorn Iatmul cult houses. Behind the eagle is a second zone consisting of a cluster of about a dozen enormously tall wooden poles carved with exquisitely elaborate Iatmul and Kwoma motifs and patterns (figure 1). A series of brightly painted Kwoma poles forms another aesthetic cluster, while the fourth area of the garden consists of large sculptures in pumice, an entirely new medium for the carv-

Figure 1. A forest of ambiguous art: The New Guinea Sculpture Garden at Stanford University. Photo by E. K. Silverman.

Figure 2. The unfinished sculpture titled *Untitled*. Photo by E. K. Silverman.

ers since stone is rare in the Sepik flood plain. At night, the objects are aglow from ground-level spotlights.

The artworks are wonderful. The stone sculptures largely represent Sepik mythological creatures modeled after Western sculptures found elsewhere on the Stanford campus. The carved poles subtly blend traditional and modern motifs so that, for example, ancestresses wear grass skirts. Many of the carvings beautifully wind around the natural contours of the wood, offering a sense of three-dimensionality that was not traditionally incorporated into Sepik carving. One of the most brilliant works in the garden is a bare pole that contains only a hint of the sculpture it might have become. This work, titled *Untitled* (figure 2), expresses the processual aspects of the garden and the unfinalizability and partiality of any interpretation.

The garden wonderfully plays with themes of light and shadow, revelation and concealment, nature and culture. It is and is not mysterious, contemplative, quiet, and surreal. The popularity of the garden, and its refusal to remain contained within any scholarly discourse, is a powerful commentary on anthropology. The Stanford

Anthropology Department was so apprehensive about the project, and so unwilling to participate in an event that could have become an unsettling spectacle of savagery, that it largely shunned the garden until its completion. But the department now holds an annual diploma ceremony in this space. In this sense, the garden both resists and accedes to anthropology.

The logistics of the project were enormous. Mason raised $250,000 in individual donations. One could sponsor a fern for $250, a palm tree for $500, a bench for $750, and so forth. Large donations are acknowledged, like the artworks themselves, by name. Corporate donors included Bechtel Corporation, Chevron, and Air Niugini. Funds were also supplied by the Na-

Figure 3. Art or mechanical reproduction?: *The Thinker.* Photo by E. K. Silverman.

tional Endowment for the Humanities, Stanford University, and wealthy Palo Alto families. The university allowed Mason a permanent site. He arranged for several dozen hardwood trees to be shipped to Stanford from Asia.

Ten carvers were flown to California from the Sepik by way of Hong Kong, a journey that far exceeded their previous travels. Once they arrived, the carvers were the toast of affluent Palo Alto and multicultural Stanford. They dined at catered events in mansions and performed with African American drummers outside dormitories. The carvers received six-month educational visas. Mason arranged for health insurance and a host of local individuals, organizations, and businesses supplied food, medical care, clothing, transportation, recreation, and a trip to Disney-

land. The community also lent various skills, materials, and labor during the creation of the garden. While the event centered on Papua New Guineans, it also enacted the wider liberal aims of U.S. participatory democracy.

Mason graciously allowed me to spend a week or so with the carvers in the early summer of 1994, prior to my return to the Sepik. I personally knew two of the men from my own fieldsite, one of whom was a primary fieldwork collaborator. We attended a party in the hills of San Francisco, cooked the standard Sepik fare (boiled chicken and rice) and drank Budweiser beer, and viewed Arnold Schwarzenegger's blockbuster film *Terminator 2* while discussing differences between Kwoma and Iatmul cosmologies. As a reporter for the *San Jose Mercury News* said, "One has a handmade ax in his hand and a Harley-Davidson cap on his head; they converse in their native dialects and pidgin while they await boxed lunches of Kentucky Fried Chicken and Pepsi" (Steinmetz 1994).

A Grove of Ironies

The "spirit of the project" framed the carvers as "artists" and not, as in older taxonomies, exotic specimens of primitive savagery and mystery. The project labeled the Sepik men as "master carvers." In so doing, the project positioned the men in a Western category defined by rare artistic genius, a category defined by the very terms of connoisseurship that once marginalized Melanesian art as something less refined than Western masterpieces and high art (see Price 1989). In this way, visitors approached the carvers and their works not as primitives with their crafts, but as authentic artists and their art. There is, however, no comparable category of "master carver" in the lexicon or social structure of Iatmul society. Ironically, the garden fostered the Western appreciation of non-Western art by substituting one Western category for another. This is not to cast any doubt on the moral vision of Mason. Quite the opposite. It is to indicate the ironies that arise from the processes of categorization when we seek to engage artworks created in a contemporary, transnational "contact zone."

In Mason's vision, a significant goal of the project was *not* to recreate a traditional, Melanesian setting. Rather, the garden was "an opportunity to experiment with and reinterpret New Guinea aesthetic perspectives within the new context of a Western public art space." The carvers could thus create art that blended traditional themes with the ideals of modern sculpture, such as individual expression and the creation of art solely for a contemplative gaze. The carvers were explicitly encouraged to shun traditional forms and motifs. Instead, they were counseled to experience and express their individual artistry in ways not possible, or so it seemed, in their villages. But this effort proved problematic for the artists, and frustrating for the organizers, since the carvers initially hewed traditional, clan-specific motifs and forms. Ironically, some art and artifact dealers implore Eastern Iatmul in their village to refrain from creating anything that deviates from the traditional canon.

The project, we might say, tried to synthesize yet separate the Papua New Guinean carvers into two categories: Melanesians *and* artists. It was on the basis of the former identity that the men were brought to Palo Alto. Once there, the garden tried to encourage these men to shift their identity into the latter category. But the carvers, I believe, understood their identity firstly as Papua New Guineans and only secondly as artists. In the main, they created variations on Iatmul and Kwoma art. Or, as we will see, they produced a variety of modernist "masterpieces." At Stanford, we could conclude that innovation was more elusive than in the touristic Sepik. Ironically, it was not a "public art space" in California that readily fostered aesthetic innovation but the pursuit of money in the village.

Mason expressly sought to counteract Western moral and artistic hegemony. As Clifford (1997b:196) has subsequently remarked, the sculptors at Stanford were engaged in an interactive process that was at least as important as the finished products of "art" and "culture." The community was not so much invited to observe the carvers, which it did, but to participate in various collaborative programs. In addition to daily site tours, bamboo flute performances by the carvers, and a public lecture series, there were Friday night barbeques, "story time" with the artists, and a variety of outreach programs for school children, such as on-site bark painting. There were other unanticipated interactions as well. At one point thieves made off with a few of the sculptures, which were later returned. And the pronounced phalluses on several of the male carvings proved somewhat controversial, though this controversy was not as vocal as that over the sexual imagery of the Papua New Guinean sculptures at the University of Technology in Sydney (Hayward 1995:15). All of these interactive encounters are vital to the authenticity of the works.

The artists were not brought to Stanford as savages for festive display to Western viewers (see Rony 1996). While the "master carvers" were brought to Stanford University precisely because they hail from another space-time in the Western imaginary, Mason and the project explicitly tried to reduce the distance between Us and Them. The carvers were artists, not ethnographic spectacles. They were allowed an opportunity, or so it went, to negotiate with wealthy Californians on their own terms. They also negotiated with Mason on the setting of their works, thus contesting an older model of artistic re-presentation in which curatorial authority was absolute (see Clifford 1991; Ames 1992). Indeed, Mason specifically made several trips to the Sepik to negotiate the terms of the entire project. The garden was, for example, created by both young and elderly men and was an idea proposed by the Iatmul and Kwoma themselves, not Mason. The garden was an intentional effort to disperse curatorial authority.

The garden emphasizes artistic individuality, not timeless anonymity—much like tourist art. Beneath each work is a label that identifies the title of the piece and the artist's name. The overall message seems to be that *authentic* art drives from the consciousness, subjectivity, and creativity of individuals. The idea of anonymity that once defined "primitive art" derives from Western myths of the premodern

Other. But the contrary assumption is equally problematic since it presupposes panhuman concepts of self, personhood, art, and creativity. The relationships between artistic work, name, and identity nevertheless remain problematic—especially since tourist art, even when signed by the artist, is rarely featured in authoritative art spaces.

A newspaper report on the garden spoke about "exotic . . . representations of carvings that would appear on or inside a Papua New Guinean spirit house" (Hayde 1996). From this angle, the garden was a failure. The carvings are *not* totemic insignia. They are supposed to be viewed as art, not exotica. And the garden was intended to provide Papua New Guineans with a setting in which to express the Western aesthetic ideals of individual expression and innovation, not traditional motifs. That is to say, the press was largely unable, or unwilling, to share Mason's moral and taxonomic vision. For them, the garden sustained, not subverted, the hegemony of Western artistic categories.

The sculptures that received the greatest amount of press and notoriety are two carvings in wood and pumice respectively that expressly resemble Rodin sculptures that can be seen elsewhere on the campus of Stanford, *The Thinker* (figure 3) and *The Gates of Hell* (e.g., Hayde 1996). This fame reproduces an earlier taxonomic moment in the twentieth century when primitive masterpieces were defined on the basis of modernist ideals. In the "Features" section of *The Stanford Daily*, the latter sculpture was deemed "a nice example of art free of cultural boundaries" (Quinones 1997). One wonders if those boundaries were also absent when later in the article "the figures become positively lurid in moonlight." Such comments aside, the lack of "cultural boundaries" is of course incorrect. The garden is thoroughly framed by Western artistic categories. It is, after all, a "public art space" at an elite university! The project sought to rehumanize people once dubbed as primitive. This moral vision replaced one set of Western categories (primitives mindlessly replicating ancestral forms) with a new set (high art, "master carvers," and so forth). The garden, I am suggesting, is perhaps best viewed as a conversation of shifting taxonomies.

The opening celebration for the sculpture garden, which I did not attend, was chaotic, an anarchic hybrid of late twentieth century artistic practices that involved some 3,000 people: performances by the Center for Computer Research and Acoustics at Stanford; improvisational theater and dance; piano and violin music; complementary wine and cheese; "formal attire requested"; an all-night drum and dance ceremony by the carvers with "Congolese, Tahitian, Native American, Taiko, and Korean drum groups" (see Hangai 1996). Performance artists enacted Sepik creation myths. There was a "potluck barbecue and free drinks." Guests were invited to "bring your own drum." The carvers spoke to the crowd, and wept.

The event both sustained and subverted the intent of the garden. On the one hand, it allowed for otherwise muted expressions of ethnic diversity. Indeed, many people in the community valued the garden during its creation precisely because it

brought together ethnic and class groups that do not ordinarily interact. But the garden seemed to throw together all differences into a grand cacophony such that no unique difference was heard. Or rather the opening event, like the garden itself, sought to mute conventional categories in a type of taxonomic chaos.

Since its completion, the garden remains a central space on the Stanford University campus and the wider community. After a 1998 tsunami devastated four coastal villages in Papua New Guinea, the garden was the site of a fundraising potluck dinner. "Many people on campus feel closely connected to the island as a result of the garden," said the Stanford Report (1998). Every Friday night during the warm months a West African drum circle invites the community to the garden to participate in drumming, dancing, and song. They describe the garden as "a beautiful, sacred place very conducive to good vibes" (Djembe-L FAQ 2005). A vast array of organizations use the garden for dinners, meetings, and discussions. A quick search on the Stanford University Web site reveals some of the events held at the garden: a discussion among transfer students, a National Science Foundation dinner, a lunch for the Women's Community Center and the Lesbian, Gay, Bisexual and Transgendered Community Resources Center, a welcoming party for new civil and environmental engineering students, an event organized by the Stanford African Students Association, as well as the diploma ceremony for Stanford's Anthropology Department.

Conclusion

The collaboration at the sculpture garden "resulted in concrete expressions that visually challenge the constraining narratives of art/artifact, authenticity/inauthenticity, and primitivism that are often forced onto non-Western artists" (Sculpture Garden Home Page 2005). At the same time, the garden supports the very same categorization scheme that generated these distinctions given that, for no other reason, the garden is commonly mentioned in connection with the Rodin Sculpture Garden, which is also located at Stanford. But this, I believe, is the great success of the garden. Like tourist art, the New Guinea Sculpture Garden both sustains and subverts dominant categories and categorization.

The aesthetic force of these works lies not solely in the appreciation of their visual qualities, which is substantial. Rather, these works are important because they resist the dominant art-culture system and its institutionalization of authenticity. At the same time, the juxtaposition of the Stanford sculptures and the Sepik tourist works re-created traditional categories such that tourist art became high art while high art became tourist art.

Finally, Sepik River tourist art and the New Guinea Sculpture Garden, as artistic "contact zones," encourage us to rethink the usefulness of aesthetic categorization. Rather than ask what these works are, we might best ask what they are not.

Questions for Discussion

1. Silverman accepts that tourist art in the Sepik River region is not "traditional" art, but he argues that these objects are not entirely novel. What conceptual problem does this conundrum present for scholars who study non-Western art?

2. The Sepik carvers brought to the Stanford campus were encouraged to be innovative in their carving and that they should not simply replicate the carvings they might have carved back in their villages in Papua New Guinea. But the carvers had trouble accepting such artistic freedom. How could we explain their reaction?

3. In what ways does Silverman feel that the carvings in the Stanford sculpture garden are similar and different from the tourist art he had seen on the Sepik River?

4. Initially, the Department of Anthropology at Stanford had some misgivings about the sculpture garden project. What were their concerns?

Acknowledgments

This article is based on fieldwork in the Eastern Iatmul village of Tambunum during 1988–1990 and June–August 1990, whose residents kindly tolerated my presence and questions. I gratefully acknowledge support from a Fulbright Award, Institute for Intercultural Studies, Wenner-Gren Foundation for Anthropological Research, University of Minnesota's Department of Anthropology and Graduate School, and DePauw University. I also thank Jim Mason and, for inviting me to write this article, Pamela Rosi and Eric Venbrux.

References

Ames, M. M. 1992. *Cannibal Tours and Glass Boxes: The Anthropology of Museums.* Vancouver: University of British Columbia Press.

Clifford, James. 1988. "On Collecting Art and Culture," in *The Predicament of Culture: Twentieth-Century Ethnography, Literature, and Art*, ed. James Clifford, pp. 215–251. Cambridge: Harvard.

———. 1991. "Four Northwest Coast Museums," in *Exhibiting Cultures: The Poetics and Politics of Museum Display*, ed. I. Karp and D. Lavine, pp. 212–254. Washington, DC: Smithsonian Institution Press.

———. 1997a. *Routes: Travel and Translation in the Late Twentieth Century.* Cambridge: Harvard University Press.

———. 1997b. "Museums as Contact Zones," in *Routes: Travel and Translation in the Late Twentieth Century*, pp. 188–219. Cambridge: Harvard University Press.

Djembe-L FAQ [online]. 2005. Available: http://www.drums.org/djembefaq/CA_drumcircles.htm.

Errington, Shelly. 1994. "What Became Authentic Primitive Art?" *Cultural Anthropology* 9:201–226.

Hangai, D. 1996. "Sculpture Garden Artists to Return for Opening." *The Stanford Daily* (May 28). Available: http://www.daily.stanford.org/5-28-96/NEWS/NEWsculpture28.html. Accessed 2003.

Hayde, M. 1996. "Garden of Delights." *Palo Alto Weekly* (May 24). Available: http://www.service.com/paw/morgue/cover/1996_May_24. ARTS24.html. Accessed 2003.

Hayward, P. 1995. "A New Tradition: Titus Tilly and the Development of Music Video in Papua New Guinea." *Perfect Beat* 2(2):1–19.

Jules-Rosette, Bennetta. 1986. "Aesthetics and Market Demand: The Structure of the Tourist Art Market in Three African Settings." *African Studies Review* 29:41–59.

Kasfir, Sidney L. 1992. "African Art and Authenticity: A Text with a Shadow." *African Arts* 25:40–53.

Leccese, M. 1994. "Carving the Garden." *Landscape Architecture* 84:20.

Mead, Margaret. 1938. "The Mountain Arapesh." I. An Importing Culture. *Anthropological Papers of the American Museum of Natural History* 36:139–349.

———. 1978. "The Sepik as a Cultural Area: Comment." *Anthropological Quarterly* 51:69–75.

Pratt, Mary L. 1992. *Imperial Eyes: Travel Writing and Transculturation.* London: Routledge.

Price, Sally. 1989. *Primitive Art in Civilized Places.* Chicago: University of Chicago Press.

Quinones, C. 1997. "Backyard Art: Sculpture on The Farm." *The Stanford Daily* (September 25). Available: http://www.daily97%2D98/intermission/int9%2D25%2D97/features/index.html. Accessed 2003.

Rony, Fatimah T. 1996. *The Third Eye: Race, Cinema, and Ethnographic Spectacle.* Durham: Duke University Press.

Root, Deborah. 1996. *Cannibal Culture: Art, Appropriation, and the Commodification of Difference.* Boulder: Westview.

The Sculpture Garden Home Page. 2005. "The Project" [online]. Available: http://www.stanford.edu/~mjpeters/png/proj.html.

Silver, Harry R. 1979. "Beauty and the 'I' of the Beholder: Identity, Aesthetics, and Social Change among the Ashanti." *Journal of Anthropological Research* 35:191–207.

Silverman, Eric K. 1999. "Art, Tourism, and the Crafting of Identity in the Sepik River (Papua New Guinea)," in *Unpacking Culture: Art and Commodity in Colonial and Postcolonial Worlds*, ed. Ruth B. Phillips and Christopher B. Steiner, pp. 51–66. Berkeley: University of California Press.

———. 2000. "Tourism in the Sepik River of Papua New Guinea: Favoring the Local over the Global." *Pacific Tourism Review* 4(Special Issue: Local Perspectives on Global Tourism in South East Asia and the Pacific Region, ed. H. Dahles and T. van Meijl):105–119.

———. 2001a. "From Totemic Space to Cyberspace: Transformations in Sepik River and Aboriginal Australian Myth, Knowledge and Art," in *Emplaced Myth: Space, Narrative and Knowledge in Aboriginal Australia and Papua New Guinea Societies*, ed. J. Weiner and A. Rumsey, pp. 189–214. Honolulu: University of Hawai'i Press.

———. 2001b. *Masculinity, Motherhood, and Mockery: Psychoanalyzing Culture and the Iatmul Naven Rite in New Guinea.* Ann Arbor: University of Michigan Press.

———. 2004. "Cannibalizing, Commodifying, and Creating Culture: Power and Creativity in Sepik River Tourism," in *Globalization and Culture Change in the Pacific Islands*, ed. V. Lockwood, pp. 339–357. Upper Saddle River, NJ: Prentice-Hall.

Stanford Report [online]. 1998. Available: http://www.news-service.stanford.edu/news/1998/july29/papua729.html. Accessed 2003.

Steiner, Christopher B. 1994. *African Art in Transit.* Cambridge: Cambridge University Press.

Steinmetz, J. A. 1994. "New Guinea Carvers Bring Art to Campus." *San Jose Mercury News* (June 6).

Torgovnick, Marianna. 1990. *Gone Primitive: Savage Intellects, Modern Lives.* Chicago: University of Chicago Press.

New Uses for Native American Art

*I*n this section, Morgan Perkins and Alexis Bunten consider new uses for Native American art in contemporary North America. Like Nancy Mithlo (article 17), they draw on their own involvement with Native American artists and the production of art. In the first piece, Perkins is concerned with the issue of appraising art evaluation and whether the Euro-American term "art," in the modernist sense of art for its own sake, is appropriate for cross-cultural use or not. He stresses the usefulness of Native American viewpoints to challenge this key concept in the international art world and in the anthropology of art. In the second article, Alexis Bunten considers how southeast Alaskan Native people use their "tourist art," initially produced for external consumption. She notes how such objects are given new meanings and functions that in many respects are quite indigenous.

Morgan Perkins takes up a question raised by Sue Ellen Herne, a Mohawk woman and artist: "Do we still have no word for art?" The short answer is that a word for art still does not exist in Mohawk, nor do Mohawk artists intend to create one. As Perkins explains, the conceptions and practices of Akwesasne Mohawk of upstate New York have been shaped in part by a "long history of Mohawk contact with the Euro-American system of art." Herne therefore had to grapple with "the conventions of two overlapping systems." She faced the problem of how her work—as created by both an artist and a Mohawk woman—could be evaluated, since "art" is too narrow a term to do justice to Mohawk understandings in which Mohawk practices are fully integrated with their cultural life. Accepting the viewpoint of Mohawk practitioners as authoritative, Perkins points out that such a perspective calls into question the use of the term "art" as a cross-cultural category in the anthropology of art (see also van Damme, article 3). Consequently, he suggests that the question might be rephrased: "Why should there be a word for art in Mohawk?"

In other words, the Mohawk case may be productive in challenging the current modernist notion of "art" in the international art world, dominated as it is by "the Euro-American system of art." What is more, when (contemporary) indigenous understandings of artistic practices are acknowledged, they challenge the accepted system and sharpen the recognition that the system itself is dynamic and contested. However, in so doing, Perkins feels that Mohawk artists are bringing within reach the avant-gardist ideal of moving art closer to life.

Perkins also discusses a number of works by people who define themselves as both Mohawk and artists. He makes a plea for considering the multiple and distinct ways in which the concept of "art" is engaged rather than presupposing a global uniformity. For Perkins this variability can best be understood by focusing on how people learn the conventions of particular art worlds: "Education forms the basis through which knowledge of any cultural system is acquired and it is this

knowledge that determines the forms and practices that have come to be called art on a global scale."

In article 14, Alexis Bunten concentrates on a very different case, southeast Alaskan Natives' consumption of their own "tourist art." Nevertheless, like Perkins, she examines new roles for contemporary art and artists. She argues that these mass-produced objects may be too easily dismissed by anthropologists and art historians as "inauthentic" expressions of Native culture. Yet, even though these objects are mass-produced they have come to play a significant role in the ceremonial and everyday life of southeast Alaska Native peoples. The challenge of her article is to explain why Native individuals and groups have come to accept tourist art as having cultural value.

Although initially made for non-Native visitors as souvenirs, ranging from prints of eagles to decorative blankets and miniature paddles, these objects with Northwest Coast visual imagery have, as Bunten shows, been "incorporated into the local, indigenous social fabric." The ubiquity of the visual imagery is reminiscent of the lavishly decorated objects of daily use in the past. As had happened before, the tourist market gave impetus to a cultural renaissance and strengthened the Native sense of belonging. However, the unique works or "traditional" objects that Native artists now execute only for special commissions within the "fine art" market are no longer affordable to most Native people. The affordability of "tourist arts" has thus made them suitable as meaningful substitutes. Like mainstream Americans, southeast Alaskan Natives have come to express their identity in terms of their choices of consumption, including the items that they display, use as decorations, collect, and use as gifts.

Following Kopytoff's idea of "a cultural biography of objects," Bunten shows how after purchase, "tourist art" takes on new meanings in the Native domain. And it can have new significance in interactions between Natives and their non-Native associates. There appears to be a whole range of uses for such objects, often with the most important functions being to reinforce social relationships and to mark a certain identity. For example, objects figure as gifts in contemporary potlatches; they are also tokens that may be given to celebrate graduation from a university, or they are kept as personal tokens of identity. Bunten gives the example of a successful Native (Tlingit) businesswoman who adorns her office with prints of eagles. This woman says that, "Eagles are my crest [heraldic figure of her moiety]. Eagles give me spiritual strength to get through each day." In this sense, such objects have taken on a more personal meaning for coping with the Western business environment.

Another prominent example is an object that Bunten was involved in creating. This was the production of a special blanket with an innovate "lovebird" crest—an item that could be decorative but could also be worn in a traditional manner. The "lovebird" motif broke with traditional conventions since it depicted in one symbolic form the two complementary main crests (raven and eagle) that represented

both exogamous Tlingit moieties. As a result of this innovation, a blanket with the double crest could be used by all members of this Native society. Bunten makes it clear that Native entrepreneurs increasingly have in mind a local, Native clientele alongside their non-Native tourists. Thus, markets for "tourist art" and for popular Native art intersect in an unusual way. Native consumption can turn these artworks into "indigenous objects" with specific functions and meanings that can be understood as "authentic." In other words, Bunten refers to an authenticity that is not inherent in the art objects but relates to what Native people do with them, giving Natives the authoritative voice in determining value.

"Do We Still Have No Word for Art?"

A Contemporary Mohawk Question

Morgan Perkins

When asked to help sponsor a lecture series on the relationship between art and contemporary Mohawk (Kahniakehaka) culture, I was immediately intrigued by the proposed title. It came in the form of a question (the title of this article) posed by Sue Ellen Herne (Kwanerataienni), a Mohawk woman, an artist, and the curator of the Akwesasne Museum. This seemingly simple question strikes at the core of the anthropology of art. What follows is an examination of the complex issues raised by the use of the term "art" in a particular cultural context. This particular usage has important implications for the anthropological understanding of contemporary art on a cross-cultural level.

A Word

It has become something of a cliché among anthropologists, and those interested in the topic of art in a cross-cultural context, to cite an old, yet continuously evasive, concern. Anthropologists and art historians have long reported that in many societies there simply is no term for art. Is it appropriate, then, to use the term "art" to describe a range of objects and activities in cultures that do not have a comparable term in their indigenous language? Although this general problem has perhaps been over simplified, it is still an important point that should be examined in much greater detail. Indeed, the very existence of the anthropology of art—when using the term "art" and focusing, as it often has, on a cross-cultural approach—is brought into question. For better or worse, the term "art" has come into common usage on a global scale. But is it accurate? This is a significant question, so I will simply contribute to the debate by considering its usage in a particular culture, that

of the Akwesasne Mohawk of upstate New York. Within this debate, two points are absolutely essential. The title question was asked by a woman who defines herself, at least in part, as an artist, and she asked it about her own culture.

There is often a reluctance to use the term "art" cross-culturally, particularly when "art" is used to describe forms or practices in a culture other than one's own. Now, in this case, just who is being asked the question, "Do we still have no word for art?" And who can really answer it? If it is being asked of other Mohawks, it necessitates a self-evaluation of both received beliefs about cultural heritage from within the community, and an assessment of the stance that will be taken toward the image of culture that is presented in a global context. By using the term "still," the question references the long history of Mohawk contact with the Euro-American system of art. It implies that Mohawk have been involved in different linguistic and evaluation systems, in reciprocal and evolving relationships. It suggests that the speaker has reached a point in which the use of the term should be evaluated.

Whether the term is used in English or in Mohawk is dependent on the conceptual basis on which it is formed. By this I mean that there are concepts that may have comparable qualities—of evaluation, style, use, and so on—but which are referred to by differing, though often comparable, terms in the languages in question. I shall return to this linguistic point shortly. Let us first consider a few more details about the framing of the question itself.

Many of the nuances and challenges embodied in the title question arise from Herne's own broad training and experience. She learned Mohawk practices such as basketry and beadwork from members of her family and community. She also attended the Institute of American Indian Arts (IAIA) in Santa Fe, New Mexico, and the Rhode Island School of Design. Herne's background demonstrates that the title question was posed by someone who learned the conventions of two overlapping systems. Thus, she has particular insights into their qualities and the relationships between them.

Before further examining the complex implications of the title question for the anthropology of art, it is important to identify the original idea underlying the question. When asked to explain her initial motives, Herne offered the following:

> Environment and culture are related to traditional art and there is continuity and a connection [between them]—they are one in the same and you can't have one without the other. It transcends the Western idea of what art is and the way that art is defined is not really adequate for Native art—it doesn't really fit, it still really isn't our term. Even though we do contemporary "art" and there are those who fit into the art world, there is a large amount that they do that is very different—that is more tied to the community and the environment. (Herne, pers. comm.)

This explanation does not deny a certain applicability of the term "art" to the forms and practices of her culture, it simply points out that something is lost in the translation.

Charlotte Townsend-Gault (1992:100–101) strikes at the heart of this matter in her essay on the landmark 1992 exhibition of contemporary First Nations art at the National Gallery of Canada: "In the end, cultural difference is expressed not by attempting to find common ground, common words, common symbols across cultures. It is finally dignified by protecting all sides from zealous over-simplification, by acknowledging a final untranslatability of certain concepts and subtleties from one culture to another." While there are certain concepts that may translate quite readily, there are some that obviously do not, and those distinctions must be respected.

So the answer to the question about a word for "art" remains hanging in the air. If the title question asks whether there is a word for "art" in a broad, cultural sense, then the answer is yes. As Herne points out, the term is commonly used when speaking in English, and it is often used with a sense of pride that the quality of the work has gained recognition. In 1988, for example, forty basket makers from Akwesasne traveled to the Metropolitan Museum of Art to accept the New York State Governor's Award for Excellence in the Arts on behalf of all of the basket makers of Akwesasne (Lauersons et al. [1983] 1996:3).

Acknowledging that the translation is imprecise, I will therefore continue to use the term to discuss its broader implications. To the extent that anthropology necessitates a general process (however inexact) of cultural translation, let us examine some of the concerns raised by a close reading of the original question's phrasing as well as a consideration of its wide connotations. Perhaps the most important step is to acknowledge that, however much influenced by external forces, efforts to understand the Mohawk conception of art should be based on the viewpoints of Mohawk practitioners themselves. As Jeremy Coote (1992:248) has advocated, we must ensure that "an attempt is made to see art as its original makers and viewers see it." Although different audiences may offer interpretations that vary from the original intent, the initial authority and point of departure for interpretation must begin with the intention and, if it is available, the voice of the producer.

This question of authority is evoked with a remarkably strong stance in a work by Shelley Niro (Bay of Quinte Mohawk) entitled *Surrender Nothing Always* (figure 1). Both the image and the words demand the recognition that contemporary Mohawk forms span a full spectrum of materials, styles, and practices. On the one hand, the turtle rattle (embodying beliefs and forms relating to the Mohawk creation story) highlights the continued presence of traditional knowledge and practice in the production of contemporary forms. On the other hand, the paintbrushes and palette knife symbolize the varied lives and artistic forms that have evolved over time. The words go to the foundation of our question about "art" and who defines it, while reinforcing the notion of continuity and connection between all forms of Mohawk cultural practice. The words place authority directly in Mohawk hands.

I was rather surprised during a conference panel discussion when Niro was asked by an audience member whether she considered herself a "Mohawk artist" or just an "artist" (this session was organized by Nancy Mithlo; see also Mithlo's

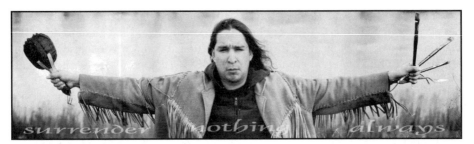

Figure 1. Shelley Niro (Bay of Quinte Mohawk), *Surrender Nothing Always*, 2003. Digitized photograph. Image courtesy of the artist.

discussion of the Venice Biennale project in which Niro participated [article 17]). The comment did not question that Niro was an artist—this was presumed. But this question, like that surrounding indigenous words for art, is something of a cliché. It highlights the continued perceptions that circulate around art and identity politics. Niro later recalled: "I probably was annoyed and amused. I do consider myself a Mohawk artist, that's because I am. But it's something I don't think I think about as I make my art" (Niro, pers. comm.). Identification as an "artist," with any range of additional identifying characteristics (or not), depends very much on the choice of the individual and to a large extent, the nature of one's education. G. Peter Jemison (cited in Fox 2003:37) has written, "To say that I'm an Indian artist is not a shortcoming; it represents who I am and is the very source of my thinking." In contrast, consider the following by Bob Hazous (Wade and Strickland 1981:16; Schneider 1996:188):

> I've lived in many different situations, with Indian families, my own included; with white people; in the city and in the country. I've related to all different kinds of people in different settings. With this background have come a lot of different feelings and experience. So I don't see why I have to do Indian art. Yet that's where the paradox comes in: I'm still doing Indian art.

While motives and feelings about labels obviously vary, most of the works discussed in this article were produced by those who identify themselves as Mohawk and as artists. Whether they identify themselves as "Mohawk artists" first and foremost depends very much on the choice of the individual. Should Mohawk art be defined on the basis of ethnicity, technique, medium, artistic intent, or some other equally flexible criteria? Placing these issues in a comparative perspective may begin to clarify the circumstances that surround the incorporation of contemporary Mohawk art and artists into a global art world—circumstances that reveal as much about the Western concept of art as about the Mohawk engagement with that concept.

Whether particular works are viewed as "traditional" or "modern" largely depends on the cultural system from which they are viewed. Judgments about the

relative authenticity of a particular work will often be made by those outside the community in which it was produced—whether they be collectors, curators, or anthropologists. In some contexts innovation is valued, while in others, strict adherence to prescribed formal qualities is preferred—however, there is far more overlap between these extremes than might readily be acknowledged. The impact of various art institutions—galleries, museums, markets, and so on—on the evaluation of objects has been thoroughly explored by anthropologists and art historians in a variety of cultural contexts (see Graburn 1976; Price 1989; Steiner 1994; Welsch, article 18). Most culturally relevant to the case at hand is Ruth Phillips's (1998) account of the trade in Native American souvenirs—including several examples from Akwesasne. She demonstrates the complex dynamics embodied in the production and reception of objects made for sale. Mohawk beadwork, for example, has a long history that predates European contact. Its indigenous usage encompasses its adaptation for trade and, more recently, its display as contemporary art. An excellent example of the range in forms that appear in this display comes from the exhibition Across Borders: Beadwork in Iroquois Life (figure 2). The exhibition in general, and this installation in particular, highlights the vast range of beadwork

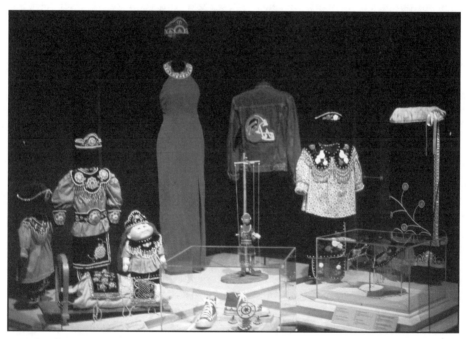

Figure 2. Display of contemporary beadwork from Across Borders: Beadwork in Iroquois Life, 2001. Exhibition organized by the McCord Museum and installed at the Canadian Museum of Civilization. Photo by M. Perkins.

forms that have been created. It emphasizes that changes in form and use are not necessarily indicators of a loss of cultural knowledge and relevance, but rather dynamic demonstrations of artistic and cultural flexibility (Perkins 2004).

The international "contemporary" art world—as seen in its institutions and structures—is fundamentally based on Euro-American systems of art evaluation. This international art world has increasingly embraced forms produced by living artists working from a vast range of cultures, which have often interacted in subtle, and not so subtle, ways over the course of their histories. These facts necessitate a fundamental reevaluation of the use of the term "contemporary." The term may be appropriate in the context of a self-referential Western art history, structured with an emphasis on progress and innovation. The term is not, however, appropriate in a cross-cultural context where the many forms produced in varying styles are products of complex cultural systems with distinct, indigenous, and often adaptive criteria for use and evaluation.

Thus, my view of contemporary art takes as its point of departure the presumption that contemporary art is that which is produced in the present, regardless of medium or style. Conceptions of relative "traditional" or "modern" qualities—in which even the term "modern art" has itself become rooted in a past period—*may* be appropriate for work produced in the Euro-American sphere. Even here the cross-cultural influence of so-called "primitive art" on the creation of "modern art" raises many questions about such independence (see McEvilley 1984, Rubin 1984, and Clifford 1985 on this relationship; see Rushing 1995 for specific Native American influences).

Such conceptions are *not* appropriate when imposed on cultures with very different forms of aesthetic and cultural knowledge, many of which have long embodied some of the very qualities that have become defining characteristics of artistic modernity in the Euro-American tradition in just the last century. Abstraction is only one small example of a trait that was found in many non-Western aesthetic traditions before it became popular in Western art. In short, a temporal term such as "contemporary" should not be equated with a conception of work that necessarily demonstrates innovative form and content. This imprecise usage of "contemporary art" is generally restricted to work presented in art institutional contexts, in particular conceptual styles, and with a certain consciousness of global dynamics and the self-referential art historical sphere.

This seemingly obvious conception allows for artists working in a wide range of cultural contexts—whether producing conceptual installation pieces or objects used exclusively for ritual or personal expression—to enter the discourse of art on the same terms. Indeed, many so-called "traditional" forms are as contemporary, sophisticated, and intellectually complex as the most innovative conceptual art. In this sense, the conception of contemporary Mohawk art is very much like the conception of contemporary Mohawk culture. It embodies the things that are old and those that are new, those that are indigenous and those that are not.

Another central point raised by the title question is the relationship between the visual arts and other forms of expressive culture—music, dance, and poetry, to name just a few—as well as their integration with cultural life in general through activities such as the teaching of language, the telling of stories, and ceremonial uses. Sue Ellen Herne presents this sense of connectedness with particular clarity when she states that, "even the art that we make *as* art is not just that, it is an expression of our culture" (Herne, pers. comm.). As she pointed out earlier, this expression of Mohawk culture connects art to the environment and to the community in specific ways. Art is part of a received cultural heritage that includes all aspects of contemporary life and they may sometimes be perceived from differing viewpoints as either positive or negative in nature, as we will see in some of the works discussed in the following section.

The embeddedness of art within a broader context has been central to many anthropological efforts to present the functional nature of particular forms in different cultures. Anthropologists have often viewed these functions in contrast to art historians' efforts to focus on objects' formal qualities (see McMaster 1999 for a contrasting approach to an aboriginal art history). As Susan Vogel (1991) has succinctly demonstrated, however, the debate between form and function is not mutually exclusive. The same object that may be used in a ceremony, for example, can also be considered for display in an art gallery, and as a source of income. Is it fair to expect members of other cultures to conform to a vague definition of "art" when that definition continues to be debated in its own language? Even the limited application of the term "art," simply to refer to material culture, runs counter to the anthropological effort to place the vast range of artistic or aesthetic discourses around the world into their particular functional and cultural contexts. These contexts should not be considered as hermetically sealed units since cultures influence each other constantly on both extreme and subtle levels (see Danto 1988; Vogel 1988; Gell 1996 for a discussion of the relationship of art to artifact).

The global discourse about art has influenced the contexts and conceptions of even the most seemingly "traditional" aesthetic forms. Perhaps terms such as "art" and "aesthetics" are so embedded in their linguistic and conceptual position in the West that it may be difficult to accept their cross-cultural applicability (see, e.g., Coote 1992; Morphy 1992; Ingold 1996). There has been a certain discomfort among anthropologists with the use of a term that is often associated with a particularly elite conception of culture as hierarchy, in contrast to the predominant anthropological concern with culture as a set of common characteristics or forms of knowledge (for a history of the anthropological study of art, see Morphy and Perkins 2005). Yet, this need not be the case. A singular focus on art as a reflection of a set of conventions in one culture does not preclude its ability to evoke a vast range of meanings, qualities, and practices across cultural boundaries—if distinctiveness is kept in mind.

Many Mohawks define themselves, at least in part, as artists, and expect that their work will be shown in galleries and sold in markets as "art." The motives for

adopting this term varies—perhaps it is done out of the recognition of quality, cross-cultural necessity, or simply out of courtesy to those who do not speak Mohawk. It is important to mention that the title question was posed by someone who speaks English as her first language and, like most of the artists I will discuss, has made a conscious effort to learn Mohawk. Some of the older artists speak Mohawk as their first language, but many younger artists do not speak more than a few words of Mohawk. Several of my Mohawk students have noted with a certain irony that instead of learning to speak Mohawk from their family or in their community, they are learning by attending language classes held down the hall from my office in the Anthropology Department at the State University of New York at Potsdam. The teaching of language and the teaching of "traditional" art forms were often activities that occurred simultaneously and now a conscious effort must be made to learn either.

This observation returns us to the essential matter of cultural and linguistic translation embodied in the title question. In contrast to the affirmative answer when interpreting the question as one regarding the use of the word "art" by Mohawks speaking in English, the answer regarding its existence in the Mohawk language is very different. The brief answer is no. There is still no specific word for "art" in the Mohawk language, despite the fact that the language often incorporates nonindigenous words such as "computer." The fact that "art" has not been translated attests to the very fact that "art" cannot be considered a separate concept in the Mohawk point of view. There is great complexity, however, in the language used to refer to specific practices such as basketry (*athere'shón:ah*) and beadwork (*tekatsi'nehtará: ren*). Sue Ellen Herne is very clear on this matter. "There are words for many things, but there is not a different word for art; these things are not separate from culture as a whole" (Herne, pers. comm.). With this distinction in mind, let us now consider work produced by some individuals from one particular community to demonstrate various Mohawk uses and conceptions of the word "art."

Contemporary "Art" at Akwesasne

My own slow process of learning about Mohawk conceptions of art has only been possible because I have been fortunate to live and teach near the remarkably welcoming artistic community at Akwesasne. The Mohawk Reservation at Akwesasne has a complex history that has resulted in several contemporary political and cultural divisions. It straddles the border of the United States and Canada and only certain political institutions on the reservation have official recognition on a state, provincial, or national level in either country. In contrast to these institutions is the Mohawk Nation Council of Chiefs, the government recognized by "traditionalists," who follow longhouse beliefs (for historical details see, e.g., Morgan [1851] 1962; Tooker 1978; Snow 1994). It is the one government that spans all geographic

sections of the reservation even though a large percentage of the population does not follow this system or recognize its authority. It is under this system that Akwesasne and other Mohawk communities form the "Eastern Door" as members of the Iroquois Confederacy or League of the Iroquois (Haudenosaunee). The league originated with the membership of five tribes—Mohawk, Oneida, Onondaga, Cayuga, and Seneca—and it was later to include the Tuscarora. The conception of heritage often represented in various art forms is one that includes the changes, whether they are perceived as coming from outside or from within, that have been, and continue to be, at work in the community.

These political and related environmental issues often feature prominently in the work of some Akwesasne artists. There have been violent conflicts over the role of gambling in the community, for example, and local industrial pollution in the St. Lawrence River has had devastating health and environmental consequences. Experimental forms may lend themselves more readily to commentary on certain difficulties associated with contemporary life. In a catalog for an exhibition at the IAIA that included work by the Akwesasne artist and poet Alex Jacobs (Karoniaktakeh), the exhibition curator, Joseph Sanchez (2003:6), wrote that the exhibition's goal was to:

> express the complex stories of Native America, stories that go beyond where we came from and present the realities of our lives, both positive and negative. Diabetes, alcoholism, suicide, casinos, language, land and water rights, tribal colleges, NAGPRA [Native American Graves Protection and Repatriation Act] and cultural appropriation are just a few of the issues facing Native Americans in the 21st century.

I would suggest, however, that preserved forms from the past also lend an intimacy and access to cultural knowledge that is profoundly relevant to contemporary beliefs and practices relating to such issues as identity. Indeed, even if a work is not intentionally concerned with controversial issues, those issues may have a subtle impact. The clay gathered from the river for pottery and the sweet grass collected for basketry, and often held in the mouth while weaving, may be contaminated. Some Akwesasne artists have considered producing what Alex Jacobs calls "toxic art," involving materials that are literally polluted (Jacobs, pers. comm.).

Another topic for many artists—relating directly to the title question—is the concern over the loss of their language. This is a crucial moment in time since there are few fluent speakers remaining due to past pressures to assimilate into mainstream American culture. These pressures encouraged the neglect of the Mohawk language and were often accompanied by forced residence in boarding schools. Elders and teachers who are fluent speakers are working with those members of the younger generation who are interested in learning Mohawk. Artists have addressed these concerns in a variety of forms.

In an exhibition entitled What Are We Leaving for the 7th Generation? Seven Haudenosaunee Voices, seven artists were asked to address the issue of inheritance

and responsibility as it relates to the Haudenosaunee philosophy of the seventh generation (Perkins 2002). This philosophy encourages everyone to consider how their every action has consequences for the seventh generation to come, just as the current generation inherits the consequences of decisions made seven generations before. The works by Katsitsionni Fox (with whom I co-curated the exhibition) and Sue Ellen Herne take direct positions towards the problems and potential solutions that face contemporary Mohawk culture. In her introduction to the catalog, Fox (2002:4) writes:

> Our relatives survived the attempted genocide of our people. They survived disease, warfare, prejudice, displacement, deceit and injustice. It is nothing short of a miracle the gifts that they were able to leave for this generation. I am forever grateful to them, when I hear the tiny, yet proud voice of my six-year old daughter reciting the Thanksgiving Address in her Native tongue. . . . Today our generation faces new challenges including diabetes, heart disease, pollution of the sacred earth, water and air, the loss of our language, culture and way of life.

This is the heritage that is received and is often addressed in contemporary art at Akwesasne. The following examples move loosely from forms that have been considered more "traditional" to those that might be considered more "modern." There is, however, considerable fluidity between the different media and their varying conceptions. This fluidity, as conceived from a Mohawk perspective as part of a broad conception of contemporary culture, will not always be evaluated by others on those terms. I will merely outline a few aspects that, in my opinion, highlight the title question regarding Mohawk conceptions of "art." So too must I limit myself to a few of the many different media in which individuals work (on these varied forms see, e.g., Johannsen and Furguson 1983, and the journal *Akwesasne Notes*).

Among the many older forms that continue to be produced, such as beadwork and pottery, Akwesasne is particularly renowned for its basketry and great efforts have been made to pass these skills on to the next generation (figures 3 and 4). While particular styles are often associated with certain families and individuals, there is a sense of commonality that allows techniques to be shared and ensures both the preservation of old forms as well as new innovations. The dynamic nature of the form and its connection to the marketplace is readily acknowledged, as exemplified in the following description from a catalog produced by the Akwesasne Museum.

> In the past, whole families shared in the production of baskets. Basket making was the primary means of support for many families, through many lean years—from the turn of the century until the 1960s. . . . Freed from the financial dependence on basketry as a livelihood and from the necessity of meeting inflexible demands of wholesale basket merchants, the basketry as a whole has taken on a special individuality as a result of the personal freedom and growth of each artist. . . . Each generation learned the old and invented its own new techniques. A very unselfish art, basket makers are flattered at imitations by

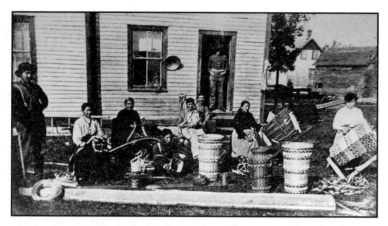

Figure 3. Basket makers displaying their work in front of Jake Fire's house at Akwesasne (circa 1906). Original photographer Francis San Jule. Courtesy of the Akwesasne Museum.

other Mohawk basket makers of their original patterns and surface designs. Much pride comes from knowing that a particular design is important enough to be useful to other basket makers. Many of them call on old family patterns for unique designs no longer frequently produced. (Lauersons et al. [1983] 1996:10–11)

This perspective demonstrates that basketry is viewed by members of the Akwesasne community as an art form in its own right—one that is recognized for both its functional and aesthetic qualities. The market has, at different times, imposed a range of expectations, sometimes relating to production levels or to materials and forms based on external notions of authenticity (such as a preference for natural rather than synthetic dyes). Yet those producing the baskets have created their own system of production and evaluation that is both vibrant and supple.

In conversations with those who have learned basketry in recent years, I have frequently heard references to the process of learning or creating basketry techniques as one that takes place in a home setting, perhaps in a kitchen. Often surrounded by fluent Mohawk speakers telling stories and exchanging news about lives and daily events, young people come to experience basketry not simply as something profoundly connected to the past, but more immediately as part of everyday life and language. Among the most renowned Akwesasne basket makers, the late Mary Adams (Kawennatakie) began basket making as a way of supporting herself and her family. Over time it became part of her daily life and a way to keep her family united. "My kids are always around me when I'm making baskets. That's why when my children have kids, I keep telling them, why don't you make baskets then you watch your own kids. Don't get a babysitter. You make enough money, if you make baskets, and then you keep your kids" (Cook 1990:50).

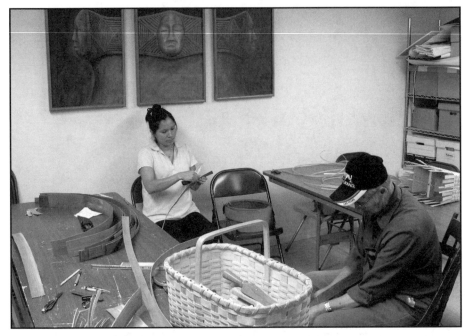

Figure 4. Henry Arquette (Atsienhanonne) teaching a basketry class at the Akwesasne Museum, 2005. Photo by M. Perkins.

This intimate connection between basketry and daily life is an example of the conception of art as integral to culture that Sue Ellen Herne and many others have described—the culture inherited from the past as well as the culture of the everyday. Producing baskets is not simply about preserving an abstract "tradition," one often conceived from the outside as rooted in an idealized past. It is also about experimenting, surviving, spending time with family, talking to neighbors, or putting food on the table—it is about living.

In response to the sadness often expressed at a perceived loss of tradition, Deborah Doxtater (1995:20) offers an alternative perspective in an essay for an exhibition called Basket, Bead and Quill.

> If "tradition" is merely the surface appearance of form, then those who lament the passing of Native traditions are justified in doing so. But if "tradition" is really collective community and individual processes which are evoked by continuing culturally powerful metaphors such as "basket, bead and quill," among others, then "tradition" is very much alive.

Among a younger generation of contemporary artists, work that may very well be produced for display as "art" in institutional venues still often embraces meanings that evoke this powerful notion that "tradition is very much alive." Let us consider a piece

of Sue Ellen Herne's own work. Although the piece to be discussed is perhaps not representative of her past work—which has primarily involved painting with a distinct interest in basketry—it is remarkable as a broad, reaching integration of the full spectrum of contemporary Mohawk art styles. It was produced as a contribution to the 7th Generation exhibition previously mentioned and its components represent personal reflections on her own and her family's place in that continuum. Because her father was a steelworker—Mohawk men have become renowned for their work on skyscrapers—she often had to move and lived a rather nomadic life as a child. She felt

Figure 5. Sue Ellen Herne (Akwesasne Mohawk), *Mohawk Samsonite,* 2002. Mixed media installation. Photo by M. Perkins.

that her family took their culture and identity with them when not living at Akwesasne, as if it were packed in a suitcase, thus the title of her work (figure 5).

My first installation, "Mohawk Samsonite," is an autobiographical piece. It relates to my painting in that it is personal, yet it is vastly more autobiographical than my paintings. It is created with actual objects and images that are from my home. My dad's suitcase and some of his ironworking tools; a basket that belongs to my mother; a chair from my Grandpa and Grandma Herne's house. . . . It is based on the premise that what we have to give to the next seven generations is, in large part, what we have been given over the past generations. Baggage and all.

I am in one of the photos and am also represented through the things I've made—the decoration on the cradleboard, the fingerwoven sash, and the basket making tools that I own. My sons are represented by the cradleboard itself and are in several photos. We are the fifth and sixth generations in the piece. They have given me the role of mother and I am trying to pass what is important on

to them. They were carried in the cradleboard, though not as often as I would have liked. My grandpa was carried in one regularly; my parents and I were never in one. Some of our culture has skipped a generation before showing its face again. . . . It is up to each generation to take what has been passed to us and make the best use of it that we can. (Herne 2002:12)

Her eloquent wordplay on the theme of baggage, both cultural and personal, is an example of the direct engagement many Mohawk artists have with the complexities and problems associated with contemporary life. As a whole, the work was produced as "art," but many of the components are materials for which the term does not apply. It might readily be placed in the context of contemporary art that uses "found objects," or be categorized as "installation art" that intentionally resists commodification by its impermanence. The temporary nature of Herne's piece, however, was due to the simple fact that, after being shown in two venues, the piece had to be dismantled because her father needed to use his ironworking tools. The work itself and the words used to describe the concepts embodied within it attest to the integration between art and community that prevents the concept of "art" from becoming a separate category.

Another artist, Katsitsionni Fox, draws on a range of forms and themes in her installation work entitled, What are We Leaving for the Seventh Generation? She uses a range of media to symbolize this philosophy and confronts social concerns by insisting on mutual responsibility. One component of the installation features seven prints, each of which has one figure that represents one generation. She places herself at the center with the figures on one side representing three generations of ancestors, and on the other her daughter and two fetuses representing the generations unborn. These images are displayed in conjunction with materials, such as corn and beads holding particular cultural significance, and underneath each image are figures made from soil—bodies for those who have passed away, footprints for those who still walk the earth, and faces for the unborn generations. On her work, she writes:

Our elders tell us to think ahead seven generations when making decisions today. This philosophy is very profound. Our actions have a ripple effect, like a stone thrown into water. They effect our children, their children and the ones yet to come. We in turn feel the effects of the actions of generations before us, whether they are positive or negative in nature. . . . I hope that my actions honor who I am, as an artist, an educator, and a mother. I hope that the stones that I throw today ripple out to the generations that follow me, to my children who are here, and to my grandchildren not yet born. (Fox 2002b:10)

The sense of responsibility expressed in these words and interactive visual forms exist within a broad sense of culture. She uses the venue of the art gallery as a forum for education, and during the exhibition she arranged several visits and projects for her students at Akwesasne where she teaches art (figure 6). As part of

Figure 6. Katsitsionni Fox discussing her work with her students from Akwesasne, Gibson Gallery, 2002. Photo by M. Perkins.

her effort to involve the audience during the exhibition, she asked people to choose a stone inscribed with different words (both positive and negative) in both Mohawk and English, and to drop that stone into a pool to create the symbolic ripples that link different generations. The words inscribed on the stones included *independence, dependence, thankfulness, toxins, compassion, shiny things, debt,* and *corn* (figure 7). Most of the stones that people dropped in the pool had positive words, likely reflecting the participants' conscious effort to accept responsibility for conditions in the future.

The use of words takes on another level of significance if we consider the work of Alex Jacobs, who often merges words and imagery in his work as both a visual artist and a poet. Much of his work engages with themes that have particular connections to Akwesasne, but he also works on a broad, cross-cultural level through, what he calls, the "reappropriation" of Native American images and stereotypes. The Last Indian was an installation that drew on objects and images—such as sports mascots and cigarettes with Indian images—of the consumer society that has surrounded and appropriated indigenous cultures. These were scattered beneath and framed around the image of Sitting Bull peering over the edge of a reappropriated and reconstituted Mount Rushmore—a central symbol of the American appropriation of indigenous land (figure 8). On the relationship between his work and categories of art and language, Jacobs (2003:5) writes:

> I started out doing mixed-media, multimedia, performance, installation and environmental art and then found out that these were terms for what I did. My

Figure 7. Katsitsionni Fox (Akwesasne Mohawk), *What Are We Leaving for the 7th Generation?* (detail), 2002. Mixed media installation. Photo by M. Perkins.

Figure 8. Alex Jacobs, *The Last Indian,* 2003. Mixed media installation. Photo courtesy of the artist.

art materials, over the years, have included any imaginable discard there is. At times I basically became a street person, dumpster diving, finding relics on trails and fences, going through discards and trash. . . . As Native artists/designers/ conceptualists/thinkers . . . I believe we are also engaged in sciences such as archaeology, anthropology, sociology, psychology and biology. Trash, chaos theory, dissonance, degradation/decomposition, impermanence, recycling are all valid artistic concepts in the big picture.

While each of these individuals' experiences are distinct, with respect to artistic training and practice, they are representative of an increasingly diverse range of lifestyles—within the Mohawk community. They are also typical among indigenous artists globally. They have learned and engage with the conventions of two systems that partly coincide. Ultimately, this interaction of systems brings us to what I feel is the key to understanding the significance of the title question about "art"—the role of education. Education is the fundamental process through which the concepts that are represented by this word are learned and interpreted in different cultural contexts.

"Art" and Education

If we are to understand the varied ways in which the use of the term "art" plays a role in contemporary Mohawk culture, it is essential to understand the different ways that people have learned to think about this concept. Since one of the primary goals in the anthropological study of art is to attempt to understand the framework for the interpretation and use of objects from the perspective of the producing culture, we must begin with the process that describes the conventions of this framework. In short, one must understand the methods of education. The use of the word "art" is directly connected to the learning of the conventions of a particular art world—conventions that include the display of work on walls and pedestals in galleries, attendance at exhibition openings, and the marketing of art in general. I view art education broadly as a process that moves in two directions. It includes the process of learning techniques and meanings, but it also includes the use of art and its practice to educate the artist and the viewer on an infinite range of issues. I include myself in this latter sense because most of what I have learned of Mohawk culture began with, and has generally been filtered through, my exposure to its art. The lecture series that gave this article its title was also organized to promote a greater understanding of Mohawk culture in the local region.

Art education often takes place under structured conditions, such as in a classroom, studio, or gallery. However, the communication of visual and cultural knowledge from one person or generation to another may be most effective when the methods used are adapted to the needs of the artist and culture. Each of the artists that I have discussed acquired their skills and knowledge through a range of

methods that include independent study, family and community gatherings, apprenticeships, and training in urban art schools. Some are art educators in academic settings, some teach in their local communities, and all pass on their different forms of knowledge through art forms.

The exploration of the systems of art education is a method that I have found increasingly useful for understanding contemporary art in a cross-cultural context (see Perkins 2001 for a comparable study of contemporary Chinese art education). Education forms the basis through which knowledge of any cultural system is acquired and it is this knowledge that determines the forms and practices that have come to be called art on a global scale. In a statement that is particularly relevant when considering the different art worlds within which contemporary Mohawk artists circulate, Nicholas Thomas (1997:264) makes a convincing argument for the reassessment of former definitions and categories.

> The distinction between "Western" and "non-Western" needs to be rejected as an instrument of disciplinary framing because it has ceased to correspond with any real division of cultural domains or practices. Much indigenous art is now produced for a market; in some cases it is produced by people who have been trained in art schools, who work with "Western" media and techniques, and who sell through dealer galleries rather than craft shops. Even those resident in remote communities and deeply grounded in traditional forms of knowledge may be well aware of the category of the artist and may be anxious to be recognized in those terms.

This is not to say that these conceptual divisions do not persist in the minds of many—producer and consumer alike. Indeed, different forms of training may become a source of conflict—both within communities and from the viewpoint of perspective consumers—by building potential opposition between those who create materials that preserve old forms and those who are more experimental.

In the Native American art world, for example, differences in training often manifest themselves in a perceived division between "urban Indians" and "reservation Indians," even though the styles produced may have less to do with one's residence than one's training (see Svašek 1997 for an example from Ghana, and Morphy 1995 on similar divisions among Aboriginal Australians). In some settings the preservation of old forms may be linked to their continued use in rituals, while in others the same notion of preservation may be driven by market forces that impose external notions of authenticity. These distinctions are often vague and can readily play into the hands of forgers eager to satisfy the demands of the market (see Hill 2002 on the Native American art trade, and Steiner 1994 on the African art trade). In short, the form of one's education may play an essential role in determining one's fundamental knowledge of a culture's artistic system. Yet, it may just as readily be a source of more superficially perceived differences that play into the categories established by art markets, galleries, and assorted venues for contemporary art. As interesting and evocative as this latter process may be, I am far more

interested in the dynamics of the former. For it is the essential role of education in establishing specific forms of knowledge about any particular cultural system of art that lends the most insight into the nuanced concepts embodied in our title question about any particular culture's word for "art."

Knowing the context of an artist's art education adds considerable insight into the artist's intentions—for example, Mary Adams learned basket making by watching her mother while Herne, Fox, Jacobs, and Niro all attended art institutions. This knowledge is even more helpful if one recognizes that the process of art education occurs on two fundamental levels. On one level there is the acquisition of the skills that allow one to reproduce, and potentially innovate, forms. On the other level is the acquisition of knowledge about the community of practitioners and the broader social system of which they are a part. In this sense art education involves the creation of identity and the learning of rules and conventions—a way of being in different art worlds and indeed the world at large. This process of learning may occur at home, where identity is formed based on cultural similarity, in an external context, where identity is learned in contrast to difference, or in any combination thereof. Sue Ellen Herne, for example, recalls how the art classes she took as a child off the reservation made her first realize that the basketry and other forms she had learned at home had such a distinct and close association with her culture. In short, for her the process of learning art was also the process of learning about being Mohawk.

While my conception of such knowledge formation is rooted in the role of art education, it may be useful to consider the broader analysis of education as occurring in, and reproducing, communities of practice as embodied in the theory of "legitimate peripheral participation" (Lave and Wenger 1991). This concept refers to the many forms of acculturation and social learning that occur beyond the context of the specific learning goals framed within any educational experience (see Herzfeld 2004 on this process among artisans in Greece). The range of different cultural contexts within which learning takes place often involves a subtle process that has less to do with instruction than with lived experience—a distinction between "talking about a practice and talking within it" (Lave and Wenger 1991:30).

Among the many examples of this process are the classes in basketry and other Mohawk forms that are held at the Akwesasne Museum and the work of many Akwesasne artists who teach in the local schools (see figure 4). These experiences reinforce the connections between material forms and the broad range of knowledge associated with Mohawk cultural identity. In an effort to encourage children to express their own insights into their culture through contemporary art, for example, a unique exhibition was organized by the Akwesasne Museum called Gathering Knowledge. In the exhibition proposal, Sue Ellen Herne stated that the concepts behind this exhibition "revolve around our artistic traditions, the role of traditional and contemporary art in our culture, the changes in Akwesasne that the elders have witnessed, and how the youth believe these changes can be addressed." This was a particularly unique approach since Mohawk children were the curators.

One last example illustrates the supple nature of Mohawk conceptions of art and education. For an exhibition entitled Learning from Akwesasne one of my anthropology students from Akwesasne named Shelby Loran designed an installation called Histories of Akwesasne. Her installation was a mosaic of quotations and images—some of which celebrated Mohawk culture and others featured old derogatory stereotypes from the newspapers of the local non-Mohawk community. These materials were placed on a quilt that she made for her child, highlighting the fact that views of Mohawk culture, from both inside and outside of the community, have created the sense of identity that she will pass to the next generation. When reinstalled at the Akwesasne Museum, Loran added to the installation a list of all known Akwesasne residents who had been sent to the Carlisle Indian School (1879–1918) to learn how to adapt to nonindigenous American society. While Loran was not trained as an artist, Sue Ellen Herne felt that the installation had both artistic qualities and cultural material that was of considerable importance to the local Mohawk audience. What began as a student exercise in anthropology and museum education thus became "art" when placed on display among the works by Fox, Herne, and the other artists described previously.

Conclusion: Another Question

It is with no little irony that the title question, which comes from a culture where there is no word for art, should raise more questions about the conventions of a cultural system where there is a word for art. For it is in that latter system that this category remains open to debate, even as a great deal of ink is spilt over its existence in various other cultures. Perhaps the title question could be mirrored in an alternative form. Why should there be a word for art in Mohawk? This question opens a dialogue that challenges the notion that the Mohawk perspective should conform to rules and conceptions that are not of its own making.

A global system of contemporary "art" now primarily exists only insofar as those who produce work choose to have their material, or some selection or aspect of it, defined as such. Certainly, that label may be bestowed on material after the fact, as has often been the case. In some ways the contemporary situation has disturbing similarities to the early influences on modernism, in which forms were borrowed from diverse cultures to revolutionize the Euro-American system without much concern for the cultural context of the borrowed material. Indeed, Picasso famously said that "everything I need to know about Africa is in those objects" (Rubin 1984:74). Contemporary enthusiasm for "multicultural" participation in the global system is encouraging, yet that inclusion is often restricted to those working in "contemporary" media and conceptualizations. Despite the conceptual complexity of that work, there is generally little room for those working in styles that are perceived as "traditional." Nor is there generally sufficient interest in

understanding the subtle nuances of the cultural systems from which all forms emerge. Today, the participation by others is more willing, and those working outside or across the Euro-American system of art have the most potential to challenge the conventions of a global art world based on that system.

It often proves beneficial to critique the dominant system in place, just as it is beneficial to obtain that critique from those who can circulate in it and gain insights about it, but are still outside of the system in fundamental ways. The Mohawk conception of art—and indeed that of the majority of cultures where there is no distinct category of art separate from social and cultural identity—actually strikes at the core of the Euro-American system of contemporary art. The driving force of that system—the desire for the new to challenge the orthodox—has largely been determined by the concepts of the avant-garde. The historical ideal of the avant-garde—as rooted in the work of Marcel Duchamp—has been concerned with the dismantling of art as an institution in order to return art to the praxis of life (Bürger 1984). This ideal engaged with forms from cultures where this very goal had already been met. Ironically, the response has generally been to make great efforts to strip the examples from successful cultures of their original context. Since the wide range of artists who now produce contemporary art often have their roots in holistic cultural contexts they have the potential to fundamentally alter global dynamics.

Clearly the questions that are raised concerning the avant-garde goal of merging art with life lie at the center of anthropological concerns over the relationship between form and function. It is important to recognize that function goes beyond the physical to include the social, economic, and symbolic functions of material. In that sense, work produced in the Euro-American tradition—which promotes individual innovation that is seemingly functionless—is not necessarily any less functional than that produced in many other cultures. Rather than consider the global influence of "art" as a process that creates conformity, attention should be paid to the many distinct ways with which the concept is engaged. Daniel Miller (1995:3) has suggested the term "differential consumption" to refer to "the sense of quite unprecedented diversity created by the differential consumption of what had been thought to be global and homogenizing institutions." Rather than expect artists to conform to a set of culturally specific rules and conventions in order to participate in the institutions of international contemporary art, those institutions might be better served—and indeed even come closer to achieving their avant-garde goals—if they become willing to really learn about other systems and appreciate the forms that come from them. On some levels most art reflects individual and cultural beliefs and experiences, but an appreciation of the distinct ways that different cultural systems engage with that concept opens the door to multiple and decentralized conceptions of what is modern.

The notion of sharing distinct beliefs is embodied in one of the core symbols of the relationship between Mohawk and Euro-American traditions. The *guswhenta,* or two row wampum (figure 9), embodies the philosophy that two cultures can

Figure 9. Ray Fadden (Tehanetorens), *Two-Row Wampum* (Guswhenta), 1999. Collection of Six Nations Indian Museum. Photo courtesy of John Fadden (Kahionhes).

influence one another while demonstrating a mutual respect that resists any efforts to control the other's destiny. The two dark rows represent two boats traveling down a river together and symbolize the parallel but different paths that are taken by the two cultures (for history and interpretations see Hill 1992; Tehanetorens 1999). In formats ranging from "traditional" quahog shells, synthetic beads, paints, and even performance, this symbol has been reproduced faithfully and reinterpreted creatively by countless individuals—only some of whom may define themselves as artists (see, e.g., Hill 1998; Tehanetorens 1999). The Mohawk boat contains the integrated conception of art and the other boat contains the framework for the Euro-American conception of art—the ideas can be shared and compared, but they remain distinct to each vessel. There is much that the Mohawk perspective can teach about art, if those in the other boat are willing to learn.

The final answer to the title question about the word for "art" must come from within the Mohawk vessel. The answer has been a clear "no." There has not been a word in Mohawk for art, nor has the choice been made to create one despite its common usage in English. As long as it remains clear that the term is insufficient to evoke their full complexity, there is a willingness to have certain aspects of Mohawk culture defined as "art" since an appreciation of their aesthetic qualities is readily acknowledged. Without a doubt, nonindigenous influences have played a strong role in the Mohawk conception of art and an awareness of its distinctiveness in contrast to others. What this influence has not done, however, is prompt those involved in the preservation and innovation of the Mohawk language to create a word for art in Mohawk.

Questions for Discussion

1. What are the various roles that contemporary art play for Mohawk people today?

2. How do Mohawk and non-Native peoples differ in their approach to contemporary Mohawk artworks?

3. How does this Mohawk case study of the role of art differ from what has typically been observed as the role of art in non-Western societies?

Acknowledgements

A word of thanks must go to Sue Ellen Herne for simply asking the title question and for her patience and commentary as I grappled with it. Another word of thanks must go to Katsitsionni Fox, Alex Jacobs, and Shelley Niro for their thoughts and to Martha Lafrance for her help with the Mohawk language.

References

Bürger, Peter. 1984. *Theory of the Avant-Garde*. Minneapolis: University of Minnesota Press.

Clifford, James. 1985. "Histories of the Tribal and the Modern." *Art in America* April:164–215.

Cook, Katsi. 1990. "Weaving a Life: An Interview with Mohawk Basketmaker Mary Adams." *Northeast Indian Quarterly* 7(4)(Special Issue: Unbroken Circles: Traditional Arts of Contemporary Woodland Peoples):47–53.

Coote, Jeremy. 1992. "'Marvels of Everyday Vision': The Anthropology of Aesthetics and the Cattle-Keeping Nilotes," in *Anthropology, Art, and Aesthetics*, ed. Jeremy Coote and Anthony Shelton, pp. 245–273. Oxford: Clarendon Press.

Danto, Arthur. 1988. "Artifact and Art," in *ART/artifact: African Art in Anthropology Collections*, ed. Arthur Danto, R. M. Gramly, Mary Low Hultgren, Enid Schildkrout, and Jeanne Zeidler, pp. 18–32. New York: Center for African Art and Prestel-Verlag.

Doxtater, Deborah. 1995. "Basket, Bead and Quill, and the Making of 'Traditional' Art," in *Basket, Bead and Quill*, pp. 11–21. Thunder Bay, Ontario: Thunder Bay Art Gallery.

Fox, Katsitsionni. 2002a. "Curators," in *What Are We Leaving for the 7th Generation? Seven Haudenosaunee Voices*, ed. Katsitsionni Fox and Morgan Perkins, p. 4. Potsdam, NY: Roland Gibson Art Gallery, SUNY.

———. 2002b. "Artist Statement," in *What Are We Leaving for the 7th Generation? Seven Haudenosaunee Voices*, ed. Katsitsionni Fox and Morgan Perkins, pp. 10–11. Potsdam, NY: Roland Gibson Art Gallery, SUNY.

———. 2003. "We Are Connected to the Land," in *Lifeworlds—Artscapes: Contemporary Iroquois Art*, ed. Sylvia S. Kasprycki and Doris I. Stambrau, pp. 34–37. Frankfurt, Germany: Frankfurt am Main.

Gell, Alfred. 1996. "Vogel's Net: Traps as Artworks and Artworks as Traps." *Journal of Material Culture* 1(1):15–38.

Graburn, Nelson H. H., ed. 1976. *Ethnic and Tourist Arts: Cultural Expressions from the Fourth World*. Berkeley: University of California Press.

Herne, Sue Ellen. 2002. "Mohawk Samsonite. Artist Statement," in *What Are We Leaving for the 7th Generation? Seven Haudenosaunee Voices*, ed. Katsitsionni Fox and Morgan Perkins, pp. 12–13. Potsdam, NY: Roland Gibson Art Gallery, SUNY.

Herzfeld, Michael. 2004. *The Body Impolitic: Artisans and Artifice in the Global Hierarchy of Value*. Chicago: University of Chicago Press.

Hill, Greg. 1998. *"Po-cohaunt(s)us,"* in *IrokosenART/IroquoisART. Visual Expressions of Contemporary Native Artists,* ed. Sylvia S. Kasprycki, Doris I. Stambrau, and Alexandra V. Roth, pp. 109–110. ERNAS Monographs 1. Altenstadt, Germany: European Revies of Native American Studies.

Hill, Richard W. 1992. "Oral Memory of the Haudenosaunee: Views of the Two Row Wampum," in *Indian Roots of American Democracy*, ed. José Barreiro. Ithaca, NY: Akwe:kon Press.

————. 2002. "Blood Work: Debating Authenticity of Indian Art." *Native Americas* 19(1/2):56–61.

Ingold, Tim. 1996. "1993 Debate: Aesthetics is a Cross-Cultural Category," in *Key Debates in Anthropology*, ed. Tim Ingold, pp. 250–293. London: Routledge.

Jacobs, Alex. 2003. "Exhibition Statement," in *4 Views*, ed. Joseph Sanchez, p. 5. Santa Fe: Institute of American Indian Arts Museum.

Johannsen, Christina and John Furguson, eds. 1983. *Iroquois Arts: A Directory of a People and Their Works*. Warnerville, NY: Association for the Advancement of Native North American Arts and Crafts.

Lauersons, Judith, et al. [1983] 1996. *Teionwahontasen (Sweetgrass is Around Us): Basketmakers of Akwesasne*. Hogansburg, NY: Akwesasne Cultural Center.

Lave, Jean and Etienne Wenger. 1991. *Situated Learning: Legitimate Peripheral Participation*. Cambridge: Cambridge University Press.

McEvilley, Thomas. 1984. "Doctor, Lawyer, Indian Chief: 'Primitivism' in 20th Century Art at the Museum of Modern Art in 1984." *Artforum* 23(3):54–61.

McMaster, Gerald. 1999. "Towards an Aboriginal Art History," in *Native American Art in the Twentieth Century*, ed. W. Jackson Rushing, pp. 81–96. London: Routledge.

Miller, Daniel. 1995. "Introduction: Anthropology, Modernity and Consumption," in *Worlds Apart: Modernity Through the Prism of the Local*, ed. Daniel Miller, pp. 1–22. London: Routledge.

Morgan, Lewis Henry. [1851] 1962. *League of the Ho-dé-no-sau-nee or Iroquois*. Reprint. New York: Corinth Books.

Morphy, Howard. 1992. "From Dull to Brilliant: The Aesthetics of Spiritual Power Among the Yolngu," in *Anthropology, Art and Aesthetics,* ed. Jeremy Coote and Anthony Shelton, pp. 181–208. Oxford: Clarendon Press.

————. 1995. "Aboriginal Art in a Global Context," in *Worlds Apart: Modernity Through the Prism of the Local*, ed. Daniel Miller, pp. 211–239. London: Routledge.

Morphy, Howard and Morgan Perkins. 2005. "The Anthropology of Art: A Reflection on its History and Contemporary Practice," in *The Anthropology of Art: A Reader*, ed. Howard Morphy and Morgan Perkins. Oxford: Blackwell Publishers.

Perkins, Morgan. 2001. Re-viewing Traditions: An Anthropological Examination of Contemporary Chinese Art Worlds. PhD diss., University of Oxford.

————. 2002. "Viewing Seven Generations? Reflections on Contemporary Haudenosaunee Art," in *What Are We Leaving for the 7th Generation? Seven Haudenosaunee Voices*, ed. Katsitsionni Fox and Morgan Perkins, pp. 4–7. Potsdam, NY: Roland Gibson Art Gallery, SUNY.

————. 2004. "Continuity and Creativity in Iroquois Beadwork." *American Anthropologist* 106(3):595–599.

Phillips, Ruth. 1998. *Trading Identities: The Souvenir in Native North American Art from the Northeast, 1700–1900*. Seattle: University of Washington Press.

Price, Sally. 1989. *Primitive Art in Civilized Places*. Chicago: University of Chicago Press.

Rubin, William. 1984. "Modernist Primitivism: An Introduction," in *"Primitivism" in 20th Century Art: Affinity of the Tribal and the Modern*. 2 vols. New York: Museum of Modern Art.

Rushing, W. Jackson. 1995. *Native American Art and the New York Avant-Garde*. Austin: University of Texas Press.

Sanchez, Joseph. 2003. "Acknowledgements," in *4 Views*, ed. Joseph Sanchez, p. 6. Santa Fe: Institute of American Indian Arts Museum.

Schneider, Arnd. 1996. "Uneasy Relationships: Contemporary Artists and Anthropology." *Journal of Material Culture* 1(2):183–210.

Snow, Dean. 1994. *The Iroquois*. Oxford: Blackwell Publishers.

Steiner, Christopher B. 1994. *African Art in Transit*. Cambridge: Cambridge University Press.

Svašek, Maruška. 1997. "Identity and Style in Ghanaian Artistic Discourse," in *Contesting Art: Art, Politics and Identity in the Modern World*, ed. Jeremy MacClancy, pp. 27–61. Oxford: Berg.

Tehanetorens (Ray Fadden). 1999. *Wampum Belts of the Iroquois*. Summertown, TN: Book Publishing Company.

Thomas, Nicholas. 1997. "Collectivity and Nationality in the Anthropology of Art," in *Rethinking Visual Anthropology*, ed. Marcus Banks and Howard Morphy, pp. 256–275. New Haven: Yale University Press.

Tooker, Elizabeth. 1978. "The League of the Iroquois: Its History, Politics, and Ritual," in *Northeast*, ed. Bruce Trigger, pp. 418–441. *Handbook of North American Indians*, Vol. 15. Washington, DC: Smithsonian Institution Press.

Townsend-Gault, Charlotte. 1992. "Kinds of Knowing," in *Land Spirit Power: First Nations at the National Gallery of Canada*, ed. Robert Houle, Diana Nemiroff, and Charlotte Townsend-Gault, pp. 74–101. Ottawa: National Gallery of Canada.

Vogel, Susan. 1988. "Introduction," in *ART/artifact: African Art in Anthropology Collections*, ed. Arthur Danto, R. M. Gramly, Mary Lou Hultgren, Enid Schildkrout, Jeanne Zeidler, pp. 11–17. New York: Center for African Art and Prestel-Verlag.

———. 1991. "Always True to the Object in Our Fashion," in *Exhibiting Cultures: The Poetics and Politics of Museum Display*, ed. Ivan Karp and Steven D. Levine, pp. 191–204. Washington, DC: Smithsonian Institution Press.

Wade, E. L. and Strickland, R. 1981. *Magic Images: Contemporary Native American Art*. Norman: University of Oklahoma Press.

Commodities of Authenticity

When Native People Consume Their Own "Tourist Art"

Alexis Bunten

Introduction

*I*n 1999 and 2000, I worked at the Sealaska Heritage Institute (SHI), a regional, Native-owned and operated nonprofit organization in Southeast Alaska, whose mission is "to perpetuate the Tlingit, Haida, and Tsimshian cultures." I was part of a team that designed a Pendleton Mills blanket named *Yaakoosqé X'óow*, or Blanket of Knowledge. This blanket was produced for a fundraising effort to support Southeast Alaska Native culture and heritage language programming. Inspired by Northwest Coast Chilkat blankets, Yaakoosqé X'óow was intended, in part, for sale within the tourist and collector markets. Since the blanket was first offered for sale in the spring of 2000, I have observed it worn as traditional regalia at Native events, as a decoration in the homes of Native Alaskans, and as a gift exchanged between members of the Native Alaskan community. Contrary to the expectations of anthropologists and art historians who study traditional Northwest Coast art, these commercial blankets have become quite meaningful to Native Alaskans. This article explores the history of Yaakoosqé X'óow and how Native people have adopted and made use of this and other commercial and "tourist art" objects for indigenous purposes.

When I explored this phenomenon as a graduate student, I found that in fact, Southeast Alaska Natives actively consume Northwest Coast art, much of which would be considered "tourist art" (see, e.g., Graburn 1976). Although individuals purchase art objects for their own personal use, Southeast Alaska Natives often con-

sume art objects with the intention of giving them away to others within specific contexts. Through this process, commercial arts are placed into the Native social and cultural milieu in ways that resonate with traditional (and neotraditional) worldviews. Moreover, local Native consumption and circulation of commercial art is motivated by both Western and non-Western concepts about the meanings and functions of art. In this Southeast Alaskan community, commercial arts produced for non-Native consumption have entered into the process of becoming transformed and incorporated into local, Native systems of meaning and aesthetics.

Looking at non-Western commercial art from this framework raises several questions. For what purposes do Northwest Coast Native people consume their own commercial arts? How do local, Native people select this type of art for purchase? How does commercial art

Figure 1. The front page of Sealaska Heritage Institute's (formerly Foundation) information and sales brochure for Yaakoosqé X'óow.

circulate within the local, Native community? How does local consumption of commercial art affect the production of such objects? Can commercial art assume a "traditional" role despite the fact that it was produced for outside consumption?

Studying the Contemporary Art Scene in Southeast Alaska

My interest in indigenous consumption of their own commercial arts began when I researched contemporary Native Northwest Coast art in 1998 for a senior honor's thesis at Dartmouth College (Bunten 1999). This interest intensified when I assisted with the design of Yaakoosqé X'óow. Making Yaakoosqé X'óow and experiencing its local reception became an inspiration for my master's thesis at UCLA (Bunten 2002), upon which this article is partly based.

During the summer of 2001, I observed both everyday and special events where Native art is displayed, both publicly and privately. I met with Tlingit elders, museum curators, scholars, those involved with Native arts education, gallery owners, and non-Native consumers. In order to make distinctions between categories of art objects and their local circulation patterns, I contrasted the public and private spaces where Northwest Coast art is placed. Then I documented these spaces with photographs, visiting Native homes, artist's studios, and private office spaces. I also viewed Northwest Coast art in public spaces, which included local schools, office buildings, Native cultural centers, city and state buildings, public trails, parks, and stores such as K-Mart. Through these activities, I discovered which types of art objects were being consumed by whom, where differing objects were displayed, as well as how they were appreciated and used within the Native Alaskan community.

This article examines the ways in which Southeast Alaska Native people consume their own commercial arts in a multicultural setting. Instead of placing great importance on the non-Native middlemen and consumers, such as buyers, museum curators, or tourists, this article focuses on the Native agents themselves. I argue that commercial Native art objects, often deemed as "inauthentic" or regarded by collectors, curators, and academics simply as a by-product of cultural commodification, can become a tangible part of the contemporary Native cultural experience. When such objects are used as indigenous objects they take on a new meaning and become "authentic" in ways anthropologists and art historians have not always recognized.

I set the stage for this article with a general overview of the importance and meaning of art in traditional Northwest Coast cultures. Next, I discuss the ways that scholars have regarded Native art produced for outside consumption. I suggest looking at local reappropriation of commercial art as a way of understanding the social and emotional impacts of art objects, particularly those typically ignored

because of their categorization as "tourist art." Finally, I present examples of the ways that Southeast Alaska Natives reappropriate commercial Northwest Coast art, returning to a discussion of Yaakoosqé X'óow's local usage. Throughout, I emphasize the multiple perspectives that Native people apply to their consumption of art objects.

Art and the Tlingit, Haida, and Tsimshian Peoples of the Northwest Coast

Now, as in the past, Northwest Coast art permeates the lives of the Tlingit, Haida, and Tsimshian peoples, who live in Southeast Alaska. The Native peoples of the Northwest Coast have long been identified as having rich art traditions. The people themselves see art as playing a vital role within their cultures. Prominent Haida artist Robert Davidson explained that "art was one with the culture. Art was our only written language" (Holm 1990:604).

Before art became a commercial product for the region, Northwest Coast Native peoples made art in diverse media for various purposes. Art decorated everyday items such as baskets and fishing implements. Northwest Coast designs decorated special objects such as masks and woven blankets used in ceremonies, as well as objects made by shamans. Particular totemic designs, called crests, are associated with specific matrilineal clans and adorn clan-owned totem poles, blankets, carved copper sheets, and the walls of houses (among many other items). A crest is a heraldic figure, usually an animal that belongs to a particular clan. In Tlingit, Haida, and Tsimshian cultures, people are divided into two exogamous moieties, represented by the image of the eagle and raven or wolf and raven. Each moiety is subdivided into matrilineal clans, and each clan owns the rights to their own symbol (crest), which was obtained in the distant past and is passed down through continued usage.

When European tools and materials became available, Native peoples in Southeast Alaska, as elsewhere along the coast of British Columbia and Washington, incorporated these tools and materials into their art-making. These innovations gave rise to button blankets used in ceremony (see Jensen and Sargent 1986). During the nineteenth century, artists adapted their designs for new materials such as argillite for carved figures, as well as gold and silver for jewelry. There was also considerable elaboration during this time in the carving of totem poles (see Jonaitis 1999). Many of these innovations were conceived with an outside audience in mind and eventually become forms of tourist and collector's art.

The most distinctive features of Tlingit, Haida, and Tsimshian art is the formline described in detail by Bill Holm (1965, 1990). Since the mid-1960s, when the style underwent what has been called a "renaissance" (Halpin 1981; Hawker

2003), the characteristic formline design of Northwest Coast Native art has steadily gained in popularity both around the country and internationally. This renewal of interest in traditional art forms was closely tied to increasing Euro-American interest in Native Americans, an emerging worldwide "primitive" arts market, as well as the local and national civil rights movements that were occurring among Native Americans (Bernstein 1999). Over the last thirty years, the consumption of contemporary Northwest Coast artworks produced for the Western market has increased significantly among collectors, tourists, and Southeast Alaska Natives. (For further reading on contemporary Northwest Coast Native art, see Steltzer 1976;

Figure 2. Interior of a Southeast Alaskan studio in a gallery/souvenir shop. Photo by Alexis Bunten.

Stewart 1979; Drew and Wilson 1980; Macnair, Hoover, and Neary 1980; Hall, Blackman, and Rickard 1981; Nuytten 1982; Duffek 1983, 1986; Blackman 1985; Jensen and Sargent 1986; Shadbolt 1986; Bringhurst and Steltzer 1991; Hoover 1993; Thom 1993; Davidson and Steltzer 1994; Wyatt 1994; Brown 1997, 1998; Herem 1998; Wright 2001.)

Like traditional art, nearly all Northwest Coast art made for outside consumption is decorated with a crest design. According to traditional protocol, a particular crest design, such as the killer whale, should only be worn or used by the members of the clan that own the rights to it. Individuals outside the clan can produce objects designed with a specific crest, but only for members of the clan that own the design. For example, a wealthy clan leader may commission an artist of a different clan, or even another tribe, to create art objects designed with his clan crest. Trou-

ble would ensue if a clan violated native copyright and appropriated another's design without explicit permission (see Lewis-Harris, article 10). As in the past, many contemporary Northwest Coast artists today employ a number of different crest designs into their work. But because they are selling objects with crest designs to non-Natives outside the traditional system, their use of multiple crests is quite different from the past. A few contemporary Northwest Coast artists ask their non-Native clients what animals they feel close to and incorporate those animals rendered in formline design onto a piece. Some of these artists obtain the rights to use these crests in a nontraditional manner from the clan caretakers, but sometimes they do not. Non-Native consumers are usually exempt from any criticism concerning the usage of crest designs on contemporary art because they typically live and work outside of the clan system. (For more discussion concerning intellectual property and Northwest Coast art production in Alaska, see Hollowell 2004.)

Today, a visitor to Southeast Alaska can find Northwest Coast art for sale in a number of venues, from the airport to the fine art gallery. Objects made for outside consumption vary from miniature plastic totem poles mass-produced by a non-

Figure 3. Tlingit artist Anna Ehlers demonstrates weaving a Chilkat blanket. Although Mrs. Ehlers takes commissions for Chilkat weavings—one of the finest forms of Tlingit art—this particular blanket was made for a specific individual within the Native community. Photo by Alexis Bunten.

Native manufacturer in Southeast Asia to expensive locally produced handmade objects. In addition, many Native artists produce art intended for use within the Native community, custom-made for local clientele. My discussion of the Native consumption of commercial arts includes what is typically termed "high" and "low" arts, both of which are consumed by the local Native community and circulate within it.

Rethinking the Dichotomy between "Tourist Art" and "Traditional Art"

In the twentieth century, scholars looking at non-Western art typically supported a notion that qualitatively separated art objects made for inside (Native) consumption from those made for outside (non-Native) consumption. Nelson Graburn (1976:6) defined tourist arts in his seminal publication, *Ethnic and Tourist Arts*. For him, tourist art arose

> when the profit motive or the economic competition of poverty overrides aesthetic standards, satisfying the consumer becomes more important than pleasing the artist. These are often called "tourist arts" or "airport" arts and may bear little relation to the traditional arts of the creator culture or to those of any other groups.

This distinction between tourist and traditional arts described by Graburn exhibits the assumption that tourist arts and traditional arts exist in separate paradigms of production and consumption. Scholars writing in the 1980s and 1990s (including Graburn [1999] himself) recognized that ethnic art objects that are intended for sale to outsiders do not always fit so neatly into the schema proposed in 1976. For the purposes of clarity, I refer to art objects made for local use outside of the art market as "traditional."

As commonsensical as Graburn's distinction may be, there are nevertheless other ways of thinking about objects and their usage. Nearly every society, including those in Western countries, has art production intended for sale, thus, artworks are simultaneously commodities as well as art (see, e.g., Plattner 1996). One need only think of the many art fairs that pop up during warm months in most U.S. metropolitan areas. From watercolorists to photographers, artists cover the walls of their tents with artwork that appears nearly identical to the others. Clearly these artists must bend to consumer demands. It is no different with Alaskan Native art objects that were made intentionally as commercial, non-Western art, and as a result these artworks regularly respond to non-Native consumer demands.

An alternative framing of these non-Western artworks is to consider them as neither purely Western nor purely Native in origin and inspiration. Terminology often used to describe contemporary ethnic arts (which attempts to encompass

both Western and non-Western influences), such as "hybrid" (Clifford 1988) "entanglement" (Thomas 1991), and "reintegrated art" (Anderson 1979), do not precisely fit the everyday patterns of production, consumption, and circulation of Native commercial arts that I have observed. These terms, in fact, can actually get in our way and hinder a deeper understanding of commercial art that takes into account the intersections between Native and non-Native ideologies and social practices surrounding art consumption.

Instead of approaching non-Western art objects from perspectives (and invariably some of these perspectives are Native views) that are applied to the object by those who purchase, display, store, and use them, scholars have tended to create categories that resonate with Western understandings of the function of art. As a result, these categorizations may tell us more about the political and sociocultural orientation of the scholars than they tell us about the art form's Native producers and consumers. I am not the first to express such concerns, as Sally Price (1989), Shelly Errington (1998), James Clifford (1988), Molly Lee (1999), George Marcus and Fred Myers (1995), and Ruth Phillips (1998) have offered similar arguments. But the end result of this conventional analysis is little understanding of the ways that Native actors interact with their own arts according to multiple understandings (Western, non-Western, and individualistic) of the meaning and power of art.

Let us be clear from the outset that the Native peoples of Southeast Alaska have been in touch with the outside world for more than two centuries. They are actively involved in the ordinary commerce of American life. They understand mainstream American ideas and values. But at the same time they possess their own cultural ideas as Native peoples that they have maintained alongside more mainstream concerns and values (see Phillips 1998). By categorizing the processes of non-Western art's production and consumption, some of the nuances of Native engagement with their own living art forms can be overlooked.

Rather than focusing on the categorizing processes of production and consumption, I suggest an analysis of Northwest Coast art objects following Igor Kopytoff's (1986) biographical approach, in which different meanings may be applied to the objects by their makers and consumers within different contexts. For example, an art object may be considered a commodity, a museum object, a decoration, an index of identity, or a symbol of a culturally defined relationship depending on how the object is procured, displayed, stored, and used over time. The same artwork may serve all of these ends during its lifetime, and it may serve many of these functions simultaneously. Furthermore, the meaning or aesthetic form of an object may be challenged by some members of a Native community (see Kahn 1999; Lewis-Harris, article 10).

Multiple, local viewpoints tend to be isolated from the study of non-Western art. When they are incorporated into analyses of non-Western art, local opinions are often used to valorize cultural activity in its own terms. All too often the "Native viewpoint" identified by anthropologists represents an indigenous culture untouched by the global economy and its hegemonic influence. Native understandings of art

stem from everyday practice and reflect the dynamic interactions that take place in the contemporary context, which take into account factors such as age, gender, and status. This case study attempts to integrate the "Native viewpoint," which is always multiplex, into the larger framework of cross-cultural encounters that take place during the processes of consumption and circulation of Native commercial art objects.

Native Consumption of Their Own Commercial Arts

Nora Marks Dauenhauer (2000:101), a well-respected Tlingit poet and scholar, expressed the frustration I share concerning the academic and popular portrayal of Northwest Coast art.

> Northwest Coast art has usually been described from a formalist, non-Native point of view in written works. From the [sic] Native viewpoint, these descriptions are nearly always incomplete, for the Native viewpoint tends towards the functional, or contextual. The Native worldview would ask beyond just issues of form—how an art object functions within a generation of Native people and across the generations. For a traditional Tlingit person, art ties many components of life together. History (the stories of covenants among people, animals, spirits, and the land), song and dance, visual art, ritual use of an art object are inseparable. Museum displays and books often do injustice to this traditional sense of totality and, therefore, can be disconcerting to Native people.

For Southeast Alaska Native peoples, like many indigenous peoples, the meaning of art extends beyond its formal qualities. The art form takes on different roles, each of which has a different impact on everyday life.

Southeast Alaska Native peoples purchase, circulate, and display Northwest Coast commercial art for several reasons, the most important being: (a) as an index to identity vis-à-vis other Native people as well as non-Natives, (b) for use in Native events and ceremonies, and (c) for decorative display in both public and private settings, such as the office and home. These three categories do not cover all the uses of commercial art that have become reincorporated into the local Native community, nor are they exclusive of one another. In all three of these functions, local use of commercial Northwest Coast art reinforces social relationships. Art, thus, indexes membership within a cultural group. Part of this indexical function is simultaneously achieved by the circulation of objects through gift exchange, and by the use of traditional objects in ceremonial contexts that uphold the traditional clan-based social system. By displaying and circulating commercial art objects, these objects can become part of the local sociocultural system bounded by Native ideas concerning the function of their own art.

When a Northwest Coast object is made for sale, it starts off its social life as a commodity, whose main purpose is to bring in money for its maker. But even here, because it is made by a Native artist it will take on the indexical function of identi-

fying him or her as a member of the Tlingit, Haida, and/or Tsimshian tribe. When sold, the very act of removing a commercial art object from an artist's workshop, gallery, or gift shop immediately transforms the object from its primary role in commercial exchange to one that has a cultural meaning for its consumers. The display of art objects may point to the Native art owner's many different social positions, his or her ability to travel within and outside of Alaska, and so on. Art objects may also reflect the personal attributes, such as pride in his or her heritage, and accomplishments of their owners or be an expression of the social ties within the Native community and beyond.

Through the process of removal and then reintegration into the local Native community, even "tourist art," which is often considered outside traditional Native networks by scholars, becomes linked to traditional understandings of the function of art in both everyday and ceremonial life.

Perhaps the most pervasive use of commercial art by Northwest Coast Native people is to display clan identity in all settings, from everyday life to the most traditional events. At the *koo eex*, or the Tlingit memorial potlatch, commercial art objects can be used alongside "traditional" art objects. Occasionally, a commercial art object can become *at.óow* (clan-owned), with its own name, history, and ceremonial function, to be displayed at official clan events. Tlingit elder Paul Jackson described the concept of at.óow to me:

> At.óow is something that the clan has. Something in their history has happened so they would put it on something; a totem pole, a carving, or a robe, a Chilkat robe, and this becomes part of the history of the people and they would take care of it from generation to generation and it becomes at.óow. And there are many things that we call at.óow.

Objects that are transformed into at.óow are not displayed in the same way as commercial objects. They are stored and brought out only for ceremonial use. Crest designs themselves are considered at.óow and emerge as a key index of identity.

In addition to becoming at.óow, commercial art objects may be used as a part of the potlatch ceremony in a different manner (for further reading on the Tlingit potlatch, see Kan 1989, 1990). Commercial art objects, such as miniature, decorated paddles, are occasionally mass-produced to be given away to guests at a potlatch along with other gifts such as money, blankets, and food. Gift giving is an integral aspect of the potlatch and serves to maintain reciprocity between clans of opposite moieties. Among Tlingit people, the host clan gives gift items to their guests, who are members of the opposite moiety. These gifts, and generally speaking the potlatch itself, are meant to repay guests for services rendered surrounding the death of a member of the host clan approximately a year before the potlatch ceremony. For this reason, the koo eex is sometimes referred to as a "payoff party."

Unlike objects of at.óow, art objects that are given away at a potlatch are not clan owned; they now belong to the individual recipient. Whether commercial art

objects are incorporated into clan property or given away, they nevertheless can play a key role in the contemporary potlatch, an event that upholds traditional values and beliefs, binding clans together in obligatory social networks of exchange. Giving or receiving gifts according to one's position as host or guest affirms one's identity based on membership within a Tlingit clan system. Similarly, displays of at.óow (such as a clan hat carved in the shape of a crest animal) at potlatches also affirms membership and a specific social role within a particular clan.

Outside of the ceremonial context, Native people from Southeast Alaska also strategically display art objects to index their own multiple social identities. Today, a Tlingit person's life experience may weave in and out of a number of different social spaces, some of which are culturally "Native," while others may be considered "non-Native" or a combination of the two. Northwest Coast art is pervasive throughout these multiple social locations, it can be displayed on the body, in the home, at the office, on the car, and so on. Again, commercial art is often juxtaposed to noncommercial art, particularly in private settings such as in the home or office.

In addition to heralding one's clan affiliation, Northwest Coast art objects may reference occasions where these objects have been given as a gift to express appreciation. There is no cultural protocol that mandates that gifts of art must be "traditional." Moreover, commissioning traditional art from an artist is generally out of the price range of the average person unless it is discounted. "High" art and jewelry sold in galleries typically costs hundreds of dollars. Thus, commercial

Figure 4. Interior of Native home in Southeast Alaska decorated with objects of Northwest Coast art. Photo by Alexis Bunten.

objects, or small tokens, may satisfy this role as a gift. And although it occasionally occurs, most Native consumers of Northwest Coast art will not purchase art made by non-Natives.

Gift giving creates new relationships as well as confirms existing ones. Any art object given as a gift can point to the recipient's accomplishments as, for example, a political activist, a leader in the Native community, a business person, or the completion of college, to name but a few. Although my focus has been on the Native use and ownership of commercial art objects, it is important to note that non-Natives who are tied to Native families, organizations, heritage sites, workplaces, and the like also receive gifts of Native art from Native people. Personal relationships, whether clan based, nuclear family based, or of some other sort, are nurtured and built through gift giving. Gifts also assist business transactions or relationships, such as when Native art objects are given away for service in the workplace or to clientele. In different gift-giving settings, Native ideologies about the appropriate use of commercial (or noncommercial) Native art are negotiated according to context. Through gift giving, Northwest Coast art reflects the multiple contemporary social roles and relationships that we should expect to occur in any multicultural setting.

It is important to note that while commercial art has been integrated into the local Native community, noncommercial items continue to be produced for Native use as well. Someone may compensate an artist for these objects with cash, through barter, or the artist may simply gift them, his or her reward being increased prestige within the Native social system. In addition to objects made expressly for use within Native communities, older art objects, particularly objects of at.óow, are passed down through clans and families. Some objects of at.óow are cared for by the clan caretaker, still others are held in local museum collections and brought out for events. At.óow, as I suggested above, are not intended for everyday display. Because many Northwest Coast items have been sold or stolen over the years, ending up in the hands of museums and wealthy collectors of Northwest Coast art, there is a limited number of traditional art objects in local circulation (see Cole 1985). Those that remain in Native hands are cherished as heirlooms.

Traditional art and regalia are highly valued by the Native people who are involved with cultural activities and events. But not everyone is in a position to obtain these objects through inheritance, gift giving, or purchase (and, of course, some of these objects cannot be purchased). A friend of mine once exclaimed, "*Ishaan!* (poor, unfortunate) I have no artwork in my house! When my husband and I start making more money, I am going to buy some Tlingit artwork to put on the walls. . . . All I have is this print that my husband gave me, and these bracelets that [her brother-in-law's employer, a local artist] gave us. Some day I want my walls to be covered in art." Nevertheless, lack of access to traditional or "high" art objects through social ties or for socioeconomic reasons does not prevent Native people from engaging with art objects in their everyday lives. Rather, the meaning

of the art object—often regardless of workmanship and quality—holds personal significance for its owners.

Although many Native art collections include gift items, this does not imply that Native owners are passive concerning their personal collection and display of Northwest Coast art. For example, when asked why her office was decorated with so much Native artwork, particularly depictions of eagles placed in the center of the main wall, one Tlingit woman replied, "Eagles are my crest. Eagles give me spiritual strength to get through each day." This woman, who was the director of a large company, explained that she purchased the prints because they had a significant meaning for her as a Tlingit woman trying to attain spiritual balance while succeeding within the Western workplace. These prints were juxtaposed to aesthetically finer objects of Northwest Coast art, as well as other art objects received as gifts from many tribal origins. For this woman, prints of eagles were removed from a commercial context and were placed into the central visual space of her office. They became an index of her identity, and at a very personal level they were the most significant pieces in her office collection. In this case, a powerful Native business leader had reappropriated commercial art and attributed important cultural meanings to her prints of eagles. For this Native business leader, prints of eagles do not manifest a commodified view of Native culture, as they were likely intended to do. Instead, they symbolized her identity through her moiety, the eagle.

Figure 5. Picture of an eagle on the wall of a Tlingit businesswoman's office representing her main moiety. Above the eagle print is a Tlingit paddle, and next to it is a photograph of a dancer wearing a Chilkat robe. Photo by Alexis Bunten.

It is not surprising that this woman chose the art objects that depict her moiety as most significant to her. An art object's crest design often overrides other aesthetic considerations. Native Alaskan entrepreneurs are aware of this trend, and in some cases have attempted to create objects for a crossover market that incorporates potential Native and non-Native buyers.

Yaak̲oosqé X'óow is an example of this type of art object. We designed it in a manner that lends itself to wearing, in addition to the more typical display of Pendleton blankets on walls, beds, and couches. The design includes a large raven on the main body of the blanket balanced by an eagle on the Pendleton patch. The use of the emblems of both moieties, rather than a specific clan design, allows the blanket to be given to and used by all members of the Tlingit social system, as no one clan "owns" the generic eagle or raven design. The design does not restrict usage by any moiety or clan because it balances both moieties through the "lovebird" design of eagle and raven together, and all clans belong under one of the two moieties.

This particular design is called the "lovebird" because the eagle and raven moieties are exogamous according to traditional Tlingit protocol. Therefore, eagles and ravens "love" one another. While the lovebird motif is a common design on contemporary commercial art objects, it is not a traditional design. When this motif was originally conceived in the nineteenth century, it was strikingly innovative. According to

Figure 6. Print ad for Yaak̲oosqé X'óow created by the author. The figure at the top left of the ad is the eagle design depicted on the blanket patch to balance the raven motif used in the main blanket design. Compare this image with the two different traditional Chilkat blankets worn by the men with Yaak̲oosqé X'óow.

traditional ideas about art, no two moieties or clans were ever depicted on the same object since an art object's main function was to represent a specific clan and moiety.

The team that created Yaakoosqé X'óow worked hard to create a blanket that respected the protocols of design ownership and appealed to a crossover audience. The design team consisted of approximately four main individuals. I researched Chilkat blanket designs and selected clan-neutral elements to be incorporated into or inspire the raven design. This was a special task because I had to select design elements of a raven that did not infringe on existing or past designs (which are the intellectual property of specific clans) on Chilkat blankets. Copying the design of an existing blanket would have required clan permission, and likely restricted the usage of the blanket by members of other clans for those who followed traditional protocol. In addition to myself, a Tlingit elder, who was SHI's Tlingit language expert, consulted on the cultural appropriateness of the design we chose, shaped the final raven motif, drew the eagle for the blanket patch, and helped to devise the blanket's name. A Tlingit graphics designer rendered the blanket design into a computer template. SHI's non-Native publication's department manager was the liaison with Pendleton Mills. Other members of SHI's staff also assisted with various aspects of consultation, design, and marketing. The president of SHI, Rosita Worl, conceived the blanket project and oversaw all aspects of production.

When the blanket was first manufactured, I was asked to "introduce" the blanket by "dancing it" with a Tlingit and Haida dance group at a popular basketball tournament attended by Native people from throughout the region. The blanket was presented to the audience with a speech announcing its upcoming sale. The act of dancing with Yaakoosqé X'óow at a neotraditional Native event literally demonstrated its viability as an object appropriate for local Native consumption.

SHI's design and marketing strategies were successful. Rosita Worl described the acceptance of the blanket by the local Native community:

> The idea of the blanket was to serve multiple purposes. We were looking for a vehicle to raise money, and accomplish both goals—to be used within the Native community and sold to visitors to the region as authentic Native art. Our culture is like a blanket. It [Yaakoosqé X'óow] was designed as if one could wear it. We saw people already wearing it at the last Celebration. It was [also] used in an adoption [ceremony]. We purposefully kept the price really low and only sold it for a nominal [profit] and now people are asking to purchase it for potlatches so we have reduced the cost for people who want them for ceremonies. . . . We get a lot of sales at graduation too for gifts.

Since 2000, Yaakoosqé X'óow has become a part of the contemporary Southeast Alaska Native experience. It has been consumed and circulated throughout multiple venues, and for multiple purposes. I have seen it displayed in peoples' homes and offices, worn or given away at nonceremonial Native events, and it has been incorporated into the potlatch. This blanket's meaning and function alternates according to the context in which it is incorporated.

Final Thoughts

Today, Northwest Coast art is integrated into the global economy while it continues to serve vital roles in the lives of Northwest Coast Native peoples. Although many scholars and art enthusiasts have written on the subject of Northwest Coast art, it is often in terms of what Clifford (1988:222) refers to as the "modern art-culture system," where non-Western objects are classified as "scientific" or "aesthetic" and given a relative value according to the contexts of Western display, reception, and circulation. As a result of this kind of analysis, little attention has been paid to the ways that contemporary Northwest Coast art is consumed and circulated within the Native communities that produce it. Further complicating the matter, more and more Native artists are producing artwork for overlapping markets. The production of non-Western commercial art for cross-cultural consumption overrides simple distinctions between items made for consumption within the Native community and those made for a non-Native market (cf. Phillips 1998; Bunten 2002).

From an outside perspective, Native displays of their own commercial art may not appear any different from those of a non-Native collector. For example, Euro-Americans and Native collectors both typically show their artwork in the home. However, the meaning of these objects for their owners can be quite different. I argue that the circulation and consumption of art objects among Southeast Alaska Natives often intentionally differs from the circulation and consumption of Southeast Alaska Native arts among non-Native consumers (Bunten 2002). The most common example of a different manner in which a Native person may consume their own commercial art pertains to clan-based identity. Southeast Alaska Native individuals often select, purchase, and circulate a commercial art object whose crest design upholds the Native social system and cultural values. A more striking difference between Native and non-Native consumption of commercial objects is evident when these objects are incorporated into ceremonial life. In this case, these objects are handled and displayed according to cultural protocols. Other commercial art objects, such as Yaakoosqé X'óow, are consumed and circulated in multiple venues and for multiple purposes. What is interesting about this phenomenon is that a single object can be consumed and circulated in multiple contexts, serving various aesthetic and social roles throughout its existence.

The fact that mass-produced tourist art can easily be incorporated into the local, indigenous social fabric contradicts classic anthropological gift theory, which assumes that handmade items have more "value" than commercial objects (Mauss 1967; Cheal 1996). Deconstructing the "gift/commodity opposition," Fred Myers (2001:6) argues that, "Indeed, the contrast between value as produced in organizations of difference ('qualitative' value) and the value as a measure of relative price in transaction ('quantitative' value) may underlie significant dynamics within the structure of social action." In order to become socially meaningful to Native consumers,

commercial art objects undergo a process of symbolic transformation from a commodity of exchange (quantitative value) within the Western capitalist system to an owned object for exchange and/or display according to Native values and protocol (qualitative value within the system). Kopytoff (1986) refers to this process as "singularization": the objects are made singular, and, therewith, they are decommodified.

In order to understand the social force of commercial art objects within Native communities, it is necessary to analyze this art according to Native beliefs and the practices surrounding the objects. Furthermore, stating that there is a "Native" way to consume and circulate art objects does not discount the fact that Native consumers of tourist art follow Western patterns of consumption and gift giving as well as the more traditional Native patterns.

Many Southeast Alaska Native people are keenly aware that their interaction with Northwest Coast art pieces is often informed by both Native and non-Native concepts tied to art. When I asked a Tlingit artist his opinion about how to define "traditional" Tlingit art, he responded:

> Well that question can be answered on so many different levels. Whether something is traditional from an aesthetic point of view, or a cultural point of view, that is, how it's being used by the people who own it. And it all depends. Usually in the Tlingit sense, it was all determined by the term at.óow. I read it in Dauenhauer's book. Page 22. [Laughter]

Although this artist was only 22-years-old at the time the interview was conducted, he displayed a sophisticated consciousness of the meanings of Northwest Coast art culled from various local and global, as well as Native and non-Native, sources. As a young artist just beginning his career, this individual already recognized the primary factors that move consumers of Northwest Coast art to engage with the art form. Native observations that reveal local understandings, such as this artist's, are sorely missing from academic analyses of contemporary indigenous art. By looking at the ways in which Native Alaskans reappropriate commercial art objects, it is possible to see how they actively produce, reaffirm, and even resist their ethnic identity and social positions in contemporary cross-cultural settings.

Questions for Discussion

1. Why would realistic images of eagles have important meanings for some Native people in Southeast Alaska? For what groups would these artworks not be significant?

2. What is the role of the contemporary Native artist in Southeast Alaska?

3. When anthropologists live in a Native community they typically refer to it as "participant observation." Would an anthropologist move outside the boundaries of participant observation if he or she were to contribute to a local project such as Yaakoosqé X'óow? Should Bunten's involvement be

considered differently if she happened to be working in the community as an anthropologist?

References

Anderson, Richard. 1979. *Art in Small Scale Societies.* Englewood Cliffs, NJ: Prentice Hall.

———. 2000. *American Muse: Anthropological Excursions into Art and Aesthetics.* Upper Saddle River, NJ: Prentice Hall.

Bernstein, Bruce. 1999. "Contexts for the Growth and Development of the Indian Art World in the 1960's and 70's," in *Native American Art in the 20th Century,* ed. Jackson Rushing, pp. 39–56. London: Routledge.

Blackman, Margaret. 1985. "Contemporary Northwest Coast Art for Ceremonial Use." *American Indian Art Magazine* 10(3):24–37.

Bringhurst, Robert and Ulli Steltzer. 1991. *The Black Canoe: Bill Reid and the Spirit of Haida Gwaii.* Vancouver: Douglas and McIntyre.

Brown, Steve. 1997. "Formlines Changing Form: Northwest Coast Art as an Evolving Tradition." *American Indian Art Magazine* 22(2):62–73, 81–83.

———. 1998. *Native Visions: Evolution in Northwest Coast Art from the Eighteenth Through the Twentieth Century.* Seattle: University of Washington Press.

Bunten, Alexis. 1999. Contemporary Northwest Coast Art in Southeast Alaska. Thesis, Dartmouth College.

———. 2002. Commodities of Authenticity: Reappropriation of Commercial Northwest Coast Art in Southeast Alaska. Master's Thesis, University of California Los Angeles.

Cheal, David. 1996. "'Showing Them You Love Them': Gift Giving and the Dialectic of Intimacy," in *The Gift: An Interdisciplinary Perspective,* ed. Aafke Kompter, pp. 95–106. Amsterdam: Amsterdam University Press.

Clifford, James, ed. 1988. *The Predicament of Culture: Twentieth Century Ethnography, Literature, and Art.* Cambridge: Harvard University Press.

———. 2004. "Looking Several Ways: Anthropology and Native Heritage in Alaska." *Current Anthropology* 45(1):5–30.

Cole, Douglas. 1985. *Captured Heritage, The Scramble for Northwest Coast Artifacts.* Norman: University of Oklahoma Press.

Dauenhauer, Nora. 2000. "Tlingit *At.óow,*" in *Celebration 2000: Restoring Balance Through Culture,* ed. Susan Fair and Rosita Worl, pp. 101–106. Juneau: Sealaska Heritage Foundation.

Davidson, Robert and Ulli Steltzer. 1994. *Eagle Transforming: The Art of Robert Davidson.* Vancouver: Douglas and McIntyre.

Drew, Leslie and Douglas Wilson. 1980. *Argillite: Art of the Haida.* North Vancouver: Hancock House Publishers.

Duffek, Karen. 1983. *A Guide to Buying Contemporary Northwest Coast Indian Arts.* Vancouver: University of British Columbia Museum of Anthropology.

———. 1986. *Bill Reid: Beyond the Essential Form.* Vancouver: University of British Columbia Press.

Errington, Shelly. 1998. *The Death of Authentic Primitive Art and Other Tales of Progress.* Berkeley: University of California Press.

Graburn, Nelson H. H., ed. 1976. *Ethnic and Tourist Arts: Cultural Expressions from the Fourth World.* Berkeley: University of California Press.

————. 1999. "Ethnic and Tourist Arts Revisited," in *Unpacking Culture: Art and Commodity in Colonial and Postcolonial Worlds,* ed. Ruth B. Phillips and Christopher B. Steiner, pp. 335–353. Berkeley: University of California Press.

Hall, Edwin S., M. B. Blackman, and V. Rickard. 1981. *Northwest Coast Indian Graphics.* Vancouver: Douglas and McIntyre.

Halpin, Marjorie M. 1981. *Totem Poles: An Illustrated Guide.* Vancouver: University of British Columbia Press.

Hawker, Ronald W. 2003. *Tales of Ghosts: First Nations Art in British Columbia, 1922–61.* Vancouver: University of British Columbia Press.

Herem, Barry. 1998. "Bill Reid: Making the Northwest Coast Famous." *American Indian Art Magazine* 24(1):42–51.

Hollowell, Julie. 2004. "Intellectual Property Protection and the Market for Alaska Native Arts and Crafts," in *Indigenous Intellectual Property Rights: Legal Obstacles and Innovative Solutions,* ed. Mary Riley, pp. 65–98. Walnut Creek: Alta Mira Press.

Holm, Bill. 1965. *Northwest Coast Indian Art: An Analysis of Form.* Seattle: University of Washington Press.

————. 1990. "Art," in *Handbook of North American Indians,* ed. Wayne Suttles, pp. 602–632. Washington, DC: U.S. Government Printing Office.

Hoover, Alan L. 1993. "Bill Reid and Robert Davidson: Innovations in Contemporary Haida Art." *American Indian Art Magazine* 18(4):48–55.

Jensen, Doreen and Polly Sargent. 1986. *Robes of Power: Totem Poles on Cloth.* Vancouver: University of British Columbia Press.

Jonaitis, Aldona. 1999. "Northwest Coast Totem Poles," in *Unpacking Culture: Art and Commodity in Colonial and Postcolonial Worlds,* ed. Ruth B. Phillips and Christopher B. Steiner, pp. 104–121. Berkeley: University of California Press.

Kahn, Miriam. 1999. "Not Really Pacific Voices. Politics of Representation in Collaborative Museum Exhibits." *Museum Anthropology* 24:57–74.

Kan, Sergei. 1989. *Symbolic Immortality: The Tlingit Potlatch of the Nineteenth Century.* Washington, DC: Smithsonian Institution Press.

————. 1990. "Cohorts, Generation, and Their Culture: Tlingit Potlatch in the 1980s." *Anthropos* 84:405–422.

Kopytoff, Igor. 1986. "The Cultural Biography of Things: Commoditization as Process," in *The Social Life of Things: Commodities in Cultural Perspective,* ed. Arjun Appadurai, pp. 64–91. Cambridge: Cambridge University Press.

Lee, Molly. 1999. "Tourism and Taste Cultures: Collecting Native Art in Alaska at the Turn of the Century," in *Unpacking Culture: Art and Commodity in Colonial and Postcolonial Worlds,* ed. Ruth B. Phillips and Christopher B. Steiner, pp. 267–281. Berkeley: University of California Press.

Macnair, Peter L., Alan Hoover, and Kevin Neary. 1980. *The Legacy: Tradition and Innovation in Northwest Coast Indian Art.* Victoria: British Columbia Provincial Museum.

Marcus, George E. and Fred R. Myers. 1995. "The Traffic in Culture: An Introduction," in *The Traffic in Culture: Refiguring Art and Anthropology,* ed. George E. Marcus and Fred R. Myers, pp. 1–51. Berkeley: University of California Press.

Mauss, Marcel. 1967. *The Gift: Forms and Functions of Exchange in Archaic Societies.* Trans. Ian Cunnison. New York: W.W. Norton.

Myers, Fred. 2001. "Introduction: The Empire of Things," in *The Empire of Things: Regimes of Value and Material Culture,* ed. Fred Myers, pp. 3–64. Santa Fe: School of American Research Press.

Nuytten, Phil. 1982. *The Totem Carvers: Charlie James, Ellen Neel, Mungo Martin.* Vancouver: Panorama Publications.

Phillips, Ruth B. 1998. *Trading Identities: The Souvenir in Native North American Art from the Northeast, 1700–1900.* Seattle: University of Washington Press.

Plattner, Stuart. 1996. *High Art Down Home: An Economic Ethnography of a Local Art Market.* Chicago: University of Chicago Press.

Price, Sally. 1989. *Primitive Art in Civilized Places.* London: University of Chicago Press.

Shadbolt, Doris. 1986. *Bill Reid.* Vancouver: Douglas and McIntyre.

Steltzer, Ulli. 1976. *Indian Artists at Work.* Vancouver: J. J. Douglas.

Stewart, Hilary. 1979. *Robert Davidson: Haida Printmaker.* Vancouver: Douglas and McIntyre.

Thom, Ian, ed. 1993. *Robert Davidson: Eagle of the Dawn.* Vancouver: Douglas and McIntyre.

Thomas, Nicholas. 1991. *Entangled Objects: Exchange, Material Culture and Colonialism in the Pacific.* Cambridge: Harvard University Press.

Wright, Robin K. 2001. *Northern Haida Master Carvers.* Seattle: University of Washington Press.

Wyatt, Gary. 1994. *Spirit Faces: Contemporary Masks of the Northwest Coast.* Vancouver: Douglas and McIntyre.

· · · · · · · · *Section Seven* · ·

Curatorial
Authority

*T*he question of who has the right and authority to represent indigenous expressive culture has been hotly debated during the last two decades. The issue of curatorial authority over native art—in terms of the international art world—will be discussed in this section. More than ever, curators are now aware that they are continually engaged in the politics of representation. Attempts have been made to rectify the situation so that native people, including artists, are not simply "spoken about," but rather that they have a chance to speak about their art or to speak in exhibition of their art. The (mis)representation of Asmat art is the subject of Nick Stanley's contribution. Carol Hermer discusses the unforeseen consequences that arise when curatorial authority is removed from an exhibition of African art in an American art museum. And Nancy Marie Mithlo, from the perspective of urban Native American professional artists, argues for an indigenous knowledge system approach to overcome problems of authorship and control over their art.

In article 15, Nick Stanley resists the idea of a degeneration of the art of the Asmat (West Papua, Indonesia) due to the forces of globalization. Ever since the death of Michael Rockefeller in Asmat in 1961, this art has drawn the attention of the international art world. Stanley makes clear that the local Asmat Museum of Culture and Progress has privileged the visual arts and accorded certain works a high status as museum pieces. What is more, the museum's representation of Asmat art has contributed to a distinction being made between the traditional and the modern, whereby older sculptures are associated with Asmat cosmology ("the ancestors"), while newer ones are linked to contemporary everyday life.

Stanley shows that not only are aesthetic judgments superimposed on Asmat art, but that the agency of Asmat carvers is overlooked as well. Current artists may produce quite a different art when compared with art from half a century ago. But in spite of their rapid change, mythic traditions continue to inspire carvers, who still create vibrant, distinctive works. According to Stanley, it is precisely because of adjustments to these new circumstances that Asmat art has maintained its vitality. He examines the aesthetic judgments made of Asmat art by foreigners and inter-mediaries, who predominantly favor the old as authentic (e.g., "uncontaminated") in contrast to the new, which is seen as a derived and inferior art. These foreigners thereby exert curatorial authority over Asmat art in the nexus between local pro-duction and the consumption of its visual legacy in the outside world.

Stanley has a keen eye for the complexity of this interaction. He suggests that outside demands from the Indonesian and Western markets supersede local con-cerns. He also discusses the "policing of standards" by outsiders, such as in the annual carving competition, and how these standards are involved in the produc-tion of Asmat art. Commercialization has made both old and new art forms com-modities. In this context, the relatively rare older pieces become the yardstick for

judging recent works. Asmat artists continue to be portrayed as contemporary ancestors in the discourse of foreign visitors—for example, they are seen as "Stone Age woodcarvers in our time." Whereas "the core of Asmat culture" concerns "harmonizing and restoring balance in the world," outsiders have chosen to associate the art mainly with head-hunting. In this view, external influences will inevitably result in a decline in the quality of Asmat art.

Stanley makes it clear that Asmat people, rather than being passive victims, are able to assert their identity and cultural values in their art for patrons all over the world. The transformation of Asmat art, shaped by interacting internal and external forces, should thus be seen to engage mutual entanglements. Asmat artists and curators have visited museums in North America and Europe. European and American artists have traveled in the reverse direction. As "artist-ethnographers," they had their own agendas in the visual representation of the Asmat. Yet Stanley feels it doubtful that the Asmat works of Western artists who visit the region can be seen as part of a real dialogue with their Asmat colleagues.

In article 16, Carol Hermer analyzes an experiment about African art at the Seattle Art Museum. This exhibition attempted to minimize curatorial authority (some would say "translation"), engaging the politics of contemporary (postmodern) museum curation. This exhibition took an innovative step beyond earlier precedents by trying to make indigenous voices heard, by removing almost entirely all forms of curatorial authority. This lack of curatorial authority was expressed in the absence of labels and text panels. In addition, Africans from the exhibit's source cultures acted as guest curators and advisors and had their say regarding the selection of objects to be exhibited. Their voices could be heard, quite literally, in taped interviews, in an audio tour, in videos screened on the walls, and in other contextual recordings throughout the galleries. Exhibit organizers also refrained from using scripts and they did not add comments or titles to audiovisual materials.

In considering visitors' responses to the exhibition, Hermer indicates that, while most responses were positive, the negative comments were instructive. The main problem was that many visitors felt disoriented without any labels to guide them through the exhibition. Discomfort was particularly relevant for visitors who had to rely on visuals and sounds for guidance rather than the more familiar written text. What is more, some visitors saw negative stereotypes about Africa confirmed in the exhibition. Hermer explains that "absence of authority allows the audience to let loose preconceptions that would be suppressed in a traditional art museum context." Left to their own devices and without further guidance, instead of African voices being heard, these visitors created an imaginary exhibition of their own.

In article 17, Nancy Marie Mithlo discusses the efforts of the Santa Fe Native American Arts Alliance (NA3) to create culturally significant art free of the restrictions imposed by commercialism or institutional curatorship. The forum that the NA3 selected for this challenging endeavor was the global stage of the Venice Bien-

nale. For two of their exhibition projects there—in 1999 and in 2001—the primary agenda was "self-interpretation." Mithlo reflects on this activist intention and "self-chosen identity." She describes the group's primary goals as overcoming issues of authorship and control by working as an arts collective. In 2001, hopes for this collaborative vision and indigenous ownership collapsed, however, when one artist's video—a reworking of Disney's film *Pocahontas*, which challenged its stereotypes about Indians—was withdrawn by the group's organizers who feared retaliatory legal reprisals from the Disney corporation. As Mithlo points out, this self-censorship became a poignant example of Native internalized notions of disempowerment and subordination. The author nevertheless argues that identification and application of an indigenous knowledge system approach must continue if Native empowerment in the search for self-knowledge is to go forward in contemporary Native arts production.

Living with the Ancestors in an International Contemporary Art World

Nick Stanley

When the Monumental Sculpture of the Asmat exhibition opened at the Olympic Arts Festival in Australia in September 2000 at Sydney College of the Arts, it signified a clear public recognition of the significance of Asmat art in a world context. The importance of this show was further reinforced by the account that appeared in the most internationalist of Pacific arts publications, *ART AsiaPacific,* at the same time. The author, Tod Barlin (2000:69), explained the way in which Asmat art had come onto the international marketplace and indicated how Asmat art has been influenced by the demands of purchasers. He singled out two contrasting markets:

> The Western art market, which looks for older, used pieces and carvings that are made along traditional lines; and the domestic Indonesian market, which seeks objects that are aesthetically very different from those originally produced by the Asmat. The Indonesian market requires a symmetrical and polished look, and the carvings are made from hardwood. Tables and chairs with traditional Asmat designs, ashtrays, and other decorative items are made in abundance.

There is much truth in this distinction between an Indonesian and a Western market. Indonesian emporia and department stores like Sarinah in Jakarta are full of tribal art, some made by carvers from Asmat and based on traditional styles. As Barlin indicates, there is a tension between producing high-volume, low-value objects for a local mass market and work that has intense artistic involvement recognizable to a discerning collector.

But to contrast the Western market as one that is essentially only interested in historic pieces, domestic Indonesian taste is judged to be restricted to souvenir trinkets, which risks collapsing a range of different perspectives and ignores a complex interaction that is aesthetically and sociologically important. On the one hand,

some of the reproductions in Sarinah are well executed. But on the other hand, there are also objects there that are made in Jakarta factories, as well as in workshops in Makasser and Bali. Asmat imagery is also copied fairly faithfully in silverware made by the silversmith Joyce Spiro. Thus, Barlin's polarized model needs to be reconsidered.

First, however, it is useful to see where such a model as Barlin's has come from. Perhaps unwittingly, the display in the Asmat Museum of Culture and Progress can be seen as contributing to this distinction between the modern and the traditional—polished hardwood storyboards versus the old shields, *bisj* poles, and drums. In Ursula Konrad, Alphonse Sowada, and Gunter Konrad's (2002) catalog of the museum's collection, pieces of both types are much in evidence. And in the museum itself the first type is on display in the front left-hand gallery—an exhibition of contemporary carvings from an annual festival—while the second is in the large rear gallery. A further distinction could also be made. The old work is work made with and for the ancestors, a form of memorialization of these ancestors, containing a retrospective focus. The newer work illustrates and reflects events of contemporary daily life.

From this perspective technology, materials, and treatment are all at variance with one another. In this view, the older is always judged superior to the newer.

Figure 1. Asmat Museum of Culture and Progress, Agats, Papua Province, Indonesia. Photo by Nick Stanley.

Novelty inevitably involves a decline in artistic standards and comes from suggestions made by foreigners. While accepting this perspective generally, it is interesting to note that Tobias Schneebaum (1985:50), an artist and commentator on the Asmat, argued that change may, however, also produce a more complex and sophisticated treatment in the carving. So, for example, following the intervention of Father von Peij, the carvers of Atsj started to carve prow heads using ironwood rather than the softer palm wood. The results were work that was ever more delicate and much admired by purchasers. Yet, in Schneebaum's view, because of these refinements the art became "refined out of existence."

This argument has been rejected by some Indonesian sources. The Asmat Progress and Development Foundation, a recognized Indonesian sponsored organization, takes a position in direct contradiction to that advanced by Barlin. The foundation (1990:23) has argued that it was not Indonesians but Western tourists and antique dealers who demanded Asmat carvings as home decorations, thus trivializing their significance. It is, however, difficult to reconcile this thesis with the contents of tribal art shops across Indonesia, nearly all of which contain Asmat carvings.

There is a strong counterargument opposed to the notion that the old is necessarily superior to the new in Asmat carving. In its most robust version, there is Jac Hoogerbrugge's (1973:27–29) contention that much of the older work was inferior in execution, while newer work has a freshness of interpretation. Furthermore, Hoogerbrugge (1993:149–153) argues that there is a strong sense of innovation and willingness to incorporate new elements in Asmat art. For example, he documents motifs taken from Thai matchboxes and Indonesian official iconography that were incorporated into canoe prows and other carvings (see Hoogerbrugge and Kooijman 1997, illustrations 62 and 135). Dirk Smidt (1995) argues forcefully that in recent decades there have been important developments in Asmat art, including the emergence of new genres and new forms of rendering the human figure. Indeed, both authors argue that it is precisely this openness that keeps Asmat art innovative and part of a living tradition. As Bishop Sowada argues (Konrad et al. 2002), art requires continuous metamorphosis if it is to survive. He stresses that Asmat art has to change in direct relationship to the changes taking place among the Asmat, including their perceptions of the world. Otherwise it will die, as other traditional arts have elsewhere. Indeed, the art of the Asmat exists now as a changed art (Sowada, pers. comm.).

Behind this disagreement among specialists there persists one common theme, an issue of aesthetic judgment. Both Hoogerbrugge and Schneebaum explicitly invoke questions of artistic standards. As early as 1969, Hoogerbrugge insisted that, "As a result of an insistence on quality, many objects faithful to traditional design and motif were produced" (Hoogerbrugge 2000). Early in his stay in Agats—about 1973—Schneebaum (1988:2) struck a similar tone: "The next time they came, I told them, we would be more selective and would reject work that had been hacked out too quickly." While both were alive to the notion of "indigenous aesthetics," their inner sense of value required what I call—without pejorative

intent—the policing of standards. This makes for a very troublesome issue in cross-cultural aesthetics and comparative systems.

At this juncture, I want to return to my earlier remark, that there may be a viable alternative to the polarized view of Asmat art as being either "genuine" (when created for original spiritual purposes) or "instrumental" (when created with a jaundiced eye to the quickest return for the least effort). Behind the argument between the old and the new and the sacred and the profane, as seen in the writings of Hoogerbrugge and Schneebaum, there lurks a tendency toward teleological thinking. By this I mean that there is an implied trajectory of change in the development of Asmat art from a relatively uncontaminated, and in some ways ideal, past to an unsatisfactory present. This style of thinking is, of course, by no means restricted to developments in Asmat. It is part of a wider argument about the fate of indigenous art and culture in a globalizing world. It comes in a number of versions.

The simplest and most direct formulation states that as cultures and economies are co-opted into a world system they become systematically peripheralized and superexploited by core cultures (Regin and Chirot 1986). So craft products in the "Asmat style" in the Indonesian and other markets are a logical result of such trivialization. A more open version, such as that offered by Nelson Graburn (1976:13), argues that change is inevitable, but its direction may be dependant on a number of variables. Traditional art may persist alongside what he terms "up-to-date functional arts." Nevertheless, once new art forms appear they usually have a dramatic impact on earlier forms.

There are, however, more complex models that have a direct significance for the development of Asmat art. The first of these is Igor Kopytoff's (1986:72) celebrated "cultural biography of things." While the main thrust of Kopytoff's argument has been admired for the way in which he likens the historic fate of an artifact to the human life span, another aspect of his thesis deserves consideration, namely, the drive to commoditization, which is seen particularly in the compulsion to make every exchange involve money rather than goods. Essentially, this means that in the Asmat context even old objects made outside and prior to a cash economy, such as the bisj poles, the *wuramon* (soul-ships), *jipai* masks, and ancestor skulls, acquire a cash value and become items to be traded. Another consequence, once such trading begins, has been for purchasers like Hoogerbrugge and Schneebaum to use the standards of traditional work as the means of judging contemporary art. So, a set of demands have been created to compare artifacts made under essentially quite different circumstances. Few, if any, contemporary pieces could stand the comparison if the time involved in their creation was not entered into the equation.

But there is yet another, and from my perspective a more satisfactory, alternative that involves reciprocity rather than a simple, unidirectional model of artistic and cultural change. Robert Welsch (1998, 1:279, 312) suggests some of the dynamics involved in purchase in his study of an expedition to the north coast of New Guinea early in the twentieth century. He shows that a collector could apply

heavy pressure on local people to sell items that he or she particularly wanted, but at the same time, locals could be both resistant to selling things they valued and insistent that the collector purchase items that they wanted to sell as part of a wider deal. This theme is taken up by Nicholas Thomas (1991) in his argument that across the Pacific the agendas of both indigenous peoples and Europeans involved a double and intertwined system of appropriation from one another. As will become apparent, objects of apparel do not simply translate from a Western context to an Asmat one without some significant local transformation. The same could be said about Westerners who use an Asmat ornament such as a dogs' teeth necklace as a kind of jewelry worn for public occasions in the West.

The dominant image of Asmat art and culture in the West is that of a dynamic and fiercely competitive set of people living a life in isolation from the rest of the world, isolated by geography, time, and social contact. This image creates a sense of a vacuum. The pressure is always directed inward: the collectors, the dealers, the figures of authority, all emanate from without and impact on Asmat life. This image becomes consolidated in the variety of accounts from visitors and scholars that comes to reinforce a similar narrow set of tales and values. The range of treatment and detail remains surprisingly limited. Each tale embroiders the dominant narrative and perhaps adds some marginal additional information. It is as though a trope has been permanently established, one that could be summarized in the form of an oxymoron: "Stone Age woodcarvers in our time." The physical constraints of a difficult terrain become translated into a comment about the material condition of the people themselves. As I hope will become clear, this is an illicit transposition for a number of related reasons. But, most significantly, this trope denies agency to Asmat people. In this image, the Asmat remain subject to events and external pressures in particular.

One of the contributing factors to this picture may be the particular way in which the visual and the artistic are privileged in external perceptions of Asmat culture. The Asmat are renowned for their art, which is always related to its origins in a head-hunting culture. Throughout the published accounts of visitors, the terms Asmat and head-hunting are inextricably linked in nearly every title. It is their ferocity towards strangers that forms the leitmotif in the accounts of their response to the outside world. From the seventeenth century to the mid-twentieth, this history is one of minimal engagement confined largely to conflict and suspicious barter. Fons Bloemen (1998), for example, offers an extensive selection of accounts of such encounters in his *First Contact: Original Reports of Initial Encounters between Europeans and Papuans of South New Guinea from the 17th until the Early 20th Century.* So when collectors at the beginning of the twentieth century began to acquire objects from the Asmat, they did so with two perspectives in mind: both the imagery in the designs and the traditional use that the objects had had in head-hunting culture were central to the objects themselves. All the major accounts and catalogs relate the art to its historic and symbolic origins in head-hunting (e.g., Schneebaum

1985, 1990; Smidt 1993; Konrad and Konrad 1995). The result is that a very strong visual and symbolic reference system is now associated with Asmat art. This is doubly unfortunate as it serves to conceal and ignore that the core of Asmat culture is not tied to head-hunting and cannibalism but rather to harmonizing and restoring balance in the world. Furthermore, such a singular perception fails to take into account that many of the feasts and rituals were not acts of revenge but active events celebrating and cementing communal values.

The Museum of Culture and Progress in Agats has served to consolidate the preeminence of visual craft for the Asmat. Their carvings have an enhanced status through being housed in a prestigious setting, but one that is also inserted into another Western reference system, the museological. This venue and display has provided the basis for a subsequent reciprocal, if not always equal, relationship between Asmat and their art and the world outside Asmat (see Stanley 2004). One of the most apparently surprising reoccurrences over the past quarter century has been the way that Western artists have casually dropped into Asmat. Schneebaum in 1973 was the first. He had heard of the region, as did many other artists subsequently, because of the death of Michael Rockefeller in Asmat in 1961 (Bergman 2000). Schneebaum was a precursor to a new breed of visitors, the "artist-ethnographer." By this term I do not mean to imply that these people were necessarily trained anthropologists, but that they came with artistic sensibility and ethnographic interests. Their range of intentions far exceeded those normally associated with ethnographers undertaking fieldwork. But the artistic and economic structure present in Asmat gave these artists a particularly privileged access—as artists themselves, they came with a visual agenda that they could test against this novel setting.

Some of these artists share a realist perspective commonly found in anthropology (O'Hanlon 2000:66); they reflect on the singularity of what they have encountered and its significance for a more general view of the world. Ostensibly, this can often look as though the artist is simply using an Asmat visual reference to advance his own work. (All of the artists I consider here are male, which may perhaps reflect on the gender of "artistic adventure" during the 1990s in southwest Irian Jaya.)

So, for example, Ingo Wegerl's *Brazza Man* is immediately recognizable and suggests a reference to Schneebaum's much reproduced photographs of his companion, Lamalo (Schneebaum 1988, photos: 112–113, back cover).

But the structure of the image, a centrally focused square portrait, situated within a block of eight other less distinct Asmat portraits, is consistent with much of his other work produced in this same grid format. It also relates to his interest in producing icon-like representations. However, a further claim is made on Wegerl's behalf by his commentator in the catalog:

> The illusive high degree of reality in Ingo Wegerl's portraits can practically penetrate the observer "under the skin." Consequently people have attested to the painter a "X-ray glance" on the desired object in turn. This burning interest not to be easily satisfied with external appearance and to search the real essence of people

and things under the surface, was and it still is a fundamental spring for Wegerl that put himself [*sic*] artistically in discussion with the surrounding world. (Hildebrand n.d.)

This realist agenda builds on Schneebaum's meticulous observation that can be seen in his early line drawings.

Other work is allusive rather than representative. Matthieu Knippenberg's *Soulship* (Museum van Bommel-van Dam 1991) does not require detailed knowledge of the wuramon, nor does it share its features with the original, being constructed of bone

Figure 2. Ingo Wegerl, *Brazza Man*. Photo by Nick Stanley.

and metal instead of wood. But the skeletal structure immediately suggests both the concept of a canoe and an ethereal space. The sculpture provides a transformation without injury to the original from which it derived.

But some of these visiting artists have had a more active sense of engagement. Fons Bloemen, in his twelve prints reproduced in his *First Contact* series, employs superimposition to juxtapose the traditional imagery of ethnographic photography with that of European classical iconography. So *Victim of Arrows* employs a sepia toned photograph of a group of Papuans posed with bows and arrows. On top of this image he placed a negative image of a Saint Sebastian-like figure bound and pierced with arrows.

By way of contrast, his next print (*Hearthunters*) has a graphic repeat series of cupids aiming their bows at a corresponding number of females holding up hearts. In front of this backdrop is a photographic, detailed study of four Papuan warriors facing the backdrop with their backs to the viewer.

Bloemen does not lecture us on how to read his prints. Indeed, he reminds us, "the visual language is killed by words" (Bloemen 2002). Nevertheless, the viewer is invited in this practice to compare one imaginary world with its obverse. Elsewhere Bloemen attempts cultural and artistic translation more directly. His *Voedselketen*

(The Chain of Food) is an example in point, as his commentary makes clear: "When I returned from south New Guinea I realized that the chain of generations is the main issue of the traditional Asmat culture and I used this thought in this painting."

Superimposition is also used by Roy Villevoye in his massive installation *Gate*, which was erected in 1999 as part of the Panorama 2000 event in Utrecht's Domkerk Cathedral, the seat of the Roman Catholic Archbishop and the center of Catholicism in the Netherlands. On a blind wall of the Domkerk Villevoye placed a huge photo print of an Asmat warrior peering from behind a shield. The scale of the print against the body of the church and the relationship of the image to the Gothic arch into which the Asmat shield fitted served to emphasize the contradiction between the two elements. Seen from a current secular perspective, the image makes one reflect on the troublesome relationship between Christian missionaries and indigenous people. On the other hand, the work *Gate* can be considered as an act of completion and reconciliation. One commentator remarks: "The fact that this image, confiscated from New Guinea, has now ended up on a European cathedral makes it clear that Villevoye's montage technique can be regarded as an alternative import/export circuit, which operates in a manner different from the global market of Benetton and MTV" (Lütticken 2001). In Domkerk it is almost missionization in reverse. Both Bloemen and Villevoye, through their use of superimposition, attempt to break down the normal hermetic division between "us" and "them" seen so frequently in ethnographic imagery. In one sense both artists are involved in what might be termed "the return gaze," available in Western iconography from all those subjects in paintings like Velasquez's *Las Meninas*, where we are reminded of the very activity we are engaged in. As Ine Gevers (1995) notes, "'The Other' is not only being represented: the Other is speaking for himself and likewise making us into 'the Other' as well."

Whether this shapes a genuine form of "reverse ethnography" remains a tricky question. *Neither* Bloemen nor Villevoye came to their task as naïve artists stumbling into an ethnographic theater of operations. Bloemen's (1998) original historic research was exhibited in the text of *First Contact*. Jan Dietvorst and Roy Villevoye's film *May 1, 2000: A Peace Ceremony at the Pomats River* quietly and unobtrusively chronicled a reconciliation ceremony between Asmat villagers and outsiders held on the Pomatsj River at the village of Sawa Erma throughout a complete day. But there remains, nevertheless, a significant issue for all of these artists and for ourselves to consider, namely, the reciprocal impact of this range of work in Asmat itself. At first glance, it is easy to see how the generation of this imagery, and the recognition of the Asmat world that it entails, widens general public interest in the West. A further corollary might be that further tourism is subsequently promoted or that demand for Asmat carving is further stimulated. But whether this exposure provides sufficient basis for reciprocal development is still a live question.

In passing, it is worth noting that the "vacuum" (the unidirectional movement of visitors into Asmat) I suggested earlier has been partially eased by Asmat adven-

turing in the other direction. In 1990 and 1991 a group of carvers and performers from West Papua, including both Dani and Asmat, made their own tours of Europe and North America. In New Orleans, in particular, these artists had the opportunity to make contact with African Americans. A similar tour to North America was made in 2000. This time the Asmat carvers/performers spent time with First Nation Americans on a reservation. Other invitations to spend time in Europe have been taken up recently (see Dietvorst and Villevoye 2001). Asmat students have regularly studied elsewhere in West Papua, and further afield in Indonesia and Europe. This has been particularly the case with respect to the curators at the Museum of Culture and Progress, who have studied Asmat collections in Europe and America.

One major contemporary exhibition offers a good case study of some of the questions of reciprocity involved in Western artistic treatment of Asmat culture. Villevoye's exhibition Rood Katoen (Red Calico) at the Rijksmuseum voor Volkenkunde, Leiden, in 2001 (Rijksmuseum 2001) has caused considerable interest, appearing as it does as an inaugural exhibit at the reopening of the Dutch national museum of ethnography. In Red Calico some twenty-five T-shirts are exhibited on mannequins in a brightly lit gallery. As the artist and collector explains:

> The deal was that I would here and now exchange these ragged pieces for good quality new ones that I bought from Indonesian settlers in Agats. I gave every

Figure 3. Exhibition entitled Red Calico, curated by Roy Villevoye, Rijksmuseum voor Volkenkunde, Leiden (semi-permanent exhibition), 2004. Photo by Nick Stanley.

owner free choice of my collection of new T-shirts. Occasionally somebody pre-
ferred to sell his or her piece for money. (Villevoye, pers. comm.)

In his catalog text, Gosewijn van Beek (2001:81) goes on the offensive. He con-
siders the immediate impact the exhibition might have on the viewer: "Here we are
confronted with people dressed in Western rags, an image of third world poverty
and dejection we are all too familiar with. It seems we are looking at a Salvation
Army appeal, a poverty parade." But this is only a feint; van Beek wants us to look
again. Why is it, he asks, that shirts are shredded so drastically while shorts and
women's undershirts remain uncut? The answer, he suggests, is that what we are
looking at is not the culture of poverty, but an aesthetic, a "versatile vehicle for
local identity construction." The cuts represent a form of individual customizing to
turn the shirts into "stylistic assets." It is even suggested that this customizing may
perform a function analogous to scarification and create a "new cultural skin" (van
Beek 2001:81, 87, 88, 91).

Another quite different interpretation is offered by Yufen Biakai, namely that
the shirts were shredded as a symbol of displeasure at the activities of agents of the
Indonesian state in West Papua (Sowada, pers. comm.). I think that it is possible to
accept elements of both explanations. Certainly, the aesthetics of braiding and
deconstruction are excitingly displayed in the exhibition Rood Katoen. Yet, this
should not deny a political motivation in the activity of shredding.

This exhibition and the way we are asked to reconceptualize our immediate
reading of material from the third world clearly challenges us to inspect our
assumptions. Is it possible to accept Villevoye's exhibition at face value? It seems to
me that in order even to attempt this we need to rethink our notion of reciprocity,
especially visual reciprocity. To clinch the matter the exhibition curators would
need to justify their visually plausible argument through discussion with the "art-
ists" (the customizers of the shirts) in order to elicit a clearer account of what is
going on in the transformation of these utilitarian objects into items of style.

From the outset, style has been part of the sustained intercourse between the
Asmat and their foreign admirers, an issue always at stake, as the first part of this
article has argued. But style is also a topic that necessarily admits change. The
exhibition in the left-hand gallery of the Museum of Culture and Progress in Agats
attests to the dynamic changes that have occurred in Asmat carving over the past
two decades. The interrelationship between the carvings offered at each annual fes-
tival and the judges' comments would make in itself a fascinating subject for fur-
ther study (see Stanley 2004). One thing is certain. The carvers have been ever
sensitive to external advice, criticism, and example. One final example of change in
carving is to be seen in the new style of carving from the village of Per.

This series of heads has been hewn out of driftwood bulks of timber, the source
of much danger for those navigating the rivers of Asmat. The new model derived
from the carved houseposts of the traditional *jeu* (longhouse). These have carved
human features emerging from the pole. To Ursula Konrad, this work suggested a

similarity from consideration of two European contemporary artists. Gonn Mosny's work exhibited in 1998 was a group of roughly hewn tall posts on a stone pedestal and surmounted by a rough stone reminiscent of heads (Galerie Benden & Klimczak 1998). The second source was a large installation by Vollrad Kutscher of 144 tall plinths, each surmounted by identical ceramic hands holding a mask as though it were a mirror (Kutscher 1997:21). In both of these examples the idea of emergence is important, and it is this concept that is compared with the Per heads that are released from the timber bulk by the carvers.

I have, in this article, considered the interrelationship between Asmat carvers and the world without. Undoubtedly, the visual world, like the social, economic, and material world, in Asmat is almost unrecognizable in comparison with that of half a century ago. What I have argued is that it is possible to conceive of contemporary art, even the most narrative of storyboards, and the new heads from Per as relating to the art of the ancestors, even if the relationship has changed dramatically. For it is the source of imagery in its mythic form that survives, even if subliminally, to still make Asmat art immediately recognizable and utterly distinct. As long as wood remains available in Asmat, it seems that Asmat men will continue to carve. And, it should be belatedly acknowledged, women will carry on working in fibers derived from wood and other sources. This engagement with the creation of aesthetic form remains a source of both pride and confidence. That the work created now is markedly different from fifty years ago should not be seen as a mark of decline, but of vitality and continuity in a swiftly changing world.

Questions for Discussion

1. What role have foreign buyers and collectors played in shaping the forms of contemporary Asmat carvings?

2. If contemporary Asmat carvings are largely made for sale to foreigners, can we still refer to them as Asmat art?

3. Stanley suggests a kind of interplay between Asmat and foreign artists. What is he referring to and what form does this interchange take?

4. Stanley discusses an exhibition of shredded T-shirts that were once worn by Asmat men at a museum in the Netherlands. In what sense do these shirts represent art?

Acknowledgments

Adapted from Nick Stanley, 2002. "Living with the Ancestors in an International Art World," in *Asmat, Perception of Life in Art: The Collection of the Asmat Museum of Culture and Progress,* ed. Ursula Konrad, Alphonse Sowada, and Gunter Konrad. Mönchengladbach: B. Kühlen Verlag (in English, German, and Indonesian). I am

very grateful to Ursula Konrad and Bishop Alphonse Sowada for their editorial comments and suggestions. I also thank the artists cited for their constructive criticism. The views expressed here are, however, mine and not necessarily shared.

References

Asmat Progress and Development Foundation. 1990. *Asmat*. Jakarta: Author.

Barlin, Tod. 2000. "A Continuing Tradition: Asmat Art of Irian Jaya." *ART AsiaPacific* 28:66–69.

Bergman, David. 2000. "Forward," in *Secret Places: My Life in New York and New Guinea,* ed. Tobias Schneebaum. Madison: University of Wisconsin Press.

Bloemen, Fons. 1998. *First Contact: Original Reports of Initial Encounters between Europeans and Papuans of South New Guinea from the 17th until the Early 20th Century.* Netherlands: F. Bloemen.

———. 2002. Fons Bloemen Web site. Available: http://www.fonsbloemen.nl/book/in.htm.

Dietvorst, Jan and Roy Villevoye. 2001. *Us/Them*. Video recording.

Galerie Benden & Klimczak. 1998. *Gonn Mosny*. Cologne: Galerie Benden & Klimczak, Edition Parterre GmbH Art.

Gevers, Ine. 1995. "But Is It Art? But Does It Matter?" in *Am Rand der Malerei*. Bern: Kunsthalle.

Graburn, Nelson H. H., ed. 1976. *Ethnic and Tourist Arts: Cultural Expressions from the Fourth World*. Berkeley: University of California Press.

Hildebrand, Markus. n.d. *Ingo Wegerl*. Ascona: Galleria Sacchetti.

Hoogerbrugge, Jac. 1973. "An Evaluation of Present-Day Asmat Wood Carving." *Irian: Bulletin of West Irian Development* 2(1):24–35.

———. 1993. "Art Today: Woodcarving in Transition," in *Asmat Art: Woodcarvings of Southwest New Guinea,* ed. Dirk Smidt. Singapore and Amsterdam: Periplus Editions in association with C. Zwartenkot.

———. 2000. "Collector in the Tropics: Jac Hoogerbrugge," in *Tribal Art Traffic: A Chronicle of Taste, Trade, and Desire in Colonial and Post-Colonial Times,* ed. Raymond Corbey, pp. 152–153. Amsterdam: Royal Tropical Institute.

Hoogerbrugge, Jac and Simon Kooijman. 1997. *Seventy Years of Asmat Woodcarving*. Breda: Rijksmuseum voor Volkenkunde.

Konrad, Gunter and Ursula Konrad, eds. 1995. *Asmat Myth and Ritual: The Inspiration of Art*. Venezia: Erizzo Editrice.

Konrad, Ursula, Alphonse Sowada, and Gunter Konrad, eds. 2002. *Asmat, Perception of Life in Art: The Collection of the Asmat Museum of Culture and Progress*. Mönchengladbach: B. Kühlen Verlag.

Kopytoff, Igor. 1986. "The Cultural Biography of Things: Commoditization as Process," in *The Social Life of Things: Commodities in Cultural Perspective,* ed. Arjun Appadurai, pp. 64–91. Cambridge: Cambridge University Press.

Kutscher, Vollrad. 1997. "Portrait-Installationen 'Einatmen-Ausatmen.'" *Kunst Zeit* 4:21.

Lütticken, Sven. 2001. "Roy Villevoye: Giving and Taking." *Jong Holland* 17(1):12–18.

Museum van Bommel-van Dam. 1991. *Beelden uit het Moeras: Fons Bloemen, Matthieu Knippenberg*. Venlo: Museum van Bommel-van Dam.

O'Hanlon, Michael. 2000. "A View from Afar: Memories of New Guinea Highland Warfare," in *Anthropologists in a Wider World: Essays in Field Research,* ed. Paul Dresch, Wendy James, and David Parkin, pp. 45–68. Oxford: Berghahn.

Regin, Charles and Daniel Chirot. 1986. "The World System of Immanuel Wallerstein," in *Vision and Method in Historical Sociology,* ed. Theda Stocpol. Cambridge: Cambridge University Press.

Rijksmuseum voor Volkenkunde. 2001. *Roy Villevoye, "Rood Katoen" (Red Calico).* Leiden: Rijksmuseum voor Volkenkunde.

Schneebaum, Tobias. 1985. *Asmat Images from the Collection of the Asmat Museum of Culture and Progress.* Agats: The Museum.

———. 1988. *Where the Spirits Dwell: An Odyssey in the New Guinea Jungle.* New York: Grove Press.

———. 1990. *Embodied Spirits: Ritual Carvings of the Asmat.* Salem, MA: Peabody Museum of Salem.

Smidt, Dirk. 1993. *Asmat Art: Woodcarvings of Southwest New Guinea.* New York: George Braziller in association with Rijksmuseum voor Volkendkunde.

———. 1995. "Innovation in Asmat Art and Its Presentation in Museums," in *Asmat Myth and Ritual: The Inspiration of Art,* ed. Gunter Konrad and Ursula Konrad, pp. 437–450. Venezia: Erizzo Editrice.

Stanley, Nick. 2004. "Can Museums Help Sustain Indigenous Identity?—Reflections from Melanesia." *Visual Anthropology* 17(3–4):369–385.

Thomas, Nicholas. 1991. *Entangled Objects: Exchange, Material Culture and Colonialism in the Pacific.* Cambridge: Harvard University Press.

van Beek, Gosewijn. 2001. "Catalog Text," in *Roy Villevoye, "Rood Katoen" (Red Calico).* Leiden: Rijksmuseum voor Volkenkunde.

Welsch, Robert L., ed. 1998. *An American Anthropologist in Melanesia: A. B. Lewis and the Joseph N. Field South Pacific Expedition, 1909–1913.* Vols. 1 and 2. Honolulu: University of Hawai'i Press.

16 Curatorial Authority and Postmodern Representations of African Art

Carol Hermer

*D*o our art and anthropology museums have the right to speak for other peoples whose cultural expressions they exhibit? If not, as many curators and others now believe, how should these museums devote themselves to the task of "translation" (Frese 1960), so that the audience gets some understanding of the art? Or, as John Mack (2001:198) puts it, "The credentials of the interlocutor are challenged by the assertion of the ultimate authenticity and intelligibility of the indigenous voice. Where does the authority of the hapless curator lie? Is it possible to bridge the gap?" In this article I present an analysis of Art from Africa: Long Steps Never Broke a Back, an exhibition of African art mounted by the Seattle Art Museum. In particular, I am concerned with the question of what effects postmodern contemporary curatorship had on the general public's reception of the show's art.

Postmodernism has encouraged us to assess the world around us in relativist terms. We acknowledge that cultural assumptions and personal histories influence our perception of what we see. And we also acknowledge that from the perspective of much of the world, the presentation of art, history, and literature has been formulated with a Western bias, leaving indigenous interpretations largely unheard and unseen (Clifford 1988, 1997; Karp and Lavine 1991; but see Durrans 1992). In the world of the Western art museum this perspective has resulted in an effort by curators to expand their presentation of art from "other" cultures to include local viewpoints and perspectives (e.g., Roberts, Vogel, and Müller 1994; Shelton 2001, 2003). Yet, no matter how sincere these efforts have been, they have not necessarily achieved the desired result.

The exhibition Art from Africa: Long Steps Never Broke a Back at the Seattle Art Museum is a case in point. (Throughout I refer to the show by its abbreviated title Long Steps.) Having indigenous curators (cf. Ames 1999), or curation in dia-

logue with source communities (Peers and Brown 2003), does not in itself make an exhibition intelligible to the visitors, especially when the art exhibition has a predominantly Western or multicultural audience. First, I consider the conceptualization and making of Long Steps. Next, I examine visitors' responses to the exhibition. I illustrate the risks of misinterpretation caused by removing curatorial authority by discussing another exhibition on Africa in North America, Into the Heart of Africa, at the Royal Ontario Museum. Finally, again examining Long Steps, I point out that in a number of cases the removal of expected authority—found, for example, in the comfort of labels—gave free rein to visitors' imagination. Rather than resolving the so-called crisis of representation, at times it had the reverse effect by confirming preconceived ideas. One of the lessons learned is that postmodern curation will have to pay considerably more attention to the art of translation, if indeed the voice of "the Other" is to be heard.

The Making of Long Steps

At the Seattle Art Museum, which has been fortunate to have received major collections of African, Asian, and Northwest Coast Native American art, the African collection comes mainly from the estate of Katharine White. The display of the art of the "Other" poses problems for curators who want to avoid what they term an anthropological presentation while providing a meaningful context for the viewer.

As used by curators of art museums, the term "anthropological" refers to something most anthropologists regard as archaic and antiquarian, namely the mere amassing of cultural artifacts and displaying them without regard to their aesthetic qualities. For anthropologists, on the other hand, the "art" museum tends to display objects from non-Western cultures in isolation, devoid of cultural context, often without regard either to the significance of the object or the value it holds for its maker.

Recent exhibitions have tried to address the museum visitor's lack of knowledge of the creators of these objects by including videos of performances and photographs of artwork in context (but most still rely on curatorial authority to explain the object's function with labels and text panels). One example of this approach was the exhibition Closeup: Lessons in the Art of Seeing African Sculpture at The Museum for African Art in New York, which used scarcely any labels (Thompson and Vogel 1990). Long Steps went a step further, and was innovative in that it attempted to replace curatorial authority with voices from the African cultures whose art was represented in the exhibition.

During the year prior to the exhibition's opening, the museum invited several artists, performers, and scholars—all of whom were members of the cultures whose art was on display—to add their curatorial voices to the presentation. The central premise, devised by Curator of African and Oceanic Art Pamela McClusky, was to

create an immersion experience of African art for the visitors as defined by indige-
nous voice. In addition, the museum was committed to showing the continuity of
what are usually regarded as "traditional" art forms—often glossed as "out-
moded"—in their contemporary settings.

The exhibition arose from a book written by McClusky (2002), which became
the catalog for the exhibition. This book was different from many catalogs (but see
O'Hanlon 1993), as it went beyond the customary information involving the con-
text of production of the art on display to discuss specific and detailed case studies
describing the history of collecting the objects. It used information gleaned from
most of the advisors.

The guest curators visited the museum for varying periods, from several days
to several weeks. Some were resident in Seattle and could be consulted at length.
Each was first shown the objects that the museum wished to include in the exhibi-
tion. They were also shown other objects from the same cultures in the museum's
collection. At this time, they had the opportunity to add or subtract objects from
the original exhibition checklist. Each guest was then videotaped discussing each
object in turn, as well as any other subjects that they felt gave context or relevance
to the artworks. Taped sessions ran from one to five hours. Advisors were also
asked to record audio interviews that could be used for the audioguide to the exhi-
bition. Questions and topics in the audio sessions were similar to those recorded on
videotape, but the audio quality was better than on the videotapes because they
were made in a soundproof booth.

The backgrounds of the advisors varied and included art historians, philoso-
phers, performers, and even nonprofessionals such as ordinary citizens. Babatunde
Lawal, an expert on Yoruba Gelede performance, discussed the collection of Gelede
masks. Daniel "Koo Nimo" Amponsah, a musician raised in the court of the
Asantehene of Akan, Ghana, brought his intimate knowledge of court dance, ges-
ture, and proverb to illuminate the many goldweights, items of jewelry, and fabric. A
detailed discussion of Kongo philosophy and cosmology was obtained from FuKiau
Bunseki, a sociologist and teacher, who had undergone training as a traditional rit-
ual specialist (*nganga*) in order to fully appreciate his native beliefs. Kakuta Hamisi,
a Maasai warrior with a degree in visual anthropology from Evergreen State College
in Olympia, Washington, was also helpful in two ways. First, he created his own
collection of beadwork and household items for the museum, arranging to exchange
personal possessions from his home community for funds to build a school in Mer-
rueshi, Kenya, that would teach traditional Maasai values along with secular sub-
jects. In addition, he also videotaped the collecting process for the exhibition.

Gilbert Mbeng came as an emissary from the Kom kingdom of Cameroon,
sent by the *fon* (king) of Kom to correct any misinterpretations about the practices
associated with Kom artworks. He had interviewed many of the elders and court
functionaries of the palace and several of the pieces in the Seattle collection had to
be reinterpreted through his information. Won-Ldy Paye, a Dan performer and

Figure 1. A video of performers from the Egungun masquerade group Ayan Agalu plays behind their costumes on display.

writer who had fled the Liberian civil war, brought his knowledge of masking traditions and meanings to re-create a troupe of masqueraders in Seattle. He also loaned his complete costumes to supplement the museum's masks. Mende women's masks, used in the secret practices of the Sowei society of Sierra Leone, created the greatest problem as initiates are forbidden to speak of them. Even those who had discussed the ritual in print balked when asked to do the same on camera. Finally, Mende writer Hannah Foday discussed the sense of connectedness brought on by seeing the Sowei masks today, a response that took her back to her first encounter during her own initiation in Sierra Leone. The only non-African advisor was Robert Farris Thompson, who had previously worked extensively on the Katharine White collection and who chose certain artworks to illustrate his thesis of African movement as embodied by the sculptures (Thompson 1974).

After the advisors had left, materials collected during their visits were logged, transcribed, and edited into various packets of information to accompany the exhibition. The first of these was the audiotour. Previous audiotours produced by Acoustiguide could be heard in the surrealism exhibit at the Tate Gallery in London and in the Sichuan exhibit that was displayed at the Seattle Art Museum and the Metropolitan Museum of Art in New York. They were made according to a particular formula. The surrealism tour was done by a single narrator with accented voices added by actors playing the roles of the artists. In the Sichuan tour, which used the recorded voices of several Chinese scholars, a narrator introduced the speaker, who then discussed the specific object. All of these were scripted prior to recording. But for Long Steps the curatorial staff wanted something very different.

Instead of scripts, the interviews were recorded in an open-ended fashion with only the topics predetermined in advance. Once the interviews were transcribed, the curators selected which particular words and phrases provided by the advisors should be used to describe the artworks on display and then created from them scripts without any additional narration or introduction. The music or sound effects they collected from the advisors were also sent to Acoustiguide, who then created the finished mix. The result was a very natural sounding audiotape. Unfortunately, some of the African accents were strong and required some concentration to follow with an untrained ear. For hearing-impaired visitors a transcript of the audiotape was made available. In a couple of cases the curatorial staff relied on written questions given to the Acoustiguide staff to use when the advisor was out of

the country and could not travel to the United States. Yinka Shonibare, for example, was recorded in London and a previously recorded videotape interview with Magdalene Odundo was used for their sections in the exhibition.

The second source of information for visitors was compiled from tapes of performances, either collected by the advisors or by museum staff. Some were taped specifically for the exhibition. These were edited into videos that were projected on the walls of the exhibition space, adjoining the dis-

Figure 2. Yoruba Gelede masks from Nigeria stand against a backdrop video of Gelede masks in performance.

play of the costumes or artwork shown in the videos. These videos were given contextual background music, but no titles. One was an introductory video, set to street sounds and radio music one might hear on an African street, that took visitors on a walking tour through six African countries from south to north. On the wall opposite, a tape of the funeral of the late Asantehene Opoku Ware II played, showing clothes, jewelry, stools, and hunters' shirts similar to those on display. A third tape consisted of a discussion of the collection of Maasai objects made by Hamisi, while a fourth, by BBC producer Sarah Errington, showed funeral processions in Ghana with elaborate coffins. The fifth was a compilation of masquerades from West Africa, including a performance by Won-Ldy Paye's resident Dan troupe, Village Drum and Masquerade.

Another source of information was a collection of edited videotapes of the interviews with the advisors. These, averaging thirty minutes in length, were coded onto MPEG-1 files and were available to visitors on computer monitors. Visitors could choose to see all or part of any of the ten available interviews.

Finally, for visitors who insisted on reading their information, profile books were placed with each subject area along with photographs of the advisor. These included the following items: (a) a short biography of the advisor with a map of the area from which the artwork he or she discussed originated; (b) photographs of some of the art on display together with a text similar to the audiotape; and (c) additional information taken from the video or audio interviews, but again relying on the spoken words of the advisor. For visitors with time to linger in the exhibition, a continuous showing of films made by African directors played in a special section of the gallery.

What was not available anywhere in the exhibition, however, were labels identifying each object, or even more general labels identifying the region or country of origin. The only time the authoritative voice of the curator appeared was in the introductory and final stops of the audiotour, scripted specifically for the audiotour. Copies of the catalog were available on a podium for visitors to consult.

The Varied Responses to the Exhibition

The exhibition opened with a great deal of publicity, both in newspapers and on television. The media were intrigued by the personal stories of the advisors, particularly by Kakuta Hamisi, the Maasai-warrior student mentioned above. It was also one of the liveliest—and probably the noisiest—shows ever put on by the museum with its competing sound tracks from the five videos as well as the cinema gallery. The first two weeks involved endless adjustments and readjustments. The store personnel and security guards begged us to turn down the sound. But doing so removed some of the ambience of immersion.

During the exhibition, visitors were asked to complete comment questionnaires. At the same time, the museum employed a market research organization to conduct its own study about attracting a more diverse audience. Most respondents had positive things to say about the exhibition and, as expected, the majority of negative comments concerned the lack of labels. Many visitors were horrified that they were expected to listen and look rather than read. One viewer wrote, "I came to see the art, not to watch TV or listen to radio. Audio tours and profile books can be a nice addition, but there is no excuse for not including labels to identify at a minimum the object's name, use, and place and date of origin."

Figure 3. Gilbert Mbeng from Kom, Cameroon, discusses the Kom royal sculptures he reinterpreted for the museum.

Another wrote, "I really wish audio tours did not replace labels. What happens to people who can't hear well or don't like technology to their ear??? Please let us enjoy art for itself at our own pace with our own voice and background music in our head." Yet another complained, "I am very disturbed that there were no signs telling where the exhibit was from and the date of its manufacture. There are so many uninteresting words on the audios that I never bother with them but, for the first time, they were needed." Others commented on the annoyance of having to have the equivalent of a cell phone glued to their ear to get any idea of context. There were many similar comments. It was as if, without the written text, visitors did not know how to orientate themselves to the narratives being presented in the exhibition. A few visitors did get the point of eschewing labels. As one wrote, "This Africa show with the vocal stories is the most intimate exhibition. I feel as if a friend was sharing their home and culture. Hope this can be done again as it's like living with art not just studying it."

Another criticism, leveled by a single commentator, was that the exhibition was essentialist in that it depended on a single informant for each section. But this

approach was invalid in that the chosen advisors had not obtained their knowledge by relying on their own experience as a member of the cultural group, but had carefully studied their own culture from both an insider and outsider point of view.

A more vocal criticism, which was much less expected, came from some people who expressed dismay at what they saw as the presentation of negative stereotypes in the image of Africa. One visitor commented that the "objects are from a time long past" and more attention should be given to current art. Another was "sick of constantly seeing Africa put down." A similar negative reaction was reported by a museum trustee who took a visiting African friend on a tour of the exhibition and was very upset by his dislike of the show.

Figure 4. Kakuta Ole Maimai Hamisi from Kenya describes the markings on a Maasai warrior's shield.

The strongest negative reaction appeared in an alternative Seattle weekly, *The Stranger.* Entitled "African Nightmares, the Colonialism of Looking," it invoked a putative conversation between an art critic, Emily Hall, and a Zimbabwean African academic, Charles Mudede (Mudede and Hall 2002). Mudede starts the dialogue:

> CM: Every time I walk into a major museum in America or Europe and come across the African art section, my heart panics, and I want to run away from the nightmare gallery of monsters with big teeth, mothers with big tits, mammals with reptilian bodies. Everything in the African art section is so crude, so rudimentary, I wonder why Westerners admire and collect these incomprehensible figures, these fetishes with a thousand nails driven into them, these dead animals hanging on hideous-looking oracle gowns.
>
> African art is not for Africans, but for Westerners. . . .

Hall's response is equally telling.

> EH: It was impossible to walk through the galleries and simply enjoy the work. You have to reckon with a sense of guilt at your own white ignorance, and anyone who says otherwise is lying. . . . And although I found many of the masks and the robes and the statues beautiful and compelling, I got a strong whiff of Orientalism about it all—in the sense of foreign-as-exotic, so perhaps Africanoiserie would be the right [invented] term. That these are things we shouldn't be looking at, and that we might ruin them by looking at them. Like the Masai [sic] beaded necklaces, whose colors used to have specific meanings embedded in them, but have been emptied of meaning since the Masai [sic] gave it up to create pretty combinations for tourists.
>
> For the record, we should say that we looked at the exhibition without the benefit of the audio tour, without which we were almost helpless.

Both Mudede and Hall admired the modern pieces of Magdalene Odundo and Yinka Shonibare and the photographs of Seydou Keita and Malick Sidibe. Mudede comments:

> It's truly regrettable the monsters from the past dominated the exhibition. The monsters were having a ball, and the more interesting, more beautiful works were hiding in the corners worried about what would happen to them when night fell and the museum was closed. Could you imagine spending the night in the African art section? I would rather suffer a night in King County Jail.

And Hall adds, "I found that my discomfort evaporated when I looked at the contemporary work—when you look at it, it looks back at you. That is to say, looking at them doesn't feel like plundering."

Of course, listening to the audiotour could have aided their appreciation. It would have made it clear, for instance, that the Maasai colors were not only still important, but that none of the objects in the exhibition had been made for tourists but were taken by the people themselves, from their own homes and bodies, as a gift to the museum.

I need to emphasize that these were unusual reactions. By far the majority of visitors responded positively to the show and its vision of Africa. But the vociferousness of the negative reactions was interesting. How could someone have interpreted a show that went to so much trouble to incorporate an African presence and to show the place of traditional art in contemporary Africa as negative to Africans?

Removal of Curatorial Authority: Another Exhibition Misunderstood

In some ways Into the Heart of Africa, shown at the Royal Ontario Museum in Toronto during 1989–1990 (Cannizzo 1989), encountered similar problems (Fulford 1991). This early exhibition presented photographs, documents, and collections from various Canadian missionaries and soldiers who had worked in Africa. It attempted to look at Canadian attitudes toward Africa that were prevalent in the early days of colonialism. The show had been carefully curated to depict those attitudes as arrogant, racist, and condescending. Yet, by simply presenting this point of view, it was viewed by many museum visitors as endorsing that perspective. Visitors condemned the exhibition as racist itself. This possibility proved so controversial that the exhibition was forced to cancel its tour to four other cities. In addition, descendants and friends of the missionaries and soldiers were equally irate at the show. For them their friends and relatives had gone to Africa with good intentions. Many had done good works that benefited the communities in which they lived, but were now being maligned by this exhibition.

As the curator Jeanne Cannizzo stated in an interview, "The museum as a theater doesn't present just one play, it presents as many plays as there are visitors. Because I think that the visitors are the playwrights and the directors and the audience as well" (Fulford 1991:27).

But Into the Heart of Africa was, in essence, a show about whites in Africa and it was presented from a white point of view, even if highly critical of that point of view (for further reviews, see Cannizzo 1991; Ottenberg 1991; Schildkrout 1991). In con-

Figure 5. A video interview of FuKiau Bunseki from the Congo plays on a monitor in the gallery.

trast, all of Long Steps, with the exception of the section by Robert Farris Thompson, was presented from an African point of view. One could argue that by collating, editing, or choosing the material these perspectives were mediated by whites, but the original material had come from African sources and the final edited versions had been approved by them. How then could it still be interpreted as derogatory to them?

Arnold Shepperson (2002:3) refers to the term "slot," originally coined by John Marshall, to describe the assumptions that filmmakers bring to their work and that most of the audience shares. He suggests that the slot people bring to their idea of "Africa" is one of difference, of the Other, and that this view is shared by many Africans. He cites several films by African directors to illustrate his point. Shepperson remarks,

> Now Africa has struggled with a duality, a two-fold objectivation of its people; one is Romantic, the other is Realist. The former says African people live closer to Nature, are less corrupted by Civilization. Others still consider that being "closer to Nature" means that civilization is a mission, because in a state of Nature Man is savage, living a life, as Thomas Hobbes put it, which is "nasty, brutish, and short."

I suppose it is possible that some viewers could have seen the video of the Asantehene's funeral procession in that romantic vein, concentrating on the noise of the drums and the half-naked bodies, their traditional robes dropped to the waist to show mourning, and not recognize the extraordinary pageantry and order that prevailed in a throng of thousands.

According to Ben Enwonwu (2000), some Africans find the acceptance of Afri-

Figure 6. The Golden Stool of the Asante, Ghana, is carried in the procession commemorating the funeral of the Asantehene, Opoku Ware II.

can art having value in its traditional context as problematic. The contemporary African artist is struggling to move away from Western preconceptions of traditional African art and may resent the view that the art represents a spiritual "romantic" African world. Many Africans are still haunted by Lucien Lévy-Bruhl's (1922) vision of a "primitive mentality."

At first glance the complaints about a lack of written text and those of negative depictions of Africa seem to stem from totally different points of view. But I think that both reference a particular complex of behavior that is inherent in a visit to an art museum. And both stem from the calculated removal of curatorial authority in the presentation of the artwork.

Visitors' Confusion: Confirmation of Preconceived Ideas

To try and understand the ontology of these various criticisms, I would like to look more closely at what actually happens when a visitor enters a museum. A museum exhibition is a narrative that is presented to the public. Narrative creates and defines one's position. To an extent the existence of labels gives the visitor a clue as to how to form an opinion, whether they agree or disagree with what is written. It is not that narrative was missing from Long Steps, it is that there were many narratives and no single overarching narrative expressed in a typically Western chronological form. As part of its premise, the show asked visitors to form their own narrative, and for many this was too challenging. Absence of authority allows the audience to let loose preconceptions that would be suppressed in a traditional art museum context. As a result, they approach the material through their own prior understandings of the meaning of Africa and its art. Only if they stayed and really engaged with the material were these preconceptions likely to be modified.

If reaction to lack of authority is one way these reactions can be linked, the performance of self that is enacted by a visitor to an art museum is another. A museum is primarily an educational space, but an art museum is specifically elitist. It is filled with objects that have been given a special aura by virtue of their selection for display. A natural history or science museum is also seen as educational but it does not convey the same challenge to the "taste" of visitors and its narratives are usually more clearly stated. Most visitors enter an art museum with an awareness that they are expected to come to an opinion about what they see and how it is presented. By expecting a visitor to have an opinion, the museum challenges the visitor to perform (cf. Goffman 1959). Frequent museum visitors have already cultivated a specific persona that comes into play as they enter. The Lord (2002) survey, commissioned by the Seattle Art Museum, found that regular visitors were more disturbed by the absence of labels than new visitors. Regular visitors who had

some experience of Africa were less disturbed and new visitors felt free to partici-pate in the open spaces by moving to the music of the videos. Visitors create mean-ing for their experience by performing their role in the constitution of the exhibition and by re-creating the identity they have chosen for themselves. For some visitors, the role they choose to play encourages them to look for negative portrayals, whether these negative images are present or not. For others, like Hall and Mudede, the role they seek may be that of iconoclast.

In discussing the telling and retelling of history, Elizabeth Tonkin (1992) refers to memories that are transmitted to fit around a structure, a genre, and this retelling maintains a version of the past that people can use for their own ends. She goes on to write that because our identities are both personal and social, individuals may be supported or threatened by public representations of pastness that either seems to guarantee their identity or appears to deny its significance. This pattern fits equally well with the presentation of art and could explain Mudede's reluctance to engage with the show.

In her book *The Ones That Are Wanted*, Corinne Kratz (2002:174) makes an extensive analysis of audience reaction to her own show, Okiek Portraits. In it she describes a situation that has many parallels to the reaction to Long Steps. She dis-cusses the response to an informal presentation of the photographs that were dis-played on the walls of her university department without any labels. There was considerable negative reaction to what was interpreted as an objectifying of the Afri-can people in the photographs. She writes, "Visitors bring their own knowledge and expectations when they encounter the context offered in the exhibition; their knowl-edge, expectations, and interpretations are also related to sociopolitical currents."

Explaining further, Kratz quotes art critic and cultural historian John Berger: "The aim must be to construct a context for a photograph, to construct it with words, to construct it with other photographs, to construct it by its place in an ongoing text of photographs and images" (Berger 1980:64 cited in Kratz 2002:175). And she continues:

> But that context is only a guide offered with hope and optimism; the use and interpretation of images cannot be controlled. The most carefully constructed context is still liable to reconfiguration, omission, misconstrual, and multiple interpretations. . . . In contests over ownership and power, identity politics prime people to interpret images through a hermeneutic of suspicion and blame that usually also assumes those whose images are presented are innocent or duped. With little contextual guidance, the photographs . . . were more open than usual to interpretation.

And Catherine Lutz and Jane Collins's (1986) study of *National Geographic* photo-graphs showing the power of captions to inform the reading of images bolsters this point of view.

In some ways any exhibition of art from the "Other" lays oneself open to mis-interpretation. As Kratz (2002:176) sums it up:

> In political debates over representation, preinterpretation might also include a readiness to assign bad intentions to those who use certain representational forms and techniques. This interpretive grid disregards viewers' own interpretive abilities and involvement while projecting a determining power onto others. . . . With no textual framing or explicit contextual guidance, viewers may be especially involved in and responsible for interpretation. . . . Further, the ascription of bad intentions stresses exoticizing tendencies alone. It typically ignores the complex dynamic between exoticizing and assimilating interpretations, though most exhibitions accommodate both simultaneously, in varying degrees.

Goffman (1974) defined context as being bound up in the participants' sense of what is going on, rather than the actual situational setting. McClusky and the Seattle Art Museum tried a bold experiment, attempting to bring a new understanding of Africa to the public. But removing the expected authority, as found in the comfort of labels, gave free rein to visitors' imagination to define the context of the exhibition and their place in it. Many visitors allowed themselves to become immersed in the new experience. But some, unused to being active interpreters in a museum setting, created an exhibition invisible to most and light years away from curatorial intentions.

Conclusion

At issue in this article has been the removal of curatorial authority and the representation of African art versus its reception by an audience accustomed to certain conventions. The politics of representation in museums has increasingly become a topic of strident debate. As a result, curatorial authority has been undermined, leading to what I would like to call "a crisis of translation" in view of the audience and their otherizations. In spite of its best intentions, for some people the Long Steps exhibition neither helped to improve their understanding of the African art on exhibit nor did it open their ears to indigenous voices.

Questions for Discussion

1. What is meant by the "crisis of representation" in museums and the human sciences?

2. Why have museum exhibitions, in particular, been in the frontline of debates on the politics of representation?

3. Removal of curatorial authority gave free rein to the preconceived ideas of some members of the public visiting the African art exhibition in the Seattle Art Museum. In some cases it had an adverse effect on the museum's intention to make indigenous voices heard. What do you think the museum could have done to ameliorate this situation?

Acknowledgements

This article was adapted from a paper originally published as "My Africa, Your Africa: Can 'Our' Africa Exist," *Visual Anthropology* 17(3–4):387–399, 2004, special issue: Confronting World Art, ed. Eric Venbrux and Pamela Rosi.

References

Ames, Michael M. 1999. "How to Decorate a House: The Re-Negotiating of Cultural Representations at the University of British Columbia Museum of Anthropology." *Museum Anthropology* 22(3):41–51.

Berger, John. 1980. *About Looking.* New York: Vintage.

Cannizzo, Jeanne. 1989. *Into the Heart of Africa.* Toronto: Royal Ontario Museum.

———. 1991. "Exhibiting Cultures: Into the Heart of Africa." *Visual Anthropology Review* 7(1):150–160.

Clifford, James, ed. 1988. *The Predicament of Culture: Twentieth-Century Ethnography, Literature, and Art.* Cambridge: Harvard University Press.

———. 1997. *Routes: Travel and Translation in the Late Twentieth Century.* Cambridge: Harvard University Press.

Durrans, Brian. 1992. "Behind the Scenes: Museums and Selective Criticism." *Anthropology Today* 8(4):11–15.

Enwonwu, Ben. 2000. "The African View of Art and Some Problems Facing the African Artist." *Ijele: Art eJournal of the African World* [online]. Available: http://www.ijele.com/vol1.2/enwonwu4.html.

Frese, H. H. 1960. *Anthropology and the Public: The Role of Museums.* Leiden: E. J. Brill.

Fulford, Robert. 1991. "Into the Heart of the Matter." *Rotunda* 24(September):19–28.

Goffman, Erving. 1959. *The Presentation of Self in Everyday Life.* New York: Anchor Books.

———. 1974. *Frame Analysis: An Essay on the Organization of Experience.* New York: Harper and Row.

Karp, Ivan and Steven D. Lavine, eds. 1991.*Exhibiting Cultures: The Poetics and Politics of Museum Display.* Washington, DC: Smithsonian Institution Press.

Kratz, Corinne. 2002. *The Ones That are Wanted: Communication and the Politics of Representation in a Photographic Exhibition.* Berkeley: University of California Press.

Lévy-Bruhl, Lucien. 1922. *La Mentalité Primitive.* Paris: Librairie Félix Alcan.

Lord Cultural Resources Planning & Management Inc. 2002. Seattle Art Museum: In-Gallery Audience Research Report. Unpublished report.

Lutz, Catherine and Jane Collins. 1986. "The Photograph as an Intersection of Gazes: The Example of *National Geographic.*" *Visual Anthropology Review* 7(1):134–149.

Mack, John. 2001. "'Exhibiting Cultures' Revisited: Translation and Representation." *Folk* 43:195–209.

McClusky, Pamela. 2002. *Art from Africa: Long Steps Never Broke a Back.* Princeton: Princeton University Press.

Mudede, Charles and Emily Hall. 2002. "African Nightmares: The Colonialism of Looking." *The Stranger* (February 20).

O'Hanlon, Michael. 1993. *Paradise: Portraying the New Guinea Highlands.* London: British Museum Press.

Ottenberg, Simon. 1991. "Into the Heart of Africa." *African Arts* 24(3):79–82.

Peers, Laura L. and Allison K. Brown, eds. 2003. *Museums and Source Communities.* London and New York: Routledge.

Roberts, Mary Nooter, Susan Vogel, and Chris Müller, eds. 1994. *Exhibition-ism: Museums and African Art.* New York: Museum for African Art.

Schildkrout, Enid. 1991. "Ambiguous Messages and Ironic Twists: Into the Heart of Africa and The Other Museum." *Museum Anthropology* 15(2):16–23.

Shelton, Anthony. 2001. "Unsettling the Meaning: Critical Museology, Art and Anthropological Discourses," in *Academic Anthropology and the Museum,* ed. Mary Bouquet, pp. 142–161. Oxford: Berghahn.

———. 2003. "Curating African Worlds," in *Museums and Source Communities,* ed. Laura Peers and Alison K. Brown, pp. 181–193. London and New York: Routledge.

Shepperson, Arnold. 2002. "Colonial Experiences and the Concept of 'Being African'" [online]. Available: http://www.nu.ac.za/ccms/amp/projectarticles.asp?ID=4.htm.

Thompson, Jerry L. and Susan Vogel. 1990. *Closeup: Lessons in the Art of Seeing African Sculpture from an American Collection and the Horstmann Collection.* New York: International Museum of African Art.

Thompson, Robert Farris. 1974. *African Art in Motion: Icon and Act in the Collection of Katherine Coryton White.* Los Angeles: University of California Press.

Tonkin, Elizabeth. 1992. *Narrating Our Pasts: The Social Construction of Oral History.* Cambridge: Cambridge University Press.

17

Native American Art in a Global Context

Politicization as a Form of Aesthetic Response

Nancy Marie Mithlo

We have all been colonized. Our strength is in our diverse approach to addressing our colonization.

—Gabriel Lopez Shaw

An analysis of the production of contemporary Native American arts demands a critical engagement with indigenous systems of knowledge. In advocating an indigenous knowledge systems approach, I am not proposing a reconciliation of art and anthropology, nor am I privileging Native American studies as an alternative. I argue that the conceptual frameworks commonly used in the analysis of form, style, consumption, and display of indigenous arts fail to capture the essence of artistic intent. My elevation of subjective interpretations as the key locus of inquiry reflects broader conceptual developments that seek to share power with subject populations, not to restrict legitimate interpretive power to anthropologists and art historians.

The subjective experience of Native American artists in the context of global and historical concerns is the focus of this article. In this sense, a 100-year-old legacy of curatorial colonialism has produced profound disorganizations of unique knowledge systems, the total ramifications of which, at this point in history, we can only guess. I conclude that the ability of artists to produce culturally meaningful statements has less to do with economic constraints alone and is more poignantly informed by internalized notions of disempowerment and subordination.

The subjugation of indigenous peoples under colonialism results in many forms of oppression, from which the arts are not immune. For more than a century museum curators, anthropologists, art historians, and art dealers have controlled

and shaped the dissemination of Native arts systems, distorting this knowledge into forms that are incoherent and often unrecognizable to indigenous peoples themselves. Such control represents a new kind of colonialism that now confronts indigenous artists when they try to present their work to the public. In this sense I view academics as just one type of patron or consumer of Native arts.

A focus on institutions and patrons of Native arts cannot significantly enhance a reading of indigenous aesthetics or worldviews. I propose shifting the locus of the analysis away from the psychology of the oppressor (what curators and other consumers feel about Native American arts) to the experiences of the oppressed. By doing so, a new discursive space is made available in which unique paradigms of knowledge may become accessible. It is therefore the internalized passions, desires, and insecurities of the artist that should serve as the basis for interpretation—and more pointedly to the concerns of this article—politicization. Focus on indigenous knowledge systems in an analysis of art allows us to consider politicization as a form of aesthetic response. In other domains indigenous knowledge systems have aided our understanding of local ecologies. In a similar way, taking indigenous systems of knowledge into account can alter the ways we study and understand developments in indigenous arts internationally.

Turning the gaze away from the collectors, the museums, the market, and even the relevance of Native art to other art movements, historically allows an opportunity to engage in self-reflective critique. The terms "politicization" and "knowledge systems" reference a concern with the motivation, self-perception, and historical self-situation of the total arts complex for Native American artists. This approach is neither descriptive nor celebratory, as are many contemporary assessments. (In fact, there is more to mourn than to celebrate.)

The method I describe is more closely akin to the writings of film theorist Bill Nichols (1992), which resembles a testimonial. Testimonials embrace the personal as political. They honor experiential knowledge, and embody social collectivities rather than represent them in an authoritative way from some external, privileged perspective. This distinction is important because a Western reading of the word politicization seems to signify an authoritative or bounded social movement often defined in opposition to another (for another critique, see Bloch 1975). In seeking an alternative reading of this concept the embodiment of collective truths necessitates an absence of control and a blurring of individual authorship. These distinctions involve multiple concepts of authority—including authorship, control, and curation. They are crucial considerations in constructing a theoretical approach that reflects indigenous realities. They are also the areas that present the greatest challenge to contemporary art theorists, including the artists themselves.

Efforts to politicize traditional arenas for indigenous arts are typically cast as either confrontational statements by individual artists asserted through the content of the work or as communal interpretations that depend on the mediating force of a curator or institutional sponsor. The Venice Biennale projects under the collabora-

tive Native American Arts Alliance (NA3) assertively sought to avoid both of these strategic maneuvers. For the past decade, I have been engaged in an inquiry about the nature of Native American arts production and I was both a participant and an observer in NA3's inquiry about the nature of Native American arts production, display, and consumption.

As a political strategy, our group avoided individualism because it so often led to vanity and opportunism. Institutionalism was eschewed because it so often demands artistic compromises to appease an audience. Ultimately, however, NA3's efforts were diminished by an internalized colonialism that emerged in themes of authorship and control. We were simultaneously both victim and victimizer. Our self-censorship became a seamless reflection of our inherited oppression. Thus, "politicization" as an outgrowth of both consumerism and public interpretation in indigenous arts is inhibited by cyclical expressions of subordination. Resistance to the external turned into internal oppression. Self-perceptions of race and ethnicity appear to be inescapability formed in opposition to the flawed and biased interpretations of others.

Anthropology has long been based on the premise that as anthropologists we seek to learn about others so that we can better understand ourselves. Examination of the exotic was a seemingly self-evident way in which to compare and contrast learned or "natural" behavior. Ironically, the status of "the other" in the new millennium appears to rely on the same interpretative framework as before. In order to understand ourselves we too must understand those whose worldviews depart from our own. The challenge of articulating indigenous knowledge is the ability to articulate paradigms of thought that have become buried and often obscured due to forced assimilation—loss of land, language, and religion.

For Native peoples and anthropologists supportive of Native rights, the key response has been to critique the interpretations of others—in film, advertisements, research findings, social programs, and economic development initiatives. Yet, is this reexamination of stereotypes, ideologies, and philosophies of the oppressors a useful strategy in light of pressing internal social concerns such as health, education, and self-determination? I argue that in the realm of aesthetic theory, as it applies to Native arts, this reactive stance is actually harmful.

As a tool of liberation for marginalized peoples, art has historically been tied to the economic returns of the market, often bartered hand in hand with tourism or other revitalization efforts. Rationalizing arts commerce as a means of promoting self-esteem or developing cultural centers as a tool of social empowerment are no longer justified as an effective means of self-expression. Tribal endeavors that seek to gain acceptance through the traditional arts channels, whether the marketplace or the museum, are reacting to the ignorance of others. They are not engaging in a proactive stance to create self-determination or legitimacy (but see Ames 1999).

Tribal cultural centers and majority museums, which retain large collections of traditional indigenous material, have seemed to offer double benefits for indigenous people, providing cash from tourists on the one hand and offering an opportu-

nity to "tell our story" on the other. Whether it is tourists supporting the local economy with arts consumption or the interest of the mainstream in learning more about multicultural issues via the museum, the focus of both is to serve non-Natives with arts or information capital. I contend that this self-serving agenda is no longer valid or necessary in a world where subject populations exercise their right to deny research that does not directly benefit their own people.

Yuchi artist Richard Ray Whitman (2001:208) laments, "so much is put upon us to give, give, give. We respond by give, give, giving." This accommodation to the emotional and educational needs of others diverts communities from the important work of defining their own interpretations of indigenous cultural politics. Self-expression should start with wisdom, not the ignorance of others. It is this proactive stance that has fueled recent collaborative Native American art statements at the Venice Biennale 1999, 2001, and 2003. The obvious impact, however, was subtle, even obscure.

Umbilicus: "What is the center of our reality?"

The NA3 was formed in 1997 by a group of artists, intellectuals, and educators based in Santa Fe, New Mexico. Influenced by indigenous colleagues from Canada and Australia who had exhibited at the Venice Biennale in 1995 and 1997, the NA3 chose Venice as the location to make an international arts statement. Our purpose was to give Native people the opportunity to make art that would be meaningful to Native communities, free of the commercial pressures to produce politically neutral work for consumers. The resulting projects were the exhibitions Ceremonial, sponsored in 1999, Umbilicus in 2001, and Pellerossasogna in 2003. Our goals were theoretically rich and complex. We debated, agonized, and struggled to articulate a contemporary statement that reflected a self-chosen identity.

In the end, it was not an easy equation for those other than the organizers to comprehend given the complexities of our lived realities at the turn of the millennium. Why would Native Americans go abroad to speak to their own communities? Is a pan-tribal statement possible, given the vast disparities of unique tribal values? What can an elitist, international venue give us that we could not accomplish ourselves at home in the United States?

The project was equally burdened by mixed reviews about our legitimacy. Stereotypes of disempowered, impoverished, and amateur Native American artists failed to capture the reality of urban, professional, and mobilized Native participants. Often we were asked, "Who let you go?" as if permission was required. Once in Venice several viewers asked, "Where are the Indians?"

In drawing this example of indigenous arts actions after a century of exploitation of Native American arts, I do not engage in self-congratulating or celebratory assessments. In fact, I wish explicitly to expose the areas where the project failed to

meet its goals. Specifically, I focus on the areas of tension and disagreement concerning authorship and control. What follows therefore is an analysis of the path any indigenous, colonized people might travel. Santa Fe is a useful metaphor to describe where generations of arts commerce in a tourist destination spot can lead. What, then, is to be learned from the actions of urban, politically engaged, self-aware, Western-educated, intertribal, Native elites asserting identity on a world stage? In a cultural arena that is increasingly globalized, these findings may articulate what might be expected in communities that are postcommerce and mobile in an era defined as "late imperial" (Biolsi and Zimmerman 1997:7).

Symbolic Politicization: "Our existence is self-evident"

The primary agenda of exhibiting in Venice was self-interpretation. It was an attempt to show "that our art came from our culture and that we were going to try desperately to get it back to our culture" (Haozous 2001). In addition, the process of organizing was to be communal. No curatorial control or institutional sponsorship fueled the project. Both the content and the process privileged group control, avidly avoiding any individual statements. By engaging in a concerted communal arts production were we trying to re-create an authentic sense of self? Were we longing for a time that has passed under the sweep of global capitalist norms?

In standard academic discourse, ideas of authenticity are commonly interpreted in the "imperialist nostalgia" mode as a vestige of the corrupt legacy of colonialism (Rosaldo 1989:68–87). The desire for all things authentic automatically identifies indigenous traditions as lacking in concepts of dynamism and change. It also exposes the covert implications of power that are exercised when one group challenges the self-definition of another. This is not the sense in which I interpreted the collective's actions.

Organizers explicitly aimed for "right thinking" and "proper behavior" as the impetus for a return to communal sensibilities (Mithlo 2000). Maori theorist Linda Tuhiwai Smith (1999:73) suggests that a longing for authenticity can signal alternate meanings for those of the colonized world. She argues that belief in an idealized self may be appropriated as a means of "reorganizing 'national consciousness' in the struggles for decolonization." Smith refers to the ways these "symbolic appeals" are strategically important in political struggles.

The act of applying to and being accepted by the institution of the Venice Biennale as an *al latere* exhibition was a political coup, symbolic of our empowerment—a Native arts organization sought and gained acceptance as a sovereign nation by an international organization. For this group, it was the equivalent of gaining entry into the United Nations. Likewise, the curators of Authentic/Ex-centric: Conceptualism in Contemporary African Art explained their determination to exhibit African diaspora art at the Biennale by stating, "If you do not exhibit, you do not exist!"

(Vetrocq 2001:113). This identification and enactment of symbolic acts are indicative of indigenous attempts to exercise control over predetermined social situations.

Floyd Solomon, Laguna educator and artist, states:

> The task that lies ahead is to begin to seek and develop an artistic language which communicates the experiences of Native Americans within contemporary society without having the language be confused with the expressions of mainstream America or the traditionalism of past Native American images. (Mitchell 1992)

Similarly, artist Mateo Romero (2001:208) asserts the possibility of "a portrait of the artist in current vernacular."

These challenges suggest the crucial role of language in transforming the inaccurate representations of the past. The metaphor of language seems particularly appropriate as indigenous artists seek symbolic control of their statements. Words as symbol embody power and control over abstract thoughts and actions. As symbols only, however, they also ultimately fail to address the enactment of empowerment organizers sought in the participation in worlds previously unavailable to even our parents a generation before.

Capitalist Determination Rejected: "What is the center of our reality?"

The late Lloyd New, president emeritus of the Institute of American Indian Arts, authored the definite statement on the use of cultural difference as a basis of creative expression. At the heart of his ideology was the belief that Native Americans no longer had to be poor to be authentic. As a person who knew poverty from his childhood, New would often declare, "I'm not going to apologize for driving a nice car or living in a nice home" (New, pers. comm.). Clearly, during the early decades of contemporary Native arts production (1960s–1980s), economics played a solid role in how Native artistry was evaluated.

A poignant testimony to the privileging of wealth in Native communities can be drawn from the newspaper accounts of the deaths of two Native artists in Santa Fe. The headline following the discovery of Grey Cohoe, a Navajo printmaker, who at the time of his death was destitute, stated, "Friends say man found dead in alley was artist with alcohol problems" (Terrell 1991). In contrast, the news account of the death of Earl Biss, a Crow painter who successfully sold his work, read, "Master oil painter, Earl Biss, 51, dies" (Soto 1998). No mention is made in the article that Biss died of a brain hemorrhage allegedly brought on by cocaine intoxication. Both men died of substance abuse, yet one was praised while the other barely received the dignity of his profession: "friends say he was an artist."

Class distinctions have become the major indicators of integrity and worth in Native arts. This value system has become incorporated into Native ideology as well. As a professor of museum studies at the Institute of American Indian Arts (a tribal college in Santa Fe), I would often encounter prospective students brought in by well-meaning high school counselors who declared, "He's a great student, why he just sold a painting in Gallup for $600!" Such scenarios suggest that an unchecked market economy might naturally lead to "capitalist determination"— the idea that economic worth overrides all other considerations, including communal or social values.

In order to understand the path of contemporary Native arts development from a low-wage tourist production to highly valued objects of art, a short historical synopsis is in order. A tremendous outpouring of what was considered to be "breaking news" in both academic and popular publications in the 1970s and 1980s concerned the incorporation of modernism into traditional mediums. The common premise was that Indians were finally "free" to express themselves as they saw fit and were no longer inhibited by quaint, but outmoded, social customs or by ignorant tourists who wanted only pots and two-dimensional paintings (Brody 1971). The problematic nature of this approach is exposed when one considers the ramifications of simultaneously claiming that modernism has saved Indian art and that Indian art is inherently modern. Each of these assumptions is troubling. In one we wonder why the Native requires saving from his or her own cultural norms, especially by the fine arts. In the other we may challenge its functional, biological, and racist assumptions that Indians are naturally good artists (Mithlo 2001).

Following an almost glutinous spate of reckless arts commerce in the late 1980s, the Texas oil money gave out and the flush populations migrated to the Pacific Northwest on computer capital, leaving the Southwest market dry. During this time of art famine, many artists simply dropped out of the market, and those that stayed tended to be the mature, savvy lot that had moved work in the region for decades. It was largely this group that we drew from in conceptualizing the next great step for Native arts: politicization. The original participants tended to be over 50 years of age, at the prime of their career, vocal, either economically successful or well-known as a personality in the arts, and disenfranchised. By disenfranchised I mean unsatisfied with current modes of reception and interpretation of their work, despite a few decades of their "making it" in the mainstream. Their participation in the Biennale did not stem from economic need, for each artist was responsible for funding his or her own travel and shipping. A symbolic appeal fueled participation in Ceremonial, the first Native American art exhibition in the Biennale's history. Success in this instance was clearly defined as simply "being there." Our second endeavor, Umbilicus, proved much more complex theoretically, and in terms of our impact, more difficult to read.

Problems with Politicization:
"In this way, we trace the actions of our resistance"

In an era of self-determination in tribal governance, the ability to exercise sovereignty on a world stage appeared to offer assurance of unmediated artistic expression. As one of the Umbilicus exhibiting artists summarized, "An earth relationship is still here for us. We have to redefine ourselves in terms of the earth, not economic terms" (Haozous 2001:208). This earth relationship was demonstrated in both of the main components of the Umbilicus exhibition, which opened June 8, 2001, at the Scuola Grande di San Teodoro, Campo San Salvador, near the Rialto Bridge.

The curatorial theme for Umbilicus was creation and emergence. This theme originated with the collaborative vision of artists Richard Ray Whitman, Mateo Romero, Darren Vigil Gray, and Gabriel Lopez Shaw. NA3's concern with globalism and the environment was further developed on-site by artists Beat Kriemler and Bob Haozous, as they constructed an immense belly structure from aluminum and plastic rods. This feature was covered in barbed wire, laurel branches, and torn red cloth. Poet Sherwin Bitsui's work was featured inside the belly as he narrated the poem "Chrysalis" on film with visuals produced by Shaw. The belly occupied a grand exhibition hallway complete with frescos, stone, and marble, creating an indigenous sense of place within the historic architecture. In an attached cloistered

Figure 1. Piazza San Marco. Photo courtesy of Bob Haozous.

Figure 2. Scuola Grande San Teodoro, Campo San Salvador, Venice, Italy. Site of the 2001 NA3 exhibition Umbilicus. Photo by Bob Haozous.

room, Shaw's video *The Story of Maize* addressed the uses of propaganda and the importance of self-knowledge. The strongly evocative video was completely scripted by Shaw on-site. Below, I explore this video component of the exhibit as emblematic of the tensions about authority that indigenous artists face. Tellingly, and applicable to my reference to indigenous knowledge systems, none of these negotiations was visible to anyone apart from the organizers.

A problem arose when Shaw previewed his Biennale contribution to the organizers a few days before we were to leave for Venice. It is important to note that unlike standard curatorial methods, the NA3 organizers did not become involved in what objects or projects the artists would present. Participating artists were free to sponsor whatever statement they chose. A component of this open-ended process was the fact that there was no money available for shipping. Hence, artists were totally responsible for getting their work (and if possible, themselves) over to Venice. Certainly this mandate inhibited some invited artists from even participating, not only because they lacked personal funding, but from an unwillingness to seek financial support or to learn how to do so. The gallery system of Santa Fe does

not ask this of artists, and some degree of resentment arose from the collective's expectation that artists participate in all aspects of the exhibition process, including fund-raising. Two of the artists initially invited to exhibit in Venice ultimately chose not to participate.

Thus, near the date on which we were scheduled to leave for Venice members of the collective first viewed the video submission Shaw planned to show. His piece featured a powerful reworking of the Disney film *Pocahontas,* originally released in 1995. Shaw's careful editing and overlay of appropriated music to the visuals enabled a completely different reading of this historically based narrative. Shaw's artistic intervention was important on several counts. His critique attacked the manner in which contemporary society unquestioningly accepts whatever version of reality corporate America produces for our consumption. In his words, we are "chumps" (Shaw, pers. comm.). The ethnic and racial overlay implicates simultaneously Native communities as fodder for the stereotypes implicit in the Disney version and as uncritical consumers. The reworked product scathingly portrays Native sexism and violence against Native women, as well as Native male rage against white appropriation of Native women. Violence, the destruction of the

Figure 3. Exhibit team members in Campo San Salvador, Venice, Italy, June 2001. Left to right: Lorenzo Marangoni, Tullia Giacomelli, Gabriel Lopez Shaw, Nancy Marie Mithlo. Photo by Bob Haozous.

Figure 4. From inside the belly structure looking up into frescos during installation of the 2001 NA3 exhibit Umbilicus in Scuola Grande San Teodoro, Venice, Italy. Photo by Bob Haozous.

earth, unchecked technology, and religion were all fair game for Shaw's skilled manipulation of the Disney original. In all, it was a very effective piece.

But questions arose in relation to our legal liability. One of the board members, who had previously been sued by Disney, commented, "They are swift and unrelenting. They will shut us down." Shaw, the youngest of the group and the only one without material investments such as a home that he might loose in a court battle, was intent on using the piece. Other organizers, some of whom had recently lost a court case over artistic freedom, were unwilling to take the chance. Quite simply we were both tired and afraid of another legal entanglement. As a proposed solution, we offered to convey the nonprofit to Shaw before we left the country, leaving him as the sole responsible party. But there was no time to make such arrangements. Ultimately, organizers were forced to ask him to use another piece. To his credit, Shaw agreed, scripting a final video presentation on-site in the five days available to us when we mounted the exhibition.

Tellingly, this self-censorship was characteristic of market negotiations. A patron (the Biennale) creates the illusion that the creative intent of the artist is pri-

mary—sales components are invisible. Yet when an exchange is to take place in which money (or information) is to be transferred from the producer to the consumer (or the Biennale audience), rules suddenly apply. What is your price range? Do you have others in another color? May I get a discount if I buy two? These market conversations paralleled our self-imposed restrictions. Could he make the video with a shorter Disney clip? Was it possible to use other animation? What if he shortened the piece to under a minute?

Although other developments paralleled this example, the *Pocahontas* controversy, and ultimately its censure, illustrates how even our reworking of politicization resulted in an exercise of everything we sought to avoid, particularly individual control. In its desire for a rehabilitating authenticity, NA3 sought a communal response to the artistic censorship that the Southwest market mandates to produce decorative arts. Optimistically, we thought that by exhibiting on a global stage this type of control could be avoided. Tragically, the buy and sell of the market arena held fast even within the theoretical goal of politicization. Here in the ultimate free for all, an international stage where even sounds coming from the earth, rooms of smoke, or a choir that does nothing but scream counts as art, even serious art, here too we were subordinated. Our fears of censorship were confirmed upon our arrival in Venice, where we found a Disney store outlet only a few hundred yards from our venue. Indigenous artists did not have the right to critique an appropriation of their own history because a global corporation now owns it.

Challenges to Developing a Conceptual Framework: "They just are"

Appropriation is not a new story for Native Americans. As outlined by Laurie Ann Whitt (1999:183), the formula consists of three phases: (1) defining the resources of indigenous peoples as common property (for example, land, songs, medicine, and stories), followed by (2) transformation of these resources into commodities that may be privately owned, and finally (3) obtaining political and social control as well as economic profit from indigenous natural, cultural, and genetic resources. Whitt summarizes, "This is not only 'legal theft' of indigenous resources; it is legally sanctioned and facilitated theft." Similarly, Deborah Harry asserts that in basic ways Euro-American values conflict with indigenous notions of group rights. She suggests the manner in which individuals may not be free to sell their knowledge because "either the knowledge cannot be sold according to the group's ethical principles or because permission of a larger group is required first." She concludes, "In areas where we believe we have group rights, these rights are ignored by the mainstream ethical protocols" (Harry, Howard, and Shelton 2000). In the contemporary Southwest Native American arts market subjective appraisals of owner-

Figure 5. NA3 team members at the opening of the 2001 NA3 exhibit Umbilicus at the Scuola Grande San Teodoro, Venice, Italy. Beat Kriemler (left) and Gabriel Lopez Shaw (right). Photo by Bob Haozous.

ship are reflected in a statement by Nambe ceramicist Lonnie Vigil. In a *New York Times* essay chronicling the most recent Indian market in Santa Fe he states:

> I'm the person who creates it, but it's Nambe Pueblo pottery. It belongs to my ancestors, my ancestry, to my family and to our community. Unlike Western art, we don't claim the work as our own. (Brockman 2002)

These indigenous systems of knowledge that privilege community or communal rights are unlikely to be incorporated into standard arts discourses, except for legal mandates such as repatriation that bring collective ownership and about concepts of nonalienation to a public level. In the example of recently produced art and in the realm of fine arts reception, a consideration of communal ownership or even group censorship is largely unavailable. Authorship is intimately tied to legal sanction, power, control, and ownership.

During the preview of the Umbilicus exhibit several hectic arts writers would hurriedly assess the exhibit and then summarily ask for an object list. When NA3 organizers explained that the works were largely communally produced, writers typically expressed either dismay or dismissal. The process of communally produced and sanctioned (even if censored) art was seen to be an immature or amateur response when compared to the seriousness of the other Biennale art on display.

"neither the power
to save or destroy the world rests with us,
but only a choice
to save or destroy
ouselves"
—from "the story of the maize"
mantaka 2001

Figure 6. Still from *The Story of Maize* (produced by Mantaka Media). The video was one component of the 2001 NA3 exhibition Umbilicus. Photo courtesy of Gabriel Lopez Shaw.

This assessment of a flawed attempt to politicize Native arts on a global stage may not appear relevant to those responsible for interpreting ethnographic or historical collections. I suggest however that the continuing crisis of representation be reevaluated. What is now a crisis for some is more than a century of genocide for others. The utilization of indigenous knowledge systems as a theoretical construct for arts assessment may result in unforeseen paradigm shifts. It is crucial that core conceptual frameworks in arts discourse, such as authorship, ownership, and control, are exposed as inextricably bound in individualistic, competitive, and legalistic frameworks that inhibit accurate cultural understandings.

My call for a subjective testimonial approach ensures that these new findings will have relevance for the indigenous artists and theorists who are most intimately affected by the academic consumption of their work. Current ethical mandates call for no less. Systems of production, consumption, and reception of Native arts, seen within the context of inhibited or censored knowledge systems, have the ability to outline the contours of this theoretical perspective in practice. Even failed efforts inform the determination of symbolically authentic political acts. Exhibiting artist Richard Ray Whitman's (2001:208) featured statement in the Biennale catalog captured this sense of empowerment in the search for self-knowledge, "I began to see

when I was not yet born, when I was not in my mother's arm, but inside my mother's belly. It was there that I began to learn about my people."

In sharing a draft of this work with Lonnie Vigil, the Nambe ceramicist cited earlier, I lamented about the lack of a paradigm to legitimize and codify Native American arts. Vigil (pers. comm.) serenely replied that Native arts do not need to be legitimized by anyone, "They just are." This self-legitimizing stance, so prevalent in Native political efforts generally, indicates why there appears to be

Figure 7. Still from Umbilicus (produced by Mantaka Media). The video was one component of the 2001 NA3 exhibition Umbilicus. Photo courtesy of Gabriel Lopez Shaw.

no meaningful common ground within which to discuss areas of interest for both Native arts practitioners and the academy. Critical thinking about indigenous approaches to education incorporates this self-legitimizing status.

In their recent analysis of Indian studies programs, Duane Champagne and Jay Strauss (2002:8) conclude that "Native American studies does not have to and should not reflect the intellectual specializations and categories of U.S. or Western scholarship." Instead, the authors advocate nation building, conceived of as an active engagement with Indian nations. Similarly, Native political analyst Steven Newcomb (2003) maintains that the trust relationship of tribes to the Unites States, so often utilized as *the* reference point for tribal political gains, is in reality a relationship of colonial domination, "a perpetual system . . . designed to hold indigenous peoples and their homelands in bondage and subjection to the American people, for the political and economic benefit of the United States."

This suspicious perspective toward established theoretical paradigms is the result of centuries of exploitation of every resource imaginable—land, water, religion, and the arts. The development of a critical and subjective arts discourse should therefore be situated within debates about the appropriation of other cultural resources, with an awareness that even subject communities may exercise internalized oppression against their own members who attempt to define sovereignty. The conclusion that an indigenous arts discourse must by definition occur outside of established intellectual disciplines and political structures thus moves the weight of responsibility to indigenous nations themselves to articulate these distinct analyses, a burden that will likely only be undertaken when the need for this type of codification is deemed necessary.

Questions for Discussion

1. What was the primary agenda of the Native American Arts Alliance exhibiting at the Venice Biennale?

2. What were the political efforts of the Native American Arts Alliance and how were these efforts related to their art?

3. How are market mandates (economic determinism) replicated in academic arts discourses?

Acknowledgments

This article was written for the 2002 annual meeting of the American Anthropological Association's Society for Visual Anthropology invited session World Art Worlds: Sighting Future Horizons in Visual Anthropology, organized by Pamela S. Rosi and Eric Venbrux. It was also adapted from a paper originally published as "'We Have All Been Colonized': Subordination and Resistance on a Global Arts Stage," *Visual Anthropology* 17(3–4):229–245, 2004, special issue: Confronting World Art, ed. Eric Venbrux and Pamela Rosi. I would like to thank the collective members of NA3, now named the Indigenous Arts Action Alliance (IA3), for their thoughts and efforts, including the 2003 IA3 sponsored Venice Biennale exhibition Pellerossasogna—The Shirt featuring the work of Bay of Quinte Mohawk artist Shelley Niro. The NA3 archives have now been accessioned into the special collections at Stanford University.

References

Ames, Michael. 1999. "How to Decorate a House: The Re-Negotiating of Cultural Representations at the University of British Columbia Museum of Anthropology." *Museum Anthropology* 22(3):41–51.

Biolsi, Thomas and Larry J. Zimmerman. 1997. *Indians and Anthropologists*. Tucson: University of Arizona Press.

Bloch, Maurice. 1975. "Introduction," in *Political Language and Oratory in Traditional Society*, ed. Maurice Bloch, pp. 1–28. London: Academic Press.

Brockman, Joshua. 2002. "Weekend for Indian Artists to Get Their Business Done." *The New York Times* (August 22), p. B2.

Brody, J. J. 1971. *Indian Painters and White Patrons*. Albuquerque: University of New Mexico Press.

Champagne, Duane and Jay Strauss, eds. 2002. *Native American Studies in Higher Education*. Walnut Creek: AltaMira Press.

Haozous, Bob. 2001. "Umbilicus," in *La Biennale di Venezia 49 Exposizione Internationale D'Arte—Platea dell'umanita*, ed. Harald Szeeman and Cecilia Liveriero Lavelli, pp. 208–209. Milano: Electa.

Harry, Deborah, Stephanie Howard, and Brett Lee Shelton. 2000. *Indigenous Peoples, Genes, and Genetics*. Wadsworth, NV: Indigenous Peoples Council on Biocolonialism.

Mitchell, Nancy Marie. 1992. Tea Bag Diplomacy, or the Symbolism of Things. Paper presented at the San Francisco meeting of the American Anthropological Association, December.

Mithlo, Nancy Marie. 2000. "No John Wayne, No Jesus Christ, No Geronimo." *THE Magazine* August:37–39.

———. 2001. "IAIA Rocks the Sixties: The Painting Revolution at the Institute of American Indian Arts." *Museum Anthropology* 24(2/3):63–68.

Newcomb, Steven. 2003. "The Colonial Freedom of Federal Indian Law." *Indian Country Today* [online]. Available: http://www.indiancountry.com/content.cfm?id=1046256088.

Nichols, Bill. 1992. "The Ethnographer's Tale," in *Ethnographic Film Aesthetics and Narrative Traditions,* pp. 43–74. Denmark: Intervention Press.

Romero, Mateo. 2001. "Umbilicus," in *La Biennale di Venezia 49 Exposizione Internationale D'Arte— Platea dell'umanita,* ed. Harald Szeeman and Cecilia Liveriero Lavelli, pp. 208–209. Milano: Electa.

Rosaldo, Renato. 1989. *Culture and Truth.* Boston: Beacon Press.

Smith, Linda Tuhiwai. 1999. *Decolonizing Methodologies.* New York: Zed Books.

Soto, Monica. 1998. "Master Oil Painter Earl Biss, 51, Dies." *The Santa Fe New Mexican* (October 19), p. 1.

Terrell, Steve. 1991. "Friends Say Man Found Dead in Alley Was Artist with Alcohol Problems." *The Santa Fe New Mexican* (November).

Vetrocq, Marcia E. 2001. "Biennale Babylon." *Art in America* September:113.

Whitman, Richard Ray. 2001. "Umbilicus," in *La Biennale di Venezia 49 Exposizione Internationale D'Arte—Platea dell'umanita,* ed. Harald Szeeman and Cecilia Liveriero Lavelli, pp. 208–209. Milano: Electa.

Whitt, Laurie Ann. 1999. "Cultural Imperialism and the Marketing of Native America," in *Contemporary Native American Issues,* ed. Duane Champagne, pp. 169–192. Walnut Creek: AltaMira Press.

The Authenticity of Contemporary World Art
Afterword

Robert L. Welsch

*E*ach of the articles in this volume has considered innovative artworks, whose styles have emerged only recently. Sharon Tiffany, Pamela Sheffield Rosi, and, in certain respects, Russell Sharman have focused specifically on the fact that museums and highbrow art dealers have not accepted these new art forms as authentic. Paul Stoller takes a somewhat different approach by looking at one of the key venues for selling African art, the semiannual tribal art show in New York. He considers how early African art objects are much sought after, while more recent pieces that closely resemble the older ones have very little value to the same collectors. Taking a somewhat different point of view, Eric Silverman is intrigued by the local and regional processes that have allowed Stanford University's New Guinea Sculpture Garden to become accepted by the Stanford community—especially the garden's most skeptical original critics in the Department of Anthropology. Fred Myers is also drawn to the processes of Aboriginal acrylic painting and its acceptance by the Australian public. And Nick Stanley suggests that the importance of Asmat art today would not have been possible without the institutional support of well-placed foreigners.

Eric Venbrux's article takes a similar path, examining how contemporary Tiwi art—along with acrylic dot paintings—has contributed to a national Australian identity. He also considers how the same artworks are being used simultaneously in local contexts for local purposes. In the same way, Sharman argues that art in the Costa Rican city of Limón is important in establishing a Limónese identity, irrespective of whether it is accepted by collectors or museums elsewhere. Several of the authors—especially Helle Bundgaard, Jacquelyn Lewis-Harris, Myers, and Venbrux—discuss local cultural heterogeneity and a lack of local consensus about meaning or imagery in contemporary art. Nearly all of the authors have empha-

sized the diverse field of players involved in constructing a contemporary art world. Most important is the observation that there is interplay between local and foreign notions of what is properly called art.

Carol Hermer and Nancy Mithlo point out that curatorial voices themselves, even when they come from authentic indigenous curators and artists, can be deemed inauthentic in surprising ways. In Mithlo's case, copyright infringement laws prevented Native American artists from using clips from Disney's inaccurate portrayal of Pocahontas to present a more accurate and more authentic view of the same events. Hermer discusses, with some surprise, how American museum visitors interpreted an exhibition with African curatorial voices as inauthentic largely because they did not conform to U.S. stereotypes about Africa.

Generally, all of the articles speak of the "resonance of tradition" (to borrow Fred Myers's phrasing) as much as they speak to issues of innovation and the ongoing construction of contemporary art worlds. Sidney Kasfir, in particular, looks at continuity in the movement of people, objects, and ideas onto and along the Swahili coast. Even Wilfried van Damme's theoretical overview, which supports a sociobiological approach to the study of contemporary art worlds, accepts the idea that "tradition," a topic or theme studied by more than a generation of anthropologists, plays an important role in shaping the art worlds we can now observe.

One question raised repeatedly in these articles is to what extent are these new art forms authentic? This question seems to be an important one, especially given the fact that foreigners are helping to shape art in so many of the field settings described here. But this question is also important because in many of these settings foreigners comprise some of the most important markets for selling these new artworks.

For more than a century anthropological interest in art objects was largely limited to what such objects might tell us about the cultural relations among and between groups. In a sense, such comparisons of art styles, motifs, and decorative traits were studies of cultural identity. But for nineteenth and early twentieth century anthropologists, "cultural identity" typically meant something quite different from what most anthropologists today would mean by this term; in fact, few early anthropologists ever used the term at all. Objects and their decorative styles were assumed to reveal the origins of particular ethnic communities or the kinds of trade and other social connections with differing ethnic communities. These early anthropologists assumed that objects and their decorative styles were one kind of cultural survival that would persist even though other aspects of social life had changed. By studying objects one could thus learn the origins, and therefore the identities, of different peoples.

Since the 1970s, anthropologists have tended to look at objects rather differently, abandoning the earlier preoccupation with objects as cultural survival and focusing on objects as ritual symbols, as markers of different social groups within a society and symbols of important boundaries between ethnic groups. More re-

cently still, anthropologists have looked to objects as a way of unlocking worldviews that are encoded or incorporated in various non-Western aesthetic systems. Anthropologists have also looked to objects to reveal how these worldviews are gendered and how objects reinforce gender roles and expectations. As colonial systems penetrated traditional ethnic communities, anthropologists recognized that customary art forms changed, therefore art styles have come to be seen as marking colonialism as well as expressing native peoples' reaction to it.

However, the articles in this collection look to "ethnic and tourist art"— to borrow a phrase from Nelson Graburn (1976)— for quite a different purpose. The authors argue in diverse ways that in an interconnected world, anthropologists can no longer assert with any confidence that artistic productions

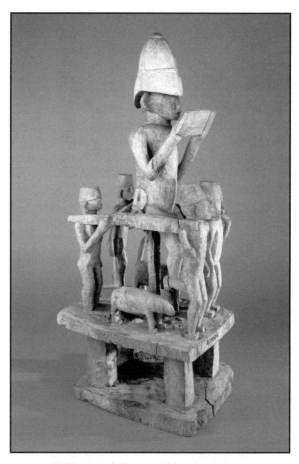

Figure 1. With colonialism, traditional artists began carving what was relevant to them in their contemporary life. Carving of a colonial officer being carried by African porters, Madagascar. Collected by Ralph Linton. A-109977. Photo courtesy of The Field Museum.

from third and fourth world communities represent a pure expression of local values, symbolism, or traditional forms. They may represent some of these expressions, but they will almost always be influenced by imagery, styles, and markets that are far away from the centers of ethnic art production.

Anthropologists and museum curators have long assumed that objects collected in the nineteenth or early twentieth century sometimes exhibited foreign influences, but by and large such early collections were presumed to represent the essence of traditional culture. But, as Edwin Wade (1985) suggested about ethnographic collec-

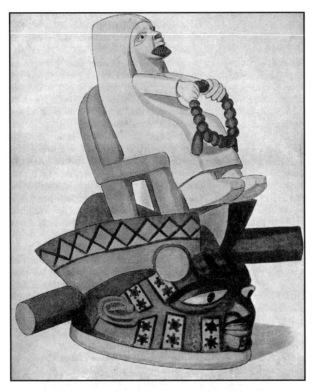

Figure 2. Sketch of a Nigerian *Gelede* mask with missionary holding rosary beads sitting on top. From Julius Lips's book *The Savage Hits Back: The White Man Through Native Eyes* (1937). Although this mask was "ethnographically" used in Yoruba dances, it reflects some of the changes that were sweeping across Nigeria.

tions from the Southwest, most museums are filled with pre-First World War objects that were made specifically for sale to white American visitors. Tourist art in the American Southwest and the Pacific Northwest offer early examples of an art world that involved what may be called "tourist art" production. In Africa, Enid Schildkrout and Curtis Keim (1998) have shown that many "traditional" objects were also created with foreigners in mind. And in the Pacific islands tourist art may not always have begun with the arrival of Captain Cook or other early visitors, but as Nicholas Thomas (1991) has shown most of the art objects in ethnographic and other museums are "entangled" with the diverse aspects of their colonial histories. Markus Schindlbeck (2002), curator at the Museum für Völkerkunde in Berlin, describes the great surprise felt by many of the museum's staff when he demonstrated how a large majority of their Pacific collection distinctly showed evidence of the impact of Western visitors on what had long been interpreted as essentially pure "indigenous" art. For more than a century, anthropologists have clung to the view that these venerable old museum collections represented some pristine past. But it is increasingly clear that these old objects typically have as much to tell us about "worlds in transition" as they do about the precontact cultures and lifeways that existed before the arrival of Europeans.

Not only do artists in all cultures make use of new and innovative designs, but they often incorporate new materials or use newly introduced tools. In Melanesia,

preceding the arrival of Western explorers or traders by a decade or more, the most important new tool was steel. Such tools quickly became objects of great value to local people and became important exchange goods. With the arrival of new tools, materials, or motifs come various kinds of elaborations. Such innovative art objects elaborate on some themes at the expense of others, so that in New Guinea one sees the introduction of steel knives and other cutting tools followed by objects with much more detailed decoration. Many art styles and decorative motifs became more complicated as artists gave up the smooth, clean lines of earlier styles. In these early colonial worlds, art objects often represent some of the first local efforts to confront colonial society. Early museum collections that included the objects that seem most traditional are often able to tell us more about the changes that occurred within these ethnic communities than about the "pristine" cultures they have long been assumed to represent. Indeed, which objects are revealed to foreigners and which are made available for sale outside the community speak directly to the kinds of changes that a community is experiencing, even if the objects were made long before the community had ever seen a European. Such objects have a great deal to tell us about the nature and direction of change that native societies experienced as well as the ways these communities confronted and made sense of the global entanglements that increasingly involved them.

For the most part the articles in this volume self-consciously consider recent production of art objects rather than early museum collections. Many of the authors have tried to dismiss questions of authenticity as irrelevant to the objects they study, since nearly every art object considered was made in a cultural and economic context that necessarily involved concerns that shared relatively few of the cultural understandings of their artists. But it is on this very question of authenticity that these articles as a collection offer their most important contribution. Each article considers objects that are authentic products of a complex interplay between cultural worlds.

In the economic global marketplace of the late twentieth and early twenty-first century, many of the objects discussed here were devalued in the international scene because they are intercultural products. Some of these objects were made in one culture for people in another. Others used nontraditional media, imagery, or themes. By the customary definition of cultural authenticity, such objects can never be authentic. According to such notions of cultural authenticity, an art object can be deemed authentic only if it adheres to some pristine cultural state. But we are bound to ask which period is pristine enough to be the baseline for cultural authenticity?

Many anthropologists may protest that any object made or used at the time of first contact should certainly constitute a suitable baseline for cultural authenticity. In the New World, for example, the European contact that followed the arrival of Columbus would indeed provide an abrupt transition from a precolonial to a colonial, postcontact society. Therefore, first contact might seem a suitable horizon for establishing authenticity.

But even here first contact is often more elusive than we might assume. Descendants of horses introduced to the New World by the Spanish that went feral and spread out into the American Southwest and Great Plains long predated contact between Native American communities and Europeans. Nevertheless, there can be little doubt that the arrival of horses profoundly transformed the societies across the Great Plains, giving them far greater mobility and control over bison herds. Such changes must surely have influenced the region's art every bit as profoundly. But is this post-equestrian, precontact art authentic according to the notion of authenticity mentioned above? Both kinds of art must be authentic, even though both make sense only in terms of dramatically different social contexts. Similarly, art produced in the American West a generation or two after the arrival of Lewis and Clark must be understood as an authentic representation of its social context, even though this more recent context involves a profoundly changed society that was only beginning to come to terms with American settlers and their desire to exploit Native lands.

Trans-Saharan contacts present a similar kind of problem as in the New World, except that in Africa contact between Africans and Mediterranean societies was much earlier and the contact passed in both directions. Nubian and Ethiopian art influences minimally date to classical Roman times, but probably date back to dynastic Egypt. Even in West Africa, trans-Saharan contacts were probably at least 1,000 years earlier than significant European contacts in North America. In his recent volume, *The Atlas of World Art,* art historian John Onians (2004) mapped out some of these connections from the earliest prehistoric times to the present.

My point here is that art objects have always been involved in complex, multicultural worlds. Intercultural contacts have been a source of innovation as artists confronted and tried to make sense of their changing cultural conditions. As George Kubler (1962) suggests in his little book, *The Shape of Time,* the act of replication itself will introduce innovation in art objects. In a similar way, the anthropologist A. L. Kroeber (1919) showed when examining changes in ladies' fashion during the nineteenth century that changes in style can often have a cyclical trajectory, influenced by both local and international attributes. When artists confront changing social and cultural landscapes, it would be absurd to assume that none of the resulting innovations reflected exotic cultural influences.

But if authenticity is not the primary attribute that anthropologists should seek, what should we be trying to discern in these diverse intercultural contexts? In the 1980s, Arjun Appadurai (1986) suggested that art objects made for global markets should be understood as commodities rather than as "art objects." Appadurai's approach—"the social life of things"—was enhanced by Igor Kopytoff (1986). His work significantly shifted our understanding of objects by suggesting that the meanings of all objects change over time or when shifted from one cultural context to another. This shift was probably more obvious to Appadurai than to other anthropologists who studied traditional art because for him art objects were always little

more than commodities. Such a notion was much harder to see if one celebrated and studied objects not for their economic significance, but for their ritual meanings and the cultural symbolisms in which they were imbued. But now that anthropologists acknowledge and recognize changing meanings, shifting symbolism, and other transformations, it seems reasonable that we should look to art objects in particular to reveal the complex, intercultural worlds in which these objects live.

To accept the premise that art objects have social lives does not mean that we are forced to view these objects merely as commodities; we can also use them to explore the shifting meaning and symbolism that such objects should inevitably have. What better place to explore how art objects shift meaning and undergo cultural transformations than with classes of art objects that have emerged out of global interconnectedness. None of the authors in this volume is seduced by the "static" meaning inherent in any object they study. Because they have largely ignored the fetishism of "cultural authenticity," these articles have been free to show that it is how artists confront changing global entanglements that is most interesting for study today. Art objects made specifically for sale to foreigners living hundreds or thousands of miles away would never be expected to have static meanings, but they will inevitably have complex social lives that are partly aesthetic and partly economic. The value of these case studies lies in showing how diverse these intercultural confrontations can be. Here Tiffany and Stoller offer the most explicit descriptions of how meaning changes as objects move from one cultural setting to another, yet each of the other articles draw on rich, local detail to show how in each society considered the art worlds being constructed are being constructed self-consciously.

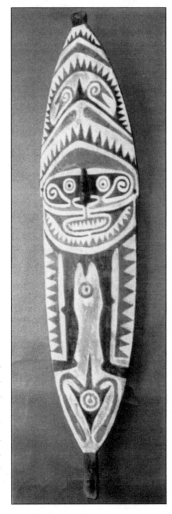

Figure 3. Traditional art can help us understand social and religious changes in tribal life. This *hohao* board, now in a private collection, is one that A. B. Lewis from The Field Museum had unsuccessfully tried to purchase at Vailala, Papua, in 1912. Villagers would not sell such objects to Lewis because they were still important in local ritual and religious life. In the following decades, missionaries and a cargo cult known as the "Vailala madness" led most villagers to sell or destroy their traditional ritual objects, including this one. Photo courtesy of Lewis-Wara Gallery.

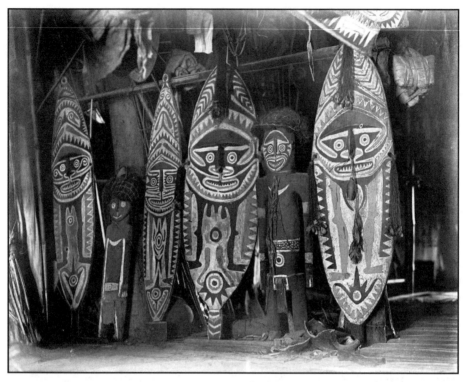

Figure 4. Carved boards and figures in a long house, showing the board in figure 3, Vailala, 1912. Photo by A. B. Lewis. A-37808 (1098). Courtesy of The Field Museum.

In a similar way, as Pierre Bourdieu (1977, 1984) suggests, art objects are at best a special kind of commodity, subject to the tastes of the wealthy classes. The meanings of art objects are clearly shaped by the different values given to them by people from different social statuses and social classes. As several of these articles show, being identified as "fine art" rather than "tourist art" is an important "distinction" that can only be applied by the consumers of art. Artists themselves have relatively little control over how their artworks will be received or understood. When all is said and done, in all of the case studies considered here, artists are dependent on the hegemonic tastes of Western consumers. Sometimes these tastes transform contemporary art into important national symbols (as Myers and Venbrux discuss in Australia), at other times Western tastes dismiss them as "tourist art" (as Rosi and Tiffany suggest in their fieldsites).

Like their ancestors before them, artists in each local context construct an art world that draws partly on the past, but which also confronts the present. These case studies are striking for how they acknowledge and embrace the fact that the

so-called "ethnic and tourist arts" are a response to global connections that are far more pervasive today than a few generations ago. But let us not dwell in a fictional "ethnographic present" of the sort that Bronislaw Malinowski invented for his Trobriand Islanders by creating an imaginary world that existed apart from contact with Western culture and its agents. All of the societies considered in this volume have not been isolated for a very long time—if they ever were. Similarly, we should not try to live in an artificially constructed "ethnographic past" (see Welsch 1998) that fetishizes the art of an earlier period as better, more significant, and more authentic than that of other periods. These supposed "traditional" or "pristine" art objects were created with an awareness of horizons broader than their local communities, however extensive this awareness may have been.

These diverse articles avoid the Scylla and Charybdis of some imagined ethnographic present or an artificial ethnographic past in favor of a middle ground that embraces the fact that all societies inhabit intercultural spaces. Together they provide a road map of possibilities for how we should understand the art being produced today. But these articles also suggest how we might reanalyze older art objects and collections of art objects long revered for their supposed cultural authenticity.

Art worlds are and always have been constructed. But more important still is the fact that art worlds have, with few exceptions, always confronted worlds beyond their local and ethnic boundaries. The art worlds discussed above are more global in their reach and correspondingly more complex and diverse than the art worlds anthropologists have customarily studied. But the processes each author explores can be found in the art worlds of previous generations. For several generations, anthropologists largely focused on the local distinctiveness of art objects as belonging to and identifying fairly static cultural traditions. Most anthropologists, until recently, ignored the connections between particular tribal societies and people in other cultures. These articles urge us to investigate and explore the nonlocal and complex intercultural character found in the seemingly local art worlds we have become used to.

If as anthropologists we ever thought about an art world in Native American, African, or Oceanic art, it was an exceedingly provincial and inward-looking world. Third and fourth world peoples were assumed to live in stable and parochial spaces that contrasted sharply with the presumed dynamism of the West and a few other non-Western civilizations. But it would be naïve to assume that any society's art world was so inward-looking that it failed to express and incorporate influences and interactions with other communities.

Few, if any, of these "traditional" societies constructed art worlds that spanned the globe like the art worlds discussed in this volume. Nevertheless, from the time of the prehistoric artists at Lascaux to those discussed here, artists construct art worlds that embrace the external world as they perceive it. Each of these articles confront an art world of quite different dimensions, sets of personnel, and scope. Ironically, the only significant overlap among all of these art worlds has to do with

the exotic Western consumers of art, a congeries of individuals that seems anything but exotic to most of the students who will read these articles.

References

Appadurai, Arjun, ed. 1986. *The Social Life of Things: Commodities in Cultural Perspective.* Cambridge: Cambridge University Press.

Bourdieu, Pierre. 1977. *Outline of a Theory of Practice.* Cambridge: Cambridge University Press.

———. 1984. *Distinction: A Social Critique of the Judgment of Taste.* Cambridge: Harvard University Press.

Graburn, Nelson H. H., ed. 1976. *Ethnic and Tourist Arts: Cultural Expressions from the Fourth World.* Berkeley: University of California Press.

Kopytoff, Igor. 1986. "The Cultural Biography of Things: Commoditization as Process," in *The Social Life of Things: Commodities in Cultural Perspective,* ed. Arjun Appadurai, pp. 64–91. Cambridge: Cambridge University Press.

Kroeber, A. L. 1919. "On the Principle of Order in Civilization as Exemplified by Changes of Fashion." *American Anthropologist* 21(3):235–263.

Kubler, George. 1962. *The Shape of Time: Remarks on the History of Things.* New Haven: Yale University Press.

Onians, John, ed. 2004. *Atlas of World Art.* Oxford: Oxford University Press.

Schildkrout, Enid and Curtis A. Keim, eds. 1998. *The Scramble for Art in Central Africa.* Cambridge: Cambridge University Press.

Schindlbeck, Markus. 2002. "Contemporary Maori Art in Berlin's Ethnological Museum," in *Pacific Art: Persistence, Change and Meaning,* ed. Anita Herle, Nick Stanley, Karen Stevenson, and Robert L. Welsch, pp. 342–352. Honolulu: University of Hawai'i Press.

Thomas, Nicholas. 1991. *Entangled Objects: Exchange, Material Culture, and Colonialism in the Pacific.* Cambridge: Harvard University Press.

Wade, Edwin L. 1985. "The Ethnic Art Market in the American Southwest, 1880–1980," in *Objects and Others: Essays on Museums and Material Culture,* ed. George W. Stocking, Jr., pp. 167–191. History of Anthropology, Volume 3. Chicago: University of Chicago Press.

Welsch, Robert L. 1998. *An American Anthropologist in Melanesia: A. B. Lewis and the Joseph N. Field South Pacific Expedition, 1909–1913.* Honolulu: University of Hawai'i Press.

Contributors

Helle Bundgaard studied anthropology at the University of London's School of African and Oriental Studies and is a Lecturer in the Institute of Anthropology at the University of Copenhagen. She has conducted anthropological field research in India and Copenhagen, focusing on the production of arts and crafts in Orissa, waste management in Chennai (India), and white minority children in Danish welfare institutions. She is the author of *Indian Art Worlds in Contention: Local, Regional and National Discourses on Orissan Patta Paintings* (Curzon, 1999) and a number of articles and book chapters.

Alexis Bunten is a graduate student in anthropology at UCLA. She has conducted several periods of anthropological field research in southeast Alaska among the Tlingit, focusing on the production and consumption of contemporary Native art. In 1999 and 2000 she was affiliated with the Sealaska Heritage Institute.

Carol Hermer taught visual anthropology at the University of Washington and has been President of the Society for Visual Anthropology. She prepared the media components of the exhibition Art from Africa: Long Steps Never Broke a Back at the Seattle Art Museum in 2002. With Karl Heider she compiled the volume *Films for Anthropological Teaching* (American Anthropological Association, 1995). She is currently working on a video production discussing the changes in South Africa through one woman's point of view.

Sidney L. Kasfir is Associate Professor of Art History at Emory University in Atlanta and Curator of African Art at the Michael C. Carlos Museum, which is also at Emory University. She has conducted field research in East Africa for many years about changing art traditions. Her numerous publications include *Contemporary African Art* (Thames & Hudson, 1999), *The Wounded Warrior: Colonial Transformations in African Art* (forthcoming), an edited volume entitled *West African Masks and Cultural Systems* (Musée Royal de l'Afrique Centrale, Tervuren, 1988), and numerous articles and chapters on contemporary African art.

Jacquelyn A. Lewis-Harris is Assistant Professor and Director of the Center for Human Origins and Cultural Diversity at the University of Missouri in St. Louis. For a number of years she was a Curator in the Department of the Arts of Africa,

Oceania, and the Americas at the St. Louis Art Museum. She has also worked as an independent scholar and curator, advising several museums, corporations, and nonprofit organizations about Pacific culture. She has traveled extensively in the Pacific for more than twenty years with an emphasis on Papua New Guinea. She recently completed her PhD in anthropology at Washington University in St. Louis. She is author of the monograph Art of the Papuan Gulf and a number of journal articles, book chapters, and exhibit catalogs.

Nancy Marie Mithlo is Assistant Professor of Anthropology at Smith College, where she directs the Tribal College Relations Initiative. Her research interests concern indigenous museum curation methods, the conflicting representations of Native Americans, and the life histories of contemporary Native women artists. She has been affiliated with the Institute of American Indian Arts (a congressionally sponsored tribal college located in Santa Fe, New Mexico) since 1985 in a variety of roles—as a student, museum director, faculty member, and consultant on distance education initiatives. From 1997 to 2003 she chaired the Native American Arts Alliance, a nonprofit organization that sponsored the exhibits Ceremonial, Umbilicus, and Pellerossasogna at the 1999, 2001, and 2003 Venice Biennales.

Fred R. Myers is Professor and Chair of the Department of Anthropology at New York University. He conducts anthropological research with Aboriginal people in Australia, concentrating on Western Desert people, their art, and culture. He is interested in exchange theory and material culture, the intercultural production and circulation of culture in contemporary art worlds, in identity and personhood, and in how these concepts are related to theories of value and practices of signification. His latest book is *Painting Culture: The Making of an Aboriginal High Art* (Duke University Press, 2002). Earlier books include *Dangerous Words: Language and Politics in the Pacific* (New York University Press, 1984, coedited with Donald L. Brenneis), *Pintupi Country, Pintupi Self: Sentiment, Place, and Politics among Western Desert Aborigines* (Smithsonian Institution Press, 1986), *The Traffic in Culture: Refiguring Art and Anthropology* (University of California Press, 1995, coedited with George E. Marcus), and an edited volume, *The Empire of Things: Regimes of Value and Material Culture* (SAR Press, 2001).

Morgan Perkins is Assistant Professor of Anthropology and Assistant Professor of Art at the State University of New York at Potsdam. He is also Director of the Weaver Museum of Anthropology and Director of the Museum Studies Program at the same university. He has conducted anthropological research in China and among the Mohawk of upstate New York. He is coeditor (with Howard Morphy) of *The Anthropology of Art: A Reader* (Blackwell, 2005), and he has curated a number of exhibitions, including What Are We Leaving for the 7th Generation? (Roland Gibson Art Gallery, 2002) and Icons and Innovations: The Cross-Cultural Art of Zhang Hongtu (Roland Gibson Art Gallery, 2003).

Pamela Sheffield Rosi is Adjunct Assistant Professor of Anthropology at Bridgewater State College in Bridgewater, Massachusetts. Her research has focused on the contemporary arts of Papua New Guinea (PNG) and the contested contributions of art and architecture for emerging national culture in PNG. She has published a number of articles and chapters, as well as curated several exhibitions of contemporary PNG art at several American colleges and at the Nijmeegs Volkenkundig Museum at Radboud University Nijmegen, the Netherlands.

Russell Leigh Sharman is Assistant Professor of anthropology at Brooklyn College, City University of New York, having completed his doctorate in social anthropology at Oxford University in 1999. He has conducted anthropology research in Costa Rica and in East Harlem (New York City). His research includes topics on the visual culture of the African diaspora in Latin America, as well as the art and ethnicity in East Harlem. He is author of *The Tenants of East Harlem* (University of California Press, 2006).

Eric K. Silverman is Associate Professor of Anthropology at DePauw University. He has conducted anthropological field research in Papua New Guinea and most recently among American Jews. His research has focused on masculinity, gender, ritual, art, and raising children. He is author of *Masculinity, Motherhood, and Mockery: Psychoanalyzing Culture and the Iatmul Naven Rite in New Guinea* (University of Michigan Press, 2001) and numerous journal articles and chapters, as well as a forthcoming book, *Circumcision and Its Discontents* (Rowman & Littlefield). He is currently writing a cultural history of Jewish dress.

Nick Stanley is Director of Research and Chair of Postgraduate Studies at the Birmingham Institute of Art and Design, University of Central England. He first studied at Birmingham University, later receiving his PhD (in 1981) from the Council for National Academic Awards (UK). He has conducted research on collections and displays within museums of Oceanic materials in Melanesia as well as Europe and North America. His current research is on the artistic production of the Asmat people in West Papua, Indonesia. He is editing a volume on the future of indigenous museums, which deals with Melanesia and northern Australia. He is author of *Being Ourselves for You: The Global Display of Cultures* (Middlesex University Press, 1998) and coeditor of *Pacific Art: Persistence, Change, and Meaning* (University of Hawai'i Press, 2002, with Anita Herle, Karen Stevenson, and Robert L. Welsch). He was the editor of *International Journal of Art and Design Education* from 2000–2002 and is the author of many articles and chapters on art, museums, theme parks, and arts education.

Paul Stoller is Professor of Anthropology at West Chester University. He has conducted anthropological research among the Songhay people of Niger in West Africa as well as with Africans living in New York City and other American cities. His research has focused on sorcery, spirit possession, medical anthropology, and

art. He has published many books, including his most recent volumes *Stranger in the Village of the Sick: A Memoir of Cancer, Sorcery, and Healing* (Beacon, 2005) and *Money Has No Smell: The Africanization of New York City* (University of Chicago Press, 2002). His other books include: *In Sorcery's Shadow: A Memoir of Apprenticeship among the Songhay of Niger* (University of Chicago Press, 1987, with Cheryl Olkes), *Fusion of the Worlds: An Ethnography of Possession among the Songhay of Niger* (University of Chicago Press, 1989), *The Taste of Ethnographic Things: The Senses in Anthropology* (University of Pennsylvania Press, 1989), *The Cinematic Griot: The Ethnography of Jean Rouch* (University of Chicago Press, 1992), *Embodying Colonial Memories: Spirit Possession, Power, and the Hauka in West Africa* (Routledge, 1995), and *Jaguar: A Story of Africans in America* (University of Chicago Press, 1999).

Sharon W. Tiffany is Professor Emerita of Anthropology and Women's Studies at the University of Wisconsin–Whitewater. She has conducted field research in Polynesia and Mexico, and has worked at length with the Margaret Mead papers at the U.S. Library of Congress. She has published extensively on issues of gender and representation, and returns regularly to Oaxaca where she has an ongoing research program. She has written or edited many books, including *The Wild Woman: An Inquiry into the Anthropology of an Idea* (Schenkman, 1985, with Kathleen J. Adams), *Women, Work, and Motherhood: The Power of Female Sexuality in the Workplace* (Prentice Hall, 1982), and *Rethinking Women's Roles: Perspectives from the Pacific* (University of California Press, 1984, edited with Denise O'Brien).

Wilfried van Damme is a Lecturer in the Faculty of Arts, Leiden University and a research associate at the Afrika Museum, Berg en Dal, the Netherlands. He received his PhD from the University of Ghent, Belgium, in 1993, having been trained both as an art scholar and as an anthropologist. His publications include *Beauty in Context: Towards an Anthropological Approach to Aesthetics* (Brill, 1996). In addition to attempting to develop a framework for the global and multidisciplinary study of aesthetic and artistic phenomena, van Damme's interests include the intellectual historiography of the anthropological study of art and aesthetics.

Eric Venbrux is Associate Professor of Anthropology at Radboud University Nijmegen. He has conducted anthropological fieldwork among the Tiwi people of Australia, as well as in Switzerland and the Netherlands. His research interests are in local religion, ritual change, material culture, and the verbal and visual arts. He is author of *A Death in the Tiwi Islands: Conflict, Ritual, and Social Life in an Australian Aboriginal Community* (Cambridge University Press, 1995) and numerous articles and chapters.

Robert L. Welsch is a Visiting Professor of Anthropology at Dartmouth College and an Adjunct Curator of Anthropology at The Field Museum in Chicago. He has conducted field research in Papua New Guinea, Indonesia, Alaska, and New Hampshire. He is the author of *An American Anthropologist in Melanesia: A. B. Lewis*

and the Joseph N. Field South Pacific Expedition, 1909–1913 (University of Hawai'i Press, 1998) and is a coeditor of *Hunting the Gatherers: Ethnographic Collectors, Agents, and Agency in Melanesia, 1870s–1930s* (Berghahn Books, 2000, with Michael O'Hanlon), *Pacific Art: Persistence, Change, and Meaning* (University of Hawai'i Press, 2002, with Anita Herle, Nick Stanley, and Karen Stevenson), and *Taking Sides: Clashing Views on Controversial Issues in Cultural Anthropology* (McGraw-Hill, 2005, with Kirk Endicott). At the Hood Museum of Art at Dartmouth College, he is currently a Guest Curator organizing the first major exhibition of art from the Papuan Gulf of Papua New Guinea in the United States since 1961.